Searching for Stars

Rethinking British Cinema

Series Editor: Pam Cook, University of Southampton

This series is dedicated to innovative approaches to British cinema. It expands the parameters of debate, shedding new light on areas such as gender and sexuality, audiences, ethnicity, stars, visual style, genre, music and sound. Moving beyond narrow definitions of national cinema, the series celebrates the richness and diversity of British film culture.

Published titles in the series:
The Beatles Movies, by Bob Neaverson
Dissolving Views: Key Writings on British Cinema,
edited by Andrew Higson
Gainsborough Pictures, edited by Pam Cook

Searching for Stars

Stardom and Screen Acting in British Cinema

Geoffrey Macnab

CASSELL

London and New York

To my wife, Catriona

Cassell
Wellington House,
125 Strand,
London WC2R 0BB

370 Lexington Avenue,
New York,
NY 10017–6550

First published 2000

British Library Cataloguing-in-Publication Data
A catalogue record for this book is available from the British Library.

ISBN 0–304–33351–4 (hardback)
 0–304–33352–2 (paperback)

Library of Congress Cataloguing-in-Publication Data
Macnab, Geoffrey, 1965–
 Searching for stars: stardom and screen acting in British
 cinema / Geoffrey Macnab.
 p. cm.—(Rethinking British cinema)
 Includes bibliographical references and index.
 ISBN 0–304–33351–4.—ISBN 0–304–33352–2 (pbk.)
 1. Motion pictures—Great Britain—History.
 I. Title. II. Series.
 PN1993.5.G7M27 2000
 791.43'0941—dc21
 99–27248
 CIP

Typeset by York House Typographic Ltd, London
Printed and bound in Great Britain by TJ International Ltd, Padstow,
Cornwall

Contents

Preface

The British stars were somewhat homely in comparison with the legendary international figures. Ivy Close and Ivy Duke were half-heartedly referred to as flappers, and photographs of young actresses in swimsuits appeared in the papers, although the home-grown vamp made comparatively little progress in this country. (Low, 1971, p. 263)

A great deal of trouble was experienced with some famous stars of the speaking stage who were won over to the speaking screen. These people, we were told, proved to be the hardest of all with which the studio hairdressers had to deal ... as a class, they have shown something of a tendency to discount requirements peculiar to the screen. *(Picturegoer's Who's Who, 1933, p. 514)*

In recent years, academics have written about British cinema in terms of its genres, leading cinematographers, great auteurs, studios, magnates, its relationship with central government, its proud documentary tradition and its social history. Bizarrely, though, nobody seems to have paid much attention to British film stars. Most of the work on stardom (notably Dyer, 1979, and Gledhill, 1991) has focused on Hollywood. When British stars are discussed, it is generally only in passing.

What are the reasons for the oversight? Perhaps the problem lies in the nature of the subject. As James Donald noted in an essay on stardom, 'until recently ... there seemed to be little inclination by film theorists to engage with the topic ... a sign, perhaps, of the gulf between theory and popular experience, but more significantly of the difficult problems posed for the academic study of film ... by the phenomenon of stardom' (Cook, 1985, p. 52). As a subject for serious academic study, he implies, stardom cannot help but seem frivolous. Perhaps the same reticence that British producers and publicists sometimes showed when it came to promoting their stars affects writers too.

It is instructive to read reviews of British films in the American trade

press, in magazines like the *Motion Picture Herald* and *Variety*.[1] Again and again, US exhibitors and distributors are warned that they will face a struggle in selling the films on their territory. Quite apart from their leaden pacing and lack of production value (however that is defined), British films are accused of lacking the magic ingredient for attracting cinemagoers – 'marquee names'. British actors, it is claimed, speak too quickly or too slowly, have impenetrable regional or upper-class accents and simply don't know how to behave in front of the camera, but it was not their technique which worried the showmen: it was their anonymity – the fact that they weren't stars.

From Cecil Hepworth and W. G. Barker in the years before the First World War through to Korda in the 1930s and Rank in the 1940s and 1950s, leading British producers put actors under contract and attempted to groom them for stardom. The fan magazines and trade papers ran popularity polls and talent competitions. British stars' life stories were written up in newspapers and books, their personalities helped advertise products from soup to soap, and their images were emblazoned on cigarette cards and posters. Some went to Hollywood, some won Oscars. From Chaplin to Cary Grant, from Charles Laughton to Ida Lupino, any number of top American names were British-born and British-raised. But somehow the idea of the 'British film star' remained an oxymoron in many people's minds.

Searching for Stars does not purport to offer a comprehensive account of the British star system. (Outside various piecemeal attempts at imitating Hollywood models, such a system never really existed.) Nor does the book attempt to discuss stardom in semiological or psychoanalytic terms. Its aims are more modest, namely, to cast light on a few forgotten faces; to consider the industry's faltering attempts at nurturing its own stars; to assess the links between British stars and British genres; to weigh up the sometimes unhelpful influence of music hall and the West End stage on British screen-acting styles; to look at some stock character types; and to trace the careers of a few key figures in the years from 1905 to around 1960, when the contract system collapsed. There is no attempt at devising grand, unifying theories about British cinema's perennial failure to create international stars. Instead, the book takes the form of a series of loosely linked case studies, starting with Cecil Hepworth's stock company and the actor–managers who flirted with cinema in the years before the First World War, and progressing through to the early 1960s. By looking at

specific stars' careers in detail, the book hopes to cast light on British film history in general.

Stars have been crucial to British cinema from the beginning and continue to shape the way that producers, fans and politicians regard the industry. In its report of March 1998, the Blair government's Film Policy Review Group underlined their importance to industry and cinemagoers alike. As consumer research revealed, 'stars endorse a film and provide clues about its likely nature and appeal ... a favourite star remains a deciding factor in choice for cinemagoers'.[2]

I am indebted to the series editor, Pam Cook, without whose patience and encouragement this book would never have been completed. Thanks are also due to Janet Joyce and Sandra Margolies at Cassell (now Continuum).

Notes

1. See, for example, *Motion Picture Herald*, 25 March 1933; *Motion Picture Herald*, 22 April 1933; *Variety*, October 1936.

2. *A Bigger Picture: The Report of the Film Policy Review Group* (Department for Culture, Media and Sport, March 1998).

Of Knights and Clowns

Before 1907, there was no discourse on the film actor. Textual productivity was focused elsewhere, for the most part on the apparatus itself, on its magical abilities and its capacity to reproduce the real. (de Cordova, in Gledhill, 1991, p. 17)

... a curious paradox: the star seems to exist at the centre of the movies, and yet the star system was only grafted on to the production system of the movies after 15 years of anonymous evolution ... (Morin, 1960, p. 8)

Of course, there is no applause in this work. The actor or actress has to perform before a camera: there is no stimulating cheering from the audience to urge them onto better efforts. This may be at the root of the disinclination of many (theatre) stars to step down ... (*Bioscope*, 22 July 1909)

A glance at a selection of stills from early British films is an eerie experience. Whether two men battering each other with sacks of flour and soot in G. A. Smith's *The Miller and the Sweep* (1897), a huge close-up of an eye in Smith's *Grandma's Reading Glass* (1900), a rubbery, grimacing face in James Williamson's *The Big Swallow* (1901) or an androgynous, long-haired youth dressed like Dick Whittington in Smith's *Dorothy's Dream* (1903), the protagonists in all the photographs are anonymous. They may be professional actors, comedians or amateurs, but their names do not survive.

At the turn of the century, British producers paid no special attention to who appeared in front of camera. 'Almost every film was dominated by one man, who devised his own equipment and methods: wrote, produced, *and as often as not acted* (with members of his family) in his own

films: and marketed and sometimes exhibited them himself. In most cases, he also sold cinematograph equipment, as well as taking films to customers' orders and carrying on an extensive export business' (Low and Manvell, 1948, p. 14).

Screen actors were not publicized on cigarette cards or railway station hoardings. They were not written about by name in the trade press. They had no more prominence than artists' models. In Britain, as elsewhere, the fascination of the new medium lay less in its ability to capture the psychology of the actor or the subtlety of performance than 'in the apparatus itself . . . its magical abilities and its capacity to reproduce the real' (de Cordova, in Gledhill, 1991, p. 17).

Films were bought and sold on the basis of their plot and manufacturer, not their performers; the idea of a system which would market and exploit stars was utterly foreign. The actors were treated either in anthropological fashion, as specimens whose movements and behaviour could be observed in comic shorts like Cecil Hepworth's *The Fatal Sneeze* (1907) or Williamson's *The Big Swallow*, or as anonymous archetypes – the lover, the policeman, the convict, the historical figure – who could illustrate a story.

There was little pattern or logic to the names and events which were noted by the new medium. Persimmon's 1896 Derby victory was captured in a famous newsreel by the film pioneer, R. W. Paul. Queen Victoria's funeral in 1901 was more extensively filmed than any other event up until then. Perhaps most bizarrely, Rover, the canine hero of Cecil Hepworth's 1905 film, *Rescued by Rover*, became a household name. Although cast opposite professional actors from the theatre – a real-life husband and wife duo – the dog was undoubtedly the chief attraction. As he scampers across town to rescue a kidnapped baby, the nascent use of parallel editing creates real tension and leads audiences to identify with the animal at the expense of the humans.

'It was rather a family affair, as usual,' Hepworth later recalled of the film. His wife wrote the scenario and played the anguished mother. He himself painted the scenery and played the anxious father. 'My baby was the baby, and the girl out of the cutting room was the nurse maid who lost her. Sebastian Smith – professional – was the soldier who was talking to the nurse, and Mrs Smith – the other professional – was the wicked old woman who stole the baby.' The two professional actors, Mr and Mrs Smith, were paid half a guinea each ('We couldn't get them for less') and

the entire cost of the venture came to a little over £7.[1] reportedly sold 400 copies at £8 each.

In the trade press, Hepworth's dog was mentioned freq actors he appeared alongside not at all. 'Since the days of Saved by Rover [sic],' noted the *Kinematograph Weekly* of 26 September 1907, 'there have been many films with animals as leading characters, but we doubt if Hepworth's famous subject has been so far equalled, unless by their own Black Beauty.' The British, it seemed, loved their animals more than their actors. At the Elmbridge Museum in Weymouth, there is a splendid photograph of *Rover Drives a Car* (1907), which shows Hepworth's dog with his paws behind the wheel and a baby in a bonnet sitting on the passenger seat beside him. Rover's popularity was confirmed by his many imitators. After the dog craze ran its cycle, one British journalist even speculated that tortoises and hedgehogs might be the next screen heroes.[2] He did not seem to countenance the idea that actors could do just as well.

When Rover died in February 1914, the redoubtable mutt earned the kind of fulsome obituary usually reserved for senior industry figures. As one trade paper lamented:

> The Hepworth Manufacturing Company have just suffered quite a severe loss in the death of their famous old dog Rover. This faithful animal had been Mr Hepworth's constant companion even before the Hepworth Company had been founded, and was the general pet of the studio at Walton-on-Thames. He was the first animal to play an independent part in a cinematograph film, and was the hero of many pictures ... Many others beside the Hepworth Company will deplore the death of this old favourite.[3]

Richard de Cordova pinpoints 1907 as the year in which 'narrative forms of cinema (comedy and dramatic)' began to take over from documentary forms, and 1909 as the year in which the 'picture personality' emerged (Gledhill, 1991, p. 24). Audiences, he argued, now had some knowledge of the players, but this knowledge was restricted to the films the players appeared in. Only with the emergence of 'the star', which he dates to 1914, did cinemagoers develop a sense of the players' lives and identities outside their screen roles.

Perhaps de Cordova's model relates accurately to the American film industry, but it provides little enlightenment when applied to its British

counterpart. In the trade press, even during 1909, the British picture personality remained elusive. The *Kinematograph Weekly* and the *Bioscope*, the leading British cinema journals of the period, scrupulously listed every new film of that year, but described each one in terms of plot, genre and sometimes moral, not actor or performance.

When actors were mentioned, it was usually because they had done damage to a farmer's field or broken the peace. And even when it came to making a nuisance of themselves in public places, the British were less conspicuous than their continental or American cousins.

> The adventures of actors for living picture subjects have often enough been the subject of articles in the newspapers of this and other countries. In such cases they have usually culminated in a public court appearance, on a charge of obstruction, and in France and America it seems to be one of the regular duties of the police to intervene in a thrilling story which is being enacted on the pavement. In England we are more law-abiding and mostly conduct the dramas in a quiet country lane or suburban street where the eye of the law is not so keen – and persons with nothing to do less likely to hamper the actors with their inconvenient curiosity.[4]

The only British actors whose names filtered into the trade press regularly, and without any stigma attached, were those denizens of the West End theatre who made lightning raids on cinema, safe in the knowledge that they could immediately return to the theatre once a day's filming was done. 'Early in the morning,' runs a typical piece in the *Kinematograph Weekly* in June 1907, 'a party of well-known West End actresses and actors sped by motor to the Old Manor House at Acton, there to produce a silent drama for the bioscope.'[5] Their names are listed: Miss Mabel Russell 'of the Merry Widow at Dalys; Miss Edith Olive of the Court Theatre; Miss Grace A. Noble'. It is assumed that readers will recognize them. The day's adventure is described almost as if it were a smash-and-grab raid.

The great actor–managers of the late Victorian and early Edwardian era were stars by any definition. They were national and sometimes even international figures whose performances were analysed in microscopic detail. Even their private lives were subject to scrutiny. Take, for instance, the following description of Sir Henry Irving, written by journalist Edmund Yates in his collection, *Celebrities at Home*:

As he jerks along the street with league-devouring stride, his long dark hair hanging over his shoulders, his look dreamy and absent, his cheeks wan and thin, the slovenly air in which his clothes are worn in contrast with their fashionable cut, people turn to stare after him, and tell each other who he is. (Yates, 1877–9, p. 63)

The fame of Irving, and of fellow actor–knights like Sir Johnston Forbes-Robertson, Sir Charles Wyndham and Sir Herbert Tree, all of whom packed out theatres in Britain and America, underlines the strength of the theatrical star system. Such luminaries of the stage were regularly photographed, sketched and painted as well as watched and written about. Their popularity was matched, and in some cases eclipsed, by that of the leading music hall artists of the day, figures like Marie Lloyd, Grimaldi, Dan Leno, Harry Lauder and George Robey, who would dart around London, appearing on several different bills in the course of a single evening.

In theory, then, theatre and music hall provided British cinema with an immense reservoir of ready talent, but the new medium was not able to take advantage of it. The industry, as the producers themselves acknowledged,[6] was under-capitalized; most producers, operating in straitened circumstances, could not afford star salaries.[7] Most producers, indeed, would not have known how to tailor vehicles around such stars: they were manufacturers, not artists. And most of the stars were loath to demean themselves in front of the camera, especially as there was no guarantee that moving pictures would last. It is a measure of the uncertainty about its future that when a brief rollerskating craze hit London in late 1909, film pundits were seriously worried that cinema would be forgotten.[8]

Nobody doubted that the medium had artistic value, although whether this lay in its dramatic or pictorial capacity was a moot point. The trade press talked about the camera's ability to achieve images 'within the reach of neither the artist nor the plate photographer', and of its capacity to rival 'the magnificent portrait photographs of the present day' in the detail it could furnish in its compositions.[9] The cinematograph, it was suggested, could enhance still photography through movement and could record moments in time, but in all the increasingly enthusiastic speculation about film artistry and film science, not much attention was paid to narrative or performance.

While the legitimate stage largely ignored its upstart new rival, there were early rumblings of discontent in music hall circles about the threat the cinematograph might present. When Gaumont threatened to show films of Harry Lauder accompanied by 'talking machine records',[10] the profession took fright. Music hall bills were already being squeezed to make way for film displays between live acts. Performers grew alarmed that they would be elbowed off stage altogether by the new 'living and singing pictures'.[11] But even they regarded the cinematograph as the equivalent of a fairground novelty, not a fully fledged new art. Many believed that film would eventually help them to advertise their live performances, and that a symbiotic relationship would spring up between the old and the new:

> The more the appetites of those who support the variety theatre and musical comedy and drama are whetted by witnessing *potted versions* of star turns and popular pieces on film, the more successful will each flourish, whilst the man, woman or child who has witnessed an exceptionally good performance on screen will never rest content until he or she has made a closer personal acquaintance with the artistes in the flesh in their own particular sphere.[12]

In his famous essay, 'The Work of Art in the Age of Mechanical Reproduction', Walter Benjamin described the way the 'aura' and 'authenticity' of a work of art, 'its presence in time and space, its unique existence at the place where it happens to be' (Benjamin, 1970, p. 222), were shattered when it was reproduced. Actors, music hall artists and their managers evidently felt similarly violated when their performances were filmed. Many stars were signed to exclusive deals with specific theatres. Whether such contracts covered live performances alone or extended to the cinematograph was a matter of fiery legal debate. There were several instances in which film producers were obliged to scrap negatives because they were seen to be breaking their performers' stage contracts. 'If a film version is materially different to the representation on the variety stage, or the piece is one which relies for its success in the music hall upon its patter, and not upon the facial or pantomimic expression of the actor, then it can be filmed with impunity,'[13] argued the *Bioscope* with self-defeating logic: if a piece relied for its success on patter, there was surely precious little purpose in adapting it into a silent film in the first place.

Britain was hardly unique in its theatrical star system. Both France and the United States boasted strong stage traditions. The legendary French actress Sarah Bernhardt appeared in her first film, *Hamlet's Duel*, as early as 1900 and, while she claimed to loathe the medium, was later lured back in front of the cameras to make such films as *Tosca* (1908) and *La Dame aux Camelias* (1911). She acted for the cameras, she stated in *Bioscope*, 'exactly as on the stage. I speak the text of the play without omitting a word.' Not that anybody could hear her. She acknowledged that the silent cinema was developing as an art form, but without sound she still believed that it was fatally compromised. 'From a theatrical point of view, it remains as far away from beauty and dramatic grandeur as ever.'[14]

Leading French stage actors were appearing in films as a matter of course by 1910. Not only Bernhardt but other such notables of the Parisian theatre world as Rejane and Le Bargy also consented to make movies, while many of the leading French playwrights of the day (Sardou, Capus and Lavedan among them) provided film scenarios.

At first, the American theatre reacted to cinema with precisely the same disdain as its British counterpart. An article in the *Washington Times* in the summer of 1909 noted that 'the moving picture machine has only one opponent in this country, and *that is the actor*'.[15] Over the following months, as if to underline how seriously American thespians regarded themselves and their craft, there was a prolonged, absurdly solemn debate in the US theatrical papers about 'whether or not an actor impairs his "dignity" by working in front of a moving picture camera'.[16]

British film-makers took umbrage at the terms of the debate. They argued that film-making was honest work 'and there can hardly be a loss of dignity in honest work'.[17] The language is instructive: film performing is portrayed as a craft, anonymous and lacking in glamour perhaps, but good, worthwhile artisan employment, whereas stage work is deemed frivolous, however lucrative.

Film producers and journalists, wary about the excesses of the theatrical star system, struck a puritanical, censorious note in defiance of what they perceived as actors' self-indulgence. 'Here, as in London,' noted the *Bioscope*'s New York correspondent, 'the actor or actress is pretty much in the position of the spoilt darling of the public. *They are made too much of*. Their photographs are printed, broadcast, and their sayings and doings are given a prominence they do not deserve ... What is the

consequence? When they are out of work, the much lauded actor or actress sometimes thinks twice before accepting a motion picture engagement, and they conceal their names for fear the theatrical manager should object or offer them lower salaries.'[18]

Despite American stage actors' lofty disdain for the new medium, cinema continued to flourish at the expense of theatre in the States, drawing away its old patrons. As ever more theatres were converted into cinemas, unemployment in the profession rose. It was suggested that there were up to 30,000 actors out of work in the USA 'due to the badness of the times and the competition of the moving picture theatre'.[19]

Whatever the 'disinclination of many of the stars *to step down*', to become '*merely a cinema actor*', it was not practical for American stage performers to go on ignoring cinema. That much became apparent in the winter of 1911 when dozens of travelling theatre companies, struggling to compete against the lure of films, went bankrupt and were forced to abandon their actors mid-tour. 'To rail at the picture theatre, and to talk of the degradation of the thespian art is all very well, and, perhaps is looked on as the correct thing to do,' responded the British trade press on learning of the US actors' plight, 'but it is far better to take advantage of the prospect which the cinematograph holds out to the actor and his art. It is not as an antagonist that the actor should regard the moving picture, but rather as his friend, and – for who can say with any degree of certainty? – even his saviour . . . '[20]

By mid-1909 all the leading American film companies (for example, Biograph, Vitagraph, Edison, Essanay) had organized their own stock companies of actors and actresses, mostly drawn from the legitimate stage. The same faces appeared again and again in these companies' films. At first, their names were not publicized. Tino Balio observes that when the 16-year-old Mary Pickford, under contract to Biograph for $5 a day in 1909, asked her bosses to build her up in the press, her request was flatly turned down (Balio, 1976, p. 136). But even without credits, there were flutterings of recognition from audiences. It was only a matter of time until the actors' identities would spill out.

For movie publicists' and myth-makers' sakes, it is convenient to have a moment when the first star was born. American cinema obliges. Just as Pallas Athena is rumoured to have sprung fully formed from her father Zeus's head, Hollywood's original screen siren, Florence Lawrence, is supposed to have been created at a stroke.

This is how the story goes. Carl Laemmle, the diminutive, parsimonious but hugely energetic showman who later built up Universal Studios, found himself some time around 1910 locked, like every other independent film-maker of the era, in a bitter spat with Thomas Edison, the master inventor who had patented well-nigh every piece of film-making equipment available. During the acrimonious skirmishes between Edison and the independents, Laemmle made a daring raid on Edison's 'talent', signing up one of his most beautiful, familiar-looking actresses. (Nobody knew her identity because Edison did not care to publicize it – she was known simply as 'the Biograph girl'.) Laemmle's cunning, showman-like trick was to announce to the world that this unfortunate woman, whose name was displayed for the first time in banner headlines, had died in a train crash. Just when the mournful public was coming to terms with the grim information, he admitted that the news of her death was premature: Florence Lawrence was in fact alive and well, and under contract to Laemmle. Henceforth she would appear exclusively in movies for Laemmle's company, IMP (Independent Motion Pictures).

There are certain problems with the myth. As various historians have noted, Edison companies were publicizing star names long before Florence Lawrence was poached. Besides, if Laemmle did invent the star system, he immediately had cause to regret it. A notoriously cautious entrepreneur, he was soon to be heard grumbling that star salaries were costing him his profit margins. As Thomas Schatz notes, he was loath to pay them, and he was not especially keen about investing in good, first-run theatres either: small wonder, then, that under his guidance, Universal remained a B-grade studio with B-grade actors while MGM, under his former protégé Irving Thalberg, blossomed on the back of its extravagant star roster (Schatz, 1989, p. 20).

Whether or not Florence Lawrence was the original American movie star, she was certainly the first to be recognized by the British. In August 1910, the *Bioscope* broke with its usual conventions by running a named photograph of the 21-year-old actress. In subsequent weeks, there were several full-page features devoted to her. 'The fact that Miss Lawrence, "the girl of a thousand faces", is the IMP star artiste and appears in most of the releases, possesses a great attraction,' enthused the magazine in an early piece about the 'Imps' (as Laemmle's films were nicknamed).[21]

In these early articles, Lawrence was not celebrated for her glamour, beauty or screen presence. It was her acting ability that British journalists

professed to admire. She was versatile – a quality more commonly associated with character actors than stars. 'Film acting is undoubtedly more difficult than that associated with the living drama. The facial expression must, to a great extent, convey to the observer all the emotions – be they jealousy, anger, love, hatred; and it is in this that Miss Lawrence excels, and creates her part into a living reality.' She was, it was stated, 'the ideal picture actress'.[22]

There is a certain irony in the way that the *Bioscope*, taking Lawrence as its benchmark, announces that film acting has changed for good. 'Now that the public is becoming more discriminating and critical with regard to moving pictures, the day of the poorly paid "super" is over,' trumpeted the paper. 'No longer do producers rely on an out-of-work professional to act in a picture drama; the best talent now procurable is obtained, and – reverting to monetary details – the salaries paid to a "first lead" by a film company would make many "legitimate" actors and actresses highly envious.'[23] But there was little evidence of a stampede from stage to screen as British actors attempted to emulate Lawrence's success.

Whatever Lawrence's impact, British producers remained wary of the star phenomenon. No British names were announced with the same fanfare in the trade press. There were regular photographs of British boxers, and continental comedians such as Max Linder from France and Tortelloni from Italy were mentioned in person, but the British players remain as anonymous as ever. Salesmen still grumbled about the unpolished way in which British manufacturers made their films: 'instead of getting a first-class actor or actress to take the leading parts, a second-rate or third-rate one is engaged.'[24]

This cheap and cheerful approach to casting is reflected in a short speech, 'Before 1910', delivered to the British Kine Society many years later by W. G. Barker, one of the leading entrepreneurs in British film culture before the First World War. (He retired from the business in 1916.) Barker recalls that he used to choose his actors from 'the Rogues' Gallery'. This was a newspaper cutting book in which he pasted the faces of all the artists that applied to him for work. 'Any who wanted more than 10s per day was *not* written to' (Barker and Hepworth, 1935, p. 2). He claims that, on the day of shooting, he would simply tell all the actors to come to the studio and would then allocate parts on a strictly common-sense basis. Ophelia in *Hamlet*, for instance, had to know how to swim, and the ghost had to be tall. Shooting would begin shortly before 10 a.m.,

there would be a 20-minute lunch break at 1 p.m., and the film would be finished by around 4 p.m. It was quick and efficient, but hardly a system to guarantee great screen acting.

It must have been as apparent to British producers as it was to their Hollywood and continental counterparts that stars were vital. They were not an indulgence but an economic necessity. As a celebrated 1927 Hollywood business prospectus pointed out:

> In the star, your producer gets not only a *production value* in the making of his picture, but a *trademark value* and an *insurance value*, which are very real and very potent in guaranteeing the sale of this product to the cash customers at a profit. (Halsey, Stuart & Co., quoted in Balio, 1976, p. 179)

Somehow, the business logic behind the star system eluded even Cecil Hepworth, who was the first leading British producer to establish his own stock company. By 1910, Hepworth had gathered around him a little repertory group at his studio in Walton-on-Thames. But he seems to have regarded his actors as functionaries. They deserved, he believed, roughly the same salary as electricians, who worked just as hard on set. He discovered most of his important stars by mistake. As Rachael Low has observed, Hepworth and his fellow producers, who had used the same unknown actors again and again in studio films, suddenly, and much to their surprise, 'found themselves in possession of a monopoly similar to that of a trademark' (Low, 1973, p. 124).

Hepworth was upset when the actors began to be recognized, thereby destroying the family business-style harmony of the Walton enterprise. He very reluctantly set to work publicizing their names.

> I foresaw that what was happening to other firms would certainly happen to us. An actor had the value which was due to his own good work. He also had a fortuitous value, not contributed by him, and due to the money spent in advertising him. That accumulated value he was free – unless, and only for so long as, he was under contract – to sell to any rival firm for as much as he could get. His new firm would, of necessity, add to that increased value and the process would go on, higher and higher, until the producers were impoverished and the actors near millionaires. That, indeed, has come to pass, and it is one of the reasons why the film

production industry is nearly always in difficulty. (Hepworth, 1951, p. 81)

Despite his misgivings, he was easily the most successful of the British manufacturers in promoting his performers, one of whom, Gladys Sylvani, has a fair claim (alongside her much younger contemporary, Chrissie White) to be Britain's first film star. By late 1911, Sylvani was appearing as regularly in the trade press as Florence Lawrence had the year before. She was referred to on posters for her film *Stolen Letters* (1911) as 'the most charming English actress'. Reviews praised her dignity and pantomimic ability. Magazine profiles fawned over her:

> Miss Gladys Sylvani is, without question, the most popular of all English picture actresses. We need not descant upon her talents, because they are well known to everyone who has been to the picture theatres with any regularity, but, at the same time, we should like to lay our small tribute at the fair lady's feet . . . there is no-one who can give so thoroughly a delightful portrayal of the 'English girl' as Miss Sylvani, and, added to her facility for being sweet and fresh and charming, she has a reserve of restrained force, as well as a considerable amount of that thing called temperament which mark her as a dramatic actress very much to be reckoned with.[25]

Sylvani was quintessentially English. Her last name was Smith, but she called herself Sylvani (her middle name) because it sounded more exotic. Before working with Hepworth, she had appeared on stage, in musicals and in dramas. However, like many of the Hepworth Company performers, she seems to have devised a special, understated acting style for screen. Review after review called attention to her restraint. 'Her manner', an admiring *Bioscope* critic wrote of her performance in *A Girl Alone* (1912), 'is absolutely free from all stage artifice . . . she does not go through the gesticulating ritual, so indispensable a part of some actresses' creed.'

By the beginning of the First World War, Hepworth films were routinely praised in the trade press for the quality of their acting.

> The Hepworth Stock Company is a little band of actors and actresses, almost all of whom have marked talent, and who by the practice they have had together in the same kind of work, have

attained a smoothness and a precision which would be impossible to newcomers or to the inexperienced ... Hepworth's films are almost always beautifully 'balanced', and by skilful direction he has accentuated or toned down individual performances, till each bears a harmonious and perfectly adjusted relation to the whole.[26]

Sylvani set the template: her lack of affectation, ease in front of camera and English modesty were precisely the qualities admired in other Hepworth performers. Above all, it was implied, they had escaped the tyranny of the stage. 'Do it simply, naturally, just like you would at home' was the instruction Hepworth would always give his performers.[27]

In their move away from melodramatic acting towards a more 'realist' style, the Hepworth troupers were following the example of D. W. Griffith's stock company at Biograph. There is no evidence that Griffith was a direct influence on Hepworth, but there are clear similarities between the two film-makers. Just as Griffith discovered Mary Pickford, Hepworth launched the careers of Alma Taylor and Chrissie White. Both film-makers were admirers of Charles Dickens and each pioneered their own brand of naturalistic acting in which detail rather than sweeping gestures were used to impart information about a character.

If there was a Hepworth type, it was the ingenuous young nymphet with a love of fresh air and the English countryside. Chrissie White, who signed up as early as 1907, was a perfect specimen. When she was nine years old, already with experience in a stage production of *Bluebell in Fairyland*, she wrote to the producer 'to say that her sister couldn't work in a film that week as requested, and would she do as well?'[28] Admiring her gumption, Hepworth gave her a part as juvenile lead in *Tillie-the-Tomboy* (1910). Later on, when she graduated to full heroine status in a series of films directed by Lewis Fitzhamon, the trade papers professed themselves enraptured.

Miss White has a charming personality and she manages to make this personality felt across the screen. One can watch her with pleasure, irrespective of the part she is playing, because she makes herself felt as an individual, and is not merely a puppet; in short, *she is quite a little feast in herself.*[29]

In a very similar mould was the fragrant Alma Taylor, who started at Walton at the ripe old age of twelve. 'Before that,' the Hepworth fan

magazine gushed, 'she lived a busy outdoor life of games and sports and long cycle rides.'[30]

Hepworth's young stars seldom wore make-up, of which he disapproved. Even after 1911, when he started making longer films and established his studio on a more professional basis, publicity campaigns emphasized how fresh and unspoiled the stars were. Critics seemed inclined to agree. 'What perfectly delightful young persons the Tilly girls are, as presented by Chrissie White and Alma Taylor!' enthused the *Bioscope* about *Tilly and the Dogs* (1912). 'Positively it does one as much good to watch them as a draught of the Moorland breezes. They are so refreshingly young, and real, and full of life. There is nothing theatrical or picture-postcardy about them.'[31]

Their acting was considered artless but honest. 'It's because she believes the play she's in that Alma Taylor has reached so dominating a position in the hearts of British picturegoers.'[32] These were upper-middle-class Home Counties girls who drank milk and lived in country houses. The *Hepworth Picture Player*, the fan magazine which sprang up in 1915, reminded its readers constantly that Taylor's home was 'in a grand old house where Anne Boleyn used to live, at Sunbury, across the Thames'. One momentous day, the house burned down.

> The pleasure of learning that Alma Taylor herself was not injured, and, in fact, that there were no serious accidents, lessens to some extent the sorrow that is felt because of the complete loss of her favourite home ... Time and again had picturegoers been told in newspaper and magazines of the wonderful old house at Sunbury in which the star has lived since she was a baby. It was only four miles from Hampton Court and was once the home of Anne Boleyn, second queen of Henry VIII. Its walls were covered with priceless carvings and paintings, but everything was lost in the fire on New Year's Eve ... Miss Taylor herself was not at home, and her small brother did several brave deeds in her absence.[33]

However trite the journalism, it underlined Taylor's popularity. It was no longer simply her roles on screen which intrigued fans, but her private life too. Not that there was ever likely to be a whiff of scandal there. By 1915 this little Miss Wholesome was topping popularity polls in British trade papers.

To build up Stewart Rome's personality with the public, a very

different strategy was needed. 'Manly', 'outdoors', 'handsome', 'vigorous' were the words that kept on cropping up in Rome's profiles in the Hepworth fan magazine. He may have been born near Newbury, an effete Englishman, but Australia helped roughen his edges. 'It was there that he learned the hard work of bridge building, and it was there too that the hardships of rough life in a new country taught him the ways and motives of a powerful man that a colony produces.'[34]

Hepworth's efforts at catapulting his ingénues and his rugged male lead to fame and fortune were painstaking, if belated: eventually, Taylor, White, Rome and Violet Hopson, 'the dear delightful villainess', were appearing on London Underground posters and on cigarette cards. In early 1914 one actress associated with Hepworth even formed a production company in her own name, Ivy Close Films. Together with her director husband, Elwin Neame, Close intended to produce films which would be 'sold and published by the Hepworth Manufacturing Company'.[35] A former beauty contest winner, she was one of the first stars anywhere to set up on her own: Ivy Close Films predated United Artists (the independent Hollywood company formed by Chaplin, Pickford, Griffith and Fairbanks) by five years. Close was also probably the earliest British star to base her screen image entirely on glamour. As the trade press noted of *Dream Paintings* (1912), her first film with Neame: 'its fanciful story allows her to pose becomingly in various costumes and attitudes, including the celebrated Pears Soap advertisement, Bubbles.'[36] In other words, her acting ability mattered less than the way she looked in front of camera.

When Chrissie White fell in love with and married the male romantic lead Henry Edwards, it looked as if Hepworth had stumbled on Britain's very own answer to Mary Pickford and Douglas Fairbanks. The duo played opposite each other in a series of romantic melodramas, some of which were directed by Edwards, an aspiring film-maker as well as actor. They were certainly popular, 'the most important romantic partnership in British films', as Rachael Low called them (Low and Manvell, 1948, p. 72). Here was probably the first British screen couple whose private lives seemed to mirror their professional roles. Somehow, though, neither they nor their contemporaries could match the lustre of their Hollywood counterparts. British actors were paid a pittance (as little as £5 a week, according to Low's reckonings at a time when even minor American stars could hope for at least £20,000 a year).

Still, Hepworth never overcame his resentment at the way his stars eclipsed even his own efforts. Late in his life, he remained bitter about the circumstances in which Stewart Rome left Walton to join the rival company Broadwest at the end of the First World War. Rome's real name was a mouthful – Wernham Ryott. The Hepworth Company had provided him with his new identity and did not want him to take it with him when he left. The name 'Stewart Rome' was Hepworth property: perhaps it could be given to some other unknown actor. After protracted legal wrangles, Ryott won his case. He continued to call himself Stewart Rome and to profit from all the publicity lavished on him during his days at Walton. The case confirmed Hepworth's worst suspicions that stars had the potential to destroy the industry but also, in hindsight, hints at his own limitations. While he went about building up his players' reputations in pragmatic fashion, he never had the flair or chutzpah to establish a star system along American lines.

Hepworth's eccentric film-making style, in particular his dislike of conventional cutting, meant that his stars were rarely seen in the kind of luminous close-ups that immortalized Hollywood's sirens. In his most ambitious picture, *Comin' through the Rye* (1923), Alma Taylor is obliged to compete with picturesque landscapes, crinoline dresses, top-hats, croquet lawns and a rambling country house for the camera's attention. The symbolism is also a little on the ponderous side. When the heroine believes she has been abandoned by her fiancé, the rye field in front of the house is bare; but when true love blossoms again, so do the crops. Hepworth's film-making aesthetic was based on his love of the English countryside. His studios were based in the heart of rural England, by the banks of the Thames, providing easy access to 'hills, woods, valleys, river scenes, sporting centres, picturesque homes of the wealthy and in fact all that is beautiful and interesting in England'.[37] In his influential essay on heritage cinema, Andrew Higson argues that Hepworth used pastoral imagery in a bid to foster a new kind of 'quality' prestige British cinema (Higson, 1995, pp. 26–97). However, the idea that, even in 1923, he was unaware of the importance of stars is surely mistaken. The very existence of the Hepworth Picture Player fanzine suggests otherwise.

Hepworth wrote in his autobiography that his mission had always been to 'make English pictures, with the English countryside for background and with English atmosphere and English idiom throughout'.

Sometimes these attempts at pastoral film-making left his cast looking like over-dressed mannequins. Arguably, he lacked the showmanship to exploit the actors he groomed to the hilt. (According to contemporary reports, he was a 'man of great earnestness ... a quiet-voiced, grey-eyed fellow'.) Occasionally, he even failed to notice the talent in front of him. Ronald Colman, who went on to become a huge name in Hollywood, barely registered a ripple when he passed through Walton-on-Thames to star opposite Alma Taylor in *Anna the Adventuress* (1920).

As his thoroughly conventional choice of material reveals, Hepworth was also stymied by his own notions of good taste. Outside original screen stories, he produced Forbes-Robertson's *Hamlet* (1913) and a wretched Dickens adaptation, *David Copperfield* (1913), which was written and directed by the prolific Thomas Bentley, a former engineer turned actor. Its opening inter-title hints at its shortcomings: 'Arranged by Thomas Bentley (the Dickensian character actor) on the actual scenes immortalized by Charles Dickens.' There is no fluency to the storytelling; it is merely a series of tableaux, offering pale caricatures of the scenes drawn for Dickens by his great illustrator, Hablot K. Browne (Phiz). Mr Micawber, in particular, is a disappointment: a thin, balding, middle-aged man who conspicuously lacks the shabby grandeur of, say, a W. C. Fields. Perhaps Bentley's approach was influenced by his experiences performing Dickens skits in music hall. His elliptical, stagey style may well have been deliberate, but even if he was aiming to create a new film-making aesthetic, the film still seems painfully short of the exuberance that characterizes the best Dickens adaptations, whenever and wherever they are made.

During his early days in the industry, as Hepworth reminisced in a late 1940s issue of the *Penguin Film Review*, he used to travel round the country giving illustrated lectures. One of the pictures he liked to show was 'a hand-coloured film of Loie Fuller (a music hall actress) in her famous serpentine dance'. If censorious parsons seemed likely to complain, he would pass the film off as 'Salome Dancing before Herod'. But he would never have dreamed of asking two such demure young Home Counties heroines as Alma Taylor or Chrissie White to dance the Dance of the Seven Veils.

A rather more adventurous approach to publicizing stars was taken by Hepworth's contemporary, W. G. Barker. In the autumn of 1910, Barker announced that he was planning a film version of Sir Herbert Tree's

celebrated stage production of Shakespeare's *Henry VIII*. He had per-
suaded Tree himself (undoubtedly the most famous British stage actor of
the time) to appear along with the rest of his company. The great actor–
manager was to play Cardinal Wolsey. Arthur Bourchier, almost as
well-known, was to play King Hal, and various other stage notables
(Henry Ainley, Gerard Lawrence, A. E. George and Violet Vanburgh
among them) were to join the cast, which would number more than
150.

With a true showman's instinct, Barker announced that he was only
going to make 20 prints of the film – 10 for London, 10 for the provinces
– and that he was going to destroy them all after six weeks. 'Thus there
would be no probability,' he announced, 'of a worn and grainy film kept
together by the aid of threads and pins, being shown on the screen of a
tenth-rate theatre,' something which he referred to as 'a travesty of the
real thing, a horror and a nightmare'.[38] He informed the press that he
would be paying Sir Herbert 'a sum which has never been equalled by any
theatrical company for a single picture in the history of cinemato-
graphy'.[39] In the event, Tree earned £1000 for a day's work.

What seemed like wastrel extravagance was, in fact, shrewd marketing.
It conferred an unlikely respectability on the new medium. If Tree, 'the
foremost man in his profession', was prepared to appear in front of the
cameras, then it was likely that many of the other leading actors of the
day, who had previously scorned cinema, would do likewise. By captur-
ing such eminent talents, Barker was also helping lure 'a better class of
patron, what may be called the stall and box person',[40] into the picture
theatres. And he was tapping a national resource: just as Hollywood had
its Westerns, Britain could have Shakespeare.

Perhaps predictably, the first attempt at making *Henry VIII*, in late
November 1910, was sabotaged by bad weather, always a hazard for
British film-makers working on location. In the end, the film was shot in
a single day the following February. The actors performed exactly as in
the original play without any concessions to the camera.

Asked by a friend what it was like to play a Shakespearian role in front
of the camera, Tree responded with typical grandiloquence: 'One throws
oneself into the thing as one goes into a submarine. You take a dive – a
plunge as it were – into the unknown, and calmly await the result ...
Before the film was finished I wondered if I had not deteriorated –
whether, like playing the pianola, I might lose my touch. In playing before

the camera I found that an entirely different method is required, as different as sculpture is from painting ... I thought I was quite passable – thanks to the operator ... ' (Warren, 1937, p. 60).

At least this early dalliance with film did not cost much in terms of the great actor's time: Barker did not like to dally. *Henry VIII* started shooting early in the morning, was completed by mid-afternoon, developed in the evening, and shown to the cast at midnight.

Whatever his reservations, Tree waxed sententious about his experience for the sake of posterity and the trade press. 'I am proud,' he said, 'to have had the honour to present the picture. It is the first permanent record of the great English actor's art. Garrick, Kean and Sarah Siddons – to mention only a few – are but names in the minds of the people. Tree, Bourchier, and Violet Vanburgh will – by means of the cinematograph – live for all time in their wonderful representation of their art ... '[41]

Thanks to Barker, this 'permanent record' was quickly erased. In mid-April, after the film had been given a six-week run, he called in the prints as promised and burned every last one of them.

Nevertheless, the film of *Henry VIII* signalled a mini-boom in Shakespeare adaptations. Another leading English actor, F. R. Benson, made versions of *Macbeth* (1911) and *Julius Caesar* (1911), there was a *Hamlet* (1910) from the Scandinavian company Nordisk, and Barker himself went on to collaborate with H. B. Irving on a high-budget costume drama, *Princess Clementina*.

Barker was a contradictory figure. The most flamboyant showman of the day, he spent the early part of his career hiring unemployed music hall artists to swell the ranks of his stock company at Ealing Studios and paid them virtually nothing. ('There was no such thing as an agent, for no one worried about names,' an old-timer later remembered. 'The legitimate stage had a great scorn for the "flickers" '.[42]) Yet he spent thousands on *Henry VIII*, and then made an equally lavish version of *Hamlet* (with actor–director Charles Raymond) in 1912, established his own stock company of 'All-British Players' (Fred Paul and Fred Morgan among them) and did his best to transform comely young matron Blanche Forsythe into British cinema's greatest attraction by showcasing her in his extravagant productions of *East Lynne* (1913) and *Jane Shore* (1915). Forsythe briefly achieved a mild popularity with British cinemagoers before vanishing from the screen in 1917. Barker himself retired from the industry in 1916. Although he had done more than anybody else to attract

star names to cinema, it seems that he was never really much interested in actors or drama. 'All my cinema life,' he later confessed, 'I pinned my faith to news' (Barker and Hepworth, 1935, p. 4). He was much more excited about shooting the Derby or the Boat Race and then rushing the film into cinemas than he was about making extravagant screen adaptations of literary or stage classics or grooming actors to appear in them.

Barker's experiment with Tree seemingly inspired even Hepworth, who in 1913 produced a film of *Hamlet* starring another actor–knight, Sir Johnston Forbes-Robertson. Unlike *Henry VIII*, it survives. A determinedly eccentric endeavour, it nonetheless offers a fascinating insight into the difficulties even the most established stage actors faced in amending their techniques for the screen. The film opens just as one might expect. Draped in flowing black robes and golden necklace, Forbes-Robertson is seen cutting a suitably melancholy figure on the Elsinore battlements. A mysterious, wraith-like creature with folded arms, presumably the ghost of Hamlet's father, hovers behind him. Guards in tin-pot costumes loll idly by, their bored expressions giving away the fact that the ghost is really just a bearded man with a diaphanous sheet thrown over his head who is conjured out of thin air by projection tricks. Sir Johnston shudders as an intertitle announces 'Most foul and unnatural murder'.

In many ways, Hepworth's *Hamlet* (directed by the Hepworth Company actor, E. Hay Plumb) is a quintessential British heritage film. There is landscape (gloomy Denmark is recreated on the sunny Dorset coast), there is cultural prestige (Shakespeare adaptations make for rather grander cinema than the average slapstick two-reeler), there is rigid, respectful camera work (most scenes are shot in tableau fashion, as if being witnessed from the front row of the stalls), and there is some eccentric, very mannered acting. Above all, there is silence.

Shakespeare without sound is the kind of heroically quixotic endeavour that would probably only occur to British producers. With this particular *Hamlet*, as with Barker's *Henry VIII*, there is a clear sense that the film-makers regard themselves as conduits: they are not trying to mould or interpret the material, but merely to record it. They are preserving a celebrated West End production, by the full Drury Lane company, as if in aspic. Apart from the occasional intertitle, there is very little to assist the spectators to discover what the film is about. It is assumed that they already have an intimate knowledge of the play.

Sir Johnston, at 60 already roughly 35 years too old for the part, plays the Danish prince in feverish fashion. He grimaces, rolls his eyeballs, and pounds the skies with his fists, accentuating every movement in the hope that his sheer animation will compensate for the deadly quiet that accompanies his soliloquies. The drama largely devolves on his face and gestures. He holds poor Yorick's skull in his hand as if it were an oversize apple and declaims the famous speech about once knowing him well. As he wrestles with his conscience by the seashore, his bony features rekindle memories of Max von Sydow in an Ingmar Bergman film. He makes sure we know he is pondering the metaphysical monstrosity of existence by the way he screws up his features.

It is dangerous to make summary judgments about acting styles in silent films without attempting to provide a context. As Roberta Pearson notes, there was a radical shift in cinematic acting in American films between 1909 and 1912. 'Actors,' she suggests, 'moved from a performance style heavily influenced by theatrical melodrama to a style allied to "realist" movements in literature and theatre' (Pearson, 1992, p. 4). What we may today dismiss as histrionic, undisciplined overplaying was rooted in theatrical heritage. As they swooned, grimaced and waved their arms around like windmills, silent actors were using a 'conscious system of conventional signs for portraying characters' emotions' (*ibid.*, p. 5).

This same argument could doubtless be applied to British screen acting too, but it is worth noting that the most vociferous critics of British silent film performances are not historians writing with the benefit of hindsight, but the actors' contemporaries themselves. To put it bluntly, salesmen, trade journalists and sometimes even producers believed that British silent screen actors were often lousy. As 'Cynicus', a columnist in the *Bioscope*, put it, 'of our acting, the less said, the better ... give us actors, men, women and children – not strange, puppet-like machines, obeying the unseen, but nevertheless, painfully obvious, stage manager and his call of action! action!'[43]

Given the sometimes exaggerated respect that British film-makers paid to well-known stage actors, it is ironic that so many should complain about the overly theatrical style adopted by British screen actors. Unlike their French or Italian counterparts, it was observed, these actors were not at ease with mime. They resorted to 'stage artifice', 'gesticulating ritual' and 'conventional theatricalisms' when simplicity and understatement were called for. The problem was exacerbated by the quality of

the performers hired. They were not the leading lights of the English stage, but often anonymous third-raters. And even when prominent stage actors were lured in front of the cameras, they struggled to adapt to the new medium. Many distinguished thespians seemed congenitally incapable of amending their technique for the camera. Take, for instance, the case of Sir Charles Wyndham, cast as Garrick in a Hepworth-produced film based on the eighteenth-century stage luminary's life. 'The technique of films,' Low Warren notes, 'was beyond him. He could not grasp the idea that dialogue then played no part in the operation, and as he strutted before the camera, he would constantly snap his fingers and mumble – to an imaginary prompter "off" stage: "Lines, lines! Damn it! Give me my lines."' (Warren, 1937, p. 61). 'When the British actor makes up his mind not to speak,' sighed an exasperated critic, 'he will learn to converse in pantomime, and so learn to compete with his French and Italian brothers – who have been doing it from their birth.'[44]

Another, related problem was that stage actors often failed to hit their marks: 'the result being that the dramatic effect of some of the entrances is lost, and much of the action cut out of the line of vision.'[45]

On stage, Sir Johnston Forbes-Robertson was renowned for his restraint, for his delicate gestures and mellifluous, cerebral style. 'He stands completely aloof in simplicity, dignity, grace and musical speech from the world of the motor car and the Carlton Hotel . . . the only actor I know,' playwright George Bernard Shaw once wrote of him, 'who can find the feeling of a speech from its cadence.' On the silent screen, almost inevitably, the magic vanishes. Although *Hamlet* was shot on real locations, he acts as if he is still strutting and fretting his way across the stage of the Old Vic.

Each soliloquy is performed – mimed – as if to an audience. Years later, in the mid-1950s, when the 1913 *Hamlet* was rediscovered, John Gielgud praised Sir Johnston's expressive use of his hands and suggested the film offered a valuable record of a famous theatrical performance. In filmic terms, however, the performance simply does not work.

Along with Tree, Sir Johnston was one of the foremost Shakespearian actors of the day, 'the supreme Hamlet of our time'. He followed in a venerable tradition which stretched right back into the eighteenth century. He had studied under Samuel Phelps, who acted under Macready, a former pupil of Sarah Siddons, who performed alongside David Garrick. As thespian family trees go, this could hardly be trumped. Given his

eminence and stage pedigree, it is a surprise to find him, like the equally distinguished Tree before him, performing for the benefit of the cinematograph.

Cinema, after all, was held in very low esteem by the legitimate theatre. The offspring of an 'unholy liaison between the magic lantern and the novelette', as it was once characterized by Anthony Asquith in the *Penguin Film Review*, it was regarded, at best, as a way for a 'serious' actor to earn a little extra pocket money. Many stage stars lured in front of the cameras even went as far as to demand anonymity rather than association with 'the most lurid of melodramas' (Low, 1973, p. 115). A caustic piece in the trade press in late 1911 noted that in England 'the average actor hates the cinematograph . . . he curses the invention that is taking the bread out of his mouth, hoping in his heart that the craze for the pictures will not last . . . foreign (film) actors take their art seriously and work in the light of ideals. The vast majority of English actors don't recognise the fact that there are such things as ideals.'[46] The theatrical world's suspicion of cinema lingered right through into the 1930s. In Kevin Brownlow's 1995 BBC documentary, *The Hidden Cinema*, John Gielgud recalled being told that the only excuse for venturing into cinema was 'to pay the income tax'. Forbes-Robertson himself seemed to consider movies as virtual pornography. 'A film is not a film,' he wrote in a popular daily newspaper a few years after the release of his own *Hamlet*, 'if it does not include an orgy of hugging, cuddling, and a close-up of passionate kissing; if its women are not hideous with black lips, with rouged cheeks, showing hollow in the photograph effects.'[47]

For posterity and the Danish prince's sake, however, he was prepared to swallow his scruples about cinema. He first played the role on stage when he was 44, last played it aged 64, and turned to it whenever other endeavours failed. 'A revival of *Hamlet* has saved my financial position on many occasions,' he confessed. 'When the production of a new play has spelt failure, a revival of *Hamlet* has always set me on my feet again' (Forbes-Robertson, 1925, p. 287). By reprising his most famous part for the cameras, he not only hoped to boost his bank balance but, like Tree, to confer a little dignity on the fledgling medium.

A month or two after Forbes-Robertson's *Hamlet*, the trade papers announced with unwarranted optimism that the rift between theatre and film had finally been bridged. *Bioscope*'s front page editorial on New Year's Day 1914 noted 'the recent unmistakable enthusiasm for the

cinematograph which has sprung up among famous players of the legitimate stage and also among the popular hall artistes'. The roll-call of 'notable heavyweights' who had 'essayed their art in front of the cameras' included Forbes-Robertson, Gertrude Elliott, Charles Wyndham, Violet Vanburgh, Arthur Bourchier and Martin Harvey, but the trade press failed to mention that most of these actors only appeared in films as a sideline to their main work on stage. Their occasional dabblings hardly constituted the basis of a star system.

While Forbes-Robertson all but patented Hamlet, Tree had a lucrative pet role of his own: one he played on stage countless times, starting in 1895, and successfully transferred to screen. In endless revivals of Paul M. Potter's drama, *Trilby*, adapted from George du Maurier's potboiler of a novel, he starred as Svengali, a 'weird, uncanny, dirty-fingered, unkempt, death-faced scoundrel' who somehow turns a tone-deaf artist's model into a world-famous singer through hypnosis. It is not exactly a role calling for subtlety. With his lank hair, matted beard and long, bony fingers, Sir Herbert's Svengali looks the spitting image of Alec Guinness's Fagin in David Lean's *Oliver Twist* (1948). (In other words, the characterization veered dangerously close to anti-Semitic stereotype.) Even in the film, Tree, a large, imposing figure, approaches the part in grandiloquent fashion, rolling his eyeballs, making grand sweeping gestures with his arms. Audiences seemingly loved his extravagant mimicry; thanks to the success of *Trilby*, the actor–manager was able to underwrite the building of his own theatre, His Majesty's.

Forbes-Robertson and Tree were both immensely popular actors. They flirted with cinema out of curiosity, vanity, even greed, but they were not, nor did they want to be, film stars. They regarded themselves as artists, not public mascots. When Forbes-Robertson died in 1937, a British obituarist noted approvingly how he sidestepped the perils of fame.

> A handsome face, a good figure, a voice of rare power and exquisite tone ... and a personality which radiated charm combined to make him a fore-destined hero of romance. But an artistic temperament, in the true sense of that over-worked and much abused phrase, saved him from being *merely a darling of the public*.[48]

Tree had appeared in *King John*, the first-ever Shakespeare film, in 1899. Shot on the Embankment by the Adelphi, this was a photographic

transcript of a stage production, as Tree himself later reported in an interview, 'entirely without meaning except to those who were perfectly familiar with the play and could recall the lines appropriate to the action'.[49] He was paid $10,000 by D. W. Griffith to play *Macbeth* in Hollywood in 1916, an experience which briefly jolted him out of his cinephobia: in the USA, after seeing Griffith at work on *Intolerance* (1916) and swapping notes with his new acquaintance Charlie Chaplin (who had long admired his stage performances), he suddenly began to proselytize on behalf of cinema. 'We in England have no conception of the vast influence of the moving picture in America, where it has become part of the national life of the people,' he wrote in *The Times*. 'There is at home the habit of sneering at serious work undertaken by such striving artists as Mr Griffith ... it is the invariable fate of any new medium to be ignored until it has taken root among the great necessities' (quoted in Morley, 1983, p. 28). But despite his new-found enthusiasm, he remained sceptical about cinema's ability to compete with live theatre and admitted he was often baffled by the way that movies were made out of dramatic sequence. 'To the newcomer it is somewhat disconcerting to act a scene of carousal immediately after your death scene' (*ibid.*, p. 29). His bewilderment was compounded when he saw rushes featuring Macbeth on horseback. He could not remember shooting any such sequences and yet was certain that he was watching himself. (In fact, it was a stunt double.) He steadfastly refused to amend his technique for the cameras. His insistence on declaiming all his soliloquies in full during the shooting of his silent *Macbeth*, whether or not they were needed, so exasperated his American director that often the camera was not even loaded. A sardonic trade journalist of the time observed that 'British stage actors must learn not to act to the camera but simply in front of it', but this was not advice that Sir Herbert was ever likely to heed.

There is a measure of irony in the legitimate theatre's disdain for its new rival. Both Forbes-Robertson and Tree may have been knighted and highly respected figures in Edwardian society, but few of their predecessors enjoyed such glowing approval. Until well into the Victorian era, stage acting itself had been a precarious, disreputable profession. As Michael Baker notes in his entertaining study, *The Rise of the Victorian Actor*, unlicensed players were legally classified as vagrants and vagabonds until the mid-nineteenth century; theatres were seedy and dilapidated, and invariably found in the poorer parts of town. Anybody

who flirted with theatre was considered morally suspect. (One has only to read 'The Stroller's Tale' in *The Pickwick Papers* to appreciate the lowly status of the actor in Dickens's time. 'Everybody who is at all acquainted with theatrical matters,' the novelist wrote, 'knows what a host of shabby, poverty-stricken men hang about the stage.') Tellingly, in the nineteenth century, before Sir Herbert Tree rectified matters by establishing the Royal Academy of Dramatic Arts (RADA), there was a Royal College of Music and a Royal College of Art, but no similar establishment for drama.

'With the accession of Queen Victoria,' Baker notes, 'royal patronage of the stage, largely defunct since George III's heyday, acquired a new lease of life' (Baker, 1978, p. 14). Under her aegis, a new generation of actors grew up, determined to prove that they were as righteous and respectable as any other Victorian gentlemen. This led in certain quarters to a stolid, dignified style of playing, designed never to offend.

> The source of the Victorian actor's growing respectability was also the root of his artistic weakness. In striving to combat the moral bogey which burdened his professional image, there was to be no room for the actor to develop an independent artistic ethic. (*ibid.*, p. 55)

Ironically, despite its craving for respectability, Victorian stage melodrama, with its decorative style of acting and emphasis on extravagant spectacle, shared many characteristics with early cinema. In Irving's theatre, for example, the pictorial was privileged at the expense of the word: storms at sea, violent battles and idyllic pastoral scenes were all depicted on stage in meticulous detail. As far as offering audiences visual thrills was concerned, movies were a natural progression. Nicholas Vardac points out (1949, p. 19): 'The stage constantly endeavoured to create artificially what has constituted the very essence of cinema: pictures in motion. This problem, of course, could be finally solved only by the screen.' But on the Victorian stage, occasional formal flamboyance went hand in hand with extreme conservatism. Whether they were playing brigands or corsairs, bloodthirsty Greeks or martial-minded medieval princes, actors insisted they were still gentlemen. This conservatism was all too evident in attitudes toward cinema, which was dismissed as frivolous and ephemeral.

Neither Herbert Tree nor Johnston Forbes-Robertson was entirely

beholden to Victorian convention. The former, father of Carol Reed, brother of the satirical writer Max Beerbohm-Tree, and all-round towering eccentric, was an actor in the heroic mould on stage and a flamboyant figure off it: his wives, mistresses and complicated domestic arrangements continue to inspire biographies. The latter, graceful, ethereal, and noted for the way he wrung emotion by fluttering his hands ('the most expressive I have seen on man or woman,' wrote *Times* critic James Agate),[50] dallied on the fringes of London's bohemian art world. Friendly with the Pre-Raphaelites, he even modelled for Millais and Rossetti. Nevertheless, both actors follow in the tradition of the respectable Victorian gentleman–performer: a tradition lent all the more *gravitas* when Irving became Britain's first theatrical knight in 1895. From their position at so great a height it is scarcely surprising that they looked down on cinema.

Approaching the new medium from a very different, 'worm's eye', view was Britain's galaxy of music hall stars. On the surface, cinema seemed to suit them down to the ground. Pratfalls, comic chases and stolen kisses were *leitmotifs* of many early films. Film grammar itself changed for their benefit: close-ups in British pictures were first introduced for comic rather than dramatic purposes. Such notable figures from the halls as Will Evans, who grimaced and slavered his way through the comedy, *Music Hall Eccentric* (1908), and George Robey, the bushy-eyebrowed 'prime minister of mirth', who made his screen debut in 1914, were eager early film recruits.

Ironically, the comedians often proved every bit as uncomfortable with the cinematograph as the actor–knights. Not only were they deprived of the oxygen of laughter, so crucial to their live performances. They were also straitjacketed by the demands of conventional narrative. This, historian John Fisher notes, 'is directly contrary to the true nature of music hall, where the assertion of pure self holds sway, where the performer is rather than acts' (Fisher, 1973, p. 19). On one level, as Michael Chanan argues, silent comedy may have been a liberating influence, enabling its practitioners to revive a pantomime tradition which had been all but eclipsed by the arrival of music hall in the mid-nineteenth century (Chanan, 1980, p. 135). On another, it was deeply confining.

In 'The Art of Donald McGill', his famous essay on seaside postcard humour and the British, George Orwell suggests a dichotomy which can

be expressed in a number of different ways (Orwell, 1980, pp. 183–95). At its crudest, it is a tale of North against South: of working men's clubs and music halls against genteel theatres. It is also a tale of comedy against drama; of earthy, physical humour against cerebral wit. Orwell describes this as a 'Don Quixote/Sancho Panza' combination (*ibid.*, p. 192). Early British cinema's battalion of actor–knights and clowns sum up this opposition perfectly. Sir Johnston Forbes-Robertson embodies all the qualities of the former, while a certain Pimple, the most popular screen comedian of his day, perfectly represents the most conspicuous traits of the latter.

For a few brief years (1912–16), this tousle-haired nincompoop (his real name was Fred Evans) was a phenomenon, probably as well-known to British audiences as Chaplin himself. Early on, he played postmen, sailors and soldiers in a series of ever more goofy comedies. Then, when the inspiration ran dry, he turned to burlesque instead. Week after week, from a studio on Eel Pie Island in the River Thames, he used to lampoon the hit film of the moment with his own slapstick version of it. His pictures were shot quickly on minuscule budgets, with scripts written by his brother Will, who also acted in them, as did his uncle, Will Evans. 'Every week, in fair or foul weather, a new comedy was produced; and when he was not working, perhaps on three days in each week, Fred Evans went off in his Pimple outfit to make a personal appearance at a picture house' (Montgomery, 1954, p. 67). Evans regarded it as a sure sign of success whenever the producers of the 'big' films he was parodying tried to sue him.

Cheapskate, formally crude, the Pimple comedies ('perfect potted picture plays' as they were described in alliterative advertisements) bear striking similarities to the host of similarly chirpy, unprepossessing knockabout British farces which followed in subsequent generations. 'In spite of the fact that this series has been running for some considerable time at the rate of one production a week,' the *Bioscope* enthused, 'there seems to be no end to Mr Evans' fertility of invention, no shadow on the brightness of his humour, a humour which is often as nearly as akin to wit as is possible in a medium which receives no assistance from the spoken word.'[51]

Pimple's Uncle (1915) is typical of the series. The plot could be sketched on the back of a postcard: Pimple hopes to receive money from his wealthy colonialist uncle, and fully intends to keep it to himself,

whatever his jealous cousin has to say about the matter. The cousin learns of his greed and responds by sending him a spoof letter, saying the uncle is prone to fits of madness because of sunstroke. (Advice: If he loses his temper, sing to him. If that fails, play practical jokes on him. Never give him milk, sugar or spirits.) The cousin also writes a letter to the uncle, telling him Pimple is mean and cruel. When the uncle turns up, Pimple hides the spirits, and when the uncle asks for tea, tells him the ludicrous lie, 'We can't get milk anywhere, they've sent all the cows to the Front.' After some violent slapstick involving cakes and a soda syphon, much blustering from the uncle and fawning apologies from Pimple, the hoax is revealed and the cousin disgraced. The entire film is shot on a single set and resembles nothing so much as an extended sketch from a TV comedy show.

Fred Evans's story, like that of so many clowns, ends sadly. He was soon eclipsed by his Hollywood rivals. By late 1916, his career was already in decline. After *Pimple's Three Musketeers* (1922) he all but vanished, ending up as an extra in the 1930s. He died forgotten in 1951.

Sir Johnston and Pimple are both archetypes. One stands at the head of a list which incorporates stage actors-turned-reluctant-movie-stars all the way from Michael Redgrave to John Gielgud. The other's descendants range from George Formby to Norman Wisdom, from Frank Randle to Chubby Brown. As putative stars, these Quixotes and Panzas have their limitations. Neither seems especially predisposed toward cinema, which they invariably arrive at from another medium. While the Don may fancy himself a dashing, handsome hidalgo, and while Sancho may be certain that he has an earthy, irresistible charm, neither is exactly bathed in glamour.

Not that this was a quality necessarily lacking in British theatre. The West End furnished a steady supply of matinée idols while in music hall, running alongside the tradition of the woebegone little clown (the Dan Leno or the Grimaldi), there was the cult of the 'swell'. None came sweller than George Leybourne, the original 'Champagne Charlie'. A former engine-fitter from Gateshead who had started his stage career as a clog dancer, Leybourne went on to become as famous as Irving himself. He dressed in tails and top-hat, and his contract demanded he travel in style by horse and coach. Wine merchants, eager to promote their wares, kept him stocked with free champagne, and insisted that he make a show

of drinking it (Bratton, 1986, p. 50). (Non-stop consumption of the precious liquid contributed in large measure to his early death.) He and his great rival Albert Vance were experts at self-promotion. Not only did they tour and perform incessantly. They took out frequent newspaper advertisements and left extravagantly embossed calling cards wherever they went. Unfortunately, little of this ingenuity or showmanship went into fashioning the earliest British screen stars.

By the beginning of the First World War, there were the rudiments of a star system in British film. The major manufacturers – Hepworth, the London Film Company, British & Colonial and W. G. Barker – had all established stock companies, were making genre films and were using actors again and again in the same kind of roles. Some female stars were being marketed on the basis of their looks. Miss Ivy Close was commonly referred to on posters as 'the famous beauty actress', while Gladys Cooper, 'England's most beautiful actress', was already a pin-up girl. The comedians, notably Pimple, were achieving national recognition. 'It pays to show Pimples,' advised posters for the clown. 'They are the pick of the market, the essence of whimsical funniosity.' With Forbes-Robertson, Wyndham and Tree leading the way, there was at least a slight thaw in the frostiness with which the legitimate theatre treated the new medium. But this was very small beer by comparison with Hollywood, where Pickford, Chaplin and co. had already assumed the status of minor royalty, or even with the Continent. If only because they were working on far tighter budgets, the most assiduous British producers were still paying less attention to such matters as make-up, costume and lighting than their Hollywood counterparts. They tried, sometimes slavishly, to imitate Hollywood star prototypes, but petty snobberies and jealousies undermined their efforts. By comparison with the legitimate stage, cinema remained *infra dig*. As the *Bioscope* put it, 'comedy, drama, tragedy require the human voice, the human gesture, the human personality: these are of the theatre and at their best must remain the preserve of the [stage] actor and actress.'[52]

It did not take long for British film-makers to establish a gallery of screen types. As well as the actor–knights, clowns and ingénues, there were dashing action-heroes like British & Colonial's Lieutenant Daring (played by former boxer and stuntman Percy Moran) doing their part for king and country in a series of ripping yarns; there were smooth, unflappable aristocrats in Mayfair drawing rooms (Guy Newall and Ivy

Duke), and even one or two home-grown vamps. But the stars, like the industry as a whole, took a battering in the face of the Hollywood onslaught which started in earnest during the First World War. The big American companies, buoyed up by the size of their domestic market, could afford to make films on an altogether more extravagant level than their British counterparts. Thanks to the block-booking system, they were also able to monopolize screen time in British cinemas by forcing exhibitors to take dozens of their films in order to get the ones they really wanted (Robinson and Lloyd, 1986, p. 48).

The vast US comedian John Bunny, who tipped the scales at over 20 stone, is an emblematic figure. His sheer size and exuberance all but blew his foreign rivals out of the water at a time when Hollywood was beginning to make its first inroads into the British market. As if to underline his dominance, he even played Pickwick in a British-made version of *The Pickwick Papers* (1912). Even Pimple was overshadowed by this gigantic Falstaff of a funnyman in the early days of his career. After Bunny's premature death in 1915, largely brought on by extreme obesity, certain local comedians such as Billy Merson and Lupino Lane (who subsequently went to Hollywood himself) briefly emerged into the limelight, but regardless of their ability, they were, as Merson's case illustrates, operating at an extreme competitive disadvantage.

In his autobiography, Merson offers a bleak account of the problems that faced British film-makers during the war years. A former acrobat, Merson was already well established as a music hall artist when he first became involved with cinema in 1915. His debut, *Billy's Spanish Love Spasm* (1915), inspired by his signature song 'The Spaniard Who Blighted My Life', was a roaring success. He was so pleased with its reception (it was sold for £1000) that he signed a contract to make six more pictures, all of which he agreed to co-finance. These ranged from the outlandish fantasy, *Perils of a Pork Pie* (1916), in which our Billy chews on a deadly snack and is whisked back in time to undergo 'a heap of adventures in Ancient Egypt during the Stone Age' to *The Terrible Tec*, a misconceived (by his own admission) parody of Sherlock Holmes. Most of the films were well received by British audiences. Nevertheless, the net result for Billy was a personal loss of £4000. He attributed his problems to wartime inflation. 'Labour cost more; lighting, rentals, raw materials, woodwork, canvas, paint etc. all jumped up amazingly in price' (Merson, 1926, p. 180). While he and his colleagues attempted to scrape by, their

American counterparts were able to undercut them – to offer their wares to exhibitors at a fraction of the prices Merson and co. needed to charge to recoup their costs.

Merson's brief film career presents a paradox. His movies were generally liked, generally attracted audiences, but still contrived to lose money. The economic logic was daunting. Whereas US producers could recover their costs in the home market and use the rest of the world simply as a way of topping up profit, British producers were mainly reliant on their films' domestic performance – it was tough enough securing distribution in their own backyard, let alone breaking into the international market. By the end of the war, film-making in Britain was such an expensive business that even the most popular movies struggled to recoup their costs.

True, British producers did not have to pay exorbitant sums to stars. But this was only because they had not managed to create a robust star system of their own. A smattering of actor–knights, a few comedians and Hepworth's assortment of Home Counties ingénues were no match for the likes of Pickford, Fairbanks and Gish.

Notes

1. From a speech Hepworth gave to the British Kinematograph Society in 1935.
2. *Kinematograph Weekly*, 4 July 1907.
3. *Bioscope*, 26 February 1914.
4. *Kinematograph Weekly*, 29 August 1907.
5. *Kinematograph Weekly*, 20 June 1907.
6. See, for instance, the editorial in the 29 July 1909 issue of *Bioscope* which talks scathingly about 'the restricted scale on which most of our firms have operated'.
7. *Bioscope*, 19 August 1909. 'A great reason for the non-descript talent hitherto employed has been the refusal of well-known authors and actors to "descend" to the cinematograph, and also, of course, things have to be on a large scale to admit of firms paying the big fees demanded by these artists.'
8. *Bioscope*, 3 February 1910.
9. *Kinematograph Weekly*, 20 June 1907.
10. *Kinematograph Weekly*, 4 July 1907.
11. *Kinematograph Weekly*, 1 August 1907.
12. *Bioscope*, 12 February 1914.
13. *Bioscope*, 12 February 1914.
14. *Bioscope*, 30 April 1914.
15. Quoted in *Bioscope*, 19 August 1909.
16. Quoted in *Bioscope*, 20 July 1909.
17. *Moving Picture World*, quoted in *Bioscope*, 22 July 1909.
18. *Bioscope*, 22 July 1909.
19. *Bioscope*, 22 July 1909.
20. *Bioscope*, 11 January 1912.
21. *Bioscope*, 4 August 1910.
22. *Bioscope*, 4 and 18 August 1910.
23. *Ibid.*
24. *Bioscope*, 27 October 1910.
25. *Bioscope*, 8 February 1912.
26. *Bioscope*, 18 January 1912, p. 141.
27. *Bioscope*, 13 July 1911.

28. *Hepworth Picture Player*, no. 3, February 1916.
29. *Bioscope*, 6 June 1912.
30. *Hepworth Picture Player*, no. 1, December 1915.
31. *Bioscope*, 22 February 1912, p. 543.
32. *Bioscope*, 22 July 1909, p. 41.
33. *Hepworth Picture Player*, no. 2, January 1916.
34. *Ibid.*
35. *Bioscope*, 29 January 1914.
36. *Bioscope*, 11 April 1912, p. 131.
37. *Bioscope*, 13 July 1911.
38. *Bioscope*, 20 April 1911.
39. *Bioscope*, 10 November 1911.
40. *Bioscope*, 17 November 1910.
41. *Bioscope*, 16 February 1911.
42. *Picturegoer*, May 1928, 'Those Were the Days ... '
43. *Bioscope*, 24 August 1911.
44. *Bioscope*, 26 October 1911, p. 241.
45. *Bioscope*, 15 January 1914.
46. *Bioscope*, 2 November 1911.
47. Quoted in the *Daily Sketch*, 22 November 1927.
48. Forbes-Robertson personal file, in the library of the Theatre Museum, Covent Garden.
49. Quoted in 'Shakespeare Film as Record: Sir Herbert Tree', by Robert Hamilton Ball. *Shakespeare Quarterly*, July 1952.
50. See Forbes-Robertson's personal file, in the library of the Theatre Museum, Covent Garden.
51. *Bioscope*, 22 January 1914.
52. *Bioscope*, 26 October 1911.

The Not-So-Roaring 20s: Ivor Novello and Betty Balfour

> Large numbers of vaguely defined characters seen at a great distance, little more than walking names, trying to convey character and emotion by means of heavy make-up and exaggerated gestures, did much to justify the scorn in which screen acting was held by traditional theatre. (Low, 1971, p. 262)

When the Anglo-Welsh matinée idol Ivor Novello died in 1951, his funeral, at Golders Green Crematorium, was mobbed by thousands of weeping elderly women. They trampled over flowerbeds and fought with police just to catch a glimpse of the funeral cortège as it trundled through the city for six miles. Once they reached the chapel, their behaviour became even more aggressive. 'On several occasions women burst through the police cordon and crowded round the chapel door,' one shaken journalist observed.[1] Reports on the numbers of grieving women varied. The *Evening Standard* referred to 'a huge crowd of 7000'.[2] A rival paper put the swell at only 5000, 'some in tears, and some carrying bunches of flowers or lilacs'.[3]

For many onlookers, such scenes inevitably rekindled memories of the funeral of Rudolph Valentino, which had inspired similar outbreaks of frenzied emotion among film fans a quarter of a century before. However, mysteriously, Novello's British obituarists did not seem to think the mass hysteria had anything to do with the fact that Novello had once been a movie star. It was primarily as a composer of escapist West End musical romances that they chose to remember him. *The Times*, which neglected even to mention his film career, pointed out that 'Novello was one of those exceptional people for whom the phrase "a man of the theatre" acquires meaning and virtue. He really was a man of the theatre.'[4]

Novello's early biographers were equally selective when it came to

sifting through the details of his celluloid career. In the preface to *Ivor*, W. Macqueen-Pope, Novello's former business manager, grandly announced that he would not waste much space on Novello's youthful days. 'Nor shall I worry much about his film career. It was never really a great part of him, more of a lane through which he wandered and from which he learnt' (Macqueen-Pope, 1952, p. 25). Like his flamboyant private life (Novello's homosexuality was an open secret in theatrical circles),[5] his brief sojourn in the movies was viewed as in some way disreputable and unworthy of serious comment. Propriety demanded that a discreet veil be drawn around it.

It is true that it was seventeen years since Novello had last appeared in front of the cameras and that his film career had unravelled following an unsuccessful foray to Hollywood in the early 1930s. He had never blossomed in talkies as he did during the silent era. Nevertheless, throughout the 1920s, he was Britain's most popular matinée idol: the one home-grown actor who could compete with Hollywood counterparts like Valentino and Ramon Novarro in fans' affections. Even today, he is able to inspire flights of extravagant fancy from his admirers. In a recent essay, Gilda Tabarez argued that the reason Novello, like Valentino before him, was so convincing as a screen lover was that 'he really believed in the concepts of romance, chivalry and glamour'. She goes on to describe him as an 'unabashed Romantic and an unrepentant senti-mentalist ... His vivid, artistic portrayals provided movie-goers with a glimpse of another realm – one of poetry, imagination and emotion' (Tabarez, 1996, p. 1). These effusive sentiments echo almost precisely those of Novello's 1920s female fans.[6]

Novello was altogether too exotic a figure to fit comfortably into the British film firmament of the 1920s. He was not, like so many of his British contemporaries, a stage star who slummed in front of the cameras for a little extra money. (His acting career began in the movies.) Nor was he a rugged, taciturn type in the mould of, say, Clive Brook or Stewart Rome. His style was febrile and expressive. His attraction for audiences lay less in his ability, which was strictly limited, than in his looks. With his brilliantined black hair, lambent skin and classic profile, Novello was nothing if not handsome. For him, giving a performance was a matter of striking as many dreamy, narcissistic poses as possible; of playing to camera. 'It's a pleasure to photograph him because he takes well from any angle,' observed one of his cameramen, Hal Young, after working with

him on *The Rat* (1925).[7] Trade papers immediately picked up on his appeal, which they suggested transcended national boundaries. *Picture Show* proclaimed that he had 'every quality under the sun to make a screen star: a perfect figure and features, dark hair and eyes, and all the poetry and music of his nature, helping to build up a personality that is making him a world-wide favourite' (quoted in Wilson, 1975, p. 53).

In Novello, British cinema had somehow stumbled on its own answer to the Latin lover. His unlikely exoticism clearly caught the imagination of British filmgoers. Throughout the 1920s, he topped fans' popularity polls. During the period, several British producers had international aspirations. Novello's boss at Gainsborough Pictures, Michael Balcon, spelled out his intentions for breaking into the American market as early as 1923, when he signed up Hollywood star Betty Compson to appear opposite Clive Brook in the melodrama, *Woman to Woman* (1923). As the film historian Philip Kemp has noted, he continued importing American stars to bolster Gainsborough productions throughout the 1920s (Cook, 1997, p. 20). Balcon regarded Novello as one of the few British actors who could compete on equal terms with his Hollywood counterparts. He later acknowledged that Novello's appeal abroad was not as far-reaching as originally hoped. 'It would be silly to pretend that Novello's films had a success all over the world,' he admitted, 'but they were remarkably successful in this country' (quoted in Wilson, 1975, p. 73). Nevertheless, in the 1920s, Novello was Gainsborough's most bankable star.

It is hard to pinpoint what made Novello so popular. He was a contradictory figure, a young Welshman often regarded as a quintessential Englishman, but also likened to such Latin lovers as Novarro and Valentino. 'He appeared to violate twentieth-century codes of masculinity rooted in a Rooseveltian virility cult, and his popularity as a "Latin lover" also seemed to contradict the virulent xenophobia directed during the 1920s at immigrants from southern and eastern Europe,' Gaylyn Studlar wrote of Valentino (Cohan, 1993, p. 25). The same argument could be made of Novello in a British context. He too subverted gender stereotypes of the time. The very fact that he called himself Novello rather than using his real name of Davies hinted at his 'otherness'. Studlar suggests that Valentino's persona was largely determined by his women fans: 'He exemplified the epicene results of women's perverse search for a new model of masculinity that defied normative American models'

(Cohan, 1993, p. 27). Novello likewise seemed to fulfil a psychic need for British female filmgoers, who throughout the 1920s voted him their favourite British male star. (During the same period, he was resolutely ignored by their male counterparts.)

In his portraits, he looks dark and mercurial, but colleagues remember him as genial and easy-going. He was regarded with affection. As Balcon put it, 'we always knew he had limitations of course, but he was such an enchanting character: no side at all, none of the star nonsense, eager to learn and charming to the people he worked with' (quoted in Wilson, 1975, p. 73).

There was something subversive about Novello's brand of masculinity, a flirtatiousness and even a hint of androgyny which distinguished him from other British stars of the era. He paid infinitely more attention to costume and to make-up than they did. He was an expressionist: the key to his screen acting lay as much in what he wore and how he looked as in how psychologically convincing he was in any given role. When he was on location, playing the lead in the 1923 movie version of *Bonnie Prince Charlie*, he decided his kilt was the most dashing thing he had ever seen. He liked it so much that he wore it every day off set. It was only when his co-star, Gladys Cooper, warned him that the locals didn't care for outsiders gallivanting round the heather in tartan that Novello reluctantly climbed back inside his trousers (Wilson, 1975, p. 61). Five hundred Scots followed them round on location in Arran, many with hostile looks on their faces. 'But I wouldn't have cared had there been thousands of people,' Novello told the *News of the World*, 'I fancied myself in my kilt!'[8] It is a trivial anecdote, but it underlines how seriously he took costume.

Music as much as dress was crucial to the typical Novello performance. A composer himself, he used it to help him dredge up each appropriate emotion. 'I have come to regard Wagner as my patron saint. Much of what I personally consider my best screen acting has been achieved under the influence of the "Fire Music" from *Die Valkyrie* and the "Liebestod" from *Tristan und Isolde*. In fact, I have "suffered" in the studio so often and so intensely to the accompaniment of those immortal melodies that now I cannot even hear them in a restaurant without feeling immeasurably stirred.'[9] Arguably, Novello's relish for stylization and artifice – for the heightened atmosphere of silent melodrama – explains why his career withered away so quickly in the more prosaic era of the talkies, when

hiring an orchestra to play off-camera for the benefit of the cast was no longer feasible.

Born David Ivor Davies in Cardiff in 1893 (he changed his name by deed poll in 1927), Novello was the son of a celebrated Welsh singer and elocution teacher, Madame Clara Novello Davies. Formidably ambitious on his behalf, she encouraged his songwriting and performing from the outset. He was only 17 when his first piece of music, *Spring of the Year*, was published in 1910, and barely into his twenties when he became famous: fired with patriotic fervour by the First World War, he dashed off the sentimental anthem *Keep the Home Fires Burning* (reportedly in under fifteen minutes) in 1915. This song (later used in the play *Oh, What a Lovely War!*) earned him £17,000 as well as nationwide celebrity. Four years later, he took his first teetering steps into the film business.

Novello's entire career was characterized by a certain haphazard quality. He was 'discovered' by accident. French director Louis Mercanton spotted his photograph in the offices of the talent agency which represented him as a composer. Mercanton was immediately struck by the Welshman's good looks, and offered him the leading role in his new film. Novello, who had no acting experience whatsoever, was half-way across the Atlantic in transit from America when he received Mercanton's offer, but he promptly accepted. These biographical details, trite in themselves, were precisely the nuggets of information that fans devoured. As Leo Lowenthal points out, 'the mythology of success ... consists of two elements, hardship and breaks' (Lowenthal, 1961, p. 123). Novello's career abounds in both. The idea that any individual can be plucked from obscurity and made overnight into a film star is one of Hollywood's favourite myths. (No profile of Lana Turner ever neglects to mention the fact that she was first spotted as a teenager in a drugstore.) There is always something a little contrived about the 'lucky break'. As cultural historian Miriam Hansen observes, 'The very arbitrariness of the cinematic marketplace, the element of chance in the "discovery" of a star became part of the promotional discourse, essential to the myth that the star was a creation of his or her loving public' (Hansen, 1991, p. 248).

Whether because the Hollywood PR machine has always been better oiled than its British equivalent or because the big studios really did recruit unknowns, there have been a plethora of American stars whose life-stories read like gilt-edged wish-fulfilment fantasies. In Britain, by

contrast, stars were seldom 'born' but seemed invariably to emerge from either theatre or music hall. In the late 1920s in particular, British studios were loath to invest in the promotion and publicity that fledgling stars all required. The journalist P. L. Mannock, who wrote a regular column about the British studios for the trade paper *Kinematograph Weekly* between the wars, continually railed against the short-sightedness of the film world's publicists. He complained that it was impossible for newspapers and magazines to get good still portraits of new stars, 'because none were taken'.[10] As he pointed out, 'The creation of a film star is a systematic business and its practice a vital part of production policy.' Once a player was signed up, in theory he or she should have been paraded before the press and shown off to best advantage in a series of specially tailored films. 'That is what ought to happen. The British studio, broadly speaking, does none of these things. It sometimes makes a brave announcement that this or that artist has been signed on contract for a period. Thereupon, it lies down and goes to sleep.'[11] Mannock claimed that many British film actors of the 1920s, left to stagnate, were desperate for their contracts to end. Often, he suggested, the studios who hired them were more interested in farming them out to rivals at a profit than in using them in any films they might make themselves. Novello, then, was an exceptional case: one of the few stars of the era whose career was plotted with any guile.

Novello's début feature, *The Call of the Blood* (1920), was an overcooked melodrama about a philandering Englishman who betrays his wife with a Sicilian girl. Novello enjoyed making it enormously. 'I proved to be photogenic,' he later boasted.[12] 'The film was one of extreme beauty.' Venerable, French stage legend Sarah Bernhardt, who saw *The Call of the Blood* in private view in Paris, agreed with Novello's own estimation. She professed herself 'enraptured with the classic acting, the superb scenery and the vitality of the situations'. Moreover, she found the emotional scenes 'deeply affecting and said it was the finest screen romance she had ever seen, Phyllis Nielson-Terry [Novello's co-star] and Ivor Novello coming in for a generous measure of her appreciation'.[13] Bernhardt already had a reputation for reacting emotionally to moving images. In 1900, at the Paris Exposition, she had starred in a 'sound' version of *Hamlet*. (A projectionist hand-cranked the film to keep pace with her phonograph recording.) She was so overcome when she saw (and heard) the end result that she reportedly fainted.

Bernhardt herself had made several films with Mercanton, most notably *Queen Elizabeth* (1911). As an actress, the 'Divine Sarah', as she was nicknamed, was renowned for her graceful movement and fiery personality. In Novello, it seems, she recognized a kindred spirit. Her enthusiasm suggests his appeal was not merely limited to British cinemagoers, who regarded him as the 'new Valentino', but extended to continental audiences. It is also apt that his most fervent early admirer should be a woman since, like Valentino, Novello was often later 'perceived as a creation, of, for and by women' (Hansen, 1991, p. 261). Just as Valentino was reportedly guided in his career by the Svengali-like screenwriter, June Mathis, and by his second wife, Natacha Rambova, Novello's early steps in the industry were overseen by his mother. He had never acted before *The Call of the Blood* and he was already being acclaimed as 'one of the most intense lovers of the screen, America included' (Wilson, 1975, p. 53). If anything, it was suggested, he was too good-looking: producers were soon to be heard grumbling that they were hard-pressed to 'find someone as beautiful as Ivor to play opposite him' (Brunel, 1949, p. 102).

Choosing suitable vehicles for this new Narcissus of British cinema was indeed awkward. His first British film was *Carnival* (1921), a flamboyant melodrama about an actor playing Othello who is consumed with jealousy off as well as on stage. Novello attacked the role with customary intensity. Among his other, ill-fated early vehicles was *The Bohemian Girl* (1922), an all-star operetta which cast him alongside the legendary (if now ancient) stage star, Ellen Terry, C. Aubrey Smith (a distinguished cricketer and occasional character actor in Hollywood), the beautiful, aristocratic Gladys Cooper, and Constance Collier (with whom Novello went on to write his greatest stage success, *The Rat*). Despite the cast, this proved an ill-fated endeavour: the director Harley Knoles was unable to work out how to make opera the stuff of silent cinema. His choreography was on the eccentric side and he was unsure of where to place the camera. As the *Kinematograph Weekly* noted with scarcely veiled sarcasm, 'Ellen Terry as the nurse fills her part efficiently, but her distance from the camera nullifies her ability' (Wilson, 1975, p. 54).

Novello was yet to appear in any truly memorable movies, but even so his appeal was firmly established. When *Picturegoer* launched a £500 Popularity Contest in the winter of 1924, he was bracketed alongside Ramon Novarro and Rudolph Valentino as a likely favourite with voters.

'Britain's handsomest actor,' trumpeted the magazine, 'Britain's handsomest author, Britain's handsomest composer. Can you wonder that the ladies love him? He comes from Cardiff of musical family, and has composed songs since he was in his teens. He has so many irons in the fire that he could do with another pair of hands to pull them all out.'[14]

The results of the competition were announced three months later. Novello was placed sixth. The (predictable) winner was Valentino. More pertinently, he was the only British actor to warrant a mention in the top ten. Not even Betty Balfour, British cinema's undisputed 'Queen of Happiness', figured in the poll. As if to confirm his popularity, Novello was by then receiving roughly 2000 letters a week from devoted fans, according to *Picture Show Magazine* (Noble, 1951, p. 102).

Having been noticed first by a Frenchman, Novello next caught the attention of one of Hollywood's legendary directors. D. W. Griffith, a former stage actor himself, had already shown his enthusiasm for Britain's great Shakespearians by offering a small fortune to lure Herbert Tree to the USA to star in *Macbeth* in 1916. Now he went a step further, signing up Novello to appear opposite Mae Marsh in *The White Rose* (1923). (He too came across Novello by accident. He first spotted the young Anglo-Welshman eating ham and eggs in the Savoy Hotel.) Like Mercanton, Griffith was instantly attracted by Novello's striking physiognomy – a profile which not even John Barrymore could match.

When he arrived in America to work with Griffith, Novello was greeted variously as 'the British Adonis' and 'the Valentino of England' (Noble, 1951, p. 96). He gave such flattery short shrift. 'Please, please don't write me up as the handsomest man in England,' he told the *New York Evening Telegram*, 'I was never more embarrassed in my life. Promise me you'll cut out that rot' (Wilson, 1975, p. 61). Cut it out they soon did. Novello's performance, like the film itself, provoked barely a ripple of interest among American cinemagoers.

It did not help that *The White Rose* was one of Griffith's more lacklustre efforts, a dreary, folksy melodrama about unhappy love with little of the formal flamboyance of Griffith's earlier films like *Intolerance* (1916) and *Birth of a Nation* (1915). Although delighted to be working with Griffith, Novello was far from enthusiastic about his role as a high-minded priest who falls in love with beautiful ingénue Mae Marsh. 'I had a very stupid part,' he later complained, 'that of a sanctimonious clergyman utterly devoid of humour.'[15] He conspicuously failed to bring the

character to life. (The usually supportive British newspapers described his acting as 'priggish' and 'irritating'.) Not even Griffith seemed especially impressed with his new star's performance – he had once boasted that he could make even monkeys act, but failed to renew his option on Novello.[16]

The Welshman's always fragile *amour-propre* clearly took a dent. He was determined to redeem his reputation – if possible in a role as far removed from that of the earnest young clergyman as possible. Over the following months, he and actress Constance Collier set to work scribbling out the outré fantasy which would later become his first great stage hit, *The Rat*. 'We used to write the play anywhere,' Collier recalls in her autobiography, 'on tablecloths! on envelopes! on bits of paper! And we would sit up far into the night drinking innumerable cups of tea' (Collier, 1929, p. 271). Like Novello, Collier had a background in musical revues. She too had worked with D. W. Griffith: one of her first screen appearances was in *Intolerance* and she had appeared opposite Sir Herbert Tree in the Griffith-produced version of *Macbeth* (1916) before returning to the UK to resume her career.

It was not long since Novello had made his theatre début in Sacha Guitry's play, *Debureau*, at the Ambassadors' Theatre in the West End, and he was still far from comfortable with a live audience. 'I had acquired a complete confidence in myself when facing a battery of cameras in a studio, but when it came to the first rehearsal, I was paralysed with nerves and overwhelmed with self-consciousness and couldn't manage to speak above a whisper.'[17] Nevertheless, Pierre Boucheron, 'the young apache ... the swaggering, ultra-romantic hero of the Gallic underworld',[18] was a part tailor-made for him. He was to play it more than 600 times on stage and three times on film.

According to Collier and Novello, Boucheron was 'a character without one redeeming feature in his make-up'.[19] In other words, this was indeed as far away as Novello could get from playing pious clergymen. He loved the role.

The original screen adaptation of *The Rat* (1925) was his first film for the innovative new British outfit, Gainsborough, a company with an 'international' aesthetic. Under Michael Balcon, Gainsborough had already begun to cultivate relationships with European film-makers (most notably at Germany's UFA studios) and to import Hollywood stars (for example, Nita Naldi, Dorothy Gish).

Directed with verve by Graham Cutts, *The Rat* is full of fights, exhilarating chases (at one point, Boucheron disappears down a manhole to escape the police), and boasts its own sultry dance sequence, all too clearly based on Valentino's famous tango in *The Four Horsemen of the Apocalypse* (1921). Gaylyn Studlar has written that the tango can be seen as 'metaphorically representing the essential reality of patriarchal relations through its dramatic exaggeration of masculine domination and female submission. Its conventions permit the female spectator to enjoyably experience a ritual confrontation with male brutality' (Cohan, 1993, p. 31). Novello's violent approach to the dance underlines her point. To help his partner dance more easily, he rips her skirt at the hip. He holds her so tight that you half suspect he is going to throttle her. Most of the action unfolds in the White Coffin, a demi-monde bar full of Bohemians and ruffians. The story, which involves Boucheron seducing a wealthy, bored aristocrat whose jewels he covets, is far-fetched enough to accommodate Novello's louche, anti-naturalistic style without undue embarrassment: his Boucheron is more pantomime hero than fully-hewn character. Androgynous, infantile (at one stage, behaving like a peevish child, he bites a prison guard's hand), adept with knives, lighting himself cigarettes with studied nonchalance, Boucheron leaps around with an energy scarcely encountered before in British movies. There is no disguising the threadbare nature of the plot. Portentous intertitles ('A bored woman looked at her luxurious world and found it wanting') are used to advance the plot. Every so often, just to remind Boucheron where the best booty is to be found, newspaper headlines announce grand soirées ('At this brilliant gathering, we shall see some of the finest jewels in Europe'). Despite the manifest gaps in character and plotting and the absurd little set pieces (two women in the White Coffin fighting like wild cats over Boucheron), *The Rat* is highly entertaining and carries an undeniable erotic charge.

In a belated attempt at introducing a little realism to the sequel, *The Triumph of the Rat* (1926), the director, Cutts, hired a certain Monsieur Rosca, reputedly a genuine inhabitant of the Parisian underworld. 'In a startling looking check suit and side whiskers,' a journalist visiting the set noted, 'he looked marvellously at home in the White Coffin.'[20] The formula was much the same as before. Even in *The Return of the Rat* (1929), Novello's last screen outing as Boucheron, the exotic and far-fetched storyline remained well-nigh identical to the one told in the

43

original film. Again, Boucheron oscillated between high society and the seedy world of the White Coffin, having sword fights and doomed love affairs. He has married into the aristocracy, but his beautiful wife Zelie betrays him. He discovers her in the arms of Henri de Verrai, a nobleman to whom she owes 300,000 francs. Boucheron, his pride inflamed, challenges de Verrai to a duel, but is defeated. Bleeding profusely, presumed dead, he stumbles back to his old low-life haunts and his still loyal vagrant friends. Again and again in reviews of his films, critics drew attention to Novello's sensitivity. Even when playing sadistic, underworld scoundrels, he somehow managed to remain sympathetic. Hepwoth's male stars, most notably Stewart Rome, were marketed as 'rugged' and 'manly', but such language is rarely used in Novello's case.

Very different in tone, although boasting an equally feverish, incandescent performance from Novello, was *The Lodger: A Tale of the London Fog* (1926), directed at Gainsborough's Islington Studios by Alfred Hitchcock. Adapted from a novel by Mrs Belloc Lowndes, this is a contemporary (1920s) variation on the Jack the Ripper story. A mass murderer with a penchant for blonde-haired chorus girls is on the prowl on the mist-shrouded streets of London. Just as the hunt for him intensifies, a mysterious stranger (Novello) turns up at the Bunters' house, looking for lodgings. A typical lower-middle-class English family, they take him in. But he soon awakens their suspicions. Could he be the killer Scotland Yard is after?

Novello makes a spectacular entrance. He is first seen framed in the doorway of the Bunters' house, the bottom half of his face concealed by a scarf, a haunted, furtive expression in his eyes. The film-makers go out of their way to suggest his guilt. He does not have a clear alibi for the murders. Every night, he paces up and down his room in an agitated fashion. (Hitchcock installed a glass floor so as to film his feet from below.) He slips in and out of the house at odd hours.

Novello's character is never treated simply as potential murderer. He also has an element of the expressionist martyr about him. Baron Ventimiglia's camera work accentuates shadows. Crucifix-like bars of light are seen to flicker across the lodger's face. At the conclusion of the film, before his guilt or innocence is finally established, he is almost lynched in ritual fashion by the London mob. Despite the flickerings of humour and the director's obvious relish for romantic conspiracy (both the lodger and

a mutton-jawed detective are rivals for the love of the Buntings' beautiful daughter Daisy), this is surprisingly dark material for a star vehicle, which on one level *The Lodger* was. (The opening credits, 'Michael Balcon and Carlyle Blackwell by arrangement with C. M. Woolf present IVOR NOVELLO in *The Lodger*,' emphasize that this is Novello's show.) His character may first be feared as a killer, but, perhaps predictably, he plays him as a victim. That doleful look he wears when the mob pursues him is not so very far removed from his equally forlorn bearing when expelled from public school in Hitchcock's *Downhill* (1928). The idea of the pitiable, half-sympathetic killer might have been borrowed wholesale from German expressionist cinema. Whether Conrad Veidt's somnambulist anti-hero in *The Cabinet of Dr Caligari* (1919) or, much later, Peter Lorre's child-murderer in *M* (1931), such types recur in German films of the period. *The Lodger* belongs to exactly the same tradition, but Hitchcock's trick was to make a moody expressionist film in a specifically English context. The backstage badinage and colourful street scenes in *The Lodger* add a comic counterpoint to what might otherwise have seemed a grim, self-conscious study of a murderer. As Donald Spoto puts it in his biography of Hitchcock, 'technically, the film reflected the German influence; generically, it responded to the British predilection for crime fiction' (Spoto, 1994, p. 90).

The dénouement, in which the lodger's innocence is announced, is itself a testament to Novello's new-found status. Fans simply would not allow him to be portrayed as a murderer. As Hitchcock later told Truffaut, 'That was the difficulty. The leading man was a matinée idol in England. He was a very big name at the time. These are problems we face with the star system. Very often, the storyline is jeopardised because a star cannot be a villain.' The director would have preferred to shroud the story in ambiguity, to have the hero wander off into the night, 'so that we would never really know for sure. But with the hero played by a big star, one can't do that. You have to spell it out in big letters: HE IS INNOCENT' (Truffaut, 1967).

Gainsborough belatedly realized that, in Balcon's words, they had 'a star of the first magnitude' (Balcon, 1969, p. 36) on their hands, and promptly put Novello under contract. Hitherto, Balcon had seemed more interested in importing American stars than in grooming new British talent. Nor was he keen on long-term contracts. A glance at Gainsborough's filmography of the 1920s reveals actor after actor who made one

or, at most, two films for the company. Miles Mander, Isabel Jeans, Benita Hume and, most important, Novello are the only names that topped the credit lists on a regular basis. The terms Balcon offered Novello may not have been generous in comparison with Hollywood (even Rin Tin Tin probably got paid more), but by the usual, cheese-paring British standards, they were alluring. The actor undertook to make three films for the studio between January and September 1927. He was to receive £500 a week, and was also given the right to disapprove of stories offered him. He was under no obligation to turn down stage engagements. His total salary from each of the three films was to be 'not less than £3000'. There was a mysterious clause in the contract which bound him to 'comport himself with both dignity and decency in private and professional life and not to commit or permit any act or thing which would bring him into notoriety or contempt or disgrace' (Macqueen-Pope, 1952, p. 217).

This prim little clause hints at how worried film-makers of the time were about offending the self-appointed guardians of public morality: writers, teachers and priests who railed on about cinema as 'the devil's camera'.[21] Arguably, a whiff of scandal might have helped the staid British film culture of the 1920s. Whereas Hollywood had Fatty Arbuckle and Theda Bara, the best the British could muster were clean-living Home Counties types like Alma Taylor, Chrissie White and Henry Edwards. The British trade journals acknowledged as much.

> Part of the glamour with which Hollywood is surrounded in the eyes of the world undoubtedly consists of its reputation – whether justly or unjustly earned – for moral laxity in greater or lesser degree. It is, in fact, a first-class commercial asset . . . such matters as the frequent divorces and brief marriages of stars, and their uniformly absurd but widely broadcast views on the emotions, are part of the publicity man's most valuable stock-in-trade.[22]

Sadly, the article pointed out, Britain languished a long way behind when it came to the scandals that the world wanted to read about. As a consequence, its star system suffered. Not even Novello could help. In the end, the clause in his contract proved academic: despite his colourful private life, the only scandal Novello became involved in was many years later, during the Second World War, when he was briefly incarcerated in Wormwood Scrubs after flouting Government fuel regulations.

In his roles at least, Novello remained the archetypal bounder-with-a-heart, playing philandering husbands, suspected murderers and French jewellery thieves. In his very next film after *The Lodger*, he was cast as Roddy Berwick, a public schoolboy who comports himself with neither dignity nor decency. 'A boy in his last term at one of the great public schools', he seems to have all the trappings of the hero. In the first reel he is presented as a paragon of schoolboy virtue – star player in the rugger XV, talented scholar, all-round personable chap. But Roddy soon comes crashing down from his golden pedestal – he is expelled after admitting to consorting with Mabel, proprietress of the village teashop and local *femme fatale*. (When he realizes he will have to leave, he utters – via intertitle – the immortal words, 'Does that mean, sir, that I shall not be able to play for the old boys?') The culprit is really his friend Tim Wakely, son of a poor parson, but in a Sydney Carton-like display of selfless loyalty, Roddy assumes the guilt. He knows that otherwise Tim's father will die of shame and that Tim will lose the prestigious scholarship he has only just won. After leaving school in disgrace, Roddy heads over to Paris in search of anonymity. It is worth noting the regularity with which Gainsborough transplanted its stars to French soil whenever a whiff of exoticism was needed. As historians Ray Seaton and Roy Martin put it, '*Downhill* provides the first intimation of Gainsborough's long-standing and at times obsessional involvement with life across the Channel. A trip to France was always on the cards in Poole Street, even for Will Hay and his schoolboys' (Seaton and Martin, 1982, p. 10). Lost in France, Novello briefly becomes a professional motor racing driver, marries an actress, reaches his lowest ebb in a Marseilles doss-house, but lives to see his reputation restored.

In its way *Downhill* (1927) is every bit as preposterous a wish-fulfilment fantasy as *The Rat*. The original sketches on which it was based were written by Novello and Constance Collier under the telling pseudonym, David LeStrange. Again, as in *The Rat*, the key ingredients are masochism and narcissism: the hero shows he is suffering by striking intense, dreamy poses. Ivor Montagu, who was assigned to adapt the play for screen, was not in the slightest impressed with its self-indulgent exoticism. 'The more I studied the play,' he wrote in a memo to producer C. M. Woolf, 'the less I liked it. It was a drama of subjective action, expressed almost wholly in terms of extravagant and occasionally erotic emotion. Objective action was practically non-existent. There was no

effort to present a constructive story and there was no plot worth mentioning.'[23]

It was not just the structural shortcomings of the piece that exasperated him. He also objected to the louche, effete tone. 'I have worked in two strong feminine parts. I have also endeavoured to preserve the hero's character. If he is to marry a clean girl, we must keep him as clean as possible. He can be foolish, and quixotic, but not unmanly.'[24]

Montagu was a leading critic and theorist of the time; a committed communist (despite his aristocratic background), who helped set up the Film Society (a club which showcased avant-garde film-making) in the mid-1920s, and a leading light of the technicians' union, the ACT. His remarks, which echo the kind of criticisms levelled in later years at Gainsborough melodramas, hint at the tension which has always existed in British film culture between intellectuals and those who want to make popular, accessible films. Arguably, it was precisely the 'extravagant and erotic emotion' Novello brought to his parts, his androgynous quality, which made him such a star in the first place. Like Valentino in Hollywood, he contradicted received ideas of masculinity. He was the object of the gaze, always likely to hog more close-ups than the women he appeared opposite. He was certainly an actor in a very different mould from the other leading men of the 1920s – silent, impassive types like Clive Brook (who went to bed every night wearing a neck brace to keep his chin up) and Stewart Rome, or burly, muscular sorts like former boxer Billy Wells, star of *Kent the Fighting Man* and the inspiration behind the Rank Organization's corporate motif. (The image of Wells, bared to the waist, walloping a gong, prefaced all Rank Film Distributor's movies from the mid-1930s onwards and soon became as well-known to British audiences as RKO's bleeping pylons or MGM's lion.)

Novello loved the cameras. There is a widely held notion that he scorned cinema, appearing in movies while he was waiting for his West End actor–manager career to take off: 'It was not enough for him to see his shadow on the film and he was sure he could do better when in touch with humanity ... his success on the films only made the desire to act in the theatre all the stronger ... ' (Macqueen-Pope, 1952, p. 161). This view simply isn't supported by facts. The truth is that Novello only retired to the stage when his film career began to flounder. There is no clearer indication of his determination to succeed in cinema than the fact that he returned to Hollywood in the early 1930s when, thanks to the Broadway

success of his play, *The Truth Game*, he was offered a two-year contract at MGM by Irving Thalberg. He went out west seemingly oblivious to his earlier failure in Griffith's *The White Rose*, and determined to establish himself as both actor and screenwriter. Again, he was dismayed by his reception. His looks, it seemed, were fine, but his time was past. Novello's career flourished in the silent era. His relish for stylization and artifice, for the heightened atmosphere of silent melodrama, no longer seemed quite so appropriate in the more prosaic age of the talkies. His clipped, West End diction grated on the ears of cinemagoers accustomed to seeing him as French rogues or would-be murderers. In the age of the talkies, his celebrated profile was no longer enough.

> Someone said I was too English. This quite staggered me; it seemed such an absurd remark to make until it was explained. I was told there were at least 5000 picture houses in America whose audiences had never heard an Englishman speak. English was like a foreign language to them![25]

There was nothing wrong with his voice. His mother, after all, was an elocution teacher, and he was an acclaimed stage as well as screen actor. However, his career in the talkies began badly with a sound version of *Return of the Rat* (1929), which was also released as a silent film. The primitive recording techniques did not impress reviewers. 'The dialogue in the various scenes to which talk has been added would be more effective if it were more in keeping with the characterisation, while the speech of the actors, although perfectly clear, is a trifle too deliberate and sometimes altogether too loud,' chastised the *Kinematograph Weekly* of 25 July 1929. 'The picture has no ascertainable advantage over the original silent version.'

Novello was unhappy with the minor roles he was offered in Hollywood. A supporting part opposite his friend Ruth Chatterton in Paramount's *Once a Lady* (1931) was the best that came his way. Nor was he wholly delighted about the writing assignments Thalberg gave him. He reluctantly contributed to Garbo's *Mata Hari* (1931). Then, despite (or perhaps because of) his reputation for brittle, witty drawing-room dialogue, he was set to work devising *bons mots* for Johnny Weismuller in MGM's first Tarzan movie. (As he later recalled, 'I have never written such rubbish in my life.'[26])

He shamefacedly broke his contract, returning to Britain after only a

year in 1931. Britain's biggest star was very small beer in Hollywood and it irked him enormously. 'People were unbelievably kind but I'd mattered in England and New York, and out there I just didn't ... the studio had Ramon Novarro, Robert Montgomery, and Clark Gable, for all of whom stories had to be found, so what chance had I?'[27] He called his stint in Hollywood his greatest failure and admitted that he had learned his lesson. What had pained him most of all was his relative anonymity. 'I came away knowing that obscurity and I were bad companions.'[28]

Back home in Britain, Novello was not quite forgotten. Newspapers remained as fascinated as ever by his private life. There was a brief flurry of gossip that he was about to wed actress Benita Hume. ('When Ivor arrived at Waterloo on Friday on his return from America, he had no eyes for any of his hundreds of young women fans – all his attention was lavished on his mother and Benita Hume whom he swept away to his car in a most possessive manner.'[29]) But Hume herself was shortly Hollywood-bound, where she had other husbands (namely Ronald Colman and George Sanders) in mind, and Novello's own star seemed dimmed.

By the time sound films came along, Novello had already been working in movies for more than ten years. He may not have lost his looks but he was no longer convincing as the juvenile romantic lead. Although his fans stayed loyal, his few further British films were insipid affairs with little of the sultry exoticism of *The Lodger* or *The Rat*. His roles reflected his status as light entertainer. In one, *I Lived with You* (1933), he played a White Russian prince adrift in the London suburbs. In another, Basil Dean's *Autumn Crocus* (1934), he was cast as an Austrian inn-keeper in the Tyrol – by all accounts an embarrassing experience for everybody concerned ('Novello's schoolboy knees under his Tyrolean shorts make the audience, if not the players, feel bashful'[30]). With his screen career in abeyance, he retired into his pyjamas and concentrated on churning out the popular musical romances for which he is best remembered today.

> Mostly he wrote them in bed, dashing out to the piano in his pyjamas to write down snatches, whoever was present ... he practically lived in his pyjamas, hating, it seemed, to get up or to grow up ... often he would come up from Red Roofs, his house near Maidenhead, to play, still wearing his pyjamas under a sort of battle-dress suit.[31]

He also took sideswipes at the film industry, grandly proclaiming that the stage was 'so much more satisfying' than 'the watching of black and white shadows chasing each other across the silver screen'.[32] Despite what seems a bizarre mix of roles late on in his screen career, he complained about being typecast as a 'ladies' darling'. He insisted in one interview that this was not fair to the public: 'Every time you go into a restaurant, you don't expect to be served a soufflé.'[33]

During his heyday as a matinée idol, Novello easily outshone most of his leading ladies. The audience polls confirm that he held a far greater fascination for female cinemagoers than any equivalent British woman star held for men. He was always the cynosure: the object of the gaze. One of the few able to match his lustre was Mabel Poulton, who appeared alongside him in *The Constant Nymph* (1928). Her story stands as a cautionary tale of how badly the British industry was capable of treating its stars.

Poulton started her show-business career in unlikely fashion, as a typist at the Alhambra Theatre in Leicester Square. Her first faltering steps into the film industry were taken when her boss, struck by her similarity to Lillian Gish, ordered her to dress in a kimono and lie in front of the screen three times a day during showings of D.W. Griffith's *Broken Blossoms* (1919). As she posed like a tailor's dummy, she was 'spotted' by producer George Pearson, who gave her a small part in his mawkish melodrama about a run-down music hall star (Jimmy Daw), *Nothing Else Matters* (1920). She also appeared as Little Nell in Thomas Bentley's adaptation of Charles Dickens's *The Old Curiosity Shop*. She was paid £20 a week when she worked, but times were hard and Pearson could not afford to keep her under contract. She very nearly landed a role in Abel Gance's *Napoléon* (1927). Like Pearson, Gance had been struck by Poulton's resemblance to Gish and had summoned her over to Paris to audition her for the role of Violine, the young woman who dotes on Napoleon from afar. Although she did not win the role, she did appear in Germaine Dulac's *Ame d'Artiste* (1924) before returning home. Back in England, she finally established herself in *The Constant Nymph* (1928), playing a young woman smitten by handsome, headstrong composer Lewis Dodd (Novello). This film, an adaptation of Margaret Kennedy's 1924 best-seller of the same name, was considered a little *risqué*, both in its frank treatment of relationships and its leading character: Dodd was a Bohemian with nothing but contempt for polite society. Likened to Lillian

Gish at the beginning of her career, Poulton now suddenly seemed to remind reviewers of America's sweetheart: 'Mabel Poulton may, without fulsome flattery, be described as Britain's answer to Mary Pickford.'[34] Sprightly, intelligent and mercurial, she was heralded by Gainsborough producer Michael Balcon as having 'that inner something which enabled a few silent screen actresses to convey emotion without the power of speech' (Balcon, 1969, p. 37). A few years later, a nostalgic John Betjeman, enraptured by the memory of her performance, rhapsodized about her in the *Evening Standard*:

> Men will understand me when I say how one suddenly notices in the tube or tram or bus a girl with a pathetic face, pathetically beautiful, who seems to stand for all the thousands of people who only come out of their offices during the rush hour to go back to their little furnished rooms. Mabel Poulton stands for these.[35]

Poulton was not a vamp like her co-star in *The Constant Nymph*, Benita Hume, Gainsborough's glamour queen of the late 1920s. ('There's none that's sweeter than Benita', or 'A girl who's not a might-have-been/She's made her mark on stage and screen', as Hume's cigarette cards used to put it.) Nor did Poulton have the icy hauteur of Madeleine Carroll, another in the long line of Gainsborough stars who decamped to Hollywood. But she approached her roles with an emotional intensity few of her contemporaries could match. Not long after the release of *A Constant Nymph*, Poulton caused a stir in the fan magazines by insuring her eyes, 'those precious orbs which irradiate the screen',[36] for £30,000. (This was not simply vanity. The unshielded carbon lights often used by 1920s filmmakers were potentially damaging to sight and could cause conjunctivitis.) Her future in British cinema seemed assured. Sadly, like *The Constant Nymph* itself (the film went missing, presumed lost, for many years before a print turned up unexpectedly in a Sussex house in 1995), Poulton herself soon vanished from British screens.

As Poulton's fellow actress Chili Bouchier recalls, the arrival of sound caught British film studios napping. Bouchier played a trapeze artist in *The City of Play* (1929), which was half-silent, half-talkie. 'Nobody had considered the rather odd assortment of sounds which would issue from the mouths of the leading players. There was the stage-trained dark brown bass of Lawson Butt, the regional accent of the leading man, and my Minnie Mouse squeak' (Bouchier, 1995, p. 62). With microphones

swathed in blankets and hanging over actors' heads like magnets, it was little wonder British films now seemed more static than ever.

Like Poulton, Bouchier started her film career in haphazard fashion. The official story was that she was spotted while modelling as a mannequin at Harrods. In fact, she had responded to an advertisement in an evening paper, 'We make film stars, 3 guineas.' The advertisement was a fake, but while in the film company's offices, she caught the eye of a director, who booked her to appear in a short commercial film.[37] Her career was not plotted with any great strategic skill. She started off as a vamp in the late silent era and was taken in hand by producer Herbert Wilcox, who changed her name to Dorothy Bouchier (she changed it back to Chili in 1936) and groomed her for more upmarket roles. She starred in a handful of prestige pictures, for instance *Carnival* (1931) and *The Blue Danube* (1932), but 'following one of the biggest publicity campaigns ever accorded an English actress',[37] was nevertheless allowed to fritter away her career in a series of American-backed quota quickies. Film historian Erik Braun insists she had considerably more oomph than most of her British contemporaries. 'At a time when British film girls were notoriously stick-like, both in their acting and their physiques, she radiated an almost indecent amount of sex appeal.'[38]

As in Hollywood, talkies spelled the end of several careers. 'So many actors fell by the wayside at that time,' Bouchier remembers. 'The most regretted was little Mabel Poulton, a silent star who had the face of a lovely flower but a cockney accent which no amount of elocution lessons could eradicate' (Bouchier, 1995, p. 52). In the class-confined world of the early British talkies, this meant Poulton could play only character parts. When it came to leading roles, 'the lamentable preference was for the English of the drama schools and of South Kensington' (Balcon, 1969, p. 37). Yet the enormous popularity in the 1920s of Betty Balfour, British cinema's 'Queen of Happiness', suggested that as long as film-makers leavened their stories with suitable quantities of humour and pathos, it was quite acceptable to have working-class heroes or heroines alongside the matinée idols and drawing-room sirens.

> B is for Betty and B is for Balfour
> B is for Blue Eyes and Blinkeyes as well;
> B is for Breathless, her daring adventure
> B is for Britain, of which she is Belle

B is for Brains and Blonde Hair and Beauty,
And then a big B for she beats all the rest
B is for Betty and B is for Balfour
B is for beautiful, British and Best
(A devoted fan's letter to *Picture Show*, 9 June 1928)

A diminutive (5ft 3in), 'low-life gamine' (Low, 1971, p. 110), Balfour was born in March 1903. She made her stage début in London, aged 11. She was spotted by representatives of the Welsh-Pearson film company as early as 1914 and offered a bit part in a movie. 'Like the majority of people, I thought film acting was no end of a joke. I enjoyed the experience thoroughly, for I did not see any of the work I was doing projected on the screen.'[39] However, she did not make her first important film until 1920, when she appeared in George Pearson's melodrama, *Nothing Else Matters*, alongside Mabel Poulton. Balfour's role in the picture is relatively small – she plays a lively but scatterbrained house-maid who allows music hall star Jimmy Daw's beloved young son to wander off unattended. However, she made an immediate impression. Pearson could see, in fizzing miniature, just the kind of screen personality he wanted to develop.

With Balfour in mind, Pearson bought the rights to a popular music hall sketch, *Squibs*. 'The sketch material was quite unsuitable for our purpose, but the title had great value . . . it hinted at fireworks' (Pearson, 1957, p. 95). As it eventually emerged on screen, *Squibs* was the story of a cockney flowerseller, plying her trade in Piccadilly Circus, who is rescued from a near-fatal accident by a friendly policeman. At first she resents him, but gradually falls in love with him. The parallels with *Pygmalion* are apparent. Squibs even dresses like Eliza Doolittle. Her brand of comedy is bizarrely reminiscent of Chaplin. There are scenes of her wandering round London – chasing after buses, trying to ride a bike, and rollerskating (inevitably, she loses her balance, topples over and causes a pile-up). Her father is a drunken layabout who keeps beer by his bed.

The film proved an immediate success, catapulting Balfour to stardom. Pearson followed it up with a series of near-identical sequels. Even when she wasn't actually playing Squibs, Balfour's producers were unwilling to allow her to err too far from her new screen persona. In the preposterous *Blinkeyes* (1926) for instance, she stars as a dancer in an East End music

hall, badly in need of money with which 'to extricate her beloved uncle from the clutches of an evil Chinese'.[40] She auctions herself and is bought by a handsome young man, who immediately places her in the care of his family. Other choice roles included a general assistant in a circus who takes to the music hall stage in *Monkey Nuts* (1928), and 'a reformed female hooligan who lives to regret the curse she has put on a youthful enemy'[41] in *Little Devil May Care* (1927).

By 1924 she was already firmly ensconced at the top of British fans' polls. She retained her status for the rest of the decade, nestling alongside Novello in the British public's affections. The extent of her popularity is easily measured by the range of products she endorsed. Lux soap, Ponds vanishing cold cream, Wills' cigarettes, Grossmith's oriental face powders, Kia-Ora lemon squash, Odol's toothpaste, Warren's chocolate and Symington's soups ('delicious and most invigorating') all received her smiling seal of approval in newspapers and magazines of the day.

Unlike Novello, Balfour was popular with both male and female fans. In many ways, the two stars are the complete antithesis of one another. Balfour always got her man by the final reel, but she was comedienne more than sex symbol. She invariably wore tattered, shabby clothes, lived in the East End, kept smiling through all her misfortunes and did all she could to prove she had a heart of gold. Although she was no Lancastrian and certainly could not sing, she sometimes seems like a precursor of the 1930s favourite, Gracie Fields, another genuine folk heroine. Novello, by contrast, was seldom to be seen laughing. His star image was all about exoticism and sophistication. Both stars shared at least one unenviable trait. They were never able to match their British success abroad. Novello belly-flopped in Hollywood; Balfour did not make so much as a ripple in the US market. Regardless of the fact that her movies were silent and relied on intertitles for speech, her East End characters were still deemed incomprehensible. As the *Daily Express* noted, 'She cannot find stories which will suit her peculiar abilities and also please the whole world. "Cockney" characteristics and mannerisms, for example, are not understood outside this country, and have had to be translated, even in some of the Dominions.'[42]

Perhaps Novello and Balfour had something else in common. In their own very different ways, they were considerably more animated than the majority of 1920s British screen actors. 'She has *joie de vivre*. She is English, but somehow she has escaped the stiff-necked formality that

typifies most of our race,'[43] one enthusiastic journalist observed. Another French writer concurred, anticipating Truffaut's famous complaint that the British were temperamentally unsuited to cinema:

> The spirit behind the cinema is the very opposite of the character-
> istic British spirit ... when there are no words the face has to
> interpret the emotions, but with the exception of Betty Balfour, the
> features of English cinema actors and actresses remain perfectly
> wooden. At times, it is even painful to see them struggling to put a
> little bit of life into the scene.[44]

Inevitably, Balfour tired of being typecast as the cheerful cockney flower girl. And equally inevitably, the more she chose to vary her roles, the less popular she became. As early as 1925, she tried to shed her familiar image, appearing as a young heiress in the comedy romance, *Somebody's Darling*. She was accused of forsaking Squibs, but evidently felt no regrets. 'I don't have to wear any shabby or sombre dresses for this part. I go out and spend lots of money on beautiful Paquin gowns and frocks and wraps.'[45]

In 1926 Balfour broke with Welsh-Pearson and tried to remould herself as a sophisticated, fashionable woman of the world. (This was equivalent to Novello attempting to pass himself off as a swarthy York-shire miner.) Critics and fans did not abandon her entirely (she remained high in popularity polls throughout the 1920s) but they were suspicious of the transformation. When she appeared in *Paradise* (1929) opposite Alexandre d'Arcy (an obscure Franco-Egyptian actor being touted by the British as the new Valentino), she was chastised for abandoning her roots. 'Having once seen the Squibs series, we are rather reserved to anything in which Betty is not Squibs,' commented one critic.[46] Her choice of role hints at her frustration at being always typecast as the Cockney flower girl – she plays the daughter of a slum parson who exchanges the back streets for the Riviera after winning a small fortune in a crossword competition. The very titles of her other films of the period, *Luxury* (1928), shot in Venice, and Alfred Hitchcock's *Champagne* (1928), in which she played a British version of a jazz-age flapper, hint at the career trajectory she now wished to pursue. But neither she nor the British critics were happy with her change of direction. The snobbery was evident. By moving 'out of the kitchen into the drawing room', Balfour was considered to be getting above herself.[47]

Betty Balfour made the big mistake of her screen career when she deserted Squibs and the cockney slavey type of role for more dressy parts. Whatever her talents may be, the art of wearing clothes most certainly is not one of them. Clad in a weird collection of odd garments, with a smut across her nose and hair scragged back into an untidy bundle, Betty can convey both humour and pathos. A Paris gown swamps her personality and gives her at once an artificial air – she reminds one a little of an unhappy kitten, dressed up in some doll's clothes by a mischievous child.[48]

Perhaps predictably, Balfour struggled in the early sound era. When no financier would back her first talkie, *The Brat* (1930), she raised the money herself. In 1935, twelve years after first tackling the role, she made a sound remake of *Squibs*. But by now she was too old for the part. The gamine-like waif of the silent film had become a lively, middle-aged matron. Her producers were clearly hoping to make her into London's answer to Lancashire lass Gracie Fields, but her moment had passed. Unlike Novello, she was not able to reinvent herself as a stage star. By the mid-1930s, Britain's biggest star of the silent era was reduced to playing character parts: she was John Mills's mother in *Forever England* (1935), Jessie Matthews's loyal friend in *Evergreen* (1934). As if to emphasize her dimming lustre, she ended up cast as a dreary suburban housewife in one of her last films, *29 Acacia Avenue* (1945). Her husband was played by Gordon Harker, a comedian who, only a few years before, had been cast as her father.

Notes

1. *Daily Telegraph*, 13 March 1951.
2. *Evening Standard*, 12 March 1951.
3. Cutting from 12 March 1951. Source unattributed. Kept in Ivor Novello's personal file in the library of the Theatre Museum, Covent Garden.
4. *The Times*, 12 March 1951.
5. As Donald Spoto notes, 'Novello was never, on or off the set, especially shy about his homosexual life' (Spoto, 1994, p. 86).
6. Take, for example, the description of Valentino as a European aristocrat in a fan magazine: 'His charm is distinctly Continental ... he has the European man's appreciation of music, of painting, of literature' (quoted in Hansen, 1991, p. 258).
7. *Pictures and Picturegoer*, August 1925.
8. *News of the World*, 17 September 1933.
9. *Picturegoer*, November 1926.
10. *Kinematograph Weekly*, 14 November 1929.
11. *Ibid*.

12. *News of the World*, 8 October 1933.
13. This quotation is taken from a cutting in Ivor Novello's personal file, kept in the Theatre Museum library, Covent Garden.
14. *Picturegoer*, December 1924.
15. *News of the World*, 8 October 1933.
16. Hannen Swaffer, *London Calling* (radio programme), 19 January 1929.
17. *News of the World*, 8 October 1933.
18. *Picturegoer*, August 1925.
19. *News of the World*, 8 October 1933.
20. *Picturegoer*, August 1926.
21. A tract of this name was indeed published in the 1930s: *The Devil's Camera*, by R. G. Burnett and E. D. Martell (London, 1932).
22. *Kinematograph Weekly*, 12 September 1929.
23. Ivor Montagu files, British Film Institute Special Collections.
24. *Ibid.*
25. *News of the World*, 8 October 1933.
26. *News of the World*, 15 October 1933.
27. *Sunday Pictorial*, 15 May 1938.
28. *Ibid.*
29. Benita Hume, *The People*, 28 February 1932.
30. *Observer*, 22 April 1934.
31. Obituary by Douglas Warth, British Film Institute (BFI) microfiche.
32. *Picturegoer*, 23 September 1933.
33. *Ibid.*
34. The *Weekly Dispatch*, 26 February 1928.
35. *Evening Standard*, 18 July 1934.
36. The information about Poulton's eye insurance is taken from an unsourced 1920s cutting included in the BFI microfiche records of the actress's career.
37. Erik Braun, 'The Indestructibles', *Films & Filming*, Autumn 1973.
38. *Ibid.*
39. *Ibid.*
40. *Dundee Courier*, 14 April 1929.
41. *Daily Mail*, 29 September 1926.
42. *Daily Express*, 27 October 1928.
43. *Film Weekly*, 11 March 1929.
44. Quoted in the *Morning Post*, 29 September 1937.
45. *Picturegoer*, December 1925.
46. *Film Weekly*, 21 January 1929.
47. *Manchester Evening News*, 8 March 1929.
48. *Picturegoer*, July 1927.

The King, the Queen and the Dancing Divinity

The distance between Hollywood and Broadway is calculated at a little over 3000 miles. From Pinewood or Elstree to London's West End is only half an hour's travel by car or train. By the early 1930s this 'dangerous' proximity between screen and stage was provoking much vexed comment in the British film trade press.[1] The majority of stars continued to be drawn from theatre. Many, like the celebrated young trio, John Gielgud, Ralph Richardson and Laurence Olivier, had clauses pencilled into their movie contracts which entitled them to stop shooting in plenty of time for their evening performance in the theatre. They would finish filming at around 5 or 6 p.m., jump into a cab and disappear in the direction of their Shaftesbury Avenue changing-rooms. Meanwhile, director and technicians were left to pack up behind them. 'I found filming terribly exhausting,' Gielgud later recalled, echoing a sentiment shared by many of his contemporaries. 'I had to get up very early in the morning and was always fidgeting to get away by 5 or 6 for the evening performance, so I grew to dislike working for the cinema' (Gielgud, 1981, p. 153). After the coming of sound, Hollywood, too, borrowed actors and writers from theatre, but at least the worlds did not sit side by side. Nobody could dash back to Broadway in the evening.

The extra hours lost to film-makers because of their stars' stage commitments were not necessarily problematic. Although British film-makers might stay busy well into the night making their quota quickies,[2] most Hollywood studios would close down at a regular hour, like any other business. More damaging for the British industry was the psychological blow, the sense that performing for the cameras was still only bread-and-butter work. As Jack Hawkins put it, 'Like many actors in those days, I did not take my films seriously. One tended to regard them

as second-rate compared with the live theatre . . . little more than a means of paying one's income tax' (quoted in Richards, 1989, p. 163). This contempt for cinema is far harder to understand than that of actor–managers like Forbes-Robertson and Tree. By the 1930s films were established as easily the most popular medium of the day. 'The essential social habit of the age', as A. J. P. Taylor called them, they 'slaughtered all competitors' (Taylor, 1975, p. 392). As their popularity burgeoned, that of music hall and theatre declined. No longer could actors use the excuse that they were muted by cinema. This was the era of the talkie. Those sonorous, classically trained voices of the Old Vic thespians should at last have come into their own.

Many British stage actors were lured to Hollywood during the early sound era, but many more stayed at home and continued to condescend to appear in movies between or even during theatrical engagements. 'West End stage celebrities are breaking in to an extent which is out of all proportion to the necessity of having them,' argued P. L. Mannock in the *Kinematograph Weekly*, pointing out that specialist screen players were being pushed out of their jobs.

On a rare visit to England, one of the successful British emigrés in Hollywood, Basil Rathbone, railed against the fatal habit of recruiting stage actors to fill screen parts. 'It can't be done,' he cautioned. 'A man cannot serve two masters. His work is bound to suffer if he tries. They are absolutely distinct, separate and whole-time jobs.'[3] This was a notion that British screen actors of the time simply could not comprehend. Everybody, from young Shakespearian actors like John Gielgud to mainstays of West End musical romance like Ivor Novello, from Aldwych farceurs like Ralph Lynn and Tom Walls, to music hall favourites like Gracie Fields and George Formby, oscillated between stage and screen. To do so was considered only natural.

Nor were British studio bosses, many of whom seemed to regard publicity as tawdry and vulgar, especially diligent at promoting their stars. One even went so far as to announce that his organization 'did not propose to glamourise its stars by sending out puff paragraphs about their favourite beauty cream or domestic details about their private lives.'[4] British fans were obliged to gorge themselves on details of Hollywood stars instead. Magazines carried photo-spreads of their children, their smartly manicured lawns, tennis courts and favourite cars, and dutifully reported their marriages and engagements. There were profiles

of British stars too, but they tended to focus more on the roles that they played than on their private lives. As Benita Hume, who headed out west herself, put it, 'You can't be famous unless you go to Hollywood ... a sprained ankle in Hollywood and all the world knows about it. In London, we get nice notices if we do nice work – and there the subject ends.'[5]

British publicity techniques were crude and ineffective, primarily, it seems, because skimping on advertising was seen as a way of saving money. As one exasperated journalist complained, 'I wish publicity bulletins, in their fatuousness, would at least take the trouble to ascertain the correct spelling of their players' names ... I have never noticed such a thing in the crudest American publicity.'[6] The same journalist, P. L. Mannock, launched a telling broadside against the British industry's pitiful attempts at creating a star system. The public, the stars themselves and the showmen all realized that stars were a prime commercial asset, but, in general, the studio bosses did not.

> The creation of a film star is a systematic business and its practice a vital part of production policy. A player of notable merit is signed up, either on unexploited possibilities or on half-established reputation. He or she is boomed, sold to the press through expensive but efficient publicity, and great care is taken to show this chosen personality at its best in a constant succession of intelligently selected stories. That is what ought to happen. The British studio, broadly speaking, does none of these things. It sometimes makes a brave announcement that this or that artist has been signed on contract for a period. Thereupon, it lies down and goes to sleep. Hardly ever is an attempt made to publicise the player at all.[7]

It was impossible, Mannock complained, to get hold of good still portraits, because none were taken. There was no planning about how a star's career should be structured. Instead, he or she was thrown into the first available project, regardless of whether or not it was suitable. Either that, or the stars were left languishing under contract.

There was no doubt that the public had an appetite for glamour, whether or not the film studios satisfied it. British society was still divided along class lines, but between the wars, old hierarchies had loosened. Advertisements in film magazines implied that the kind of glittering

lifestyle which had once seemed to be the exclusive preserve of high society – débutantes, dukes and duchesses whose parties and weddings were covered in minute detail in the *Tatler* and the *Bystander* – was now accessible to everyone. *Picturegoer* carried photographs every week of young, blue-blooded beauties, looking for all the world like starlets and proselytizing on behalf of Ponds Cold Cream. A random survey of 1932 turns up 'the lovely Lady Milbanke ... with her rose-petal skin' (6 February), 'the charming debutante, Lady Georgiana Curzon', who 'guards her youthful loveliness with Ponds' two creams' (5 March), 'the lovely Lady Arlington', who thoughtfully 'discusses modern girls and their complexions' (2 April), and the (equally) 'lovely' Marchioness of Carisbrooke, who shares the intimate 'secrets of the flawless perfection of her exquisite skin' (28 May). Ponds' choice of models is revealing: these aristocrats, it is implied, have a degree of sophistication which the British screen actresses could not match.

While there were no *Sunset Boulevard*-style stories of old British silent stars living in suicidal seclusion in Home Counties mansions, it was apparent that most of the popular favourites from the 1920s were already forgotten by the start of the new decade. Hepworth's old ingénue, Alma Taylor, had the embarrassing experience of not even being recognized when she made a personal appearance at a dance hall.[8] Her contemporaries, Ivy Duke and Violet Hopson, were reduced to playing bit parts. Novello, as mentioned, retreated from movies into the cocooned world of West End musical romance when his film career began to go awry in the early 1930s. Mabel Poulton married a businessman and all but vanished from sight. Betty Balfour slipped down the cast list, playing faithful friends or devoted mothers rather than leading roles.[9] Many of the actors and directors who had migrated to Hollywood were regarded with ill-disguised hostility back in Britain. There were continual, sniping attacks on Chaplin in particular. When the legendary comedian visited London in 1931 and threw a dinner party for people he had met in Hollywood, the British press excoriated him for not inviting any representatives from the British film industry. Nor did he turn up at a function to which his old variety colleagues had invited him. 'He was in London for only three weeks,' wrote *Picturegoer*, 'and yet, during that time, he succeeded in offending scores of people.'[10] His offence was simply that he refused to be treated as a mascot. Merely by trying to safeguard his privacy, he antagonized his hosts. Edmund Goulding, the London-born director of

such films as *Grand Hotel* (1932) and *Dark Victory* (1939), was echoing a familiar complaint when he observed of the British press, 'I feel sometimes that there must be a conspiracy on foot ... to damn all my work whenever there is the smallest grounds for adverse criticism, or if my work defies hostile criticism, to keep the public utterly ignorant of the fact that I am an Englishman.'[11] The many British stars who were successful in Hollywood (Clive Brook, Ronald Colman, Herbert Marshall, Colin Clive, Ida Lupino, *et al.*) experienced the same grudging treatment back home.

Whatever their own ineffectiveness in building up stars, British producers joined with the British press heaping opprobrium on colleagues who attempted to import Hollywood names. As one journalist put it when US actors began to crowd the British studios, 'the British industry is threatened by America's Throw-Outs, Has-Beens and Never-Wasers'.[12] Such lesser lights of Hollywood as Anna May Wong, George Arliss (admittedly British-born) and even Gloria Swanson (when her career was in decline) appeared in British films of the 1930s.

Since the occasion a decade earlier when Michael Balcon had paid a small fortune to entice Betty Compson over from Hollywood to star in *Woman to Woman* (1923), expensive Americans had not always improved box-office receipts either at home or abroad. It was clear the British would have to discover their own stars. This they did – and given the emphasis that so many British film-makers of the era placed on class, glamour and heritage, it was singularly appropriate that their three biggest international names of the decade all traded shamelessly on 'snob' appeal.

Not that there was anything remotely rarefied or effete about Charles Laughton, who won the Best Actor Oscar for his role in Alexander Korda's *The Private Life of Henry VIII* (1933), the first British talkie to make a significant impression on the US market, and one which, for a change, allowed the British press to crow in self-congratulation: '*The Private Life of Henry VIII* is the best picture made in this country, the finest film we have so far turned out in our studios ... [it] will do more for the prestige of British pictures than all the "windy" writing and talk imaginable.'[13]

Laughton's Henry VIII was an explosive buffoon, a monarch of gargantuan appetite and infantile temperament, who bellowed, chewed chicken legs, and had his various wives executed, looking all the while

like an enormous, bearded baby. Watching him, it is hard not to be reminded of Freud's famous phrase, His Majesty the Child. Beneath the blubber and the bluster, he is also an oddly vulnerable figure, hen-pecked and even uxorious. His Henry, with his vast *embonpoint* and skinny little legs, follows as much in the tradition of Falstaff as of conventional king. What is most striking about him as he scuttles across screen in his tights and Tudor ruffles is his low centre of gravity. Laughton, who always prepared meticulously for his roles, told the *Sunday Express* he 'spent a lot of my time walking about the old Tudor Palace at Hampton Court, getting my mind accustomed to the square, squat architecture of the rooms and cloisters . . . I think it was from the houses and rooms that I got my idea of Henry.'[14] One can imagine the role being played by music hall star George Robey, the bushy-eyebrowed Prime Minister of Mirth, or even maybe the bumbling Will Hay. (Some critics did indeed believe the performance was rooted in the 'native vitality and vulgarity of the English music hall tradition' (Kulik, 1990, p. 93).) But Laughton invests the king with pathos as well as comic braggadocio. The glossy production values (the film was shot by a Frenchman, Georges Perinal) and coy sexual references (the suggestive script was by a Hungarian, Lajos Biros) add an air of continental sophistication.

The US advertising campaign for *Henry VIII* picked up on the prurient, 'private life' aspect of the story. As Kurt Singer notes in his biography of Laughton (1954), it was marketed as 'a super-colossal portrait of a forgiving soul, always ready to bury the hatchet – in the wife's neck'. *Motion Picture Herald*, the bible of the US exhibitors, was enthusiastic about the prospects the film offered to imaginative showmen. 'There is room for wide-open selling and exploitation in the title and its indication of the Bluebeard of kings who married six women and caused two of the six to pay for their infidelity with their deaths under the axe of the executioner . . . it's a costume piece, but *only in its setting*.'[15]

With an Academy Award and a net income of more than £30,000 from the role (he received a share of the profits), Laughton was the first actor in a British film to overshadow his Hollywood peers. But he does not make an especially satisfactory example of a home-grown British star. His roots were in theatre, not cinema – he had been a star pupil at RADA in the late 1920s. And he was already firmly established in Hollywood when *The Private Life of Henry VIII* was made: in 1932, he had given one of his greatest performances as H. G. Wells's sinister scientist, Dr Moreau, in

Paramount's *The Island of Lost Souls*. Immediately after *Henry VIII*, he returned to the USA. Although a totemic figure, he was never going to be easy to emulate. His sheer size and misshapen features made him as much freak as conventional leading man. He was the character actor as star, a British counterpart to his equally ugly and equally magnetic Hollywood contemporary, Wallace Beery. For sophisticated American cinemagoers, his appeal no doubt lay in the fact that he was an English stage actor. For most audiences, though, his background was irrelevant; whether as Captain Bligh in *Mutiny on the Bounty* (1935) or as the vindictive police inspector Javert hunting down Frederic March in *Les Misérables* (1935), Laughton was cherished for his ability to invest even the most hardbitten villains with a measure of pathos and, sometimes, even humour.

One quality Laughton possessed which many of his British contemporaries lacked was a robust, clear-cut speaking voice. There was no hint of the strangulated public school boy with a bad attack of adenoids about his mode of delivery. As another young British star of the period, Frank Lawton, observed, 'The English actors the Americans like are those who are not too English in an affected way. To talk with an Oxford accent is the shortest cut to failure. The Americans like a man who speaks pure English, which is a very different thing.'[16]

Korda might have liked to claim responsibility for Laughton's success as Henry VIII, but there was a large measure of luck about the project from the outset. Even the choice of such a quintessentially English figure as the six-times-married Tudor king as subject matter was accidental: Korda originally intended to make a film about Napoleon. 'There was no central vision behind it. He began with Laughton because Laughton was the only major international star whose services he could secure, and he picked the story because it was already familiar to him, and a relatively easy task for Laughton, who also suited the role,' Korda's nephew later explained (Korda, 1980, p. 101). The producer's subsequent working relationship with the bulbous-faced, temperamental actor was not always harmonious, and apart from von Sternberg's abandoned *I Claudius*, it yielded only one more gem. Structurally, *Rembrandt* (1936) is not especially striking – like most biopics, it is hidebound by chronology. But Laughton is superb. His sombre, introspective playing of the artist is the antithesis of his exuberant Henry VIII.

Arguably, Korda's decision to put talented young actors under contract and to establish his own repertory company at London Films was more

important to the emergence of any putative British star system than his collaboration with Laughton. Merle Oberon, Wendy Barrie, John Loder, Emlyn Williams and Robert Donat were among the youngsters signed up by Korda in the early 1930s. 'Korda realized,' his biographer Karol Kulik writes, 'that his company needed a stable of contract players. In order to avoid paying exorbitant sums to borrow "name" talents for all the roles, he decided to find new, less expensive faces with whom he could surround the few "names" he could afford' (Kulik, 1990, p. 75). In Oberon, he had discovered one of the more exotic stars in British film history. Born Estelle O'Brien Thompson in Bombay, the daughter of an English engineer and a part-Sinhalese nurse, Oberon went to enormous lengths to conceal her mixed-race background. She embroidered her past, claiming she had grown up in Tasmania and that her father was a major in the British army. She adopted a refined Mayfair-style voice and used copious amounts of make-up to make herself look more 'English'. (In her Hollywood years, cinematographer Lucien Ballard even devised a light, 'the obie', which had the effect of whitening skin, in her honour.) A former dance hall hostess, she signed up with Korda, whom she subsequently married, in 1932.

Oberon was one of the few British stars of the era who could be described as glamorous, but she was probably too glamorous for the prim tastes of 1930s film-makers. Korda had signed her up as a starlet because she was 'exotic', but he rarely managed to find the roles to suit her. More often than not, he used her as an English-rose type – Anne Boleyn in *The Private Life of Henry VIII* or Lady Blakeney in *The Scarlet Pimpernel* (1934). Her best British parts were as the beautiful dancer in *The Private Life of Don Juan* (1934), as the divorcée who ends up sharing a hotel room in fog-bound London with handsome lawyer Laurence Olivier in *The Divorce of Lady X* (1938), an opulent, Technicolor romantic comedy which showed off her glamour to best advantage, and as the evil temptress Messalina in von Sternberg's unfinished *I Claudius*. She is often accused of being a dull actress (see, for instance, David Thomson's debunking essay on her in *A Biographical Dictionary of Film*, 1994) but her unspectacular performances were prompted by her desire to conform and by unimaginative casting. She was always much better when playing transgressive roles.

British cinema's second great screen monarch of the 1930s after Laughton's Henry VIII, was Anna Neagle's Queen Victoria, a fustian

matriarch who did not manage to execute even a single husband, and who oversaw her nation's affairs with a long-suffering but benevolent patience. Despite the obvious differences in shape and temperament, there were some similarities between Laughton's and Neagle's royals, especially in the way both reflected qualities of their times. Just as Laughton's Henry VIII was not all that different from any other hen-pecked husband between the wars (a type instantly recognizable from Donald McGill's cartoons of men cowering in the wake of their formid-able womenfolk), Queen Victoria lived what can only be described as an idealized version of cosy, domestic family life with her devoted Prince Consort, Albert. She was, as Jeffrey Richards puts it, 'a genteel, loving and middle-class monarch' (Richards, 1989, p. 264).

Neagle enjoyed extraordinary success in the role (which she played twice), winning awards from various fan magazines and being touted by her ever-enthusiastic husband and promoter Herbert Wilcox as 'the greatest box-office movie star in the British empire'.[17] However, she was not an altogether natural Queen Victoria. Her casting, Wilcox later recalled, was frowned upon by distributors and fans alike, all of whom knew she started her professional career as Marjorie Robertson, Cochrane chorus girl.[18]

Neagle's metamorphosis from obscure dancer to matriarchal monarch is one of the more unlikely transformations in British film history. In an instant, she jumped several rungs in the class ladder. She was arguably Britain's most important female star since Betty Balfour, but whereas Balfour was always typecast as the cockney flower girl, Neagle was allowed much more social mobility. Her own, unswerving profession-alism (she would never complain, however many layers of make-up were plastered on her face) and Wilcox's flair for showmanship played their part in the process. It also helped that they were a husband and wife team. Interviews and publicity always emphasized their partnership. She was Trilby to his Svengali.

Wilcox put Neagle under contract in late 1931 and starred her opposite Jack Buchanan in the film *Goodnight Vienna* shortly afterward. As if to emphasize the Pygmalion-like nature of her rise to stardom she began her film career as a humble Viennese flowerseller who falls in love with Buchanan's dashing young cavalry officer.

This is a determinedly maudlin romantic comedy. Its opening intertitle hints at its mood of escapism:

Vienna in the summer of 1914 – gayest, handsomest city in
Europe, famous alike for the lilt of its waltzes and the beauty of its
women ... Vienna, capital of love, where days are made for love
and nights for kisses, and life at the imperial barracks of Schon-
brun swings gently along to the marching song of His Majesty's
Regiment of Hussars.

The very first image is of Captain Maximilian Schletoff (Buchanan) scrub-
bing himself in the shower, singing the theme song. He is the grinning, P. G.
Wodehouse-type of louche romantic hero, a type all too familiar in British
romantic comedies of the 1930s. (Witness, for instance, Barry Mackay in
the Jessie Matthews films.) As Viki, the flower girl-turned-singer he falls in
love with, Neagle displays little of her later regal mien. Her character has
little in common with the prim, matronly figure who paraded through
Nurse Edith Cavell (1939) and the Queen Victoria films. By the time she
has made her transition from ingenuous flower girl to famous singer, she is
a glamorous, world-weary woman in a décolleté gown.

Wilcox, who now put Neagle under a three-year contract, was groom-
ing her to be a sex symbol. In her next film, *The Little Damozel* (1933), in
which she again played a young singer, he dressed her in 'an outrageously
daring diaphanous dress' (Wilcox, 1967, p. 98). (Neagle's brother was so
outraged that he stormed out of a screening of the film.) Then, in early
1934, he sought to capitalize on the success of Korda's *The Private Life of
Henry VIII* by casting her as the heroine in *Nell Gwyn*. The film
provoked something of a scandal in the USA, where the Hays Production
Code, with its edict that 'excessive and lustful kissing, lustful embracing,
suggestive postures and gestures are not to be shown', was beginning to
bite. The censors took exception to the amount of Neagle's cleavage on
display ('That was as God made Anna,' protested Wilcox, 'and how
could anyone see anything but beauty in those lovely shoulders and
breasts?'; Wilcox, 1967, p. 101) and railed against Nell's immorality.
Nevertheless, Neagle's first historical drama was hardly provocative. 'A
slow costumer,' as *Variety* characterized it, *Nell Gwyn* was heritage
cinema in disguise. Just as Korda dusted down the Tudor era in *Henry
VIII*, Wilcox sought to package the Restoration in cinematic form.
Admittedly both periods (Tudor and Restoration) were characterized by
'racy' sexual mores, but in Neagle's case, at least, propriety, not promis-
cuity, was the watchword.

Like Laughton, Neagle was notorious for her painstaking approach to researching any given role. As Wilcox later put it, she 'loves nothing better than digging down and finding everything about the character she is to portray' (Wilcox, 1967, p. 99). In the case of *Nell Gwyn*, the research not only entailed steeping herself in history books, scouring museums and studying the intricacies of seventeenth-century costume design; it also required dietary measures. To get in shape for the role and 'to put on the necessary curves', Neagle force-fed herself porridge and drank gallons of milk. D. W. Griffith, for one, was impressed – some evidence, at least, that her appeal stretched to the USA. After seeing the film, he sent her an effusive telegram: 'Your Nell Gwyn is beauty and music nothing quite as wonderful as to see a new star in a rather worn-out heaven stop in other words you are the cat's pyjamas and how.'[19]

Neagle's star image relied as much on her ordinariness as her sexuality. Even in a low-cut gown, selling oranges or exchanging saucy banter with Charles II, she somehow contrived to remain defiantly down-to-earth, even homely. 'The secret of her popularity,' Wilcox later proclaimed, 'lay in qualities of charm and womanliness so typically British that scarcely one Hollywood star has ever managed to give them adequate expression.'[20] In magazine profiles, there is constant emphasis on her stereotypically middle-class background, on the fact that she was just 'a girl from the suburbs'. Fans accepted her both as plump old Queen Victoria and as archetypal, self-effacing English heroine. 'The purely English type has never had a more flawless representative than Anna Neagle. We welcome her on the screen because we can see in her our own sisters and sweethearts and because she carries out the Johnsonian rule of how an Englishwoman should dress, that is so you do not remember what she wore.'[21]

Neagle's father was a Scottish merchant navy captain. Her mother was Irish. Before becoming a chorus girl, she was a gym teacher and accomplished ballroom dancer. Unlike almost every other British star, she did not graduate to cinema after a successful theatrical career. Before *Goodnight Vienna*, Jack Buchanan had given her a leading role in his stage show, *Stand Up and Sing*. Up until then, she had been making up numbers in the chorus.

Wilcox once listed the qualities a film actress needed to become a star:

She must be pretty, have small feet, good eyes and teeth. But those features don't really matter – nothing matters so much as the desire to get on, to achieve something, to make a success of life.[22]

Neagle's ambition, he suggested, was what prompted him to 'risk thousands of pounds' on her. When he first began to groom her for stardom, she was uncomfortable with the so-called 'glamour army' of make-up artists and costumiers who were hired for her benefit. 'Anna didn't like being exotic,' wrote one journalist, 'but if the producer wanted her that way, she'd go through with it.'[23] Rather than wallow in the trappings of stardom, she preferred (she told anybody who cared to listen) hard work. She was not in the slightest disconcerted at having to look dowdy. Verisimilitude was what mattered. On both occasions that she played Queen Victoria, she was obliged to age from young girl to venerable old lady. The effect was achieved by pouring a rubber solution over her face. (When the solution hardened and she relaxed her features, wrinkles appeared as if by magic.) She wore an unwieldy contraption in her mouth which made her cheeks jut out, hamster-fashion: 'Once in, it could not be taken out for the rest of the day and I could eat no solid food.'[24]

Neagle was going up in the world. The change from the playful flowerseller of *Goodnight Vienna* to self-important leading lady was all too evident in *Peg of Old Drury* (1935), in which she starred as Peg Woffington, the daughter of a Dublin bricklayer who seeks her fortune on the eighteenth-century London stage.

With curly hair, gypsy earrings and an Irish accent, her Peg is clearly intended as a warm, earthy hussy. 'That David Garrick, sure he's the broth of a man,' is typical of the lines she spouts. But there is not a hint of spontaneity or passion about her performance. Even when she is swilling beer with the male members of the Steak and Kidney Club or cross-dressed as a young swell, fighting a duel in the Vauxhall Gardens, there is always a Home Counties reserve, a coldness, about her. When she sings, she sounds suspiciously like Vera Lynn. Even stiffer is Sir Cedric Hardwicke as Garrick, a pompous, porcine figure with a ridiculous bellow of a voice. Wilcox frequently interrupts the narrative with scenes of Woffington or Garrick performing great soliloquies from Shakespeare to rapt Drury Lane audiences. Even the melodramatic death scene in which Peg – a consumptive – swoons in Garrick's tender arms after a final, triumphant

performance seems strangely subdued and matter-of-fact despite being shot in luminous close-up. Whatever its shortcomings, though, *Peg* is still fascinating for what it tells us about Neagle's star image. It is hard to imagine a more reluctant sex symbol.

There was obvious hostility from trade press and gossip columnists alike when Wilcox announced the first of his Queen Victoria films with Neagle in 1936. This was at least partially prompted by snobbery. How, critics asked, could a former Cochrane chorus girl be expected to invest the role with suitable gravitas? Despite the Abdication crisis, the royal family was still treated with something close to reverence by most of the media. (It had been considered a radical gesture a few years before when George V decided to start broadcasting Christmas messages on BBC radio.) In his autobiography, Wilcox writes about the difficulties he faced in raising finance. Even old allies like the distributor, C. M. Woolf, frowned on the project and refused to support it. Nor was Buckingham Palace receptive to the idea. 'No royal locations were made available, nor details of the royal household off-duty,' Wilcox notes. He therefore decided he would 'treat Victoria and Albert as an ordinary married couple' (Wilcox, 1967, p. 115).

The picture was shot at breakneck pace. Wilcox saved money by using tiny models for some of the set-pieces. Nevertheless, in its own, sometimes pious, way, this was effective hagiography. Neagle, not usually the most imposing of actresses, dominates the screen, starting off as a fresh-faced 18-year-old and ending proceedings well into her eighties. Anton Walbrook is solemn and affectionate as Prince Albert (with no trace, certainly, of the sadism which characterized his roles as the murderous husband in Thorold Dickinson's *Gaslight* (1940) or as Lermontov, the ruthless ballet impresario, in Powell and Pressburger's *The Red Shoes* (1948) a few years later).

In the final reel, as if Wilcox and his cinematographer Freddie Young want to remind viewers of the strident hues of the Union Jack, the film lurches into colour: there is a sudden explosion of red and blue as Victoria celebrates her Golden Jubilee. The sheer celebratory jingoism of it all captured the imagination of British fans, many of whom seemed to have a sneaking suspicion that Neagle really was Victoria, miraculously revived. (How else can one account for Neagle being voted the most popular actress of 1937, with 15 per cent more votes than the nearest runner-up, Greta Garbo?) The film also proved a success in America,

where it helped Wilcox secure a lucrative distribution deal with RKO; and it was much admired when screened at a huge, open-air cinema on the Lido during the Venice Film Festival. The reason for this international success is not easy to pinpoint. It clearly helped that Wilcox was portraying monarchy in a confident and positive light during the uncertainty of the Abdication crisis. There is a mystique about Queen Victoria which attracted audiences then and continues to attract them now. Sixty years later, British and American cinemagoers clamoured to see *Mrs Brown* (1997), John Madden's film about the relationship between Victoria (Judi Dench) and her Highland servant, John Brown (Billy Connolly).

Wilcox released *Victoria the Great* to coincide with the centenary of Victoria's accession and then immediately started work on a sequel, *Sixty Glorious Years* (1938). This was not so much a progression as a reprise. As historian Rachael Low tartly notes, 'With the ingenuous excuse that "in the vast canvas of Queen Victoria's life . . . there were several films to be made – all different in theme and period", he [Wilcox] proceeded to cover her whole life periodically once more' (Low, 1985, p. 250). The main difference was that now everybody wanted to help. The film-makers were given access to all the palaces. Sir Robert Vansittart, Permanent Under-secretary at the Foreign Office, again co-wrote the script. An inveterate opponent of Chamberlain's policy of appeasement, he had the vague notion that by striking the imperial drum, he might be able to alert the nation (or at least its cinemagoers) to the threat of the Nazis.

Wilcox briefly contemplated following up *Sixty Glorious Years*, again a huge popular success, with a biopic about Marie Lloyd. But after seeing her parade around Balmoral and Buckingham palaces and deal with such troubles as the crisis in Sudan, the Peterloo Riots and the death of her beloved Prince Albert, British fans were not about to allow their new idol to tarnish her lustre as a lowly music hall artist. Wilcox was forced to beat a rapid retreat and cast her as Nurse Edith Cavell instead. 'It is largely in response to letters of protest from all over the country,' he wrote, 'that I have decided to drop the subject for Miss Neagle . . . judging by these letters the success of *Victoria the Great* and *60 Glorious Years* has apparently established her as preeminently an artiste for the family audience. I am afraid that the appearance of Miss Neagle as Marie Lloyd might prove a disappointment to this type of audience.'[25]

By one of those strange somersaults of popular taste, Neagle, dismissed only a few years before as 'the chorus girl from Forest Gate', was now so

royally ensconced in public affection that, at least in Britain, she would never again be allowed to play anything other than women of distinction. (Perhaps this was only appropriate. In the early 1990s, it was revealed that Neagle did indeed have royal blood – her great-great-grandmother, an assiduous genealogist claimed, was the illegitimate daughter of Queen Victoria's uncle.)

During her brief (1939–41) stay in Hollywood, Neagle was cast as shopgirl and showgirl in the RKO films *Irene* (1940) and *Sunny* (1941), but such slumming would never have been countenanced at Elstree or Pinewood. When she returned to Britain, her filmography began, as many journalists at the time noted, to read like a smart address book: *I Live in Grosvenor Square* (1945) (not so much a title as a boast) was followed by *Piccadilly Incident* (1946), *The Courtneys of Curzon Street* (1947), *Spring in Park Lane* (1948) and *Maytime in Mayfair* (1949), all films designed to cheer up glamour-starved post-war audiences. Neagle again nestled comfortably at the top of British fans' popularity polls. She was not always cast as the *grande dame*. In *Maytime in Mayfair*, she plays a hard-working career woman, managing a dress salon, while in *Piccadilly Incident*, she is cast as a young woman believed drowned who returns, as if from the dead, to discover that her husband has remarried. Nevertheless, Neagle encountered immediate disapproval whenever she strayed from normal type. For instance, when she played a French Resistance spy in *Odette* (1950), she recalls sitting incognito in a small provincial cinema and hearing fans barrack her. 'A deaf old lady in front shouted out indignantly, "Anna Neagle wouldn't do that! Anna Neagle a spy? Never!"' In 1969, Neagle was made a dame of the British Empire, confirmation that she was as much a national talisman as a film star.

Back in the days before she had had her sex appeal strained out of her, when she was called Marjorie Robertson and was still high-kicking in the Cochrane chorus line, Neagle once understudied another promising young dancer, Jessie Matthews. What their unlikely pairing underlines is that both came from the same theatrical background. They were dancers before they were actresses. Although Neagle may have done her best to disguise it in the Queen Victoria films, both moved in front of camera with an ease and fluidity which most of their British stage rivals could not match.

Matthews was as close as 1930s British cinema came to producing an international sex symbol. With her slinky costumes which hugged every

contour of her body and her coquettish, buck-toothed smile, faun-like eyes, close-cropped hair and rubbery dancing style, she resembled nothing so much as a real-life version of the cartoon siren Betty Boop. She was a febrile, energetic performer who sometimes seemed to be galvanized by terror as much as anything else. The language which she uses to describe her relationship with the camera was overtly sexual. 'I used to shrink every time a camera came near me,' she later wrote in her autobiography. 'The film camera, I felt, was like a creeping serpent ready to pick up all my nerves ... ' (Matthews, 1974, p. 2). Just as Garbo had her own pet cameraman at MGM in William Daniels, Matthews relied on the skill of cinematographer Glen MacWilliams, as well as a host of designers and costumiers to provide the backdrop in which she could flourish.

Matthews was first hired by Gaumont-British in 1931 as a straight actress. As her producer, Michael Balcon, later observed, 'Although all producers are always on the lookout for girls who can sing and dance well, Jessie Matthews did not occur to us, and when we first took her, it was not as a singing and dancing artiste.'[26]

Although she had made a few brief appearances in silent films and was already established on stage, her first important screen role was in *Out of the Blue* (1931), a low-budget British romance adapted from a stage musical. She played the daughter of a cash-strapped baronet who falls in love with a radio star already engaged to be married to her sister. She hated the experience so much she did not even take umbrage when the make-up man told her she was not photogenic. 'I wasn't, I looked like Frankenstein's little sister' (Matthews, 1974, p. 117).

The film was a failure, but prompted Gaumont-British director Albert de Courville to screen-test her for the lead role in his romantic comedy, *There Goes the Bride* (1932), a romantic yarn about a woman who runs off to Paris rather than marry a man she does not love. 'It was an exhaustive test, turned out well, and we played her in the picture,' recalled Balcon, who offered her a two-year contract at Gaumont-British on the basis of the rushes alone.[27] Not that this contract seemed to offer her much freedom over the direction of her career.

De Courville was harsh, even sadistic, towards Matthews. He clearly regarded her as his own pet discovery and expected her to jump to his bidding. Initially, at least, she did not relish screen acting in the slightest. 'I wasn't happy about it. I felt I was giving up the warmth and friendship of life in the theatre for the strange new world of film-making'

(Matthews, 1974, p. 122). Still, *There Goes the Bride* was well received, as was her next film at Gaumont-British, *The Man from Toronto* (1933), in which she played an heiress forced to impersonate a maid.

Although Hollywood musicals were in their pomp – this was the era of the great Warner Brothers toe-tappers like *42nd Street* (1933) and *Footlight Parade* (1933) – popular wisdom in the trade had it that their British counterparts were box-office poison. De Courville and Balcon therefore resisted casting Matthews in musical parts. However, she was allowed to sing and dance a little in her third Gaumont-British film, *The Midshipmaid* (1932).

The studio had acquired the rights to J. B. Priestley's picaresque novel about a travelling theatrical troupe, *The Good Companions* (1933). It had been bought, Balcon later recalled, 'not as a vehicle for anybody in particular but to make an English subject'.[28] Balcon's old partner, Victor Saville, was assigned to direct. Matthews found him altogether more congenial than de Courville. He used to tell her, 'Every time that camera creeps up, stare it in the face and say, "I am beautiful, I am beautiful!" And by God, you will be beautiful' (Matthews, 1974, p. 2). Her new-found self-confidence was apparent on screen. 'She gave a grand performance,' Balcon himself later testified.[29] Whether or not it was intended as such, *The Good Companions* was an ideal vehicle for Matthews. Her character, aspiring musical comedienne Suzie Dean, was not so very far removed from Matthews herself. Highly-strung, naive but enthusiastic, she is at once the prima donna who will do anything, and the trouper, fiercely loyal to her less talented colleagues. 'I want to be a star for my parents,' she tells the young composer (John Gielgud) who writes her songs, 'to make up for their dreary journey and rotten pay . . . to have what they couldn't have.' For all the redoubtable character performances from the likes of Edmund Gwenn (the troupe's cheery odd-job man) and Mary Glynne (their manageress), the film belongs to Matthews. That much is obvious when a crowd of paid hecklers disrupt her benefit performance. An important London agent is in the audience. Although there is a mass brawl, the theatre catches fire and half the seats seem to have been ripped out, Suzie Dean returns to the stage to complete her number. Saville shows her in huge close-up, a tear in her eye, as she sings her heart out. At this point, it is as if the actress and her role have merged – the gawky, coltish Suzie of the earlier scenes has metamorphosed into a full-blown star.

The success of *The Good Companions* changed Matthews' status at the studio. Although Balcon subsequently cast her as the pretty young baker's assistant with whom the young Strauss falls in love in Hitchcock's sugary romantic comedy, *Waltzes from Vienna* (1933), he realized that Matthews was better suited to musical than to straight acting parts. Furthermore, he decided that 'instead of putting Jessie in properties we should have to build stories round her'.[30] Saville clearly had an aptitude for making musicals. Why not combine them?

Evergreen (1934) was one of the most lavish musicals ever made in Britain. Bursting with elaborately choreographed chorus sequences of the sort that you would expect to find in Busby Berkeley's Hollywood extravaganzas, brilliantly lit by American cameraman Glen MacWilliams, boasting songs by Rodgers and Hart, and with luxuriant costumes and Alfred Junge's intricate art deco production design, it was weirdly exotic by British standards. With so much happening in front of the camera, even the flimsy, preposterous storyline (the impoverished daughter of a legendary Victorian music hall star tries to pass herself off as her mother) could be overlooked. Matthews, wearing a series of close-fitting gowns which highlight her every androgynous contour ('Hell, we've got to sell that body,' Saville told Balcon) seems fretful and ill at ease until she begins to dance or sing. But her routines, especially the solo sequence in which she glides around her vast penthouse apartment, are spectacular. Matthews was a classically trained dancer who also had experience in musical comedy. Her American-born choreographer, Buddy Bradley, was steeped in rhythmic jazz dancing. The fusion between their different styles, Matthews believed, gave her her unique style.

Balcon had attempted to sign Fred Astaire, who was in London at the time *Evergreen* (1934) was being made, with the stage show of *Gay Divorcee*, to appear opposite her. The American dancer reportedly admired Matthews enormously (and subsequently told a fan magazine, 'There is nothing I would like better than to appear in a film with Jessie Matthews') but contractual obligations prevented him from accepting her offer. Instead, winsome Barry Mackay, another of those irrepressibly cheerful British leading men who seem to have stumbled out of the pages of a country-house novel, provided the love interest. Her diminutive, bespectacled husband, Sonnie Hale, also featured as a stage director. Critics are often cruel about Matthews's accent, the refined Mayfair pip-squeak voice she adopted for stage and screen after numerous elocution

lessons. William K. Everson, Jeffrey Richards and her biographer, Michael Thornton, have argued that her popularity dwindled rapidly in the early 1940s because she was regarded as an upper-class icon. Her films, Everson suggests, 'resolutely turned their back on contemporary reality, transcending even the acceptable levels of escapism. They were hymns of praise to elegance, luxury, glitter and glamour, quite literally art deco films, and as trivial and superficial as that brief-tenured art form.'

Evergreen is certainly escapist, but it is also a backstage story with roughly the same narrative trajectory as countless Warner Brothers musicals of the 1930s. Matthews's character is a struggling chorus girl, almost fainting with hunger, who is forced to endure the whole, torturous rigmarole of auditions before she lands the part as her own mother. She sings and dances her way out of poverty. Not only Warner Brothers' brand of gritty escapism but the musicals made in the late 1920s and early 1930s at Germany's UFA Studios influenced the look of Matthews's early movies, some of which, after all, were direct remakes of earlier German films.

Historian Tim Bergfelder argues, not altogether convincingly, that Matthews's brand of modern femininity was borrowed wholesale from such UFA stars as Renata Müller and Elizabeth Bergner (Cook, 1997, p. 42). Her androgyny, 'non-classical prettiness' and frantic vitality were qualities which just as well could have been taken from Ruby Keeler (to whom she also bears a resemblance). Nevertheless, it is worth noting that the combination of influences (German production-designer, American cameraman and choreographer) resulted in a star image a long way removed from the earthiness of, say, a Betty Balfour. Even so, there was something quintessentially British about her. Her fans knew her background. They knew that her father sold fruit and vegetables in Berwick Street Market and that her brother was a champion British boxer.

It is ironic that escapism in British cinema inevitably comes with all sorts of class connotations attached. Matthews's persona was more complicated than Richards, Everson and Thornton have allowed. Although her films do celebrate luxury, she is never simply the embodiment of 'an individualist middle-class success ethic' (Richards, 1989, p. 224). *The Good Companions* is all about consensus. Although Matthews's character may top the bill at the prestigious London Hippodrome, she is still always ready to help her colleagues. In *Gangway* (1937), she is a sassy, hard-working journalist, again always ready to muck in.

Matthews was praised to the hilt in Britain and America for her work in *Evergreen*. 'The most sensational discovery in years,' trumpeted *Variety*, 'Princess Personality herself. She can sing. She can dance. She can act. She can look. She has charm, youth, beauty and a million-dollars worth of magnetism. This is not a prediction, this is a promise. Jessie Matthews will be one of the biggest box-office hits in America within the next six months.' The *New York Times* called her 'a joyous and captivating nymph'. One of the US trade papers provided her with what became her best-known sobriquet, 'the dancing divinity'.

This sort of effusive reception for a foreign star usually sparks the interest of Hollywood. After *Evergreen*, throughout the 1930s, Matthews received a series of ever more lucrative offers from the major studios: £62,500 for a single film in Hollywood, £50,000 from RKO to star opposite Astaire – this was the bait. In hindsight, it seems strange that neither she nor her bosses at Gaumont-British were willing to take it.

Perhaps Matthews's reluctance to leave Britain was rooted in her health problems. During the shooting of *Evergreen*, she came close to nervous breakdown. 'I think it was just as well,' Saville later wrote, 'that Jessie was not exposed to the Hollywood star system. They would never have understood her psychological problems or shown the patience and kindness she needs. They probably would have crammed her full of pills and she would have gone the same way as Judy Garland' (Thornton, 1974, p. 163).

Balcon's reasons for keeping her at Gaumont-British were less selfless. He knew he had 'the biggest international star in the country', and wanted her to spearhead his attempts at breaking into the American market. His plan was to cast her in two big-budget musicals every year.

First a Girl (1935), a gender-bending adaptation of Reinhold Schunzel's play *Viktor und Viktoria* which had already been made by UFA, was next. Matthews is cast as a woman pretending to be a female impersonator pretending to be a boy. Despite these complications, the film is cheerful and upbeat, with even an air of playful innocence. As Bergfelder notes, the emphasis is much more on social mobility than sexual transgression (Cook, 1997, p. 44). Nobody seemed especially startled by the cross-dressing or, if they were, they resolved to ignore it. 'Matthews has never done better,' crowed the *Sunday Times*. 'She is delightful to look at, joyous to hear.' Although American reviewers were less friendly (and *Variety* grumbled about 'the lethargic tempo' of the film), *First a Girl*

consolidated her position as the British industry's biggest draw. Again, many of the set-pieces were awesome. In one scene, Matthews, in a bird costume, was suspended on a perch in a 40-foot-high gold cage. No British studio was big enough to accommodate such a contraption. The scene ended up being shot in a damp field in the middle of the night. She then made one further film with Saville, *It's Love Again* (1936), in which she plays a chorus girl pretending to be a big-game huntress to further her career.

Matthews's characters frequently assume false identities.[31] She is never simply the high-society heroine. Working-class audiences, we can assume, were complicit with the masquerade. Despite her accent and for all her lavish costumes, they could still relate to her. Her parts always demanded a level of deception before she could gain admission into the upper-class world. Off-screen, too, she often gave the impression that she felt she was an interloper; that she was not comfortable with her new status. She was self-conscious about her protuberant front teeth. (She used embalming wax to conceal the gap between them.) And she was hugely superstitious about her hair – her so-called good-luck fringe. Even press releases and articles in fan magazines hinted at her insecurity. 'Jessie holds onto life as she holds onto her teacup,' read one Gaumont-British circular. 'She is the opposite of what great stars are supposed to be, reluctant to believe that she is famous ... always needing assurance that her work is good ... she possesses a genuine humility, pleasing to everyone but sometimes the despair of those who have worked to guide her to the top.'[32]

In particular, she depended on Saville, the one director with whom she felt confident and secure. Unfortunately for her, he was involved in his own contractual wrangles with Gaumont-British and was too ambitious to confine himself to making only Jessie Matthews vehicles. 'I have to move on, kid,' he told her as he prepared to move to Hollywood. 'I can't go on making the same kind of pictures, I shall lose all my enthusiasm for my professional life, I shall get stale' (quoted in Thornton, 1974, p. 146). He had steadily been grooming Matthews's husband Sonnie Hale to take over the directing duties on his wife's films.

In 1937 Hale directed his two films with Matthews, *Head over Heels* and *Gangway*. In the latter, Matthews plays a brassy, fast-talking London journalist who goes undercover as a maid in an expensive hotel to get the dope on a film star who is passing through town. Although her

good-luck fringe was back in place, this was not an especially memorable moment in her career. Gaumont-British always tailored Matthews's vehicles for the American market. They were British cinema's equivalent of prestige productions. But whereas Saville had made elegant pastiches of MGM musicals or British versions of exotic UFA musicals, Hale seemed set on shooting a brassy, wise-cracking comedy in the Warner Brothers way. By the final reel, Matthews ends up in New York, mistaken as a jewel thief by local gangster and upper-class English detective alike. The accents grate and the style is uncertain, as if Hale is caught somewhere between drawing-room comedy and gangster thriller. There is a certain pleasure to be had from the comic antics of Graham Moffatt, Will Hay's pudgy sidekick, as one of the newspaper boys.

Matthews was still, as *Picturegoer* proclaimed in early 1937, 'one of the single biggest assets we have in the fight to secure a proper place for British films in the international market',[33] but it was unclear how her career was going to progress. Whether through bad luck, bad health or the politicking of Michael Balcon, she had missed her chance in Hollywood. As historian Jeffrey Richards has noted, she still had not found a partner to match her. By the late 1930s, there was evidence of a sea-change in British film culture. Balcon, who had left Gaumont-British in 1936 to sign with MGM, later admitted that few of the films made in the decade had reflected 'the agony of the times'. In an era of mass unemployment, social division and the rise of fascism, the so-called 'devil's decade' (Taylor, 1985, p. 396), British cinema had often contented itself with glossy romantic comedies and knockabout farce. Countering Balcon, it might be argued that such 'escapism' was precisely what audiences wanted in a time of depression. Either way, Matthews was an ideal star for the times. The view of Richards and fellow historian, William K. Everson, that her fortunes plummeted in the 1940s because she was so closely identified with the blithe, luxurious world of her pre-war musicals – that she was not a symbol of consensus but a relic of an era many people wanted to forget – doesn't immediately convince: after all, Anna Neagle enjoyed enormous post-war success with films like *I Live in Grosvenor Square* and *Spring in Park Lane*, none of them exactly neo-realist in character. Matthews's failure to recapture her old popularity in the post-war years surely has more to do with the kind of vehicles she was offered, who directed them, and the fact that she was growing older. Unlike Neagle, she did not have a Herbert Wilcox to guide her career. Had

Victor Saville stayed in Britain, her fortunes could have been very different.

Although nearly all Matthews's films cast her as a character who, from lowly beginnings, manages to reinvent herself as high-society damsel, she was unable to reverse the process. It is symptomatic of how closely she was identified with her role as 'dancing divinity' that when she tested for the leading part in *Love on the Dole* (1941), she lost out to Deborah Kerr. By some bizarre transmogrification, Matthews, the daughter of a Soho fruit and veg trader, had become too rarefied a figure to be taken seriously in a working-class role. Ironically, Kerr, from an eminently middle-class Scottish background, was considered more plausible as a Lancashire mill-girl.

Matthews, Laughton and Neagle cut a swathe through British film culture of the 1930s. All were international figures, with a veneer of class and sophistication. They had a 'snob' value. But, by the same token, none was inaccessible. However lofty the roles they played on screen, they were also popular icons, appealing, or so the fan magazines suggest, to the broad mass of British cinemagoers. All were 'constructed' as stars to some degree or other. Laughton had Korda to guide him through his film performances. (As Karol Kulik notes, Korda is reported to have once said that the actor 'needed a midwife, not a director'.) Matthews's screen image was moulded by a series of different producers and directors, Albert de Courville, Michael Balcon, Victor Saville and Sonnie Hale among them. Anna Neagle's career was guided by Herbert Wilcox. These various impresarios took a robust approach to the business of selling their stars and their films. They had a chutzpah common enough in Hollywood but comparatively rare in Britain, where marketing and publicity campaigns were all too often undertaken grudgingly, if at all. On the face of it, the three stars are very different. Laughton is a larger-than-life figure in the style of the old actor–manager, Neagle is the virgin-princess, Matthews the dancer kicking her way into high society. But they share several traits – their star-images are predicated on notions of social mobility. Whatever the roles, whether playing monarchs, society ladies or glamorous singers and dancers, they never lost their link with their audiences. They also projected a certain kind of 'Britishness' which was fit for export.

Notes

1. See, for instance, *Picturegoer*, 4 November 1933: 'Hollywood is 3000 miles from Broadway: Ealing, Teddington and Islington are but a short distance from London. The very proximity of the studios is the cause of the present unsatisfactory position, it offers producer and actor alike the temptation to enter into contracts enabling the star to divide his time between studio and stage.'

2. Quota Quickies was the nickname for the films made in the 1930s at a frantic pace and on tiny budgets to conform with the 1927 Cinematograph Films Act whereby a certain proportion of the films shown in British cinemas now had to be British-produced. Distributors and exhibitors, who relied on screening Hollywood films for their profit margins, got round the legislation by helping finance the quickies, which they invariably showed in graveyard slots, either early in the morning or late at night.

3. *Picturegoer*, 8 January 1933, p. 7.

4. *Ibid.*, editorial, 'Should we glorify stars?' p. 5.

5. *Picturegoer*, 13 May 1933.

6. *Kinematograph Weekly*, 24 October 1929.

7. *Kinematograph Weekly*, 14 November 1929.

8. *Picturegoer*, 2 April 1932.

9. For instance, as John Mills's patriotic mother in *Forever England*.

10. *Picturegoer*, 15 July 1931.

11. *Picturegoer*, February 1932.

12. *Picturegoer*, 6 May 1933.

13. *Picturegoer*, 9 September 1933.

14. *Sunday Express*, December 1933.

15. *Motion Picture Herald*, 22 September 1933.

16. *Picturegoer*, 25 February 1933.

17. BFI microfiche on Anna Neagle, an unattributed 1936 piece by American journalist, William Wiener.

18. 'Marjorie Robertson, successful chorus girl, was quietly, and a little sadly, disposed of in a tea-shop on the corner of Wardour and Old Compton Streets on August 21st, 1930. And Anna Neagle, embryo actress and star was born' (Neagle, 1974, p. 14).

19. BFI microfiche on Anna Neagle.

20. *Picturegoer*, 16 July 1932.

21. *Picturegoer*, 28 January 1933.

22. *Daily Mirror*, 19 September 1935.

23. *Film Pictorial*, taken from the BFI microfiche on Neagle – the date is unclear.

24. *Sunday Pictorial*, 27 March 1940.

25. Press release from Denham Studios, 5 November 1938.

26. The Michael Balcon file, BFI Special Collections. Essay on Matthews dated 26 February 1937.

27. *Ibid.*

28. *Ibid.*

29. *Ibid.*

30. *Ibid.*

31. For a discussion of class, role-playing and disguise in Matthews's films, see Higson (1995, pp. 98–103).

32. Gaumont-British press release, mid-1930s, from the microfiche on Matthews.

33. *Picturegoer* editorial, 16 January 1937, p. 5.

Carnival and Consensus

Miss Gracie Fields has a wonderful command of plebeian senti-
ment and humour, expressed without any false shame or attempts
to refine what is naturally robust and exuberant . . . (*The Times*, 11
September 1933)

A person of the middle ages lived, as it were, two lives: one was the
official life, monolithically serious and gloomy . . . the other was
the life of the carnival square, free and unrestricted, full of ambiva-
lent laughter, blasphemy, the profanation of everything sacred,
full of debasing and obscenities, familiar contact with everyone
and everything. Both these lives were legitimate, but separated by
strict temporal boundaries. (Mikhail Bakhtin, 1984, p. 129)

In his 1940 essay, 'The Lion and the Unicorn', George Orwell described
England as 'the most class-ridden country under the sun' (Orwell, 1980,
p. 87). The same observation might equally well have been made about
British cinema. The upstairs–downstairs view of the world, the enthu-
siasm for courtly drama (lives of the monarchs, Shakespeare adaptations,
high-society comedies and thrillers) and the stringent dress codes (heroes/
chaps are never to be seen without jacket and tie, working-class flower
girls must always look dishevelled) reflected the social hierarchies in the
outside world. However, just as kings and queens have their fools, British
cinema's regal strain has long been counterpointed by its appetite for the
carnivalesque. Over the years, Pimple, Billy Merson, George Robey, the
Crazy Gang, Mother Riley, Will Hay, Frank Randle, Max Miller, the
Carry On team and countless others have managed to puncture the
pomposity of 'prestige' British cinema.

The clue to the comedians' revolt is often obvious on the surface, in

their appearance. Take, for example, the alarming sight of northern comedian Frank Randle dressed in his scoutmaster outfit, leering, knock-kneed, with gaps in his teeth, white hairs sticking upwards out of his scalp and a huge pipe in his mouth, wheezing boastfully about his beer-drinking exploits. A dirty old satyr, he is truly a sight for sore eyes – as far removed from Baden-Powell's ideal of the scout as it is possible to imagine. Equally ruffled and unruly is Will Hay in his schoolmaster's garb, a shambling, bespectacled figure whose appearance is as unkempt as his speech. In his floral suit and nifty little hat, Max Miller may have looked the swell, but his style of smart dressing rendered him immediately untrustworthy in the opinions of middle-class audiences. He was the comedian as spiv. 'Gert and Daisy' (the cockney characters played by sisters Elsie and Doris Waters), meanwhile, showed a genius for padding and dowdiness in their choice of outfit.

By contrast with this ragbag army of comedians, British cinema's leading actors were models of middle-class formality and decorum. Clive Brook looked as if he wore evening dress the whole day long. Ivor Novello may occasionally have affected a raffish, Bohemian air when he was playing Pierre Boucheron, but he too liked to dress immaculately. Jessie Matthews's elegant, diaphanous gowns clung to her body like a second skin. Even as buxom Nell Gwyn, Anna Neagle maintained her regal mien. Meanwhile, the 'chaps', the gallery of staunch, middle-class actors who passed for leading men in the 1950s (David Farrar, Jack Hawkins, Kenneth More and, perhaps a little uncomfortably, Dirk Bogarde) wore tweed jackets and slacks, and smoked pipes, looking for all the world like teachers in some minor boys' public school.

There are several telling little scenes in David Lean's *Brief Encounter* (1945), in which the frustrated, very tidily dressed Home Counties lovers, housewife Celia Johnson and doctor Trevor Howard, sit forlornly in the railway station buffet. Lean and his writer Noël Coward cannot resist the temptation to poke fun at the minor, working-class folk who flit around behind the scenes, characters with silly names like Albert Godby (Stanley Holloway) and Myrtle Bagot (Joyce Carey), slovenly, shapeless clothes and absurd pretensions. While Johnson and Howard simper and sigh to the accompaniment of Rachmaninov's overwrought Second Piano Concerto, the love affair between the stationmaster and the tea-lady is played strictly for laughs. The contrast between the two sets of characters, the effete Home Counties duo and the rambunctious working-class couple, is

drawn again and again in British films of the era, but in popular comedy, if not in David Lean pictures, the Home Counties types are liable to be the butt of the joke.

The rebarbative desire to mock what passes as good taste has long been one of the characteristic features of British humour. It is there in Hogarth, Rawlinson and Pope; in the savage Grub Street satires of the eighteenth century. It is the rude comic force which propels Fielding's *Tom Jones* and Cleland's *Fanny Hill*. It is Pimple's weekly inspiration in the 1920s as he tries to lampoon each new, big film of the moment. It is the motor behind Billy Merson's goofy comedies of the same period and of the Crazy Gang's skits of war films and Klondike gold rush spoofs a decade later. You can also just about see it in such unsung British films of the 1970s as Val Guest's *Au Pair Girls* (1972), Jim Atkinson's *Can You Keep It up for a Week* (1974), and the various 'confessions' films (of a window-cleaner, driving instructor and so forth) starring Robin Askwith. It is certainly there in Roy Chubby Brown's egregious feature film debut, *UFO* (1993), in which the lardy hero is kidnapped mid-performance on Blackpool pier and whisked away to space by leather-clad twenty-fifth-century Amazons to face trial for crimes against the 'gentle sex'.

In *King Twist*, his high-spirited book about Frank Randle, Jeff Nuttall posits a model of Britain which takes the south-east as the country's head and the north as its digestive system and anal tract. This is really just a more robust version of George Orwell's Don Quixote/Sancho Panza model, his distinction between the hero/saint and the worm's eye view/the unofficial self: 'the voice of the belly protesting against the soul. His tastes lie toward safety, soft beds, no work, pots of beer and women with voluptuous figures' (Orwell, 1980, p. 192).

Blackpool, Nuttall suggests, is 'a gaudy gem set on the nation's arse'. Holiday-makers from nearby industrial cities go there 'to escape the soot, the tedium, all the hard, deadening routine of slum life. To escape the massive permanence of authoritarian granite cities and towns' (Nuttall, 1978, p. 11).

It is a commonplace to observe that the British middle classes are not especially fond of discussing bodily functions. They resort, often ingeniously, to euphemism instead. The bawdy, vulgar humour of Frank Randle was too direct for Home Counties tastes. As Nuttall enthusiastically points out, all this particular comedian's 'simple humour was rooted like a catheter tube in the human digestive system and in particular the

terminal end of that system ... he reduced himself to little more than a vigorous digestive system, simultaneously taking on characteristics of the infantile and the geriatric' (Nuttall, 1978, p. 14).

This visceral approach perhaps explains why Randle's films went down so badly south of Birmingham. In the mid-1940s, his comedies were cleaning up, so to speak, in cinemas throughout the north.

> Provincial managers soon discovered that Frank Randle was 'box office'. Like a horde of Oliver Twists they asked for more, yet while Wigan and Bolton were applauding this favourite in a new guise, West End audiences, as is so often the case, were completely oblivious to his discovery. It seems that what is 'corn' in the West End is 'cream' up north.[1]

There are stories of frantic crowds breaking down the doors of their local Odeon or ABC in the rush to get into his latest movie. According to historian John Montgomery, in large parts of Britain 'his pictures took more money than those of Errol Flynn, Marlene Dietrich and Robert Taylor' (Montgomery, 1954, p. 78).

Randle, 'the uncrowned king of Blackpool', was well paid for his efforts – his salary, £1000 a week during filming – was considerably more than most reputable stars at Pinewood or Elstree were earning. Nevertheless, in London, Randle's films were virtually impossible to see. Nor did archivists deem them worthy of preservation. While one or two survive, including *It's a Grand Life* (1953), which casts lecherous old Randle as an incompetent sergeant opposite buxom young army recruit Diana Dors, the majority have long since vanished.

Nuttall's division between north and south, bowel and brain, is on the rudimentary side. It fails to account for the differences in taste within southern audiences, for instance, the barrier which seemed to exist between West End and East End audiences. 'Cheeky chappie' entertainers like Max Miller and Tommy Trinder certainly did not enjoy easy access to the smart theatres and cinemas in the West End. Nor was their humour as cerebral and polite as Nuttall seems to imply. Miller, memorably described by John Osborne as 'a beautiful, cheeky god of flashiness, a saloon bar Priapus' (Fisher, 1973, p. 84), offered audiences two choices. 'All of my jokes have double meanings. It's up to the customer to take the meaning he chooses.' On stage, he kept a white book for clean jokes, a little blue volume for dirty ones. He was a patter merchant, a cockney

wordsmith who relied on quick-fire delivery of his double-edged lines for his laughs. Both Miller and Randle inspired strong regional loyalty. Just as one failed to make much headway south of Birmingham, the other received a chilly reception in the north.

Inevitably, in front of the cameras, constrained by plot and direction and without a live audience to play off, Max Miller was a diminished figure. As his biographer John East noted, he did not photograph well. 'He had a round face, a large nose and a small cranium. Without his byplay with an audience, he ceased to amuse people' (East, 1977, p. 20). He was too outlandish a character, too much of a cynosure, to fit comfortably into a conventional narrative in which he was only one of many characters.

Randle's ornery star persona was not any easier to accommodate on film. His movies, shot for the father/son team of John and Tom Blackley at their tiny, Manchester-based studios, Mancunian Films, were atrocious – 'misshapen and badly made regional comedies' as one eminent critic described them.[2] The camera generally stayed rooted to the spot, as if it too was terrified of Randle. The cantankerous clown had a reputation for bloody-mindedness. He was a curmudgeon both on and off screen, and many of his associates were terrified of him. His film work, like his humour, was basic.

> There were perpetual attempts at scripting and direction . . . at pretending the films were, in fact, film . . . as far as the idiom went, they were not film . . . the picture frame was static as a proscenium arch. The camera angle was eye-level frontal throughout. There was no zooming, little panning, no dollying and no change of angle. The camera was in fact a man in a music hall. (Nuttall, 1978, p. 52)

In other words, Randle made few concessions either to film language or to flattering the sensibilities of critics and filmgoers in London. It was as if he was trying to blow an enormous raspberry in the face of spectators who came to his pictures in search of cosy, sentimental nostalgia.

Both geographically and in terms of subject-matter addressed, the British film industry has always been tilted in favour of the south-east. British pictures have all too frequently been peopled by haughty Home Counties types. Randle's films at least ran against this grain. Their sheer parochialism counted as one of their major selling points. Confronted

with glossy, *ersatz* Hollywood extravaganzas or smart Mayfair comedies, audiences could console themselves with the thought that Randle's style of entertainment owed nothing to artifice. In a word, it was 'authentic'. (This is a word used by Richard Hoggart in his 1958 book, *Uses of Literacy*, which celebrates an old-style working-class culture under threat from the big, bad forces of mass entertainment.) Perversely, the formal shortcomings of Randle's films were an attraction. As Nuttall puts it, 'it was partly because of a common wish to resist the American tide that the trite, ineptly made English comedy movies of the thirties and forties enjoyed such a fanatic following' (Nuttall, 1978, p. 14).

This was like alchemy in reverse. A delight in bungling amateurism was at the heart of it, a delight which extended from the sort of roles Randle and his cohorts played (a gallery of incompetents) to the production values of the films themselves, many of which were shot at breakneck speed, on tiny budgets, as if determined to show off their own shortcomings. Occasionally, the clowns might display some slapstick skill, but their work certainly was not slick by comparison with the intricately choreographed pratfalls and stunts of a Keaton or a Chaplin.

It is hard to pinpoint precisely where the cult of the gormless anti-hero begins in British popular culture. He (and it usually is a 'he') is a leitmotif in literature, with antecedents in Shakespeare (Bottom, for instance), Chaucer (*The Miller's Tale*) and Dickens. He is there in old folk tales and in myth. He is the fat, pusillanimous friar, the village idiot, the hapless warrior. He is the equivalent of Bakhtin's carnival king, a monarch for a day who manifests all the perversions and reversals in fortune which occur when the normal system is turned upside down. When the carnival spirit hits British cinema, anything is possible. In Bakhtin's words, 'it permits – in concretely sensuous form – the latent sides of human nature to reveal and express themselves' (Bakhtin, 1984, p. 122). Formal realism goes out the window. How else would the Crazy Gang be able to fly from Britain to Germany in a fish-and-chip van in the ludicrous film *Gasbags* (1940)?

Even at its wildest, however, most British screen comedy remained curiously restrained when it came to sex. From Randle to Robin Askwith, from Mancunian comedy to the egregious soft porn pics made in the early 1970s (for instance, Val Guest's *Au Pair Girls* and *Confessions of a Window Cleaner* (1974), Martin Campbell's *The Sex Thief* (1973) or Jim Atkinson's *Can You Keep It up for a Week*) an underlying puritanism is

always discernible. Beneath the cross-dressing and the jokes about formidable mothers-in-law and curvaceous Swedish nannies, there is always a faint whiff of embarrassment – a modesty which the absurdly bawdy humour and comic music only serves to exacerbate. The irreverence is only skin-deep. As Orwell observed of Donald McGill's naughty seaside postcards, with their strident images of fat women in tight bathing dresses which somehow celebrated British family life and traditions while seeming to debunk them,

> It will not do to condemn them on the ground that they are vulgar and ugly. That is exactly what they are supposed to be ... they stand for a worm's eye view of life, for the music hall world where marriage is a dirty joke or a comic disaster, where the rent is always behind and the clothes are always up the spout ... Like the music halls, they are a sort of saturnalia, a harmless rebellion against virtue. (Orwell, 1980, p. 194)

A harsher critic, Cyril Connolly, detected a concealed terror in this kind of comedy. 'This English humour,' he surmised, 'is really a synonym for fear, fear of life, fear of death ... a cosy English fear of anything and everything ... these English films I find growing more sinister, they are a kind of decadence, not romantic *fin de siècle* decadence, but a drooling softening of the brain.'[3]

In general, British screen comedians have two, very different, strategies for dealing with Connolly's 'terror' – a will to obscenity and a will to sentimentality. Whether Askwith with his inane grin, leering Randle, or Chubby Brown prancing around in his floral suit and goggles, certain British comedies feature hapless, cheeky heroes who approach sex with the sniggering, furtive enthusiasm of schoolboys breaking the rules. They are vulgar, and proud of it. There is a suspicion that, beneath their bluster, they are as terrified as Connolly suggests. But they never show it. They always have a scatological joke up their sleeves to conceal their unease. These comedians, bards of bodily function who deal unashamedly in corporeal humour, are always liable to be marginalized. Their humour is popular regionally, or with certain age groups, but rarely has a universal appeal.

It is striking how the three biggest stars to emerge in British cinema from the music hall/variety tradition – George Formby, Gracie Fields and Norman Wisdom – eschewed such obscenity. They were symbols of

consensus, not defiance. Their appeal was national rather than merely local. In the 1930s, the films of Fields and Formby promoted 'the values of decency and hard work and the overcoming of problems by individual effort' (Richards, 1989, p. 159). While Randle was drowning in a sticky puddle of beer, belching imprecations against the establishment, they were out and about trying to better their lot. They wanted sympathy as well as laughter. If their humour was ever abrasive or cruel, their cheery, upbeat songs always served to restore harmony.

Like Anna Neagle as Queen Victoria, Gracie Fields, 'the Lancashire lass', was a national symbol. As J. B. Priestley, who scripted two of her films, famously wrote about her, she embodied the best qualities of a certain kind of English woman.

> Listen to her for a quarter of an hour and you will learn more about Lancashire women and Lancashire than you would from a dozen books on these subjects. All the qualities are there, shrewd-ness, homely simplicity, irony, fierce independence, and impish delight in mocking whatever is thought to be affected or pre-tentious. (Richards, 1989, p. 170)

Born Grace Stansfield in 1898 above a chip shop in Rochdale, Fields made her first stage appearance at the Rochdale Hippodrome in 1915, and was already established as a variety star long before she made her début feature, *Sally in Our Alley*, in 1931. In some ways, she was a natural successor to Betty Balfour, British cinema's 'Queen of Happiness' of the 1920s. Like Balfour's trademark character, the cockney flower-seller Squibs, Fields played women with an irrepressible knack for staying cheerful, whatever catastrophe the world could throw at them. It was not for nothing that her films had titles like *Looking on the Bright Side* (1931) or *Keep Smiling* (1938) or *Sing As We Go* (1934). She was, as a reviewer observed of her performance in the Priestley-scripted picture, *Look Up and Laugh* (1935), 'one of those women who are always looking after other people'.[4] She saved shipyards from closure (*Shipyard Sally*, 1939), fought to have cotton mills re-opened (*Sing As We Go*), and campaigned against wealthy shopkeepers and jobsworth councillors who were trying to put the market stalls in a small town out of business (*Look Up and Laugh*). Just occasionally, she might display touches of that bungling amateurism so familiar from other British screen comedians of the era. (In *Sing As We Go*, when the mill is closed and she is forced to travel to

Blackpool in search of employment, she makes a muck of all the holiday jobs – toffee seller, magician's assistant, human spider – she takes.) But ultimately, her resilience always saved her.

Like Betty Balfour, with her hankering to play aristocratic roles, Gracie gradually moved up in the world. As Jeffrey Richards has noted, she started off in films by making 'backstreet stories' but soon graduated to 'backstage stories'. Attempts to broaden her appeal inevitably created a certain tension in her star image. While she retained her regional identity (and accent), the roles she played in the late 1930s were very different from her earliest parts. In *We're Going to Be Rich* (1938), she was a concert singer in 1880s South Africa. In *Keep Smiling*, she was the leading lady in a touring music troupe. Cyril Connolly described her as 'an actress with three selves, London, Lancashire and Imperial'.[5] She was at once the mill girl from Rochdale, the sophisticated West End dancer/singer, a symbol of the north and a regal, mother-of-the-nation figure. Her movies managed both to defy reality and to provide an authentic record of a time and a place. (The *Observer*'s C. A. Lejeune famously attacked *Sing as We Go*, arguing 'we have an industrial north that is bigger than Gracie Fields running round a Blackpool fun fair', but, as many subsequent critics pointed out, it is a far more spirited evocation 'of Northern working-class life than many a forgotten GPO documentary'.[6])

In *Shipyard Sally* Fields's face is shown in huge close-up, singing 'Land of Hope and Glory', as shipworkers and their bosses are reconciled and a new liner is launched by the queen. When she fell seriously ill in 1939, her 'condition became a cause for national concern. Special prayers were offered for her recovery, and the public waited anxiously for news.'[7] Her career was never merely confined to screen.

Her records sold by the millions in the 1930s. As if to prove that her appeal was equally strong everywhere from Rochdale to Westminster, there are reports of Parliament adjourning early so that MPs could scurry home to listen to her radio broadcasts.[8]

Fields was a paradoxical figure, a 'Lancashire lass' devoted to her roots who just happened to live for most of her life in Capri, a determinedly English performer with little obvious appeal overseas who nevertheless spent several years working for Hollywood. At first, the big American studios turned her down as 'too national', but then Fox boss Darryl F. Zanuck offered her a lucrative, four-picture contract (reputedly more than even the biggest Hollywood names were then earning). Fields

insisted that the films were made in England. She was, after all, 'our Gracie', not theirs, however much the American press may have protested. 'Lynch the timid soul,' thundered the *New York Times*, 'who kept Miss Fields from us so long on the grounds that we shouldn't appreciate her peculiarly English style of humour. We do appreciate it, appreciate it so thoroughly that hereafter we insist the English tacitly include us in the possessive when they refer to our Gracie.'[9]

Despite such seeming enthusiasm on the other side of the Atlantic, Fields's British films never did much business in the US. She briefly moved there in 1940 rather than be separated from her Italian husband, Monty Banks, who would have been interned as an enemy alien in Britain. The films she made in Hollywood were well received, if very different from her British pictures. For instance, in *Holy Matrimony* (1943), adapted from Arnold Bennett's story, *Buried Alive*, she neither sings nor dances. Instead, she plays a cheery, middle-aged widow who marries ex-valet Monty Woolley (in fact, a famous English painter in disguise). Brilliantly scripted by Nunnally Johnson, this was a brittle but witty comedy of mistaken identity which earned Fields plenty of plaudits ('I can think of no film actress who could have bettered Miss Fields' portrayal of sensible grace and mother wit . . . ' wrote the *Sunday Times*[10]), but was scarcely a star vehicle.

Stars, at least as far as Hollywood prototypes are concerned, are supposed to be aloof, glamorous and inscrutable. As Richard Schickel puts it:

> Stars were much more abstractions than they were real people. They personified, each in his different way, ideas or ideals, just as Greek gods were personifications of the great virtues. If one of them fell from grace, as several did during the wave of Hollywood scandals early in the twenties, it was a calling into question of the entire concept of behaviour, a large chunk of the moral code by which the nation lived. (Schickel, 1962, p. 13)

It is hard to apply such lofty criteria to Gracie Fields. Much of her appeal lay in her very ordinariness. Square-jawed, with pinched features, she would have looked almost plain were it not for the smile that permanently emblazoned her face. Her newspaper profiles repeat again and again that she is extraordinarily ordinary, 'wholly free from affectation', 'robust and exuberant', 'a representative of the people'. In her public

statements, as in the roles she played, she often seemed allergic to glamour. She claimed to feel out of place in London theatreland of the 1920s: 'I hadn't the faintest idea of how to behave or look like Gertrude Lawrence, Tallulah Bankhead, Gladys Cooper or any of the other great names, and their sophisticated lives terrified me' (Fields, 1960, p. 59). Nor was she at ease in the Hollywood of the 1940s, where she recalls being patronized by svelte young actresses and producers. Sometimes, she would get the man in the final reel, but her vehicles were seldom conventional love stories. She was too busy sacrificing herself for others to waste time in anything so selfish as romance.

Fields is a typical British film star in her reluctance to appear in films. Like many of her colleagues, she gave every indication of disliking the medium intensely. Her movie career began and ended under sufferance. She seemed to regard it as an unfortunate accident. Whenever she tried to retire – as, for example, she did after shooting *This Week of Grace* (1933) – the studios offered her more money to continue. She may have projected goodwill and cheerfulness on screen, but she evidently did not feel it when acting in front of the cameras. This was a job, not a vocation. Doing it enabled her to live abroad. 'Whenever I thought I couldn't stand the studio for another minute, I'd tell myself, "Making films is the price you pay for Capri," and that way I got it done' (Fields, 1960, p. 89).

Unlike Frank Randle, Max Miller or George Robey, Fields was not diminished by cinema. Her appeal was as strong on screen as on stage. Perhaps this was because she was singer as much as comedienne. ('Whenever I've wanted to get something over in life, I've usually sung it,' is the opening line of her autobiography.) Wherever she appeared, she had the knack of knitting audiences together. She led the song. They followed. Everybody went to see her. When she performed at Blackpool's Grand Theatre in the summer of 1934, she attracted an audience of 110,000 people, 'the equivalent of Blackpool's entire resident population', the publicists later proclaimed. The tremendous, epiphanic moment toward the end of *Sing As We Go*, in which she leads a huge crowd of unemployed workers back to the mill from which they were laid off at the start of the film, hints at the secret of her popularity. She was shop steward and favourite aunt rolled into one.

George Formby, Lancashire's very own answer to Private Schweyck, was the archetypal little man as hero. He had none of the self-reliance of a Fields. On the contrary, his appeal lay in his sheer, gormless fragility –

his buck-toothed, saucer-eyed demand to be loved. His father, the cele-
brated music hall star George Formby Snr, was nicknamed the 'Wigan
Nightingale' because of the way he incorporated his rasping, bronchial
cough into his stage act. Formby Senior's comedy was tough and grim, a
kind of northern gallows humour in which the star's own fragile health
was milked for laughs. He wore dishevelled clothes and ill-fitting clogs,
and told jokes against himself, but there was grit in his routines, a resolute
denial of self-pity. Formby Junior was altogether more sentimental. With
that ingenuous, rabbit-like smile, he even looks a little like Elmer Fudd.
His appeal, like that of Gracie Fields, was as much rooted in his singing as
his comedy. And like Fields, he defined himself in opposition to West End
sophistication. 'Fancy me and my ukulele on the stage where Ivor Novello
knelt before the altar with a rose in his hand,' he used to jest (Fisher,
1975, p. 86).

Not that Formby's failure to win over a few London theatregoers much
affected his nationwide popularity. Throughout the 1930s and early
1940s, he was one of Britain's highest-paid entertainers, releasing records
at a prodigious rate, making movies, and continuing his career as a live
performer. His first two films, *Boots, Boots!* (1934) and *Off the Dole*
(1935), were low-budget affairs, made at Mancunian Films with the same
lack of technical grace that characterized Randle's screen output. But, as
historian John Fisher observes in his entertaining biography of the
comedian, his formidable wife Beryl made him tidy up his act, take off the
cloth cap, and dress like a chap in tie, suit, and sometimes even dinner
jacket.

Given the way his humour relied so intently on furtive, schoolboy
innuendo, it was only fitting that Formby should be married to somebody
as bossy as Beryl. She fits the stereotype drawn by Orwell in his essay on
Donald McGill of the domineering wife who has her cowering, feeble
husband leaping to obey her, even as he cocks a snook at her behind her
back. She rigorously vetted his leading ladies, and, like a mother with a
dirty-kneed child, rationed his pocket money. Monja Danischewsky, the
publicist at Ealing while Formby was working there, memorably descri-
bed him as 'a man permanently under house arrest' (quoted in Fisher,
1975, p. 74) and tells a sad little story of how he tried forlornly to seduce
an actress while Beryl was briefly out of sight. John Fisher suggests that
Beryl apart, 'the only actress he got to kiss full on the lips was Googie
Withers, at the end of *Trouble Brewing* (1939), when both are capsized in

a brewery fermenting tank' (Fisher, 1975, p. 62). Instead, George was obliged to displace his lusts into a series of mildly risqué, voyeuristic songs about such subjects as his little stick of Brighton Rock or his window-cleaning round.

When he signed with Ealing to make his third film, *No Limit* (1935), Formby immediately moved upmarket. As if to show that he was more than simply a regional comedian, the script sees him roaming outside his native Lancashire, competing in reckless fashion in the TT motorbike race on the Isle of Man. Ultimately, he was transformed from seaside entertainer to national hero, even going as far as to wallop Adolf Hitler in *Let George Do It* (1940). In real-life, too, Formby proved his heroism, travelling across war-torn Europe to entertain the troops.

Despite his northern roots, Formby was an everyman, a comedian with an unlikely universality of appeal. When he was at his peak, he received over 90,000 fan letters. His fan club numbered 21,000 members. First his mother (who demanded that he go on stage after Formby Snr's death) and then his wife put as much guile and effort into promoting his career as had Wilcox with Neagle or Korda with Merle Oberon. Even so, it is hard to pinpoint precisely what made him so popular. An adulatory essay on the official George Formby website proclaims that 'the greatest thing about him was that he just was. His great gift was understanding the thoughts and feelings of ordinary people, and expressing them in a natural, spontaneous way.' In other words, he shared Gracie Fields's knack for breaking down the barriers that traditionally exist between stars and their audiences – like her, he was a symbol not of luxury or glamour but of consensus.

Despite signing a lucrative contract with Columbia's UK production arm after leaving Ealing, Formby's films made no impact at all in America. However, he made some inroads in other corners of the world. George's appeal, it seemed, was at its strongest in totalitarian countries. He was the little man as hero, a type guaranteed to appeal wherever there was any kind of authoritarianism. His sheer incompetence could not be construed as rebelliousness, but at least he was no conformist. In 1944, he was nominated in a poll as the second most popular figure in Russia after Josef Stalin (Fisher, 1975, p. 55), a clear example of the carnivalesque fool sharing the tyrant's limelight.

A generation later, Norman Wisdom, another diminutive comedian who mined similar seams of pathos, was guest of honour at the Moscow

Film Festival. (The movie he was accompanying was so popular that it had to be shown in a football stadium to accommodate the thousands of Soviet fans who wanted to see it.) Wisdom was equally cherished in Cold War Albania. But back home in Britain, even when he was the Rank Organization's top box-office attraction, his reception was not always so warm. In the comedian's heyday, there was one Wisdom film a year, which would always be premièred in December. Rank's accountants hoped that the Christmas spirit would lead cinemagoers to show box-office benevolence to poor little Norman, British cinema's very own answer to Dickens's Bob Cratchet, a feeble but lovable mascot. The fans came in their droves, the popular newspapers applauded him, but right from the start of his career with *Trouble in Store* in 1954, most of the highbrow critics heaped unseasonal opprobrium on his efforts. David Robinson in the *Financial Times* blamed his writers and directors for his skid into mawkishness. 'More and more they have allowed him to drift into odious sentimentality: and to indulge what looks like a personal obsession with nightmarish and unfunny situations in which he is publicly shamed and humiliated.'[11] Richard Roud was equally corruscating in the *Guardian*: 'He goes through the same series of gags, grimaces and goo. Mr Wisdom apparently enjoys great popularity. I can't for the life of me see why.'[12] 'Norman Wisdom is a problem. He recurs . . . ', sneered C. A. Lejeune after being forced to sit through his 1957 effort, *Just My Luck*.[13] This movie also prompted an extraordinarily splenetic attack from Derek Hill in *Tribune*, who claims to have walked out of the screening in a state of speechless rage.

> Don't try and tell me that the Wisdom series are harmless little comedies. They show a set of attitudes and a contempt for audiences rare even in the Rank set-up. How can we accept as sympathetic a clown who is presented as not merely awkward but an ignorant and offensive nuisance? How can we side with a comic who is shown to be a semi-literate moron?[14]

Meanwhile, Penelope Gilliat described his 1963 film, *A Stitch in Time*, as 'a nauseating combination: it is very heartless and also so sentimental that it sticks to your fingers like fly-paper.'[15] Even the generous-spirited Dilys Powell described *What's Good for the Goose* (1969), Wisdom's attempt at a sex comedy, as 'absolutely repulsive'.

In a sense, these criticisms from on high are just what Wisdom might

have expected. The writers dismissing him so contemptuously are the journalistic equivalent of the kind of characters who torment him, and whom he exasperates, in the films themselves: the gallery of establishment types played by that eminently supercilious character actor, Jerry Desmonde. There is a measure of snobbery in the way they sneer at him. Wisdom chafes such figures. His abrasive, gormless presence is more than they can tolerate. In his 'gump's' outfit – cloth cap, cheap, shabby suit bought second-hand – he unwittingly exposes the hidden layers of class prejudice which have always characterized highbrow film criticism in Britain. Confronted with Jacques Tati, Chaplin or Keaton, these critics would doubtless have been in raptures. After all, as Wisdom's old producer Hugh Stewart testifies, the star was as acrobatic and as consummate a choreographer as any of the great silent comedians.[16] It was clearly the context which grated, the fact that Wisdom's comedies were set in a little England recognizable from small-town life rather than in Culver City.

In virtually every one of his roles, Wisdom was cast in the same mode. He was always the oppressed, down-at-heel outsider. He played shop assistants, butcher's assistants, hospital orderlies, odd-job men, humble little soldiers. The names of his characters hinted at his forlorn status. He was always called Norman Pitkin or Norman Puckle or Norman Truscott. Ironically, just as the broadsheet Cassandras were attacking him and bemoaning his decline (not that they had ever applauded him anyway), the popular newspapers consistently praised him.

'His best yet' . . . 'His funniest so far' . . . 'I only have to look at Norman Wisdom and I laugh. I am just sold on that daft face, that sheepish, open-mouthed grin, those vacant blue funk eyes. Add the idiotic cap, undersized suit and the turkey-strutting walk – and there goes the best buffoon that ever fell flat on his face.' These are just a sample of the responses he elicited in the *Daily Express* and the *Daily Mail* at the very same time he was being lambasted elsewhere.[17] Nor, in general, were audiences put off by the brickbats hurled by the broadsheets. His box-office appeal remained buoyant right through the early 1960s, when some of his films used to outperform the new James Bond movies at the box office.

Wisdom is often cited as a comedian from the austerity era, somebody whose very image encouraged identification with Attlee's England of 'sweet points and clothing coupons, margarine in plain packets, kids in

balaclavas and nailed boots'.[18] He was, or so one critic pronounced, 'Pagliacci in a demob suit.'[19] In chronological terms, however, Wisdom was a comedian for the Macmillan era. However obliquely, his first film as star, *Trouble in Store* (1954), celebrated consumption, not shortages. The storylines of his pictures were often similar to those of Formby. Both played odd-job men, hapless assistants. (Wisdom even played a window cleaner in *Going Up in the World* in 1956.) Both regularly resorted to music. (Wisdom's theme song, 'Don't Laugh at Me ('cause I'm a Fool)', reached number 3 in 1954 and spent a creditable fifteen weeks in the Top 20.) Both gave every impression of being bashful with women. But Wisdom sprang from a later generation. His apprenticeship was served in the army concert party and on the small screen rather than in music hall. He was Britain's first big television star to make a career in the movies. Before he signed for the Rank Organization in 1953 he had already made an enormous impression in a series of TV specials. Wisdom's film vehicles may sometimes have seemed quaint and old-fashioned, but at least they tried to be topical. They made occasional concessions to pop culture. For instance, a Teddy boy holds up the shop where Norman Pitkin works in the comedian's 1963 vehicle, *A Stitch in Time*, while in *Follow a Star*, Norman plays a star-struck assistant in a dry-cleaner's shop. Under the firm tutelage of musical instructor Hattie Jacques ('We must keep our vowels open!'), he makes the grade as a pop star. Rival singer Jerry Desmonde makes a dastardly attempt to 'steal' his voice, but Norman eventually prevails. (In ludicrous scenes, loosely cribbed from the 1954 version of *A Star Is Born*, little Norman stands in the wings, singing his heart out, while Desmonde, centre stage, mimes to the words.)

Wisdom, Formby and Fields defy John Ellis's model of a star as 'a performer in a particular medium whose figure enters into subsidiary forms of circulation, and then feeds back into future performances' (Ellis, 1991, p. 91). They were not confined by, nor primarily associated with, one particular medium. Unlike, say, Gable or Bogart or Garbo or any other similar Hollywood name, they were not movie stars *per se*. They switched between film, music hall, TV, radio and recording. Whatever the storylines of their various movies, their own performances always stood out, often seeming more akin to solo routines than pieces of straight acting. On screen, they somehow contrived to appeal to their audiences as directly as if they were there, in person. Ellis and Richard Dyer (1979) argue that a star is somebody whose image feeds into subsidiary media.

With this trio, the process works by reverse. Their respective images were formed in the so-called 'subsidiary' media and then fed back into cinema. There was no hierarchy: it was not as if their other activities were secondary to their film-making.

In his book, *Visible Fictions*, Ellis draws a distinction between cinema, which produces 'stars', and television, which 'fosters personalities'. Such a dichotomy may make sense in terms of classical Hollywood cinema, but hardly seems adequate when applied to its British counterpart. Fields, Formby and Wisdom were nothing if not personalities. Even before television became widely available in Britain, they were ubiquitous presences, accessible through radio, film, live performance and recordings. None were obvious sex symbols. All made ready use of pathos. All promote an idea of consensus rather than individualism.

Not just with Fields, Formby and Wisdom, but with its extraordinary wide range of comic and character actors, British cinema often seems more predisposed to 'personalities' than to 'stars'. Tom Walls, who directed as well as acted in most of the films adapted from Ben Travers' famous Aldwych farces, believed that British teamwork and variety could counter the Hollywood star system. 'The weight of the whole film never lies on the shoulders of any one man,' he argued. 'You never get tired of seeing one face gazing at you in long shots, mid-shots and close-ups.'[20] As he correctly surmised, the British star system often relied more on a repertory company of studio actors than on glamorous individuals.

The ethos at Ealing Studios under Michael Balcon in the late 1930s and 1940s was consensual: there are no stars in *Passport to Pimlico* (1949) or *Hue and Cry* (1946). The same might be said of Gainsborough under Ted Black before the studio embarked on its more glamorous melodrama cycle in the 1940s. Both on screen and behind the cameras, the Will Hay, Crazy Gang and Arthur Askey comedies made at Gainsborough in the 1930s relied on teamwork, not individualism. (Wherever Hay went, his two stooges, grizzled old Moore Marriott and Graham Moffatt, were liable to follow. Moreover, the same writers and directors who made the Hay movies – Marcel Varnel, Val Guest etc. – worked with the Crazy Gang and with Askey.) From Hepworth's repertory company at Walton-on-Thames to the *Carry On* series, from Hammer (where Christopher Lee and Peter Cushing may have received star billing but scarcely played conventional romantic leads) to Rank's Charm School, the emphasis always remained on the group.

The 1940s, or so many accounts insist, were the most robust years in the history of the British film industry. This was a decade of vigorous social change. Education, health and housing were highlighted as Attlee's Labour government attempted to remould Britain in the post-war years. The very titles of some of the films of the 1940s – *Journey Together* (1944); *Millions Like Us* (1943); *This Happy Breed* (1944) – evoke the new-found sense of community. In such films, character actors were as likely to be foregrounded as stars.

Although this was the era of Gainsborough stars such as Margaret Lockwood, James Mason and Stewart Granger, it was also a vintage period for several actors who had hitherto languished a long way down the supporting cast, figures like Jack Warner, Bernard Miles, Patricia Roc and Gordon Jackson: resourceful, salt-of-the-earth types who might almost be described as anti-stars.

The love affair between airman Jackson and factory worker Roc in *Millions Like Us* is ground-breaking simply because so unfussily handled. Even when Jackson is killed in action, his fiancée's grief isn't telegraphed with melodramatic music. Instead, the scene is handled in restrained, understated fashion.

As her fan club magazine makes clear, Roc's star persona was based around her extreme ordinariness. Although she appeared in several Gainsborough melodramas and was part of the studio's star stable, she went out of her way not to appear too glamorous or aloof. The breathless, confidential tone she adopts in her 'personal letter' to her fans reads like something written to a pen-pal.

> It's been tiring work dashing from one studio to another, having costume fittings, hairdressing experiments and colour tests quite apart from actually making the films. But I haven't minded a bit, really. When I get really tired and a bit overwrought, as we all do sometimes, I comfort myself in the knowledge that I am making films for you, each and every one of you, and that cheers me up no end. Now don't you forget this is your magazine as much as it is mine.[21]

Gordon Jackson, a former apprentice engineer in the Rolls-Royce factory in Glasgow who had made his début as a young Scottish boy in *The Foreman Went to France* (1941), was equally self-deprecating: 'I don't have the make-up to be a star,' he confessed. 'To be a star you have to be prepared to stop at nothing – to be ready to make a fool of yourself if need

be. I can't do that. My trouble is that I am too underconfident and too tentative.'[22]

For many film-makers of the era, understatement became an aesthetic creed. As if to underline the fact, even a stylist like director David Lean curbed his will to extravagance when showing the death of Bernard Miles in *In Which We Serve* (1942). Jack Warner's death as PC Dixon in *The Blue Lamp* (1950), and Dixon's wife's phlegmatic response to the news of it, is played so deadpan it comes close to caricature. The realist aesthetic encouraged by the 'quality'[23] critics and by the influential British documentary-makers (all of them steeped in the teachings of John Grierson) affected fictional films and affected acting styles. Several leading film-makers of the 1940s had in fact moved into feature films via documentary – Jack Lee, Alberto Cavalcanti and Pat Jackson among them.

The idea of enduring without betraying emotion was crucial to Britain's identity of itself, 'standing alone' in Europe during the dark days of the Second World War and beyond. One does not expect Hollywood stars like Flynn, Bogart or Cagney to gush sentiment, but even by comparison with their American equivalents, British actors of the period display a sometimes chilling reticence. In Powell and Pressburger's *The Small Back Room* (1949), the bomb disposal expert played by David Farrar may be suffering from alcohol-induced hallucinations, may have a drink problem and sexual hang-ups, but whatever these seething anxieties, he somehow retains his cool. On one level, this is a facet of 'gentlemanly' behaviour, the way you expect Captain Oates or anybody else in the officer class to behave. But in 1940s British movies, this will-to-endure transcends such snobbish caricature.

Selflessness and star behaviour were not especially compatible. Nor was there much overlap between the documentary-style understatement of Grierson and his colleagues at the GPO and the Film Society and the unabashed commercialism of the hard-nosed Wardour Street renters, exhibitors and publicists. As Raymond Durgnat puts it, 'the relationship between these secular Sunday School teachers with their sound civic pieties, and all the fleshpots, fake, fun and fiddle of showbusiness was too rarely one of understanding' (Durgnat, 1970, p. 34).

The tension between reticence and flamboyance, between the unassuming behaviour of the character actor and the self-promoting antics of the star, is what makes John Mills such an intriguing, anomalous figure. Mills remains visible despite the cloaks of decency and understatement he

shrouds himself in. Whether stuck in the middle of the desert (*Ice Cold in Alex*, 1958) or stuck in the frozen climes of the South Pole (*Scott of the Antarctic*, 1948) or stuck at sea (*In Which We Serve*, 1942) or stuck in a prisoner-of-war camp (*The Colditz Story*, 1954), he is so unfailingly cheerful, brave and honest, so much the boy-next-door, one gets the sense that were he to be cast against type, perhaps to play Adolf Hitler or Genghis Khan, we would warm to his performance and have him home to tea nonetheless.

From his very earliest roles, for instance his heroic, First World War seaman who takes on a German ship single-handed in Walter Forde's *Forever England* (1935), he embodied decency and quiet heroism – qualities he showed were not the exclusive preserve of public school boy Corinthians. As if to reinforce the fact, he toppled Gainsborough Studio's aristocratic cad and rotter, James Mason, from his perch at the top of the popularity polls in the mid-1940s. It is quite inconceivable that he would ever have bludgeoned Margaret Lockwood with an iron poker (as Mason did in *The Man in Grey*, 1943). Nor, in later life, would Mills have been happy corrupting nymphets (as Mason did in *Lolita*, 1962). Whether as character actor or leading man (and he often seemed the same as both), Mills was always the same principled altruist. He was also patriotic: given the opportunity to follow Granger and Mason to Hollywood after the war, he plumped for Britain.

Sometimes, Mills seemed just a little too sanctimonious. As Pip in David Lean's *Great Expectations* (1946), he seems a little bland beside the gallery of Dickensian grotesques (Finlay Currie as the shaven-headed convict, Martita Hunt as Miss Havisham). It is highly unlikely that a mischievous little gamine like Jean Simmons's Estelle would ever have fallen for such a lacklustre hero. But in the 1950s, as prosperity set in, and as Churchill and then Macmillan attempted to gnaw away at the social contract struck by the Attlee government in the previous decade, Mills stood as a totem of the old values.

British war films of the 1950s are sometimes caricatured as exercises in jingoistic nostalgia. As British world influence dwindled, the argument runs, British film-makers looked back with longing at an untroubled imperial past. Seen in such a light, Mills, forever dressed in khaki, seems a reactionary figure. However, his brand of selfless heroism appeals as much to a popular memory of 'people power', of a time when, as historian Angus Calder put it, 'the nation's rulers, whether they liked it or

not, depended on the willing co-operation of the ruled, including even scorned and underprivileged sections of society, manual workers and women' (Calder, 1992, p. 17).

Like Formby and Wisdom, Mills was the little man as hero. Although he too occasionally played gormless fools – for instance, his hapless, henpecked young shoemaker in *Hobson's Choice* (1953) or even his Oscar-winning deaf-mute in *Ryan's Daughter* (1970) – he always set more store by dignity than they did. Still, he ranks alongside Formby and Wisdom as an everyman.

The carnivalesque tradition in British cinema subverts the established social order through ridiculing it and turning it upside down – through making clowns into kings and relentlessly mocking authority figures. But outside comedy, the cinema of consensus achieved something similar. By shifting the focus away from stars onto character actors, by emphasizing decency and restraint, by eschewing glamour and telling stories (as Michael Balcon famously put it at Ealing Studios) which 'project Britain and the British character' (Barr, 1977), film-makers were occasionally able to forget that theirs was indeed the most class-ridden country under the sun.

Notes

1. *Picturegoer*, 21 June 1947.
2. See the entry under *Somewhere in England* in *Halliwell's Film and Video Guide*, 1997 edition.
3. Cyril Connolly, *New Statesman*, 5 August 1939.
4. Quoted in Brett (1995, p. 60).
5. Cyril Connolly, *op. cit.*
6. See, for instance, David Robinson in the *Financial Times*, 19 June 1964.
7. The *Guardian*, in its obituary for Fields, 28 September 1979.
8. See the entry on Gracie Fields in Katz (1980).
9. BFI microfiche on *Keep Smiling*.
10. *Sunday Times*, 24 October 1943.
11. David Robinson, *Financial Times*, 14 December 1959.
12. Richard Roud, *Guardian*, 13 December 1963.
13. C. A. Lejeune, *Observer*, 8 December 1957.
14. Derek Hill, *Tribune*, 6 December 1957.
15. Penelope Gilliat, *Observer*, 15 December 1963.
16. Author's interview with Hugh Stewart, 1992.
17. See, for example, *Daily Mail*, 13 December 1963; *Daily Mirror*, 6 December 1957.
18. *Guardian*, 31 July 1971.
19. *Ibid.*
20. *Film Pictorial*, 29 February 1936, p. 13.
21. *International Patricia Roc Fan Club Magazine*, November 1946.
22. Gordon Jackson BFI microfiche.
23. For discussion of the role of 'quality' critics, see John Ellis in *Screen*, Autumn 1978, pp. 42–7.

Stock Types

The gentleman-amateur

He dislikes using an electric razor ... takes life in his stride, is strongly introspective, and never takes a cigarette before eleven in the morning ... His early youth was strongly influenced by the essays and letters of Robert Louis Stevenson. He goes shopping only under duress. He has never been in the Metropolitan Museum in New York, once made a furtive attempt to read James Joyce's *Ulysses*, and confesses that life has given him far more than he ever expected from it. He is intolerant of neurotics. He is always tanned and prefers wearing comfortable tweeds ... He has never played gin rummy. (From a profile of Ronald Colman in *Photoplay*, January 1943)

In 1935, the year in which he was voted 'the handsomest man on the screen', Ronald Colman played probably his most distinctive part – the vinous lawyer Sidney Carton in a lavish MGM production of Charles Dickens's *A Tale of Two Cities*. During the film's melodramatic finale, as he prepares to face the guillotine in place of a young French aristocrat to whom he bears an uncanny resemblance, he recites the famous final words, 'It's a far, far better thing that I do than I have ever done; it is a far, far better rest that I go to than I have ever known.'

It is a true moment of cinematic epiphany, all the more effective because Colman is so well suited to his role. Already middle-aged, still handsome even if without, for once, his trademark moustache, but with an air of dissipation about him, he declaims Dickens's words in his sonorous baritone, looking for all the world as if he really is ready to die. The image he presents might have been tailormade to flatter American

preconceptions about the gallantry of spiritual Englishmen. Not long after the film's release, the *Newark Star Ledger* characterized him as follows: 'Ronald Colman is a composite Englishman. He represents to the average fan everything that is England. His reserve, his clipped speech, his delayed response to an American joke, and his high irritation at having his private life disturbed makes him more British than John Bull.'[1]

Colman gained an unlikely reputation in the Hollywood of the late 1920s and early 1930s as Britain's answer to Greta Garbo, a 'male sphinx'. He was solitary and aloof, and gave a strong impression of loathing the press. Just as Garbo's reclusiveness was seen as at least partly attributable to her nationality (as a Swede, she was an outsider in Hollywood), Colman's prickliness was marked down as a character-istically British trait – it fitted in perfectly comfortably with his star image – and so was not held against him. 'I realise that nobody can be in a public business like making motion pictures without arousing a certain amount of public interest in one's affairs,' he grudgingly acknowledged in an interview in 1932. 'I realise that there must be publicity. It is only the kind of publicity to which I object, but not to publicity itself.'[2]

His reluctance to talk to the press, like his determination never to appear in more than one, or at most, two films a year, stemmed not just from modesty or diffidence, but a canny determination to avoid over-exposure (and, for that matter, hefty income tax bills – sometimes it was cheaper not to work). During the 1930s, after his split with the Goldwyn Corporation, he was one of the few major stars who remained freelance, not tied by those notorious seven-year contracts to any of the big studios. Even when he was denying he had any interest in self-promotion, he invariably offered the press just the image of himself as Anglo-eccentric that they wanted. 'Once having read that Ronald Colman is an English-man, smokes a pipe, likes solitude, likes to read, likes tennis, wears white flannels in summer, they [the readers] can't be interested in hearing it again. Repeated stories are wearying, and the subject becomes wearisome too,'[3] Colman protested, but he spoke to the press more frequently than he claimed – and his chief topic in almost every interview was how much he disliked doing so. In the early 1930s, he sued Goldwyn for releasing damaging publicity about him which implied he drank while working because he thought a 'dissipated air' made him a more charismatic screen presence. It was true that he looked more weatherbeaten than the average Hollywood leading man, but he argued that 'the deep lines in his face

which give it character' had nothing to do with alcohol or reckless living but were attributable to 'the experience of life that had come to him in perfectly legitimate ways'.[4] As no journalist ever neglected to mention, Colman had fought at Ypres in the early days of the First World War. Moreover, in his early days as an actor in Britain, he had experienced considerable poverty. A former shipping clerk and accountant, he was discharged from the army after receiving a serious injury in 1915. There was no job waiting for him back home. As he told one interviewer, 'I walked the streets of London without a job or money for three months . . . Finally, I took a job as an actor. There wasn't anything else to do.'[5] He began his stage career in 1916, and appeared in his first film a year after. He tried to combine theatre and film work, but was not particularly successful in either sphere. Several British film companies turned him down as 'unsuitable for the screen'. His marriage, to English music hall actress Thelma Raye, quickly turned acrimonious – an extra stimulus for trying to start anew in the USA. When he arrived in New York in 1920, he was a long way removed from the elegant English gentleman Hollywood moulded him to be. He came to America to make his fortune with only two contact addresses and around $50 in cash – or so the publicists later proclaimed.

A conventionally dashing leading man in Hollywood in the silent era in films like *The White Sister* (1923; opposite Lillian Gish), *Beau Geste* (1926; in which he played the title role) and *A Thief in Paradise* (1925), often cast opposite Hungarian-born siren Vilma Banky, Colman's image was transformed utterly by the coming of sound. His ringing, melancholic voice reminded everybody that he was British and made him ideal casting for any roles as romantic, world-weary roué. Hence his jaded British diplomat who looks for redemption in Shangri-La in Frank Capra's *Lost Horizon* (1937) and his charming, but gloomy, Sidney Carton.

Colman epitomized a kind of heroic defeatism – the noble, chivalric failure that has always been a touchstone of British culture. To put it bluntly, the British love to lose. It is an Anglo-Saxon trait, evident in ancient poems which, with perverse, bloodthirsty and very masochistic relish, celebrate the rout of the local army at the hands of the Vikings. But it is also a Celtic trait, discernible in the many laments for lost lands and lost kings. During the early talkie era, it sometimes became blurred with the cult of the gentleman–amateur – the strange Corinthian notion that it

was polite to accept defeat gamely. Hollywood films of the 1930s are full of defeated but still gallant Englishman-hero types: witness the roles played by Colman, Leslie Howard (perhaps most notably as the sickly medical student opposite coquettish tea-room siren Bette Davis in *Of Human Bondage*, 1934) and Herbert Marshall (Dietrich's cuckolded scientist husband in *Blonde Venus*, 1932).

Colman, invalided out of the First World War after three months' service, was a suave, unflappable leading man. Born in relatively humble circumstances in Richmond in 1891, he did not belong to the gilded world of the upper-class, Rupert Brooke-like idealists. But the image he fashioned for himself in the 1930s traded on preconceptions of the English gentleman-amateur, both reckless and debonair. In his first talkie, *Bulldog Drummond* (1929), he played Captain Hugh 'Bulldog' Drummond, a dashing detective. As Jeffrey Richards has pointed out, Drummond, at least as he appears in the pages of Sapper, has a hint of the jackbooted bully about him. As his nickname hints, he is very different from the heroes who spring to life in the pages of other, more fair-minded detective authors of the day. 'Superficially,' Richards notes, 'Sapper's books might seem to resemble Buchan's. They share a common anti-intellectualism and anti-Bolshevism . . . But a closer examination reveals a range of Fascist thuggery that would have appalled Dick Hannay or Sandy Clanroyden. Drummond and co. were definitely not of their totem' (Richards, 1973, p. 33). Nevertheless, as played by Colman in 1929, Bulldog Drummond is a consummate gentleman – dapper, witty, and not so very different from E. W. Hornung's famous jewel thief-cum-international cricketer, Raffles (whom Colman also portrayed a year or so later). He was the English gentleman *par excellence*. British producers failed to recognize his potential – 'Does not photograph well' stated Colman's first screen test in the UK – but then complained bitterly when he abandoned the British industry for Hollywood.

Another 'gentleman-amateur' who served in the First World War, briefly appeared in British silent films in the 1920s without making any lasting impression on audiences or critics (he acknowledged as much in his unpublished autobiography, *The Eighty-four Ages*), and then headed off to Hollywood was Clive Brook. His first major role was in producer Michael Balcon's extravagant *Woman to Woman* (1923), opposite Hollywood import Betty Compson, who was infinitely better paid than he was. According to trade papers of the time, she was on $5000 a week for

the ten weeks of shooting (Low, 1971, p. 141). Balcon had spotted Brook on the West End stage (Kardish, 1984, p. 44) and took a chance on him as leading man: whatever else, he was photogenic. No prints of the film survive. Nevertheless, from the stills and synopsis it is apparent that this was a full-blown melodrama in the same vein as those rococo Gainsborough films of the 1940s in which Margaret Lockwood played wicked ladies in décolleté dresses while James Mason brooded in saturnine fashion in the background. The story concerns an upright young Englishman (Brook in evening wear) who falls recklessly in love with a beautiful Moulin Rouge dancer (Compson in silk gown and feathered headdress.) The two have a child, but war comes between them. Brook is wounded at the front, and loses his memory. Amnesia, as many critics have noted, is a common plot device in British melodramas of the period (see, for instance, Barr in Cook, 1997, p. 52). Brook's character ends up marrying another woman (Josephine Earle), 'an English woman from his own somewhat upper-crust social circle'. Many years pass before he meets the dancer again when she turns up with his son in tow.

Although *Woman to Woman* was loosely adapted from a play, Brook's character is not so far removed from the kind of hero found in popular fiction of the period. As Claud Cockburn points out in *Bestseller*, his study of 'The books everyone read 1900–1939', contemporary novels were full of vagabonds and bohemians who 'turned out to be gentlemen too' (Cockburn, 1975, p. 154). Heroes often had private incomes which saved them from the inconvenience of having to work for their livings and allowed them the leisure time to indulge in adventure. The same might be said of the gentlemen-amateurs appearing in British and Hollywood films.

Brook, the 'strong, silent man of the screen', as he was described by the *Dundee Evening Telegraph*,[6] was blessed with a beautiful profile. Reputedly, he always went to bed with a strap round his neck to keep his chin up.[7] He also had a rugged, impassive quality, a stillness, not at all typical of British screen actors of his generation, many of whom, as producer George Pearson witheringly observed, resorted to 'over-acted pantomimic gesture and frozen facial expression suggesting emotion at its strongest' (Pearson, 1957, p. 183).

Reviewers praised Brook's 'essentially British masculinity',[8] his 'fine appearance and carriage'[9] and his ability to 'look sinister or fascinating, good or evil, by the moving of an eyebrow'. This may have been quiet

exasperation rather than understated technique. Like many other British screen actors, Brook had a very British dislike of being commodified as a film star. He wished, he stated in his unpublished autobiography, 'to be thought of as an actor and not as a well-known brand of goods such as Bovril, Lucky Strikes or General Foods cake mix'.[10] Not that this stopped him from going to Hollywood for twenty years to play stiff, handsome Englishmen in films like *Shanghai Express* (1932) and *Three Faces East* (1926). Brook has a fair claim to be the earliest home-grown Gainsborough star: shortly before being lured to the USA, he appeared opposite Alice Joyce and Marjorie Daw in *The Passionate Adventure* (1924). Scripted by Alfred Hitchcock, this was among the earliest films Michael Balcon produced under the Gainsborough banner at the tiny Islington Studios they had just acquired from Paramount. It was already apparent that Balcon faced a struggle to hold on to his leading names: not only Brook, but also his co-star, Victor McLaglen, headed off to Hollywood not long after the film's completion.

The third of the great gentleman-amateurs was Herbert Marshall, nicknamed 'Hollywood's perfect gentleman' by the American press.[11] Christened Herbert Brough Falcon Marshall, a former articled clerk to a city accountant, he was old school through and through. Like Colman and Brook, he saw action in the First World War. Badly injured in the Battle of Arras, he lost a leg. Not that he allowed this small inconvenience to hinder him as he limped to fame. First spotted in British silent films in the early 1920s, he was lured to Hollywood in 1929 to star in an early talkie, an adaptation of Somerset Maugham's *The Letter*, and was eventually put under contract by Paramount three years later. As his *Times* obituary noticed, the sound era saw him blossom: 'Marshall enjoyed several advantages over his American rivals. He had charm, polish and a quiet assurance; a cultured and pleasant voice, and he fitted easily and naturally into any background of sophistication and gentility.'[12] His short-lived marriage to fellow British actress Edna Best provided British fans with at least the illusion of their own Pickford and Fairbanks. As *Picturegoer* put it, '[they] are both typically English, cool and level-headed. Their team work, mutual love and self-sacrifice keep them together on the road to success – Britain's most famous lovers on and off the screen.'[13] They starred together in the Gainsborough melodrama, *The Faithful Heart* (1932). Charles Barr has pointed out that the film's storyline is roughly similar to that of *Woman to Woman* (Barr in

Cook, 1997, p. 53). Like Clive Brook in the earlier film, Marshall has a youthful affair with a working-class woman (Best), in this case a barmaid. Years later, after he has risen to the rank of lieutenant-colonel in the army and won the VC, he meets her again. Everything is against them – he is already engaged to another woman – but love draws them back together.

It is intriguing how closely Marshall and Best's real-life relationship matched that of the characters they played in *The Faithful Heart*. As the publicists never failed to remind fans, they too made enormous sacrifices to stay together. 'The film colony,' *Picturegoer* suggested in early 1933, 'has never quite recovered from the shock it received when Edna Best calmly turned her lovely back on the movie kings' dollars and ran away from Hollywood and glory because she could not bear to be separated from her husband, who was then working on the stage in New York.'[14]

A fourth actor whose career followed roughly the same trajectory as the three great gentleman-amateurs was Leslie Howard. Born Leslie Stainer in Forest Hill, south-east London, in 1893 to Hungarian parents, he spent much of his early childhood in Vienna. Not that his Eastern European background compromised his national identity – as his son put it, 'He remained at heart stoically, almost insularly English' (Howard, 1981, p. 31). A talented writer who used to contribute to the *New Yorker* and *Vanity Fair*, Howard even looked like a twentieth-century answer to the romantic archetype Sir Philip Sidney – tousle-haired and ethereal. Like Colman (and, to a lesser extent, Brook), he played slightly forlorn characters, for instance his cuckolded, club-footed English artist/medical student opposite a coquettish Bette Davis in *Of Human Bondage*. Davis's character, a working-class cockney siren, betrays him again and again. She gets the best lines. He is the scorned lover hobbling in her wake. Howard brings pathos and even a little grim humour to what must have seemed a thankless role. He had a capacity for noble suffering which more phlegmatic contemporaries like Brook and Marshall could not match. This is again in evidence in *Intermezzo* (1939), in which he plays a world-weary violinist who falls hand over fiddlestick in love with Ingrid Bergman although he is already married. He was the Confederate officer, Ashley Wilkes, in *Gone with the Wind* (1939), a character he himself described as 'a dreadful milksop, totally spineless and negative'. Howard seemed to cultivate his outer image as feeble, foppish, over-sensitive dilettante so as to show the steel beneath all the more distinctly. In

probably his most celebrated role, as Sir Percy Blakeney in Alexander Korda's *The Scarlet Pimpernel* (1934), he plays a sort of aristocratic counterpart to Colman's Sidney Carton, a dissipated, conceited buffoon who moonlights as a dashing hero. Howard reprised the role for propaganda purposes in the 1941 flag-waver, *Pimpernel Smith*, this time as a bungling archaeologist who rescues wartime refugees rather than as a Regency fop who bails out French aristocrats.

Howard came to be regarded as a national symbol during the 1940s, when he produced and appeared in a series of propaganda pics in which he invariably played some sort of English everyman. In *The First of the Few* (1942), he is cast as R. J. Mitchell, a dreamy, impractical designer who anticipates the Nazi threat before almost anybody else and graduates from building seaplanes to designing the Spitfire, although he himself dies before the war. In Powell and Pressburger's *49th Parallel* (1941), he is the pipe-smoking idealist, living out in the backwoods in Canada, whose gentleness and tolerance is contrasted, none too subtly, with the wild-eyed fanaticism of Nazi U-boat captain, Eric Portman. Howard also gave regular, morale-boosting radio broadcasts (which were relayed with great success to the USA) and produced several wartime flag-wavers, among them *The Gentle Sex* (1943) and *The Lamp Still Burns* (1943). Angus Calder notes in *The Myth of the Blitz* that Howard represented a 'visionary aspect of Englishness' which had an all-too-special resonance when the country was under threat of invasion. 'His courage and gentle humour went along with the message that England was fighting to save civilization, high culture, intellect' (Calder, 1991, p. 206). Howard embodied the qualities of the gentleman-amateur at his most mature. Instead of performing Richard Hannay-like feats of derring-do or becoming entangled in complicated romances, he selflessly devoted himself to saving his country. In doing so, he was able to escape prevailing class stereotypes. Although he played aristocratic types, he was nevertheless accepted as an everyman – someone who put others' interests above his own. The circumstances of his death were so unusual that they might have been dreamed up by John Buchan. In 1943, on his way home from a lecture tour in Spain and Portugal, the plane he was travelling in was shot down by Germans, reportedly convinced that Winston Churchill was also aboard. The mystery surrounding his death only served to strengthen his image as self-deprecating, self-sacrificing British war hero. He had been able to express a lyrical patriotism,

untainted by chauvinism. As he put it in one of his 1940 broadcasts aimed at American listeners, the English were marked by 'qualities of courage, devotion to duty, kindliness, cool-headedness, humour, balance, commonsense, singleness of purpose. But there is a master quality which motivates and shines through all these – that of idealism. Mind you, you have to be smart to spot it. The English do their best to conceal it and they succeed pretty well . . . in my case, it is the Englishman in me that is able to unearth it and the American in me that is able to stand off and marvel at it' (quoted in Calder, 1991, p. 207).

In stark contrast to Howard's idealism was the cynicism of George Sanders, a British star in Hollywood who positively radiated a sense of boredom and disdain. Whether as Gauguin in *The Moon and Sixpence* (1943), as the supercilious husband bullying Ingrid Bergman in *Voyage to Italy* (1953), or as the drama critic in *All about Eve* (1950), he achieved a mellowness of sneer which made even Clive Brook look soft-hearted. He was the gentleman-amateur as world-weary but elegant roué. He even titled his 1960 autobiography, *Memoirs of a Professional Cad*. Sanders had arrived in Hollywood in the mid-1930s, after beginning his film career in the UK. (He is seen as one of the god-like figures looking down on earth in Alexander Korda's H. G. Wells adaptation, *The Man Who Could Work Miracles*, 1936.) He occasionally played leading men: he followed in Colman's shoes as the Saint in a series of B-movies made at RKO in the late 1930s and he also starred as the Falcon in various detective mysteries for the same studio. He is best remembered, though, for the effortless way in which he conveyed world-weary hauteur. British writers Ray Galton and Alan Simpson paint a colourful picture of him at work on the Tony Hancock vehicle, *The Rebel* (1960), which they scripted. He received twice the salary of anybody else on the film, including Hancock. He insisted on having a grand piano on set. Between takes, he played selections from Sigmund Romberg and Ivor Novello, 'which immediately alienated him from the sparks and chippies, who regarded such flamboyance as the behaviour of a big-headed poofter'.[15] He had his clothes for the film made on Savile Row and leased out his own Rolls Royce to the studio. 'The man oozed style. When he was not shooting, he used to spend his leisure time driving crash-helmeted through the narrow lanes of the Kent countryside on a Vespa with his then wife on the pillion.'[16]

Sanders was the natural successor of the supercilious British stage

actors who condescended to appear on screen to pay their tax bills. Nevertheless, his performances were never as wearisome to watch as they seemed to be to give. He also set something of a trend. In later years, whenever Hollywood wanted a more refined style of villain, it would invariably turn to English actors whose qualities of refinement, mellowness of sneer and capacity for withering sarcasm could seldom be found back home in the States.

It was important for the gentleman-amateur not to be fazed, however extreme the circumstances in which he found himself. Robert Donat, one of Korda's protégés in the 1930s, played the role to perfection in both Hitchcock's *The 39 Steps* (1935) and Jacques Feyder's *Knight without Armour* (1937). Donat, though, is not as straightforward as Marshall or Brook. He was a more versatile actor, capable of tackling schoolteachers, inventors and romantic leads as well as gentleman-amateurs. He also had a knack for comedy. In both *The 39 Steps* and *Knight without Armour*, his character is shifty and secretive as well as heroic. Whether handcuffed to Madeleine Carroll or dangling from the Forth rail bridge in the former, or scurrying through a thickset forest with an absurdly furry hat on his head and White Russian Marlene Dietrich for company in the latter, he also seems far less physically reticent than the gentleman-amateurs, who tended to keep their sexuality under wraps.

The opening image of David Niven as Squadron-Leader Peter Carter in Powell and Pressburger's *A Matter of Life and Death* (1946), plummeting from the skies with his Lancaster bomber in flames, shows the reckless heroism of the British gentleman-amateur at its most extreme. His colleagues have either bailed out or are dead. With oblivion beckoning, he still manages to chat up the US radio controller (Kim Hunter) who is trying to work out what is wrong. 'Position nil,' he tells her. 'Age 27, education interrupted – violently interrupted. Religion – Church of England. Politics – Conservative by nature, Labour by experience.' Then, with flames licking at his face, he begins to recite Walter Raleigh and Andrew Marvell poetry and dictates a final letter to be delivered to his mother in Hampstead. 'I'm bailing out,' he blithely informs her, 'but there's a catch – I've got no parachute . . . I'd rather jump than fry.' 'June, are you pretty?' he asks her finally, before telling her he will come and haunt her as a ghost.

It is hard not to detect a little sly, affectionate satire in Emeric Pressburger's dialogue. This is dashing English-style heroism taken to

almost pathological extremes. Niven accepts what he presumes is certain death with all the good grace of a defeated rugger captain shaking hands with his opposite number.

An equal, but much grimmer resignation marks the way Trevor Howard's character faces his fate in George More O'Ferrall's Graham Greene adaptation, *The Heart of the Matter* (1953). Howard plays Harry Scobie, deputy commissioner of police in Sierra Leone, a dutiful, upright British colonial officer passed over for promotion despite fifteen years of exemplary service. Scobie is the antithesis of the dashing heroes played by Niven, Colman and Leslie Howard. In his way, he is as courageous, and sacrifices as much, but he is neither as handsome as they are nor quite as much of a 'gentleman'. As his shrewish, disappointed wife never ceases to remind him, he is a mediocrity without enough of a salary to indulge in grand gestures. Although infinitely the bleaker film, *The Heart of the Matter* stands as a companion piece to *Brief Encounter* (1945). Here, again, Howard's character falls in love – with refugee Maria Schell – but is forced eventually to deny his own feelings. With his upright bearing and clipped, monotone diction, Scobie is the archetypal repressed British hero – not the sort who could express his emotions in any extravagant physical way or even has the words to do them justice. Howard brilliantly exploits these limitations – his energy is all concentrated inward. In any given scene, he is buttoned up, tense to the point of rigidity, but his eyes never lose that desolate quality. (As his producer Ian Dalrymple put it, Howard 'was unique among British actors in his ability to present the man of action in the round – to suggest even the most straightforward characters are the victims of stress and bewilderment.') His reserved style makes a fascinating counterpoint to the Method acting that Brando, Clift and Dean were patenting round the same time in Hollywood. While they are always physically expressive (watch Brando prowling round the cramped New Orleans apartment in Elia Kazan's film of *Streetcar Named Desire*, 1951, or Dean bawling his eyes out at his father in *East of Eden*, 1955), Howard gives the sense of being trapped, a prisoner in his own body. He is constrained by all the old, familiar inhibitions – snobbery, sexual repression, religious guilt. There is no sense of altruism about his fate. He is not redeemed by some final-reel display of selfless courage but ends up wearily embracing his own damnation. This is failure shorn of either grace or heroism, but all the more poignant because so irredeemably bleak.

More equivocal, falling somewhere between the blithe heroism of the gentleman-amateurs and the world-weary fatalism of Inspector Scobie are the series of flawed icons celebrated by British cinema – for instance, Peter O'Toole's T. E. Lawrence in *Lawrence of Arabia* (1962) or John Mills's Captain Scott in *Scott of the Antarctic* (1948). Mills's Scott is such a doughty, honourable sort that you don't hold his failure to complete his icy journey against him. He is portrayed as courageous and diligent, his misfortunes a result of bad luck rather than bad leadership. The very casting of Mills ensures he will be treated as a hero throughout. Hardship does not lessen him in the slightest. If anything, his failure to make it to the South Pole before the Norwegians lends him an extra pathos. Captain Oates's self-sacrifice is presented as a moment of almost transcendent heroism. ('I am just going outside and may be some time,' the frost-bitten officer (Derek Bond) tells his colleagues before stepping out from the tent into the blizzard that will consume him. Over the years, his words have become a national joke. The sheer absurdity of the phrase, the under-statement and 'good manners' with which Oates confronted his death are now more laughed at than celebrated.) The rousing Vaughan Williams music in *Scott* reinforces the impression that glorious frostbitten defeat is something to be cherished. But the film does not stop to sound out what Adrian Turner has described as 'the reverberations that failure had for Imperial Britain' (Pym, 1998, p. 762). Nor does it allow its cast to tease out the ambiguities of their roles. They seldom question why they are in the frozen wastes or what they are trying to achieve. *Scott* was Ealing Studios' biggest budget film and one of their least revealing.

David Lean's *Lawrence of Arabia* offers a more ambivalent assessment of its hero. Peter O'Toole's Lawrence is neither a gentleman-amateur in the Colman or Niven vein nor an imperial archetype. He resists easy definition. 'Does he deserve a place in here?' asks a quizzical vicar during Lawrence's memorial service in Westminster Abbey, which acts as the film's overture. Tall, angular, with golden hair and intense, staring eyes, O'Toole looks as febrile as a martyr in an El Greco painting. His Lawrence shows a martyr's relish for suffering in a part which sees him whipped, left to march miles through the searing desert, taunted by British officers, worshipped by his Arab followers and then drawn into a spiral of mindless violence. O'Toole's Lawrence is nothing if not sado-masochistic. With most of British cinema's other heroic failures, the suffering was implicit and shown off-screen or displaced onto a

psychological rather than a physical sphere. In *Lawrence*, the pain is not simply something to be endured with John Mills-like fortitude. It is to be welcomed. O'Toole's Lawrence is a restless, tormented character, a narcissist whose heroism spills over into hubris. He exchanges his army uniform for Arab mufti. He shows an almost pathological relish for killing. He allows himself to be flogged. He relinquishes his officer status. His every transgressive gesture seems like a calculated affront to the ideal of the selfless, phlegmatic British hero acting with decorum and restraint.

Whatever else Lawrence was, he was not a 'chap', a type perhaps best represented by Ian Carmichael in British cinema of the late 1950s. Prancing and braying his way through Boulting Brothers comedies like *Privates' Progress* (1956) or *I'm Alright Jack* (1959) or trying to get one-up on Terry-Thomas in Robert Hamer's absurd, prurient *School for Scoundrels* (1960), Carmichael's characters cope with any worries they might have about women or work by behaving like neurotic nincompoops. With his inane grin, plummy voice and rubbery physique, Carmichael looks as if he has just fallen out of the pages of a late P. G. Wodehouse novel. He still has an upright military bearing even though the war is years past. Hawkins, More, Bogarde and Gregson were 'chaps' too, but in Carmichael, the type is no longer staunch and reliable. He has an effete, febrile, almost neurotic quality, something social commentators might ascribe to the nervousness of the country as a whole. To put it at its most simplistic, Anthony Eden's post-Suez Britain, which had lost its empire but was yet to find its role, was similarly teetering. He is the dashing hero of the John Buchan and Sapper novels, and the films they inspired, turned into an incompetent figure of fun.

With hindsight, the typical Ian Carmichael character appears a strange amalgam of 'the chap' and an equally familiar character, 'the bluff old cove'. This latter type, an upper-class counterpart to the gormless fools played by the likes of Formby, Will Hay and Frank Randle (see above), reaches its Hollywood apotheosis in Nigel Bruce's Dr Watson in the Basil Rathbone Sherlock Holmes films made first at Fox and then at Universal in the late 1930s and 1940s. Born in 1895, Bruce had been invalided out of the First World War. Recovering, he began his career on British stage and screen, appearing in character roles in such notable films as Victor Saville's *I Was a Spy* (1933) and Alexander Korda's production of *The Scarlet Pimpernel* before decamping to the USA in the mid-1930s.

Avuncular, white-whiskered, he resembled nothing so much as a walrus in a tweed suit. His rallying cry, always uttered with a look of embarrassed bafflement on his face, was 'I say, Holmes!' His Watson was doughty but rather stupid, with none of the rapier-like intellect of Holmes himself. This bluff old cove fitted so comfortably into American stereotypes about the British that he appeared in countless Hollywood films. He is Laurence Olivier's dim-witted but loyal friend in *Rebecca* (1939) and reprises more or less the same role as Cary Grant's friend, Beaky Thwaite (the name itself is a clear guide to the character), in *Suspicion* (1941). Bruce was not the only cove in Hollywood. There was an entire community of them, presided over by C. Aubrey Smith and including such redoubtable character actors as Leo G. Carroll, Reginald Denny (Algy in the Bulldog Drummond series of the late 1930s) and Melville Cooper, who specialized in playing butlers.

Back in Britain, Bruce's mantle was picked up by two character actors who were even bluffer coves than he was, Basil Radford and Naunton Wayne. As they showed in Hitchcock's *The Lady Vanishes* (1938) and Carol Reed's *Night Train to Munich* (1940), this pair were the original Eurosceptics. Stuck on a train in a godforsaken corner of the Continent, unwittingly involved in some spy adventure way beyond their ken, they reacted by reverting to type. The further away they were from Britain, the more British they became. In both films, they played the same characters, Caldicott and Charters. They appear stupid but they turn out to be heroes in a very British mould. They are phlegmatic under fire and, beneath their bluster, decent, chivalrous sorts with a distaste for bad sports and bullies. As *The Times* noted in its obituary of Radford, 'he endeared himself to theatrical and film audiences as the Englishman of a popular romantic convention. No great shakes as a thinker, this Englishman never lost his sense of values, and in the thick of fearful hazards was less dismayed by the likelihood of imminent capture than by the news that England had collapsed in the second innings.'

It is hardly surprising that Radford was cast as one of the British officers in a German camp in Ealing's POW drama, *The Captive Heart* (1946). Stuck away thousands of miles from dear old Blighty, the British officers react by attempting to turn their prison camp into a little corner of the Home Counties. They tend their gardens, sip their tea and do their staunchest to pretend they are still at home. Their behaviour is treated as heroic in a quiet, phlegmatic way.

Generally, Radford and Wayne's characters enjoyed a perfect rapport. They did not even need conventional dialogue to communicate. A murmur, a raised eyebrow about an unexpectedly low batting average, or a simple declaration of how an innings at the Oval or Lords began or ended, would suffice. But by the time of Ealing's portmanteau film, *Dead of Night* (1945), in which they feature as leads in one of the four stories, cracks were beginning to appear in their friendship. They play two fierce but friendly golfing rivals whose only real preoccupation in life is bettering each other on fairway or green. This, at least, is the case until a woman comes between them. One of the golfers plays a dastardly trick which prompts his rival into committing suicide. But the rival comes back to haunt him on his wedding night. What is noticeable throughout 'The Golfing Story' is the incipient caddishness. Beneath their genial facade, there is a little bit of the blackguard waiting to come out in both Radford and Wayne.

Cads and spivs

The cad has a long and honourable place in British film tradition. In fictional terms, he (it is always a him) has his antecedents in the raffish army officers who inhabit the pages of Jane Austen and Thomas Hardy, in Mr Jingle, the flashy ne'er-do-well of Dickens's *Pickwick Papers*, in the eighteenth-century rake, or in Patrick Hamilton's anti-hero, Ernest Ralph Gorse. As seen in British films, he is liable to have a 'magnificent masher' of a moustache, drive a sports car and light up like a fruit machine whenever a woman takes his eye. Examples of this breed include Guy Middleton, the lecherous sports master in *The Happiest Days of Your Life* (1950), Donald Sinden's louche young medical student in *Doctor in the House* (1954), and, most memorably of all, Terry-Thomas. Born Thomas Terry Hoar Stevens, he is the upper-class Englishman as bounder and poltroon, the type who cheats at sports (witness him as the crafty pilot in *Those Magnificent Men in Their Flying Machines*, 1965, or as the master of one-upmanship on the tennis court in *School for Scoundrels*, 1960). He uses every underhand method at his disposal to get his hands on money and women. He rattles off his dialogue in a nasal whinny and snorts rather than laughs. In Terry-Thomas' case, the gap between his front teeth, which stick out beneath his moustache like tusks (he has a well-nigh permanent, insincere smile affixed to his face), invariably makes him look all the more untrustworthy.

As if to re-emphasize the old hierarchies, the cad is only ever upper-class. His equivalent lower down the social scale is the spiv, also a fixture in post-war British films. The spiv emerges in the so-called 'age of austerity', the period after the election of the Attlee government in which Britain battened down the hatches, made rationing more stringent than ever, and tried to pay off its war debts. As always in times of hardship, the black market flourished. The spivs were the young mavericks who prospered on the back of the shortages, dressed in flashy American suits and winklepickers, and always seemed to have a plentiful supply of cash despite never doing a day's work. Pinkie, the teenage hoodlum played by Richard Attenborough in *Brighton Rock* (1947), was just such a type. Nicknamed 'the young Scarface' by critics of the time, he bristles with a kind of nervous energy which you never find in the staunch, reliable leading men of wartime British cinema. An adolescent anti-hero, he looks the part, dressed in dapper suit and felt hat. He is forever playing cat's cradle or fiddling with his razor. Smooth-skinned, he seems too callow to use it himself, but it is an excellent weapon. Attenborough's Pinkie is very young; he can't stand alcohol or cigarettes and seems scared by women. As if to compensate for his immaturity, he is recklessly sadistic. But however cruelly he behaves toward his credulous waitress girlfriend Rose (Carol Marsh), he retains an ingenuous quality. He is just a boy. Pinkie is the teenage rebel before the type was invented. He is the precursor of the Mods who swarm round Brighton in *Quadrophenia* (1979). Tom Riley, Dirk Bogarde's character in *The Blue Lamp* (1950), is a character in a similar mould. As critic Andy Medhurst has noted in an essay on Bogarde, he is sadistic, 'urban, contemporary and working class' (Medhurst in Barr, 1986, p. 348). The role testifies to Bogarde's own, uniquely protean qualities as an actor. Unlike his contemporaries, he was able to play everything from middle-class medical students to spivs, from Spanish gardeners to Second World War action heroes and chaps without seeming incongruous. As Riley, sneering languidly at his girlfriend while he strips his gun, he carries a sexual threat which bounders and cads like Terry-Thomas and Guy Middleton conspicuously lacked, however diligently they preened their moustaches.

Bogarde was arguably the first British star to appeal directly to the burgeoning post-war youth audience. Even in his very early films, for instance, Ian Dalrymple's *Esther Waters* (1948) and Jack Lee's *Once a Jolly Swagman* (1948), he shows a restlessness and rebelliousness

unusual in British film actors of the period. In the former, he is cast as a footman who abandons the kitchen maid (Kathleen Ryan) he makes pregnant. In the latter, he plays a diffident young factory worker who turns into a 'little flash boy' speedway rider. He was a star for a new era. As Kenneth O. Morgan notes in his study of British history from 1945 to 1990, in the Attlee years, the tension between generations became ever more pronounced. 'An official cult of sexual and cultural puritanism conflicted with the emergent consumer culture, impatience or plain boredom of young people with a drab welfarised society' (Morgan, 1990, p. 96). In both *The Blue Lamp* and *Once a Jolly Swagman*, Bogarde's selfishness is in marked contrast to the selfless heroism of the characters in most British wartime films.

When Bogarde signed his first contract with the Rank Organization in 1947 he was offered £3000 a year for a minimum of three years. By Hollywood standards, the terms were not alluring, but for an unsung British actor they seem generous enough. (Compare them, for example, with the £5 a week Bogarde's contemporary Jean Kent was paid a few years earlier when she was first put under contract.) Bogarde ended up staying with Rank, often reluctantly, for seventeen years. His discomfiture with the idea of stardom, his physique (he was slenderer and slighter than the traditional British leading men) and his epicene appearance made him the most modern of British film actors. As he himself acknowledged while talking about his 1950 film, *So Long at the Fair*, in which he appeared with Jean Simmons, he appealed to young audiences. 'The kids went to see it because Jean and I were pretty' (quoted in McFarlane, 1997, p. 69).

It is intriguing to plot the trajectory of Bogarde's career. His earliest films saw him cast as variations on the spiv. He continued to play furtive, febrile characters, for instance his murderer on the run with a little boy in tow in Charles Crichton's *Hunted* (1952), or even his Sidney Carton in *A Tale of Two Cities* (1958), but the Rank Organization seemed determined to recast him as the staunch, reliable type who so often passed for a hero in 1950s films. His discomfort at playing war officers was evident. Cast as freedom fighter Patrick Leigh-Fermor in Powell and Pressburger's adventure, *Ill Met by Moonlight* (1956), he looked distinctly ill at ease. 'He was a charmer, he was as subtle as a serpent and with a will of steel,' Powell later wrote, regretting casting him in the film. 'I wanted a flamboyant young murderer, lover, bandit – a tough, Greek-speaking

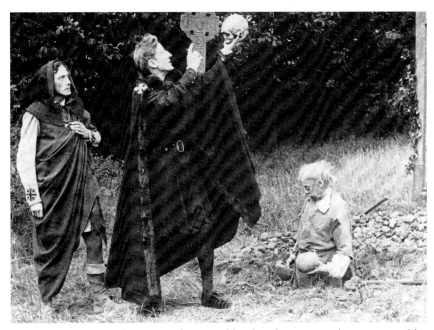

Sir Johnston Forbes-Robertson, rather too old to be playing Danish princes, scolds poor Yorick's skull in the 1913 silent version of *Hamlet*. BFI Stills, Posters and Designs.

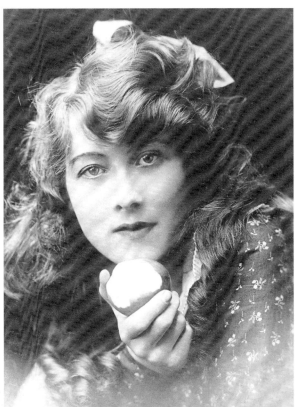

The star as wholesome English rose – Cecil Hepworth's favourite Alma Taylor munches an apple. BFI Stills, Posters and Designs. Courtesy of Carlton International Media Ltd.

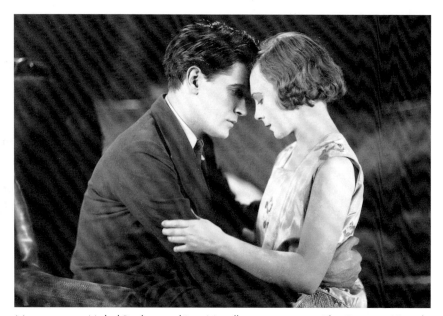

Nose to nose. Mabel Poulton and Ivor Novello get intimate in *The Constant Nymph*. BFI Stills, Posters and Designs. Courtesy of Carlton International Media Ltd.

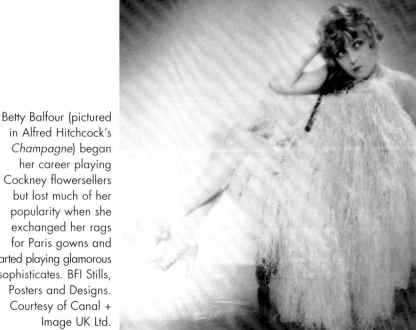

Betty Balfour (pictured in Alfred Hitchcock's *Champagne*) began her career playing Cockney flowersellers but lost much of her popularity when she exchanged her rags for Paris gowns and started playing glamorous sophisticates. BFI Stills, Posters and Designs. Courtesy of Canal + Image UK Ltd.

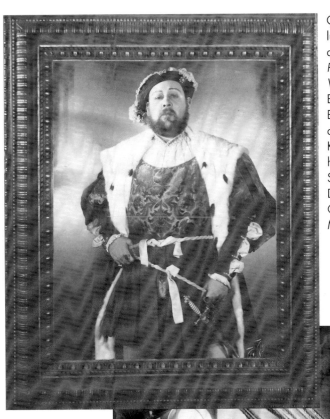

Charles Laughton's lustful braggadocio as the king in *The Private Life of Henry VIII* won him Britain's first-ever Best Actor Oscar and helped make Korda's film a smash hit in the USA. BFI Stills, Posters and Designs. Courtesy of Carlton International Media Ltd.

Jessie Matthews, the dancing divinity, caught off-guard backstage in her breakthrough film, *The Good Companions*. BFI Stills, Posters and Designs. Courtesy of Carlton International Media Ltd.

As Roddy Berwick in *Downhill*, Ivor Novello learns that he is on the verge of expulsion from his public school and won't be able to play for the old boys. BFI Stills, Posters and Designs. Courtesy of Carlton International Media Ltd.

Frank Randle as the lecherous beer-swilling scoutmaster in *Somewhere in England*. BFI Stills, Posters and Designs.

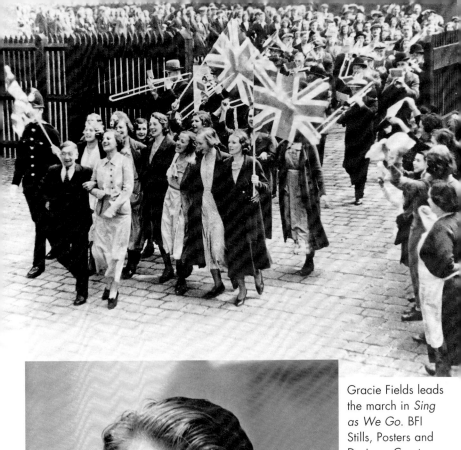

Gracie Fields leads the march in *Sing as We Go*. BFI Stills, Posters and Designs. Courtesy of Canal + Image UK Ltd.

The star as doughty, self-deprecating Everyman – John Mills in *Forever England*. BFI Stills, Posters and Designs. Courtesy of Carlton International Media Ltd.

Will Hay, Graham Moffatt and Moore Marriott stamp out crime in hilarious Gainsborough caper, *Ask a Policeman*. BFI Stills, Posters and Designs. Courtesy of Carlton International Media Ltd.

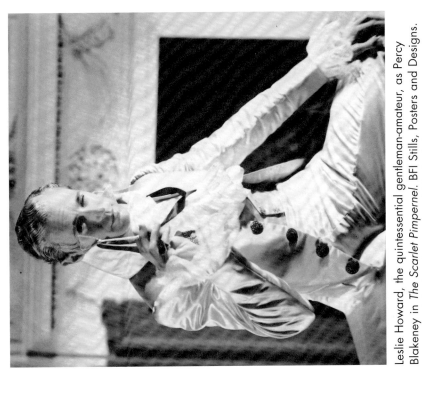

Leslie Howard, the quintessential gentleman-amateur, as Percy Blakeney in *The Scarlet Pimpernel*. BFI Stills, Posters and Designs. Courtesy of Carlton International Media Ltd.

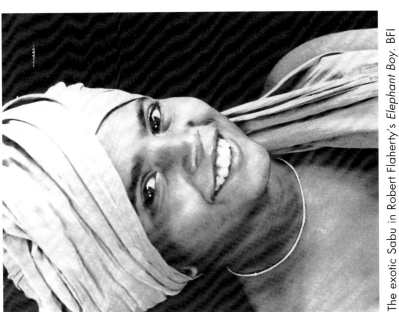

The exotic Sabu in Robert Flaherty's *Elephant Boy*. BFI Stills, Posters and Designs. Courtesy of Carlton International Media Ltd.

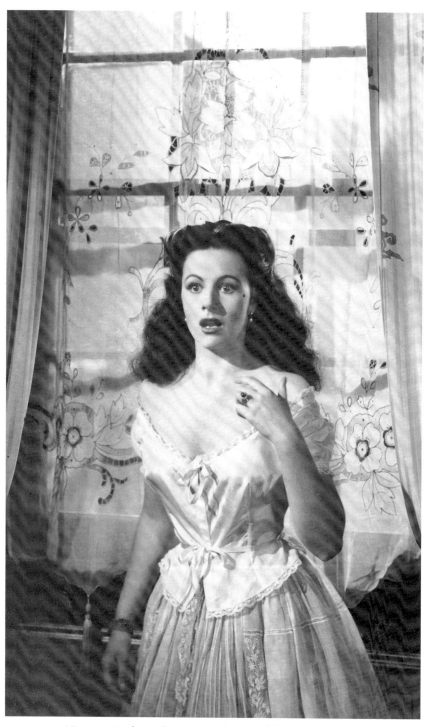

Margaret Lockwood sees a spider. A still from *Hungry Hill*.
BFI Stills, Posters and Designs. Courtesy of Carlton International Media Ltd.

leader of men, and instead I got a picture postcard hero in fancy dress' (Powell, 1992, p. 362).

Bogarde may have been the rebellious delinquent in *The Blue Lamp* (1950), but once he had become typecast as Simon Sparrow in Ralph Thomas's hugely popular comedy, *Doctor in the House* (1954), his image inevitably changed. The spiv was put in a duffle-coat and made a medical student. 'The most riotous rag ever filmed' was the catchline used by the exhibitors, but the humour in the film was as stiff and proper as the dress. This was a very conventional comedy, celebrating the jolly japes of a handful of public school types. Rugger matches, explosions in the chemistry lab, beer drinking and old battleaxe ward sisters were the prime ingredients. The sheer, cheerful inanity evidently appealed to audiences looking for escapism, but by playing Sparrow, Bogarde risked being typecast. Rank's publicity machine played up the idea that in real life, he was the same as Sparrow – a good-natured chap with no side to him. In fan magazines of the time, he is bracketed with Kenneth More, John Gregson and Jack Hawkins, actors who wore tweed jackets and flannel trousers and behaved like dashing public school teachers. Rank bosses seemingly wanted to strain the 'otherness' out of him – to transform the lithe delinquent of *The Blue Lamp* into a phlegmatic, cheerful type like Kenneth More's Douglas Bader in *Reach for the Sky* (1956). More plays Bader as a recklessly cavalier free spirit who regarded the war as the greatest game he had ever been involved in: a flying ace who refused to be discouraged from tussling with 'the Gerries', even after he had lost his legs. He spends the greater part of the war cooped up in Colditz, making the occasional fitful attempt to escape, but never losing his good-humour when he is recaptured. 'Looking back, I don't think he was all that versatile,' recalled Daniel Angel, the producer of the film. 'More was a good actor . . . but he wasn't physically a very attractive man. He couldn't play love scenes. He was more of a playboy type' (McFarlane, 1997, p. 22).

Nobody could say the same about Bogarde, but the difference between the pouting, working-class rebel in *The Blue Lamp* and the duffle-coated medical student of *Doctor in the House* was nonetheless striking.

Bogarde claims never to have enjoyed the rigmarole which went with being a star. He endured with weary stoicism what he later called 'the inanities of judging Beauty Queens, opening swimming pools in civic centres, giving bouquets to the most glamorous grannies of Hull or Gipsy

Hill' (Bogarde, 1978, p. 285). Like his lawyer in Basil Dearden's *Victim* (1961), hiding his homosexuality, he gave the impression that he had something to conceal – secretly, he wanted to be an actor, not a star. The fact that he held many of the films in which he was obliged to appear under his Rank contract in low esteem was not surprising. Predecessors like John Gielgud and Michael Redgrave had been equally scathing about British cinema. The difference with Bogarde, though, was that he distinguished between mainstream commercial cinema, which he largely despised, and what he considered the more meaningful work done by directors like Dearden, Losey and Visconti.

The experts and the boffins

The emergence of types like Bogarde's spiv in *The Blue Lamp* and Attenborough's petty gangster in *Brighton Rock* posed a challenge to authority. To put it bluntly, adults did not understand teenagers. In British sci-fi, horror and even social-problem films made after the war, it is striking how often film-makers use the 'expert' as buffer. Whether police officer, teacher, social worker or scientist, this character exists almost outside the drama, as a kind of commentator. It is as if the film-makers are not prepared to let their audiences confront a topic head-on, but need a mediating influence. In *The Blue Lamp*, just in case Bogarde's character seems too compelling and charismatic, he is counterpointed with a young, friendly police officer (Jimmy Hanley), who behaves toward his elders with a respect which Bogarde conspicuously lacks. Stanley Baker's social worker in Basil Dearden's *Violent Playground* (1958) is another example of a benevolent authority figure. The film attempts a *Blackboard Jungle*-style survey of juvenile delinquency. We see the school and housing problems of the Liverpool slums entirely through Baker's eyes. The narrative encourages us to identify with him rather than with the teenage tearaway (David McCallum) whose difficulties the film foregrounds. Although Baker falls in love with the delinquent's sister, his romance with her is secondary. His real function is as our guide – the respectable, middle-class voice of authority. (There is a certain irony in a working-class Welsh bruiser like Baker being given such a role.) Dearden uses precisely the same device in *Victim*, a film made in the wake of the Wolffenden Report on homosexuality. Dirk Bogarde's character, who is blackmailed and outed, may be a homosexual, but he is

also a lawyer – he is able to detach himself from his own personal drama and to speak with an impersonal voice of authority. Likewise, Jack Hawkins's child-therapist in Alexander Mackendrick's *Mandy* (1952). He may have a brief flirtation with the little deaf girl Mandy's mother (Phyllis Calvert) but his real function in the story is to relate facts and statistics about deafness. He, again, is the hero as expert – a commentator as much as an active protagonist.

The expert in post-war British cinema can be seen as a direct descendant of the wartime boffin. As historian Angus Calder points out in his classic books about the Home Front, *The People's War* (1992, pp. 464–8) and *The Myth of the Blitz* (1991), Britain's success against the Nazis was attributable not only to the derring-do of a handful of David Niven-like fighter pilots or the brinkmanship and oratory of Winston Churchill. It also had a lot to do with the rise of the 'boffins'. These were the scientists who threw themselves headlong into operational research, developing radar systems, assisting in factory organization, building new kinds of bombs. Ensconced in the laboratories, detached from the main events in the war, they nevertheless wielded an enormous influence. Zoologists, biologists and physicists even became national figures, explaining the most arcane mysteries on BBC radio's highly popular boffins' forum, the Brains Trust. Boffins also wheedled their way into British films, middle-class, middle-aged male voices of authority who did not so much participate in the action as commentate on it – heroes-in-absentia. These figures, grey and resolutely unglamorous, functioned as something akin to anti-stars. While the gentleman-amateurs were making their heroic gestures for king, queen and country, and the bungling fools were wreaking mischief in British comedies, the experts coldly dealt with any problems in hand.

There were certain genres in which they felt at home. Clearly, they would be uncomfortable in Gainsborough melodramas or in musicals. But in science fiction and horror films, they were an assured, natural presence.

One of the earliest boffins was Raymond Massey's character in *Things to Come* (1936), Korda's wondrous adaptation of the H. G. Wells novel. Canadian-born Massey, always a chilly, forbidding screen presence, starts the film as a civilian in 1940 Everytown, a city clearly modelled on London. It is Christmas, but rumours of another forthcoming war dampen the celebrations. While his friends are too sentimental to take

such rumours seriously, Massey realizes the gravity of the situation. Sure enough, Everytown is bombed. As the war drags on across the decades, he reappears as representative of Wings over the World, an outfit comprised of scientists and engineers who want to use their own specialist knowledge to impose peace and rebuild the world. The utopia he helps construct and which his great-grandson (also played by Massey) presides over in the Third Millennium is a faceless, antiseptic place where the human beings are little more than anonymous observers of the changes that new technology is bringing in their own lives. Much of the enduring fascination of the film lies in its ambivalence toward this technology. On the one hand, it is liberating: in the Everytown of the future war is forgotten. But it is also oppressive, a totalitarian realm in which art and imagination are spurned.

Massey's character is not quite the typical British scientist hero. There is something repellent about him in *Things to Come*, a hint that his idealism simply masks his totalitarian instincts. But his very impassivity and the way he looks out over Everytown like a wise old despot surveying his kingdom reveal him as a more familiar type than might first be imagined. He is largely reduced to speaking in sententious monologues. There is little sparkle in him. His expertise has taken over from his emotions.

Often more likeable, if equally grave, are the scientists played by Peter Cushing in a series of British post-war sci-fi and horror films. With his silver hair, lean features and sometimes distracted air, Cushing invariably looked as if he had just stepped out of the laboratory. There was an air of cultivated neutrality about him, reminiscent of old-fashioned BBC programme announcers. Whether cast in a positive light (for instance, as Dracula's nemesis, Professor van Helsing) or a negative (as Victor Frankenstein) he seldom changed his performance from role to role. A former surveyor's clerk, he was brisk, business-like, precise. (Given the huge number of films he appeared in, he needed to be.) His sober presence helped anchor even the most outlandish Hammer fantasies in the everyday – if he took werewolves, vampires and monsters seriously, so could the audience. Occasionally, Cushing was also able to hint at the nervous energy which motivates the scientists, detectives and inventors he played. His Victorian explorer back in Britain with an ancient skeleton in *The Creeping Flesh* (1972) believes that he has discovered the essence of evil, but his research drives him mad. His Frankenstein, too, is a driven,

monomaniacal character, whose devotion to his task overrides personal relationships. In *The Curse of Frankenstein* (1957), he is wild-eyed and arrogant: more Faustian anti-hero than mild-mannered scientist. In his quest for knowledge, he is prepared to disfigure corpses, betray his beloved old tutor, and even allow the maid with whom he has been having an affair to be murdered.

David Farrar's Second World War bomb-disposal expert in Powell and Pressburger's *The Small Back Room* (1949) offers an equally tormented example of the boffin-as-hero. Generally such types are distant, clinically efficient figures with hardly a hint of an emotional life, but Farrar, a limping alcoholic haunted by his own fears of professional and, it is implied, sexual inadequacy, shatters the stereotype. He is a composite figure – a rare example of the boffin as heroic failure. Powell and Pressburger expertly contrast his work environment with his shambolic domestic life. Defusing bombs is a delicate business requiring the minutest precision, but when Farrar is having drunken hallucinations about gigantic whisky bottles, you would hardly trust him with a tin-opener.

The schoolteacher

Just as British cinema has always relished its experts, it has also long had a sneaking regard for its schoolteachers. From Robert Donat's Mr Chips to Maggie Smith's Miss Jean Brody, a gallery of eccentric pedagogues has flitted across British screens, most of them extravagantly incompetent. Will Hay's blustering, crotchety nincompoop peering with myopic suspicion at his class in *Boys Will Be Boys* (1935) or evacuated with his pupils to the Isle of Skye in *The Ghost of St Michael's* (1941), sets the common-room standard. Hay as teacher is a model of distressed gentility. In his mortar-board and spectacles, he looks as sagacious as any ruffled owl. Sex is outside of Hay's orbit – none of his films provides him with any romantic interest whatsoever. Instead, he was invariably supported by an antic duo, Moore Marriott and Graham Moffatt. The former owned five sets of false teeth and specialized in playing wizened, cantankerous geriatrics, most famously his Harbottle. The latter was like the fat boy in Dickens's *Pickwick Papers*, gormless, sleepy and prodigiously lazy.

One of the great comic charms of Hay's characters lay in their unfailing ability to solve mysteries, catch jewel thieves or thwart Nazi spies – by accident. Hay's schoolteacher never consciously showed the slightest sign

of heroism or even initiative, but the ingenious plots fashioned for him by Gainsborough's stable of screenwriters enabled him to pull through triumphantly all the same. Seen brandishing his cane by the blackboard, he may sometimes resemble Mr Squeers in Dickens's *Nicholas Nickelby*, but his incompetence was never sinister. His trademark schoolteacher (and the variations he played on it as fireman, policeman or station-master) was ultimately a benevolent figure – a harassed, hopelessly inefficient but, deep down, touchingly conscientious public servant. Like Tati's valiant provincial postman in *Jour de fête* (1948), he takes his responsibilities very seriously.

A British actor who sometimes seemed like Will Hay's more serious cousin is Michael Redgrave. Although he had his share of comic roles and romantic leads, he was a virtuoso at playing solemn, preoccupied types, teachers and inventors seemingly at odds with modern life. Although he often gave the appearance that he was only appearing on the screen under sufferance and would far rather have been treading the boards of the Old Vic,[17] perhaps yelling at the winds as King Lear for Tyrone Guthrie or consorting in the dressing room with Dame Edith Evans, Redgrave had a surprisingly long and varied career as a film actor, proving himself a plausible, if extremely reluctant, leading man in his début, the Hitchcock caper, *The Lady Vanishes* (1938), displaying a stiff upper lip in a succession of war films, notably Basil Dearden's *The Captive Heart* (1946) and Michael Anderson's *The Dam Busters* (1954), and even showing a knack for comedy as Jack Worthington in *The Importance of Being Earnest* (1952).

'Earnest' Redgrave most certainly was; he generally acted briskly (as if he was in a hurry to get off screen and back to the theatre), with a bookish, schoolmasterly air, and was expert at conveying a sense of pained idealism. He was rather too intense to be classified with the 'chaps', even if he did occasionally sport a tweed jacket and smoke a pipe. With Redgrave in front of the cameras, there is always a sense of a ferocious nervous energy ready to rip through the outward reserve. Two of his most famous performances (both of which one could easily imagine done comic-style by Will Hay in a knockabout Gainsborough farce) are as the schoolteacher in *The Browning Version* (1951) and as Barnes Wallis, inventor of the bouncing bomb, in *The Dam Busters*. He plays Barnes Wallis as a nervous, stooped inventor in a mackintosh. Just as Redgrave the actor never received his dues, Barnes Wallis finds that his

schemes run aground on the rocks of Home Office and Bomber Command indifference. He is the boffin as outsider, the serious Stanislavskian caught in a world of West End farce. In the end, his perverse and unshakeable self-belief see him triumph against the odds.

Redgrave's classicist in *The Browning Version* is an equally awkward and introspective figure – a late-middle-aged public school master disappointed in his marriage and his career. His very name, Crocker-Harris, sounds forbidding and faintly ridiculous. Unable to inspire his pupils, he has turned into a cold, strict, disciplinarian. Redgrave brilliantly conveys the character's sense of self-loathing. He plays Crocker-Harris with a sort of weary, numbed fatalism – as a man thoroughly accustomed to defeat. Like the small-town everyman played by James Stewart in Frank Capra's *It's a Wonderful Life* (1946), he is on the verge of despair when a benevolent outsider intervenes. In Crocker-Harris's case, it is not an angel called Clarence masquerading as a down-and-out. It's simply one of his students, who presents him with a book of classical poetry – the 'Browning version' of the title.

Goodbye Mr Chips (1939) offers a more sympathetic vision of the beleaguered public school teacher. Its eponymous hero, played by Robert Donat, is similar to Crocker-Harris – shy and a little awkward. But whereas Crocker-Harris's plight is compounded by an unhappy marriage which sees him retreat into his shell, Mr Chips only begins to blossom as a character after he meets and marries the strong-spirited Katherine Ellis (Greer Garson). Despite her untimely death, Chips soldiers on in the classroom, teaching generation after generation of young blue-bloods.

Donat was able to play character roles and leading men with equal facility. His Mr Chips, who bumbles his way through war and bereavement, ending the film as a grey-whiskered, doddering old pedagogue, is the antithesis of the dashing Richard Hannay he played in Hitchcock's *The 39 Steps* (1935). On one level, Chips is a buffoon. His tics and grimaces aren't so very far removed from the kind of classroom clowning one expects in Will Hay comedies, but Chips is treated with affection rather than disdain. He is the schoolteacher as public school totem. Merely by enduring for so long, he helps guarantee the values Brookfield Boys' School stands for. Chips is the emblem of some woolly-minded Corinthian idealism.

Such idealism comes under intense pressure in Launder and Gilliat's *The Happiest Days of Your Life* (1950), a superbly orchestrated satirical

comedy which works both as a skit at the expense of public schools and as a comedy lampooning the hapless attempts of wartime civil servants to organize the evacuation of children to the countryside. It also pools the talents of three of British cinema's most sublimely dotty stars.

Dottiness might best be described as a polite, middle-class variation on the gormlessness patented by so many of Britain's music hall artists. It is a will-to-eccentricity, but not necessarily an admission of stupidity. You can be dotty without being asinine. It is generally the preserve of the middle-aged. (To be young and dotty seems like affectation.) Dottiness is associated with character acting rather than star performances. It implies a strained, even schizophrenic, relationship with bureaucracy. Teachers and civil servants, the people expected to administer the system, are the ones most likely to rebel against it.

Joyce Grenfell, Alastair Sim and Margaret Rutherford, who appear alongside one another in *The Happiest Days of Your Life*, each manifest a different kind of dottiness. Grenfell, the youngest of the trio, is buck-toothed, scatter-brained and endlessly enthusiastic. A former journalist-turned-revue artist, she was first spotted in British films whizzing up and down a small village on her bicycle in Anthony Asquith's bizarre wartime propaganda film, *The Demi-Paradise* (1943). This entire film exists as a sort of paean to eccentricity: its plot concerns a friendly Russian inventor (Laurence Olivier), exposed to British life at first hand, who can't help but observe the antics of the locals (Margaret Rutherford and Guy Middleton among them) with mounting, bewildered affection.

In both *Happiest Days of Your Life*, in which she plays Miss Gossage ('Just call me sausage!'), and in *The Belles of St Trinian's* (1954), also made with Launder and Gilliat, Grenfell was in charge of sports. When her lacrosse team set about opponents like wildcats, she was to be seen either standing on the touchline, waving excitedly, or running around with her whistle. (She always proved a singularly ineffective referee.)

Whereas Grenfell was absent-minded and ethereal, her occasional colleague Margaret Rutherford was a more formidable presence. As *Time* noted in a 1963 profile, she was 'the ultimate symbol of resourceful, tweedily eccentric British womanhood, of the old gals who go stamping across the heath in the wild rain, looking for stuffed shirts to poke with their umbrellas'. Rutherford invariably dressed frumpishly, in vast drape-like skirts, bonnets and big cardigans. In all her roles, whether as the professor investigating French land claims in blitz-scarred London in

Passport to Pimlico (1949) or as Miss Marple in Agatha Christie adaptations (*Murder at the Gallop*, 1963; *Murder Most Foul*, 1964), she had a clear sense of purpose. The very way she moved, head thrown back, a severe expression on her face, suggested irrevocable intent. Near the start of *The Happiest Days of Your Life*, as she marches at the front of a column of schoolgirls on the boys' public school she hopes to commandeer, she seems less like a headteacher than Hannibal confronting the Alps.

Her rival headteacher Alastair Sim, whose premises she wants to hijack, may not be as doughty, but is equally resourceful. The pleasure of the film, which was adapted from a hit stage farce by John Dighton, lies both in its depiction of the confrontation between these two titans and in their eventual, reluctant collaboration. As social historians point out, the post-war years were the era of 'Butskellism' – of consensus and unlikely alliances in British politics. The term, coined by the *Economist* in 1954, referred to the overlap in policy between the right-wing Conservative Party (whose chancellor and leading ideologue was R. A. Butler) and the socialist Labour Party, led in opposition by Hugh Gaitskell. The pact between Sim and Rutherford, inveterate opponents on every point relating to education, is equally unlikely. Both complain bitterly when they learn the Ministry has billeted their schools together, but then show enormous ingenuity in trying to convince the respective parents and governors that everything is as it should be. As two guided tours, neither aware of the other, set off in different directions, girls and boys are shunted in and out of classrooms. In the end, inevitably, Sim and Rutherford's attempt at concealment collapses. They can't keep the girls and boys apart. The film ends with the teachers, their reputations in shreds, cheerfully contemplating new careers in the distant colonies. To underline his admiration for Rutherford, Sim went on to dress up in drag and play a martinet headmistress himself in *The Belles of St Trinian's* (1954). The effect is startling – it is as if the two characters have merged into one supremely dotty being.

Both *The Happiest Days of Your Life* and the *St Trinian's* films which followed it show a kind of classroom anarchy very different from the mild schoolboy misbehaviour of the Will Hay comedies or *Goodbye Mr Chips*. They certainly don't offer a glowing testimonial for private school education. But they do hint that the old class barriers, already under pressure in the inter-war years, were loosening still further. The Boulting

Brothers' sentimental public school parable, *The Guinea Pig* (1948), in which a young lad from a poor background (Richard Attenborough) wins a scholarship to a private school, is equally critical of old-style privilege. Although Attenborough is far too old for his part (after playing the razor-wielding gangster in *Brighton Rock* the year before, his casting as a schoolboy seems almost perverse), the film is still effective in showing up the class prejudice he encounters.

The detective

The British have long relished their detective stories. A steady stream of sleuths have appeared in British novels, films and plays, whose names are all instantly familiar – Father Brown, Sherlock Holmes, Bulldog Drummond, Miss Marple, Richard Hannay, Lord Peter Wimsey. They have several trademarks in common. With the obvious exception of Marple, they tend to be male, middle-aged and middle-class. They often seem a strange amalgam between the eccentric, inquisitive teacher or inventor and the gentleman-amateur. They are played by the same actors. Both Alastair Sim and Margaret Rutherford served stints as detectives, the former as Inspector Hornleigh, the latter as Miss Marple. Even Robert Donat alternated between dashing heroes in *The 39 Steps* and *Knight without Armour* and his doddering pedagogue, Mr Chips.

For the more eccentric detectives, solving a crime is a cerebral exercise akin to a Mensa puzzle. Squalor, lust and bloodshed never much intrude in their investigations. Alec Guinness's priest in *Father Brown* (1954) is typical of the breed. Pugnacious (he likes wrestling), short-sighted and fascinated by motor cars, he undertakes to smuggle a priceless cross which once belonged to St Augustine to Rome for an important Catholic conference. He is tailed all the way by gentleman-thief Peter Finch, an erudite and ingenious criminal for whom Brown has a sneaking affection. Guinness hints that, beneath the surplice, there is something a little sinister about the detective–priest. It would not take very much to transform his Father Brown from hero to villain. Basil Rathbone, too, in the Sherlock Holmes films he shot in Hollywood, brings a bristling intensity to a role which many have played merely as a deer-stalkered oddball. Before taking on the part of Holmes, he had played a range of unsympathetic roles. The key images of him are as the glacier-cold Mr Murdstone caning his young stepson in *David Copperfield* (1933), or as

the Sheriff of Nottingham jousting on the battlements with Errol Flynn in *The Adventures of Robin Hood* (1938). (As Rathbone's case illustrates, Hollywood often liked to use suave, unflappable Englishmen as villains. Their perceived arrogance, coldness and snobbery was always compared unfavourably with the impulsive generosity and kindness of the plain-spoken all-American hero.) Rathbone's Holmes was a febrile, obsessive sort, perennially on the prowl across fog-shrouded cities and marshes. Only rarely was he to be seen in his Baker Street rooms practising the violin.

The staunch British housewife

Imagine Brecht's Mother Courage transplanted to 1939 England, given a posh accent, a house in the Home Counties, Walter Pidgeon for a husband, and a licence to shop for silly hats in Knightsbridge and you'll come close to Mrs Miniver as played by Greer Garson. This plucky wartime heroine started her fictional life in articles on the court pages of *The Times* in the late 1930s. But it took Hollywood and Hitler to turn a pampered, middle-aged matriarch into a blooming symbol of British pluck and stoicism. Garson, who won an Oscar for her efforts, is resplendent in the role. Nothing fazes her. Her clothes and hair remain remarkably unruffled, and her make-up stays intact. During one typical wartime morning, she rises at dawn, apprehends a Nazi pilot, welcomes her husband home from his sortie to Dunkirk, and then rushes to the window to see her son fly by in a Spitfire. By rights, she ought to be harassed and exhausted, but when she is caught in close-up, her eyes blaze with patriotism and her face has that miraculous lambency that only Hollywood lighting and make-up could contrive.

Mrs Miniver (1942), adapted from Jan Struther's 1939 book (itself a spin-off from Struther's articles in *The Times*), was one of the most effective propaganda films of the Second World War. Its idealized vision of the suffering but staunch middle-class housewife helped sway American public opinion round to the British cause. As Churchill said in the House of Commons, 'The film was more useful to the war effort than a flotilla of destroyers' (quoted in Beauman, 1983, p. 114). However, Mrs Miniver was much more than merely a symbol of wartime pluck. She was the most visible representative of 'a very great profession', one largely ignored by social historians. She, as Virginia Woolf put it in *Night and Day*, 'lived at home ... this curious silent unrepresented life'. Nicola

Beauman's study, *A Very Great Profession: The Woman's Novel 1914–1939*, reveals just how popular books reflecting the experience of middle-class housewives were between the wars. By her calculation, the Boots lending libraries, which catered to the reading tastes of such women, exchanged up to 30 million books a year (Beauman, 1983, p. 11). There were many, many writers exploring the vicissitudes of family life.

War foregrounded the experiences of the British housewife. As a type, she may have featured in popular fiction, but she had rarely been shown before in British films. Only when the men were away at the front and the social fabric was being stretched to breaking-point by the enemy, did she come into her own on screen. Her key virtues were cheerfulness, stoicism and commonsense. She was able to undermine flights of giddy, tub-thumping rhetoric with a single well-chosen remark. Take, for instance, the moment in *This Happy Breed* (1944) in which Celia Johnson, strolling through Hyde Park with her husband (Robert Newton) hears a Mosley-like fascist exhorting the masses at Speakers' Corner. She listens to his exclamations for a moment but then turns away. 'Let's go and have a cup of tea', is all she needs to say. That simple throwaway remark expresses defiance, uninterest and contempt in equal measure. The staunch housewife is stereotyped as a kind-hearted but sharp-tongued matriarch. Only seldom does anyone stop to ask what her endurance costs her. When they do, they find out she is not quite as self-reliant as she may first seem. Nor is she necessarily content.

David Lean's 1945 film, *Brief Encounter*, hints, however fleetingly, at how such a housewife may have to suffer. Johnson is cast as Laura Jesson, a young mother, seemingly content with her family and marriage. This is how she is described by Noël Coward in the stage directions for the play *Still Life*, from which the film is drawn:

> She is an attractive woman in the thirties. Her clothes are not particularly smart but obviously chosen with taste. She looks exactly what she is, a pleasant ordinary woman, rather pale, for she is not strong, and with the definite charm of personality, which comes from natural kindliness, humour and reasonable conscience.

As played by Cyril Raymond, her husband is a bluff, dependable sort. His favourite hobby is putting his feet up by the fire and doing a crossword.

Johnson, a slight, bird-like actress, conveys brilliantly the guilt and indecision the character feels when she becomes attracted to another man (Trevor Howard). As director David Lean acknowledged, the film broke all the usual rules about popular romances. 'There were no big star names. There was an unhappy ending to the main love story. The film was played in unglamorous surroundings. And the three leading characters were approaching middle-age' (Manvell, 1947, p. 27).

Howard plays a doctor shortly to head off for a new assignment in South Africa. He too seems embarrassed by their mutual attraction. The couple are caught in a sticky arabesque – confused by their feelings for one another and their respect for social propriety. Not even the pounding Rachmaninov score can resolve the crisis. An exercise in tantalization, *Brief Encounter* also spells out explicitly how limited are the choices that the heroine is given.

Johnson is inspired casting. Laura Jesson was her third attempt at a different kind of English archetype in a Coward-scripted film. The year before, she had played the working-class matriarch in *This Happy Breed* (1944). Before that, she was the upper-class wife of the naval commander (Noël Coward) in *In Which We Serve* (1942). In *Brief Encounter*, she has a febrile, restless quality a long way removed from her stoicism in the earlier films. Through her voice-over, her darting movements and her mournful, expressive eyes, she is able to express her character's imprisonment. The fact that Laura looks forward to her weekly shopping trip so intently suggests how frustrating she really finds her existence. She reads romances for excitement. (She is spotted with a book by Kate O'Brien, a writer specializing in tales of middle-class religious guilt, in her shopping basket.) At times, thanks to Lean's directorial flourishes and the sheer intensity of Johnson's performance, it is as if she has managed to transform her mundane family background into a setting for expressionist melodrama. The moment that Howard removes the speck from her eye is the catalyst. He is the handsome stranger she seems to have been willing into her life.

Johnson was the antithesis to the typical Hollywood star. She was self-effacing and loathed publicity. As she put it, 'I was far from a raving beauty. I was very plain and very innocent and unsophisticated. I simply thought it would be nice to act.'[18] Her private life mirrored that of Laura Jesson. Married to the author and traveller Peter Fleming, she lived in reclusive middle-class tranquillity. Rather than capitalize on *Brief*

Encounter, she went back to family life, tended the garden, looked after the children, and did not make another film for four years. 'Mrs Fleming's values are not falsified by stardom or the artificial temptations of stage and screen,' wrote the British critic Roger Manvell. 'Her experience as a woman informs her skill as an artist.'[19] While the rest of her contemporaries were loaned out from studio to studio, obliged by their contracts to work when and where required,[20] Johnson only ever took parts that she liked. She is one of the best-known actresses in British film history largely on the back of a single movie. If she was a film star (a description she would never have used of herself), it was by accident, not design. It is easy to ridicule her Laura Jesson as a repressed neurotic whose senses have been dulled by the repetitive rigmarole of bourgeois life. Even Dilys Powell attributed her success in *Brief Encounter* to the way she exposed British attitudes towards class. 'What is interesting,' wrote Powell, 'is the shading of her performance: you can't help but feeling that it is not so much the immorality of sexual infidelity that holds her back as the basic social humiliation of the circumstances. Her playing is of rare subtlety: basically it is a comment on class.'[21] But Powell's reading of *Brief Encounter* seems reductive. The film is far more than simply an allegory about the plight of suburban woman. Johnson's Laura is as much tragic heroine as bored housewife.

The sense of the housewife as beholden to social convention is reinforced by Alexander Mackendrick's *Mandy* (1952). In this case, when the wife (Phyllis Calvert) splits with her husband (Terence Morgan) after a bitter row about how best to treat their deaf daughter Mandy, she is forced to live a marginal existence in a tiny flat with next to no money. Everything is stacked against her. Even her friendship with the unorthodox therapist (Jack Hawkins) at whose school Mandy is being taught is treated like some adulterous affair. The film ends with Calvert returning to her husband despite his bullying and chauvinism. He may have made some small conciliatory gestures toward her, but this is still a capitulation. Pam Cook suggests that the film is contradictory; in 'negotiating sets of competing and conflicting ideologies it produces a vision of Britain which is at once forward-looking and backward-looking – looking forward, that is, to a new egalitarian society in which boundaries of class and sex are broken down, and looking backward to traditional structures in order to preserve them' (Cook in Barr, 1986, p. 358). The film was made at a pivotal moment in both British cinema and British social

history: 1951–2 were the years which saw the transition from Attlee's Labour government to the new, consumer-oriented world of the Tories. They were also the years which witnessed a loss of faith and spirit at Ealing Studios, whose output in the immediate post-war years had been buoyed up by the high spirits and optimism which characterized the early Attlee era. After *Mandy*, which was made by Ealing's most maverick director, Alexander Mackendrick, the spark went out of the studio's films.

It is intriguing to see Calvert, an actress best-known for her work in the Gainsborough costume melodramas of the 1940s, playing a contemporary heroine. She is a tougher and more resilient character than Celia Johnson's Laura, but ultimately, she too conforms, putting marriage and propriety above the interests of her little daughter.

The good-time girl

> English girls' temperament ought to be given more free rein. I think English girls have some temperament but they aren't encouraged to show it ... English boys and girls all have this ridiculous desire to be 'ladies' and 'gentlemen' and suppress their temperament. (Jean Kent, quoted in *Leader*, June 1946)

It is somehow fitting that Jean Kent, nicknamed 'Britain's bad girl' after her flamboyant performance in *Fanny by Gaslight* (1944), should go on to appear as a reform school runaway in her own star vehicle, *Good Time Girl* (1948). Her character in that film was the female equivalent of the spiv – that is to say, young, rebellious, and sexually and socially disruptive. She would always fight her corner. Witness, for instance, her bruising tussle with fellow prison-camp inmate Betty Jardine in Launder and Gilliat's *2000 Women* (1944), the most violent catfight since Marlene Dietrich's saloon brawl with Una Merkel in *Destry Rides Again* (1939).

Right from the early days, when Hepworth was grooming his Home Counties ingénues (Alma Taylor and Chrissie White) for stardom, British cinema had frowned on its good-time girls. The biggest female star of the 1920s, Betty Balfour, was the antithesis of such Hollywood vamps as Theda Bara, Gloria Swanson or Joan Crawford. Neither Jessie Matthews nor Gracie Fields could be described as a 'good-time girl'. Even Britain's

very own wicked lady, Margaret Lockwood, hardly fits the category. A combination of pious, Home Counties moralism and snobbery made life very difficult for the 'good-time girls'. Kent, however, bucked the trend. A stage star as a child and former chorus girl, she made her screen début in the mid-1940s and immediately struck a chord with audiences tired of prim, well-behaved heroines. In roles ranging from her South London siren in *Waterloo Road* (1944) to her headstrong gypsy in *Caravan* (1946), she established herself as a fiery, volatile presence – as close as any British star has come to matching Hollywood's smouldering Mexican spitfire, Lupe Velez. A former chorus girl, Kent had a spontaneity and vitality very different from the sometimes glacial reserve of actresses like Phyllis Calvert, Anna Neagle or Ann Todd. She was an unabashed populist who set out to please audiences, not critics or the so-called studio intelligentsia. 'I have no time for highbrow pictures which don't mean a thing to the people who go to see them,' she told *Picturegoer* in 1947. 'The fans form a mirror for a star's work if she chooses to study the reflection. They never make a mistake such as people in the trade make, and that is why I think they deserve more attention from producers than they receive.'[22] Nor did Kent mind about being typecast. 'Bad girls are usually much more interesting and give an actress great opportunities' (Stannage, 1947, p. 69), she suggested to a journalist who came to visit her on the set of *Good Time Girl*, a film in which she consorts with, variously, a lecherous Cypriot waiter (Peter Glenville), a spiv (Griffith Jones), a dance band pianist (Dennis Price) and a couple of American army deserters (Bonar Colleano Jnr and Hugh McDermott).

In the post-war years, gangster films in particular had begun to fluster British critics. 'Hardly had Hollywood decided to put the gangster into cold storage for a spell,' lamented *Picturegoer*, 'than British producers are sweating tears and blood – and pouring out thousands of pounds – to finish films about spivs and molls and all the rest of the underworld.' Key films in the British mini-cycle of the late 1940s were the James Hadley-Chase adaptation, *No Orchids for Miss Blandish* (1948), which was pronounced by the *Monthly Film Bulletin* to be 'the most sickening exhibition of brutality, perversion, sex and sadism ever to be shown on a cinema screen . . . all the women are sluts and most of the men are vicious murderers', the Boulting Brothers' *Brighton Rock* (1947), 'false, cheap, nasty sensationalism' in the *Daily Mirror*'s view, and *Good Time Girl* with Kent's delinquent cast opposite Herbert Lom's would-be Cagney

('So it was you – you little rat!'). The featured actresses in these films were not established stars like Calvert or Lockwood, but newcomers (Carol Marsh in *Brighton Rock*), juvenile leads (Kent) or obscure starlets (Lily Molnar and Zoe Grail in *Miss Blandish*). Unlike their wicked lady counterparts, they often spoke with regional, or, in Miss Blandish's case, fake American accents. In the hierarchical world of the British film industry, they were considered *infra dig.* – real British stars were supposed to be well-groomed, with clear-cut Home Counties diction. 'Very few regional accents cropped up,' recalls Olive Dodds, who was Director of Artists at the Rank Organization at the time.[23]

Critics were wont to dismiss the gangster films as tawdry, trivial and – worst of all – *ersatz* Warner Bros. Their attitude was shared by some of the film-makers themselves. In *The Blue Lamp*, made at Ealing, the murderous young spiv (Dirk Bogarde) and his girlfriend (Peggy Evans) are treated as anti-social and immature – not as glamorous, doomed lovers, like the protagonists in *They Live by Night* (1949), Nicholas Ray's début feature made in Hollywood the year before. Even the British criminal underworld rejects Bogarde after he commits the heinous crime of killing a policeman – in the film's memorable dénouement, police and underworld combine to flush him out at the greyhound races.

Stories about good-time girls invariably turn into cautionary tales. Whether they consort with gangsters or with louche, upper-class types, the effect is always the same. Despite changes in British society after the war (and in particular the loosening of the class system) the good-time girl's social ambition and careerism were regarded in a negative light. British film-makers of the period were markedly reluctant to endorse youthful rebelliousness in any form, and least of all when the rebels in question were young women. However, no producer was ever blind to the potential box-office attraction of a little judicious sex and violence. Even when films like *Good Time Girl* and *Root of All Evil* (1946) struck lofty moral positions, they still liked to indulge their audiences. As Pam Cook points out, in spite of everything

> the underworld sequences in *Good Time Girl* are exotic and glamorous: the drabness of institutional life is set against the stylishness of the world to which Gwen is attracted. The 'moral' of the story is clear (excessive consumerism is wrong), but the fantasy of unbridled consumption and 'good times' is activated to appeal

to audiences (particularly women) tired of wartime austerity and looking forward to greater economic freedom.[24]

As much as anything else, 'good times' films enabled producers to display their stars in a more favourable light than realistic social-dramas: to show off make-up, costumes and lighting.

'She wasn't quite the wide-eyed little pest she was made out to be in the film,' Kent later observed of her character in Good Time Girl (McFarlane, 1997, p. 340). The film-makers deliberately made her more unsympathetic than she is in the novel from which the script was adapted. The idea of a young, good-looking girl out to grab what she could in the way of pleasure and wealth was considered near-heresy. Teen culture was yet to be established. In her 1940s manifestation, the 'good-time' girl, epitomized by Kent, was linked to ideologies of consumption and sexual display, and was therefore considered deeply subversive.

Even into the 1950s, the suspicion about good-time girls remained. In 1956, when Ruth Ellis was executed for the shooting of her lover, David Blakely, there was a clear sense that she was being killed not simply for her crime, but because of what she represented. She had transgressed social boundaries by having an affair with a man from a different class. Moreover, she had platinum-blond hair.

Raymond Chandler, in London at the time of the Ellis execution, dashed off a famous letter to the Evening Standard. 'I have been tormented,' he wrote, 'at the idea that a highly civilized people should put a rope round the neck of Ruth Ellis and drop her through a trap and break her neck. No other country in the world would hang this woman.'

One of the ironies of Good Time Girl comes as a result of the flashback structure. The story of Jean Kent's wicked ways is recounted to an equally impressionable youngster by stern old court official Flora Robson. Having listened to Robson, the youngster decides not to emulate Kent but to return home instead. However, the youngster in question is Diana Dors, soon to turn into British cinema's most important sex symbol and not the type to be put off a good time by a few pious homilies.

It was hardly a coincidence that Dors was cast to play Ellis in J. Lee-Thompson's 1956 film, Yield to the Night. Nevertheless, Dors's stardom – the fact that she became a national sex symbol, landed a contract with RKO, and had her private life scrutinized in a more exhaustive way than any other British screen actress before her – points to a subtle change in

attitudes. In the 1950s, the good-time girl, although still frowned upon, became slightly more sympathetic. Kent, who had started in movies only a few years before Dors, was given nothing like the same amount of licence. Her career testifies to the suspicion, sometimes even hostility, with which British film-makers treated their 'good-time' girls. Signed up by Gaumont-British on a standard seven-year contract in the early 1940s, she was paid only £5 a day while working. Her contract guaranteed her 52 days' work a year and so her real earnings were £5 a week, a minuscule amount by Hollywood standards (McFarlane, 1997, p. 340). Rather than build her up as a new star, the studio loaned her out. She generally played character parts rather than leads. By the mid-1950s, her career was already in decline. She wanted to play the seductive older woman in *Room at the Top* (1959), but even on the cusp of the 1960s, British casting agents were reluctant to give such a part to a home-grown actress. They chose French actress Simone Signoret instead. As Kent ruefully put it, 'it was this old English thing that only foreigners have sex appeal. They'd forgotten me by that time, you see, they'd forgotten that I was supposed to be the sexy girl in the movies' (McFarlane, 1997, p. 342).

Dors had been dubbed 'a 17-year-old Mae West' at the start of her career by Gainsborough boss Sydney Box. In later years, her peroxide hair and startling figure led to the inevitable comparisons with Monroe and Mansfield, but there was always a large measure of self-parody about her star image. She may have looked as glamorous as any Hollywood siren, but much of her popularity with British fans rested on the fact that they knew she was Diana Fluck from Swindon, friendly, funny and down-to-earth. Her film career began at the Rank Charm School (see below), where opening village fêtes was as important as acting. In her early films, she was invariably cast in working-class roles despite her middle-class background. Even in her best work, notably in *Yield to the Night*, she couldn't escape her own star persona. As one critic put it, 'She can't help being Dors.' Her most celebrated moments were off screen: in 1955, in a contrived but still ingenious Rank publicity stunt, she appeared at the Venice Film Festival wearing a mink bikini. A year later, her petty hoodlum husband of the time, Dennis Hamilton, made the news by pushing an American photographer into a swimming pool. ('Go Home Diana Dors And Take Mr Dors With You,' trumpeted the *New York Enquirer* after the incident, describing the couple as 'two imports America could do without'.[25]) While Dors was in Hollywood, Marilyn Monroe

was at Pinewood filming *The Prince and the Showgirl* (1957). The British newspapers billed it as a 'battle of the blondes', but even they acknowledged Monroe as the winner.

The chameleons

Glamour was not something much associated with British cinema's two great chameleons, Laurence Olivier and Alec Guinness, stars who reinvented themselves again and again. Both combined stage and screen careers, but whereas the former was usually, at least in the early part of his career, the dashing lead (Heathcliff in *Wuthering Heights*, 1939; Darcy in *Pride and Prejudice*, 1940; the handsome lawyer in *The Divorce of Lady X*, 1938), the latter was the scene-stealing supporting player. Sporting a beard and tatters as Fagin in *Oliver Twist* (1948) one minute, and clean-shaven, bright and cheery as Herbert Pocket in *Great Expectations* (1946) the next, he changed appearance from film to film.

Guinness may be cherished as Britain's best-loved character actor, but he offers something stranger and more sinister than simply the mild dottiness of Alastair Sim and Margaret Rutherford. Beneath his inscrutable, palimpsest of a face, there is often a sense of seething inner turmoil. In his first important role, as Pocket in *Great Expectations*, it is nervous energy which seems to propel him. He takes a seemingly bland character and gives him an edge. Whether as bearded, long-fingered Fagin or as the thief with the sinister set of dentures in *The Ladykillers* (1955), he is the kind of pantomime villain figure to haunt a child's nightmare. When his features had not disappeared beneath the make-up, he often played moody obsessives: the priggish army officer of *The Bridge on the River Kwai* (1957), the shabby spy George Smiley in the TV production of *Smiley's People* (1982), Sidney the inventor in *The Man in the White Suit* (1951). Guinness's shifty, understated performances have the knack of conveying both innocence and venality. As Father Brown, he wears a look of vague, beatific naïveté which could have been borrowed directly from Stan Laurel but, at the same time, manages to hint at a much darker personality hidden beneath the surplice.

Make-up, costume and exaggerated movement were important to Olivier too. In *Richard III* (1955), for example, Olivier's hunchback king is first spotted standing by the throne. He scuttles forward like a gigantic beetle until his face is framed in huge close-up and then launches into his

famous rendering of 'Now is the winter of our discontent made glorious summer'.

Olivier based his make-up for the character – lank, black hair, protuberant nose – on a certain American theatre director called Jed Harris. 'The most loathsome man I'd ever met … he was apparently equally loathed by the man who created the big, bad wolf for Walt Disney.'

The Disney comparison is entirely apt. The long, lycanthropic snout concentrates attention on the eyes, which are fixed in a permanent scowl – this Richard looks throughout as if he is all set to gobble up Little Red Riding Hood.

'I know it is not the fashion to wear make-up,' Olivier wrote in his book on acting, 'but for me that's where a lot of the magic still lies.' One can see as much in Salvador Dali's painting of him as Richard III. The villainous king is shown in profile, with Olivier's half-shrouded face seeming to merge into it. 'I think of the true actor as a skeleton,' Olivier once remarked. 'Bone, just bone, on which he places and moulds the flesh.'

While he still makes much of Richard's misshapen body and the nimble, ungainly way he moves, Olivier toned down the sweeping gestures he used when playing Richard on stage. His voice, sneering, high-pitched, adds to the pantomime quality he brings to the villain. There is even a hint of music hall about his playing, a sense that he is using the soliloquies in the way Max Miller (or indeed Archie Rice in *The Entertainer*) might use patter to draw in an audience.

Unlike Guinness, who made a fleeting appearance in a Gaumont-British melodrama, *Evensong*, in 1934 but then did not start his film career in earnest until after the war, Olivier combined stage and screen work from as early as 1930 onward. He made his début in 1931, in *Too Many Crooks*. He played opposite Gloria Swanson in her only British film, *Perfect Understanding*, a strained comedy about a couple who resolve never to disagree with one another, in 1932. Then he headed to Hollywood, where he was famously spurned by Greta Garbo – she wanted John Gilbert instead of him as her leading man in *Queen Christina* (1933). Back in Britain, Korda put him under contract in 1934 (Kulik, 1990, p. 145) and tried to build him up as a star. 'He gave me opportunities which I took only disdainfully because I still despised the medium,' Olivier later admitted.[26] His impatience with his roles is often apparent. In *The Divorce of Lady X*, for instance, he plays the lawyer

opposite Merle Oberon's society woman with precisely the same scowling disdain that James Mason brought a few years later to his aristocratic sadists in Gainsborough melodramas.

Olivier and Guinness are two of the most influential but mercurial British screen actors. They slip away from easy categorization. To describe Olivier as a star seems a gross understatement, even if he was briefly groomed by both Korda and Hollywood as a matinée idol. The latter, too, resists such pigeon-holing. Like all great character actors, he was never constrained by his own star persona but was able continually to reinvent himself. Both blurred the line between the stock type (they were often cast in conventional enough roles) and the exotic other.

Notes

1. *The Newark Star Ledger*, cutting taken from the BFI microfiche collection on Ronald Colman.
2. BFI microfiche.
3. *Ibid.*, BFI.
4. *Ibid.*
5. *Ibid.*
6. 20 March 1923.
7. The information about Brook's sleeping arrangements comes from the author's interview with producer Betty Box in March 1995. Box knew Brook in the 1940s.
8. *Motion Picture Studio*, 17 November 1923.
9. *The Impartial Film Report*, 13 November 1933.
10. C. Brook, 'The Eighty-four Ages' (unpublished autobiography), p. 146.
11. BFI microfiche on Herbert Marshall.
12. *Ibid.*
13. *Picturegoer*, 11 February 1933.
14. *Ibid.*
15. *Sight and Sound*, March 1994, p. 61.
16. *Ibid.*
17. Redgrave talks about his preference for theatre over film both in fan magazines (see *Picturegoer*, 16 March 1946) and in his autobiography, *In My Mind's Eye* (Weidenfeld and Nicolson, London, 1983).
18. Celia Johnson, BFI microfiche.
19. Roger Manvell, *Celia Johnson* (pamphlet issued by British Council Overseas Press Department, 11 July 1946).
20. *Ibid.*
21. 'Who was Celia? What was she?' Dilys Powell, *Independent*, 13 October 1991.
22. *Picturegoer*, 20 December 1947.
23. Olive Dodds, in interview with the author, 1995.
24. Pam Cook, *Monthly Film Bulletin*, September 1985.
25. BFI microfiche on Diana Dors.
26. BFI microfiche on Laurence Olivier.

Exotic Outsiders

As a litmus against which to test its stock types, British cinema has frequently looked abroad. Exotic outsiders are used to jar the social, political and sexual equilibrium. On a more prosaic, economic level, the outsiders are good box-office: international stars often had a profile beyond anything their British counterparts could match. If they were expensive to hire, at least there was the hope their name above the title would spark interest at the box-office and guarantee foreign distribution.

It is strangely apt that the first commercial British talkie, Alfred Hitchcock's *Blackmail* (1928), starred a Polish-born actress who spoke heavily accented English. Anny Ondra plays the young English woman who kills a man after he tries to rape her. But the voice in the film does not belong to her. Ondra mimed the words while the British actress Joan Barry recorded them into the microphone. Her exoticism matches that of Hitchcock's film-making style. *Blackmail* not only stars a continental actress, it is also full of expressionistic flourishes that could have been borrowed wholesale from German cinema of the time. When Ondra stumbles down Whitehall at dawn, every time she notices a drunkard's outstretched hand or even a policeman directing the traffic, Hitchcock reminds us of the man she has just stabbed to death. In one scene, a neon sign of a cocktail-shaker turns into a knife as Ondra stares up at it, guilty and distraught.

Ondra was just one of many foreign stars working in the British industry in the late silent era. The obsession with exotic, foreign talent continued right through into the talkie era. The most sinister villains and alluring *femmes fatales* were invariably continental. When Hitchcock wanted a political fanatic for *The Man Who Knew Too Much* (1934), he

turned to a German, Peter Lorre, the child-murderer in Fritz Lang's *M* (1931), an actor who was softly-spoken, polite, but who brought a sinister, indefinable quality to his role as the child kidnapper simply because he was 'foreign'. When he wanted a terrorist for *Sabotage* (1936), he hired heavy-jowled, Austrian-born Oscar Homolka for the same reason. Hitchcock's motives were different from those of, say, Michael Balcon when he offered £1000 a week (then considered an astronomical figure) to secure the services of Hollywood actress Betty Compson for his film, *Woman to Woman*. Balcon was paying for a kind of glamour which only Hollywood could provide.

Hollywood was equally intrigued by the glamour of foreign stars. Whether Austrian (Hedy Lamarr), Swedish (Greta Garbo) or Mexican (Lupe Velez), imported talent lent a whiff of exoticism to American-made films. By buying up foreign talent, Hollywood weakened its rivals and extended its hegemony over world cinema. Britain's ambitions in importing international stars were more modest. In Rachael Low's words, they were trying 'to secure distribution abroad and to give their films an international appeal' (Low, 1971, p. 267). Many leading European and Hollywood stars were lured to the UK. In the 1920s alone, Tallulah Bankhead, Lionel Barrymore and Anna May Wong all appeared in British films. In the 1930s, the British industry benefited as many Europeans fled Nazism. The list of stars who appeared in British films in the 1930s encompasses everybody from Elizabeth Bergner, who fled to England in 1933, to Conrad Veidt, Peter Lorre, Oskar Homolka, Fritz Kortner and Anton Walbrook (see below).

This influx of talent created a certain anxiety. Whereas foreign stars in Hollywood complemented the roster of big American names that every studio had at its disposal, in Britain they highlighted the lack of local talent. In the 1920s the visiting stars were often disdainful about the films they appeared in – even if, as Rachael Low rather tartly puts it, 'as many of them were somewhat past their peak, they were in no position to be particular' (Low, 1971, p. 267). The fact that they continued to appear in such numbers in British productions only exacerbated an already unhealthy inferiority complex. 'Britain,' according to Low, 'appeared to have moved into the world of the stars, but this appearance was an illusion as long as it was necessary for the stardom to be created elsewhere.'

If there was one novel which encapsulated the appeal of the exotic

outsider, it was E. M. Hull's *The Sheik*, published in 1921 and filmed in Hollywood in the same year with Rudolf Valentino in the title role. The story of an English heiress kidnapped by an Arab prince, it titillated its readers both in the way it dealt with miscegenation and in its sado-masochism. In this case, the masterful, sadistic Sheik could satisfy parts which his much politer English gentleman counterparts could not even reach. The Sheik treats his aristocratic English chattel in a mercilessly cruel fashion, but that does not stop her falling in love with him. Her old English boyfriends had not had the power to touch her. But this 'fierce desert man', this 'lawless savage', as he is described, is much more to her liking.

> He was a brute, but she loved him, loved him for his very brutality, and superb animal strength. And he was an Arab! A man of different race and colour; a native; Aubrey [her brother] would indiscriminately class him as a 'damn nigger.' She did not care. A year ago, a few weeks ago even, she would have shuddered with repulsion at the bare idea, the thought that a native could even touch her had been revolting, but all that was swept away and was as nothing in the face of the love that filled her so completely ... she was deliriously, insanely happy. (Hull, in Cockburn, 1975, p. 141)

The Sheik provided a template for British cinema's exotic outsiders: the Latin lovers, the alluring but sinister eastern Europeans, even the French (if Novello's performance as Pierre Boucheron in *The Rat* is a representative example) followed in the example of Hull's sadistic Arab prince hero.

As Powell and Pressburger discovered, casting non-British actors in key roles was a sure way of showing up the idiosyncratic way in which the supposedly level-headed British characters behaved when confronted with somebody from outside their normal social orbit. Powell and Pressburger's first foreign recruit was the German Conrad Veidt, who was put under contract by Alexander Korda in the late 1930s. Something of an alchemist, Korda had a knack for combining unlikely stars and directors. He was responsible for bringing Pressburger (himself an emigré and exotic outsider of sorts) together with Powell and for the casting of Veidt in the key role of the U-boat commander in *The Spy in Black* (1939). Veidt specialized in playing villains (none more creepy than his

arrogant Nazi officer shot by Humphrey Bogart at the end of *Casablanca*, 1941). A distinguished stage actor with Max Reinhardt and former silent star in Germany, he arrived in Britain in the late 1930s trailing memories of his famous earlier roles – he had a past and it shone through. As Michael Powell put it: 'He was the great German cinema ... he was invention, control, imagination, irony and elegance. He was the master technician of the camera, who knew where every light was placed. Only in the English language did he lose his magnificent authority, walking like a tongue-tied Samson among the Philistines' (Powell, 1987, p. 305).

Veidt possessed a saturnine quality which few British screen actors could emulate. As he put it in an interview with the *Sunday Dispatch*:

> There is a strange power which comes into me, magically, it seems, and transmutes not only my inner but my physical being when I am called upon to express myself on the stage or before the camera. It is difficult to speak of this. Yet it is the most authentic thing I have experienced. It is precisely as though I were possessed by some other spirit when I enter on a new task of acting, as though something within me presses a switch and my own consciousness merges into some other, greater, more vital being.[1]

He had starred as Cesare, the automaton-like sex murderer in Robert Wiene's expressionistic masterpiece, *The Cabinet of Dr Caligari* (1919) as well as playing a gallery of other melancholic villains in German silent films. But Veidt generally brought pathos and nobility to his characters. With the exception of his vicious Nazi in *Casablanca*, his characters were rarely as bad as they first seemed, 'and I play them with pleasure because I can show a trace of humanity which lies hidden in the most wicked people'.[2]

Criticized in certain military quarters for its sympathetic portrayal of the Germans, *The Spy in Black* offers Veidt a role tailormade for him. He is Captain Hardt, a German U-boat commander who comes ashore on a remote Scottish island for a rendezvous with a teacher/spy (Valerie Hobson). Powell and Pressburger even provide him with moments which rekindle memories of his old UFA roles – there is something ineffably eerie and phantom-like about the scenes in which he drives across the island by night on his motorbike, his long black leather coat billowing behind him in the wind.

Hardt is a consummate professional with an unswerving dedication to

duty, but he is not the stereotypical *ubermensch*. He has a forlorn, even fatalistic quality. He is the kind of captain who knows he will have to go down with his ship. More ruthless than Powell and Pressburger's Colonel Blimp, he nevertheless shows a similar, old-world gallantry. He was an exceptionally handsome man, 'the best-looking man that you could imagine', as Valerie Hobson, his co-star in *The Spy in Black*, observed (Macdonald, 1994, p. 151). He may have played villains but, even as he grew older, there was still a hint of the matinée idol about him. Like Novello and Valentino, he also had an unsettling androgynous quality. 'Veidt's darkly exotic image attracted more than its fair share of gossip,' Kevin Macdonald observes in his biography of Pressburger. 'Rumours of cocaine sniffing, homosexuality and transvestism abounded. In Weimar Berlin it was commonly said that the most beautiful girl in the street was Connie Veidt out for a walk' (Macdonald, 1994, p. 151).

Again and again after using Veidt, Powell and Pressburger turned to non-British stars in their subsequent films. In *The Red Shoes* (1948), Anton Walbrook's Diaghilev-like entrepreneur Lermontov shows a dedication to the arts which the dilettante British could not match. Supremely sophisticated and elegant, and with a genius for coaxing the best out of his ballet stars, Lermontov stands as an idealized version of the monomaniacal film director himself. 'Why do you dance?' he asks the young ballerina Vicky Page (Moira Shearer). 'Why do you live?' she replies. It is the only answer he would have accepted.

Born Adolph Anton Wilhelm Wohlbruck in Vienna, the son of a professional clown, Walbrook was one of the many German, Austrian and East European actors who migrated to Britain in 1937 to escape the Nazis. He first starred in Novello's old role as Pierre Boucheron, the romantic Parisian vagabond, in the talkie version of *The Rat* (1937), but this was uncharacteristic casting. Walbrook's subsequent characters were elegant, aristocratic types. Whereas many British actors looked like stuffed mannequins in their dinner jackets and tail-coats, he was always at ease, whatever the uniform. As the German officer in *The Life and Death of Colonel Blimp* (1943) or as Lermontov, he maintains his unflappable dignity whether fighting duels or incarcerated in a British prisoner-of-war camp. His role as Mallen, the sadistic, sneering husband who tries to drive his wife (Diana Wynyard) insane in Thorold Dickinson's *Gaslight* (1940), is a typical example of the continental stars being used to generate extra menace in a role which, by rights, should have gone

to a British star. In Patrick Hamilton's original play, from which the film is adapted, the husband was a middle-class, Victorian patriarch called Manningham.

Late in his career, Powell continued to put his faith in continental talent as his casting of an unknown Austrian, Carl Boehm, as the voyeuristic killer in *Peeping Tom* (1960) demonstrated. The son of an eminent conductor, Boehm was scarcely a well-known screen actor in Britain. But he was an eerie, disconcerting presence in a role which at once seemed like a caricature of the stereotypically shy, repressed Englishman (Boehm even wears a duffle-coat) and harked back to the polite but sinister character Peter Lorre had played for Hitchcock in *The Man Who Knew Too Much* or indeed Anton Walbrook's sinister presence in the darkest recesses of the house in *Gaslight*.

Peeping Tom is set in the London film world of the late 1950s. Boehm's character, Mark Lewis, works as a camera assistant and photographer by day, and murders women by night, always trying to catch the moment of their death on film. 'The sickest, filthiest film I remember seeing,' as one of its more generous critics described it, *Peeping Tom* works both as Grand Guignol horror and as a strangely sentimental love letter to cinema itself. In the course of the film, Powell traces the entire history of the medium – using still photographs, silent black-and-white footage, 16mm footage and colour 35mm. He also satirizes film-makers such as himself. There is one memorable sequence in which an arrogant, bullying director tears his hair out in despair at the inability of an actress to perform a simple scene. The film is set in a very specific English milieu. The characters and settings are not so dissimilar from those found in the John Osborne plays or Tony Richardson films of the time. But the presence of an outsider like Carl Boehm has a defamiliarizing effect. Unlike the European stars hired by British studios to lend a little box-office lustre to their films, he is not a familiar face. Powell seems to have cast him because of his anonymity. Boehm was an experienced actor who had been appearing in films for more than a decade. He had played Schubert in *Das Dreimäderlhaus* (1958) and had appeared opposite the popular actress Romy Schneider in *Sissi-Schicksalsjahre einer Kaiserin* (1957), in which he played Emperor Franz Josef of Austria. Nevertheless, he was unknown in Britain. His anonymity added to his mystique. As Powell observed, 'He spoke English with hardly any accent. It was more like an intonation' (Powell, 1992, p. 398). Powell had originally wanted to cast Laurence Harvey as Mark

Lewis. Born in Lithuania, Harvey had the same 'outsider's' quality that made Boehm so distinctive, but on the back of his success in *Room at the Top* (1958), Harvey was already planning to go to Hollywood and so turned the part down.

Exotic outsiders need not necessarily be as unsettling as Boehm. Sometimes they were simply paraded in front of the colonial British cameras, like captive princes. This was what happened to Sabu. Born Sabu Dastagir in Karapur, Mysore, India, he was 'discovered' in India in 1935 by Robert Flaherty's cameraman Osmond Borrodaile, after Alexander Korda commissioned Flaherty to make a film based on a Kipling short story called 'Toomai of the Elephants'. A real mahout's orphan like the original, the twelve-year-old Sabu was perfect for the role in *Elephant Boy* (1937). There is, though, more than a hint of colonial bad faith about the film. Sabu is treated like a mascot. The British Imperial officer who takes pity on him is a dead ringer for George Orwell, a tall, thin and moustached man who regards not only Toomai but every other Indian character with the same patronizing indulgence that you might expect a parent to show a child. Sabu's performance is delightful. His Toomai is a mischievous, Mowgli-like imp with a permanent sparkle in his eye – a sort of Peter Pan of the subcontinent. After *Elephant Boy*, novelist A. E. W. Mason wrote *The Drum* (1938), a ripping yarn about rebellion on the North-West Frontier, especially for the new young star. Mindful of the problems he had had with Robert Flaherty shooting on location (and out of touch) in India, Korda based the production in Wales. Sabu's character, Prince Azim, is the rightful ruler of Tokot. Azim joins forces with the colonial British soldiers to banish the dastardly Prince Ghul (Raymond Massey). The emphasis may have been on action rather than politics, but the film still provoked riots in Madras and Bombay, and was hastily banned in the subcontinent. Whatever the controversy back home, the young actor was now firmly established as a star in the west. Korda claimed that, after the release of *The Drum*, Sabu received 100 letters a day from his fans (quoted in Kulik, 1990, p. 213).

Next for Sabu it was onto the flying carpet opposite Conrad Veidt in *The Thief of Bagdad* (1940). He plays Abu, the thief, 'son of Abu the thief, grandson of Abu the thief, most unfortunate of 10 sons with a hunger that yearns day and night'. Michael Powell, who co-directed the film, admired him enormously as an actor. 'It is curious to me,' he once wrote, 'that so few people, audience or critics, realize how much Sabu

gives to a film that everybody loves, like *The Thief of Bagdad*' (Powell, 1987, p. 581). As Powell points out, all the technical wizardry that was brought to bear on the movie would have counted for nothing if the human characters had appeared dull. 'It was because the leading part was played by a child, and by such a wonderful, graceful, frank, intelligent child, that the film delighted audiences all over the world' (Powell, 1987, p. 581). He used Sabu again as the handsome prince in *Black Narcissus* (1947). By then, though, the child star was a grown man of 22 and his brand of exoticism was no longer in demand in Hollywood, where he had moved some years before. As an adult, Sabu ought to have made a natural romantic lead (*Black Narcissus* showed he was handsome and charismatic) but casting agents were loath to give him the parts his abilities warranted. He may have taken out American citizenship (he even enlisted in the US army after Pearl Harbor) but as far as both Hollywood and the British studios were concerned, he was still regarded as an Indian. That, one must assume, is why he worked so infrequently in the latter part of his career, before his premature death at the age of 39.

Sometimes, the British stars themselves seemed like exotic outsiders in their own industry. Kay Kendall, svelte, elegant and a consummate comedienne, was a case in point. Few other British stars have iconic moments to match, say, the scene in which James Cagney pushes the grapefruit in Mae Clark's face in *The Public Enemy* (1931). Kendall's enshrining moment comes halfway through *Genevieve* (1953) when, drunk in a Brighton ballroom, she plucks a trumpet out of a band member's hand and proceeds to play it with extravagant, brassy élan.

While most British actresses of the era gave the impression of being terminally meek and mild, Kendall showed a refreshing disdain for the studio bosses. In late 1954, she managed the rare feat of getting herself suspended by the Rank Organization, with whom she had a standard seven-year contract, for turning down three roles in succession. Not long afterwards, she decamped to America. Her experiences do not say much for the way that Rank handled its contract artists. As one journalist put it at the time, 'In some of our studios women are treated like dogs who have to be locked up in the kennels after shooting ... if you're a film actress in Britain you spend your life smuggling your physical equipment through the customs.' She died of a blood disorder at the age of only 32.

Kendall had an air of sophistication which could not help but look out of place in homely British comedies of the 1950s. She was not the

diffident, self-effacing type like Muriel Pavlow, with whom she appeared in *Simon and Laura* and *Doctor in the House*, nor was she a down-to-earth sex symbol like Diana Dors or Susan Shaw. Had she been cast in a series of 'Thin Man'-style comedies, she would surely have flourished. She was as close as British cinema came to matching the glamour and brittle comedic talent of such Hollywood stars as Katharine Hepburn or Irene Dunne.

The schizophrenic career of Prague-born Herbert Lom, who fled to Britain in 1939 when the Nazis invaded, offers clear evidence of the confusion that seemingly overtook casting agents when confronted with an actor who did not fit their preconceived notions of how a British leading man should look and behave. Although quickly acclaimed as British cinema's answer to Hollywood's French-born matinée idol Charles Boyer, and allowed to play his share of romantic heroes, he was also often the villain. Witness his dapper, Peter Lorre-like gangster in *The Ladykillers* (1955), or his corrupt accountant, the ludicrously named Waldo Zhernikov, in the clunking British thriller, *The Frightened City* (1961). Later in his career, Lom became expert at conveying a sense of weary exasperation. As Police Chief Dreyfus opposite Peter Sellers's bumbling Inspector Clouseau in *The Pink Panther* films, he looks as if all the woes of the world have landed on his head. His casting in such comedies testifies to British cinema's ability to transform even its most dapper and handsome leading men into comic character actors. The suspicion with which he was regarded did not seem to change as he became more familiar to British cinemagoers. His role as the psychiatrist delving deep into Ann Todd's psyche in *The Seventh Veil* (1945) set the template. Here, he was supposed to be a sympathetic figure in contrast to Todd's sadistic mentor (James Mason). Whether because Lom was too young for the role and was wearing make-up which gave him a vaguely threatening air, or because the very idea of a European psychiatrist in a 1940s British movie seemed alarming, he did not come across as the reassuring figure that the film-makers intended. As he put it, 'I was a foreigner and in English eyes all foreigners are villains' (McFarlane, 1997, p. 377). His first role in British films was as Napoleon in Carol Reed's propaganda film *The Young Mr Pitt* (1942). That set the mould for the many other imperious villains he would later portray.

Perhaps mindful of the Hollywood success of Greta Garbo and Ingrid Bergman, British producers in the 1940s and 1950s were assiduous in

tracking down Scandinavian talent. Voluptuous, Oslo-born siren Greta Gynt was a glamorous fixture in many Rank films of the period, and was always to be seen at lavish film première parties swathed in fur. When she arrived in Britain as a 19-year-old, her agent Christopher Mann instructed her to dye her hair blonde and to make herself look like Madeleine Carroll. She managed to keep a high profile without appearing in especially memorable movies. Her credits range from thrillers like *Take My Life* (1947), shot expensively for David Lean's Cineguild outfit, and *Dear Murderer* (1947), made on a shoestring at Islington Studios, to the million-pound musical, *London Town* (1946). She ranked alongside Googie Withers as one of British cinema's few *bona fide* sex symbols before Diana Dors, but found precious few projects which did her justice. 'I was just put into this or that by an agent, until I didn't know who I was,' she later reflected (McFarlane, 1997, p. 266).

Probably Britain's best-known Scandinavian import was Mai Zetterling, a graduate of the same dramatic academy in Stockholm as Garbo and Bergman, who was brought over to Britain by Ealing Studios to star in *Frieda* (1947). The film's director, Basil Dearden, had gone on a talent-hunting trip to Sweden. He was generally impressed with the local talent. 'These Scandinavian stars are striking young women,' he rhapsodized in *Picturegoer* on 28 September 1946, in a bizarre echo of Cecil Hepworth, who also liked his actresses to be clean-living. 'They look the picture of health. Very few of them use make-up outside the studios, even fewer smoke or drink.' Out of all the actresses he auditioned, Zetterling caught his eye. Although shorter than most of her colleagues and unable to speak English, 'she knew instinctively what I needed'.

In *Frieda*, Zetterling played a German war bride married to an English Royal Air Force officer (David Farrar). Inevitably, she encounters hostility and resentment from the British when she comes back to live with him. She liked the role ('it had something to say ... it was controversial').[3] It complemented her striking performance in her most famous Swedish picture, Alf Sjöberg's *Frenzy* (scripted by a young Ingmar Bergman), which cast her as an ingenuous young woman caught up in an exploitative relationship with a much older teacher. However, Zetterling's subsequent British career as a Rank contract artist was less fulfilling. She was often reduced to the status of a 'dangle dolly',[4] wheeled on to lend a little glamour to creaking British productions. She showed a lot of cleavage in *The Bad Lord Byron* (1948), was the love interest

opposite Richard Widmark in *The Prize of Gold* (1955), and the seductive older woman who gets mild-mannered librarian Peter Sellers all steamed up in *Only Two Can Play* (1962). In British films of the period, the sophisticated older woman was invariably continental. Zetterling's mature vamp stands as a sort of comic counterpart to Simone Signoret's older woman opposite Laurence Harvey in *Room at the Top* (1958).

Zetterling occasionally landed more challenging roles in Ibsen or Chekhov plays on the West End stage. She made a brief foray to Hollywood to star opposite Danny Kaye in Paramount's colourful comedy-thriller, *Knock on Wood* (1954), but showed little desire to work there again. In hindsight, her acting career seems like an exercise in frustration. Only when she moved behind the camera and began to direct her own documentaries and features did she find her own voice. Her 1982 film, *Scrubbers*, set inside a girls' borstal and shot with young, inexperienced actors in the same gritty, naturalistic style as Alan Clarke's films of the period (*Scum*, *Made in Britain*, *The Firm*), is about as far away from the suburban blandishments of her Rank 1950s comedies as it is possible to get.

Sometimes, exotic foreign stars turned up in the most unlikely British films. In 1955, shortly before she stirred up such unholy passions in Roger Vadim's *And God Created Woman* (1957), a very young Brigitte Bardot was to be seen on deck alongside Simon Sparrow (Dirk Bogarde) in *Doctor at Sea*. The film's producer, Betty Box, who had spotted Bardot whilst on holiday in the south of France, later recruited Berlin-born star Elke Sommer to lend a little continental glamour to her deservedly ill-fated, very British sex comedy, *Percy* (1971), in which Hywel Bennett undergoes the world's first-ever penis transplant. Bizarrely, the sophisticated, cosmopolitan Sommer also turned up as a Russian archaeologist alongside Kenneth Williams, Charles Hawtrey *et al.* in *Carry on Behind* (1975). As such casting decisions hint, sex was indeed truly foreign to many British film-makers.

Notes

1. *Sunday Dispatch*, October 1934, quoted on Conrad Veidt home page on the Internet.
2. Unsourced cutting taken from BFI microfiche on Conrad Veidt.
3. 'Mai Zetterling Transformed', a 1949 profile of Zetterling by Ruth Miller, BFI microfiche.
4. Obituary for Zetterling in *The Times*, 19 March 1994.

Lockwood, Calvert and Some Other Contract Artists

> Phyllis Calvert, auburn haired, five feet five, is an excellent
> example of how British studios can build up a star if they really try.
> (Stannage, 1947, p. 50)

During the mid-1940s, when British cinema-going reached its peak,
Margaret Lockwood and Phyllis Calvert enjoyed a level of popularity
with domestic audiences hitherto reserved for the biggest Hollywood
stars. Lockwood topped the *Picturegoer* polls and won the *Daily Mail*
National Film Award three years in a row (1946, 1947 and 1948),
generally with Calvert only a few hundred votes behind her. (The
competition was often tight – in one year, Lockwood attracted 54,588
votes while Calvert polled 53,756.)

In terms of their backgrounds, both actresses were similar – childhood
stage stars who served an apprenticeship in low-budget British B-movies
before eventually graduating to leading roles. Calvert, born in London in
1915, began her film career in quota quickies in the early 1930s. Lock-
wood, who was born in Karachi in 1911, the daughter of a British official
of the Indian railways, and brought to England at the age of three, made
her screen début in a supporting role opposite Victoria Hopper and John
Loder in Basil Dean's adaptation of *Lorna Doone* (1934). Reckoned to
have outshone Hopper, she secured a contract with British Lion. Her
early credits ranged from Michael Powell's 1935 quota quickie, *Some
Day* (about a lift-boy's faltering attempts to impress a cleaner) to two
early Carol Reed films, *Midshipman Easy* (1935), in which she played a
buxom Spanish wench, and the musical comedy, *Who's Your Lady
Friend?* (1937), which co-starred Winston Churchill's 'dancing daugh-
ter', as she was nicknamed in the trade press, Sarah Churchill.

To begin with, the two actresses played the same kinds of parts. Lockwood was the beautiful young ingénue Imogene, 'sweet and sincere', in *Dr Syn* (1937), Roy William Neill's colourful costume drama about a vicar (George Arliss) who moonlights as a smuggler. She also starred as the bonny, apple-cheeked shepherd's daughter in Robert Stevenson's comedy-drama, *Owd Bob* (1938), alongside Will Fyffe and John Loder. This, though hardly typical of her later work, is rambunctious entertainment. Fyffe is in splendid form as her father, a cantankerous, bewhiskered old curmudgeon from Cumberland whose beloved sheep dog wins the trials every year, but also has the unhappy knack of eating all the neighbours' livestock. Loder, a handsome, upright old Etonian who had also appeared with Lockwood in *Dr Syn*, is Lockwood's romantic interest – a young shepherd whose dog eventually defeats Fyffe's.

Lockwood's most important early role was in Carol Reed's *Bank Holiday* (1938), a contemporary social drama very different from the costume romances with which she was later associated. She plays a nurse who spends a weekend away at the seaside with her boyfriend (Hugh Williams), but is nagged by the thought of a young man (John Lodge) whose wife has just died in childbirth. She cuts short her Bank Holiday, hurries back to London and saves the young man from suicide. 'Of Miss Lockwood's performance,' wrote the *Daily Telegraph* reviewer, 'I need only say that her possibilities have been sticking out a mile ever since she played her first big part two years ago. She has beauty, dignity, and an unaffected charm, and she is mercifully free of vowel mutilations and that odious trick of the British ingénue – ending every other word on a breathy higher note, supposed to suggest vivacity or emotion, whereas, of course, all it really suggests is adenoids.'[1]

Much of Lockwood's appeal, it seems, lay in the way she neatly sidestepped class stereotypes. Her voice betrayed neither traces of the Mayfair drawing room nor any hint of a regional accent. She spoke with clarity but without affectation.

Calvert, meanwhile, started her career in earnest in the brisk Launder and Gilliat scripted thriller, *They Came by Night* (1939), which also starred Fyffe. She popped up opposite George Formby as a vivacious hotel receptionist in *Let George Do It* (1940), the first of Formby's wartime vehicles; starred opposite Michael Redgrave in Carol Reed's H. G. Wells adaptation, *Kipps* (1941) – a film in which Margaret Lockwood had

declined to appear; and looked suitably demure and patriotic as the beautiful Eleanor Eden in Reed's historical flagwaver, *The Young Mr Pitt* (1942). (Robert Donat is cast as the brilliant politician who sacrifices everything, Eleanor Eden included, for the greater cause of his country.) Calvert won her part on the recommendation of Donat, who spotted her standing outside the studios and immediately told the producer, Maurice Ostrer, that he wanted her in the part (McFarlane, 1997, p. 110).

Both *Kipps* and *The Young Mr Pitt* were made for Twentieth Century at Gainsborough's studios in Shepherd's Bush. The films' producers, Ostrer and Ted Black, cast Calvert a year later in *The Man in Grey* (1943), the first of the celebrated Gainsborough melodramas. A costume drama set in the Regency era, it stars Calvert as a beautiful young aristocrat, Clarissa Richmond, and Margaret Lockwood as her impoverished schoolfriend and confidante, Hester Shaw. Clarissa is kind-hearted and generous, Hester, it turns out, quite the opposite.

Calvert and Lockwood have their male counterparts – James Mason as the louche, bad-tempered Marquis of Rohan who marries Clarissa because he requires an heir to his title, and Stewart Granger, in his first important role, as Rokeby, the impoverished young actor with whom Clarissa falls in love. To make sure audiences realized just who the villains were, director Leslie Arliss and producer Ted Black used a little subtle colour-coding. Stewart Granger later ruefully recalled that he was made to bleach his hair so that fans would know to trust him. 'James Mason the villain and Margaret the villainess had dark hair, while Phyllis, who played the heroine, was blonde, so I, as the hero, had to be blonde too' (Granger, 1981, p. 62).

The film ends on an excessively brutal note, utterly incongruous in comparison with the understated, documentary-style heroism celebrated in most wartime British films. Calvert falls ill and dies, Lord Rohan learns about Lockwood's plotting and, with sadistic relish, thrashes her to death with a poker.

With *The Man in Grey*, producers Ted Black and Maurice Ostrer and director Leslie Arliss tested the Gainsborough melodrama formula for the first time. 'Spectacle and sex, a dash of sadism, near-the-knuckle lines and an end where virtue is rewarded', were, according to the London *Evening Standard*, the key ingredients.[2] The film proved an immediate popular success despite the carping of the quality critics. ('My feelings about *The Man in Grey* are expressed by the Clarissa of the film,' grumbled William

Whitebait in the *New Statesman*. '"I don't think I can bear this. I can't. I really can't."'³) Lockwood and Calvert both went on to play variations on the same role. The former, in her most famous part, was the highway-woman in *The Wicked Lady* (1945), while the latter was the timorous wife again bullied by old roué James Mason in *Fanny by Gaslight* (1945).

Originally, Lockwood had been loath to play the villainess in *The Man in Grey*. She had felt the same misgivings about her first unsympathetic role, as Michael Redgrave's shrewish, unsupporting wife in Carol Reed's *The Stars Look Down* (1939). Redgrave's character is a working-class miner's son who has had an education and dreams of becoming an MP. Lockwood hitches herself to him in the hope of improving her social position, but rapidly cools toward him when she realizes his main interest is campaigning on behalf of the miners, not his own social advancement.

Any comparison with Lockwood's earlier roles, for instance her screw-ball heroine opposite Redgrave in Hitchcock's comedy-thriller, *The Lady Vanishes* (1938) or in Carol Reed's *Night Train to Munich* (1940), suggests how much more compelling she becomes when she is acting the spoiled or wicked lady. When she begins to sulk or plot, she immediately becomes a darker, more mercurial presence. She is always better as the gypsy or the Machiavellian outsider than as the familiar, good-natured leading lady.

Not that casting Lockwood as the villainess was always easy. While it was possible for the big Hollywood studios to play young actors in near-identical roles time and time again, British producers were obliged to cast them across genres in a range of very different parts – simply because so few films were being made. (In 1945, which is often touted as a vintage year, there were 44 features produced in Britain – only a few more than would be made by a single major Hollywood studio in a typical year.) Lockwood may be best remembered for her gallery of wicked ladies, but during her career at Gainsborough (who bought out her British Lion contract in 1937 after being impressed by her in *Dr Syn*) she also played a consumptive pianist in *Love Story* (1944), a sensitive psychic in *A Place of One's Own* (1945), and a turn-of-the-century, Lily Langtry-like music hall star in *I'll Be Your Sweetheart* (1945). She even popped up as an Edith Evans-like matriarch in *Hungry Hill* (1946), Brian Desmond Hurst's copper mining saga set in nineteenth-century Ireland. In the first

half of the film, she is in familiar groove as Fanny Rosa, a high-spirited colleen who lives life at a gallop and has two brothers (Michael Rennie and Dennis Price) madly in love with her. But as the years roll away, and first Rennie and then Price (whom she has married) die, she turns grey with worry about her headstrong young son (Dermot Walsh) and eventually even turns to heroin and gambling. Beneath the layers of make-up, it is hard even to recognize her. She was being paid well – Lockwood's initial three-year Gainsborough contract guaranteed her £3000 a year (Tims, 1989, p. 68) – but her career was hardly being handled with any great guile.

Before Lockwood's success in the Gainsborough costume melodramas, producer Ted Black had vague intentions of grooming her as Britain's answer to Myrna Loy. Following the success of *The Lady Vanishes*, he wanted to cast her opposite Michael Redgrave in a series of comedy-thrillers along the lines of *The Thin Man* films. Given that Redgrave was an anguished, introspective actor with little of the raffish insouciance of William Powell, this does not seem a particularly promising idea. Black's plans were scuppered anyway by the war. The only other film in which Lockwood and Redgrave appeared together was *The Stars Look Down*. Thereafter, throughout her career, like most other British stars, Lockwood was obliged to take whichever roles came her way. As her Gainsborough colleague James Mason put it, 'a star who is not constantly thrusting his face at the public very soon finds he is no longer in demand'.[4] Still, Black, originally from a circus background, was an inspirational showman with an uncanny knack for giving the public what it wanted. He had taken over from Michael Balcon as Gainsborough's production boss in 1936. His early years at the studios yielded a handful of cheerful, crowd-pleasing comedies with Will Hay and George Formby, but he soon realized that Gainsborough needed to create its own star stable if it was to expand. 'It seemed to me,' he observed, 'that there was a great dearth of British stars, especially as the best of them usually found a permanent home in Hollywood as soon as they were successful enough. So I set out to create some new stars by putting fresh talent into well-made pictures' (Tims, 1989, p. 70).

Black's policy was to use the same actors again and again in eye-catching roles while building them up off-screen: he put their faces on bus shelters, newspapers and hoardings. There was nothing especially original about this. For years, British stars had been used for advertising

everything from soap to lemon squash. A famous Lever Brothers ad of the 1920s trumpeted:

> Nine out of ten film stars use Lux Toilet Soap. In the Hollywood and English studios there are 714 important actresses including all stars – 98 per cent of them care for their skin this way! And Lux Toilet Soap is the official soap in the dressing rooms of all the big studios. Order Lux Toilet Soap from your grocer today. That instant foamy lather will delight you![5]

Black, though, was more aggressive in bringing his new faces to public attention than any of his predecessors since Alexander Korda, who promoted Merle Oberon and Robert Donat with similar élan in the early 1930s.

Once he had put young actors under contract, Black tried to ensure they behaved like stars off-screen as well as on. With Lockwood, this was an uphill battle. She did not seem to realize that her off-screen behaviour was as important to her fans as her actual film roles themselves. 'Around the *Dr Syn* time it was a great trouble to get her to dress up and look presentable at premières and parties. Her idea of dress seemed confined to a raincoat and beret. I had to reason with her, explaining that the public expected glamour from their favourites' (Tims, 1989, p. 77).

In some ways, Black placed himself in an invidious position. While trying to build up Gainsborough's roster of stars, he also tried to make the studio embrace an earthier, more demotic style of film-making that would 'appeal to audiences in the Midlands and North ... he aimed primarily at audiences between Watford and Newcastle On Tyne' (Seaton and Martin, 1982, p. 11). Films such as *Bank Holiday* (1938) and *Millions Like Us* (1943), about the lives of ordinary people, hint at the new kind of populist realism that Black was striving for. However, they were not the kind of pictures in which stars were easily foregrounded.

Many of the actors whose careers Black nurtured, and whose faces he guided into the fan magazines, heartily loathed their work at Gainsborough. James Mason, who signed a six-film contract with the studio, attributed his success as the sadistic eighteenth-century aristocrat Lord Rohan in *The Man in Grey* to his inveterate dislike of the role. 'I have to conclude,' he later wrote, 'that my sheer bad temper gave the character colour.'[6] He was equally bad-tempered as the sadistic husband in *They Were Sisters* (1945), a part he later admitted playing with a well-nigh

permanent hangover. Stewart Granger described his Gainsborough films as 'junk' (Granger, 1981, p. 90). Even Phyllis Calvert seemed less than enamoured of the pictures which made her famous. 'I hate the word "film star" . . . I've never been a dedicated film actress' (Aspinall and Murphy, 1983, p. 60).

Despite the constant whining from the leading contract artists, the costume dramas which the studios started making from *The Man in Grey* onwards were, above all, star vehicles. Maurice Ostrer, the executive in charge of production at Gainsborough, believed that wartime audiences wanted escapism, not realism, and was determined to provide it. Under his guidance, Leslie Arliss, writer/director of *The Man in Grey*, *Love Story* (1944) and *The Wicked Lady* (1945), offered Granger, Mason, Lockwood, Patricia Roc and Phyllis Calvert the kind of torrid emotional roles which couldn't fail to make an impression on audiences. Arliss had a special theory about his heroines. 'Yes, I like wicked women – on the screen,' he told *Picturegoer*. 'They are so much more interesting than the average heroine type. They've got more colour and fire – and they're more human.'[7]

Both Arliss and Ostrer were building on Black's policy, using the stars he had discovered. It was their choice of genre which made the difference. By pushing the studio away from realism toward historical melodrama, they were at last able to forge a definitive Gainsborough identity. Their comedy films had not been so very different from those being made elsewhere by the likes of George Formby and Max Miller. Even Black's emphasis on realism was far from unique: Ealing, under Michael Balcon, was turning out a similar kind of picture. But the melodramas were unique. For the first time in its history, Gainsborough was producing a different style of film from any of its British rivals. Moreover, the new genre provided the perfect showcase for the new stars.

In return for the chance to swagger, swordfight, wield pokers, wear Elizabeth Haffenden's costumes and parade their feelings in big close-ups, accompanied all the while by swirling orchestral music, the stars began behaving every bit as arrogantly as their Hollywood counterparts. There was the famous occasion on the first day of production of *The Wicked Lady* when Mason walloped Arliss on the nose, and almost provoked a full-blown technicians' strike in the process.[8] Mason's excuse for such aggressive behaviour was that he'd been kept waiting around on set and never used. (The technicians' union, the ACT, pointing out that he

was being paid, could not see why he was complaining.) Then there was the occasion that Stewart Granger shared a railway compartment with Arliss on the way to Cornwall for location shooting on *Love Story*. 'He asked me,' Granger recalled in his autobiography, 'what I thought of the script. Not knowing he'd written it, I told him it was the biggest load of crap I'd ever read' (Granger, 1981, p. 75). In a series of letters and articles in *Picturegoer*, Mason continued to complain about the state of the industry. He expressed the opinion that 'there was precious little glamour in British films', let fans into the secret that a certain actor in a Gainsborough film 'had to be photographed only from the waist up because he had fallen out of a window in a drunken stupor and injured his leg', and threatened to emigrate to Hollywood forthwith.[9]

While Mason's and Granger's behaviour was not exactly encouraged, it tallied with the roles they were playing. They were supposed to be rakes and bounders. Lockwood, too, joined in the dissent, and ended up suspended when she refused to accept a role in the comedy, *Roses for Her Pillow*, which was eventually made as *Once upon a Dream* (1949) with Googie Withers. Whatever tantrums the various stars threw, they still invariably topped fans' popularity polls. Nor were they ever all that severely reprimanded. The studio bosses were not about to bully their prime assets. 'Star assets were looked on as very valuable property and were handled with kid gloves as any temperamentalism on their part could ruin a film or grossly increase costs because of illness, indisposition etc,' recalls ex-Rank executive F. L. Gilbert in an unpublished memo about the British film industry of the 1940s (Gilbert, 1981, p. 16).

Gilbert suggests that the British star system of the 1940s (at least at it was run by the Rank Organization) was strictly hierarchical. On the one hand, there were the jobbing contract artists, on the other, there was the handful of big names who could carry a film. The former were looked after by casting director, Weston Drury, and by Olive Dodds (see p. 177). The latter, although also under contract, were represented by well-known agents. The most important of these was David Henley, an ex-actor and one-time colleague of theatre impresario Binkie Beaumont, who was put in charge of Rank's Contract Artists Department in the mid-1940s.

According to Gilbert, the standard, one-off fee for a star to appear in a single film was £10,000, an astonishingly high figure given that, even as late as 1951, the average weekly wage for adult males was only £8.30 (Morgan, 1990, p. 124). British stars may not have been paid as much as

their Hollywood counterparts, but they could no longer complain that they were being exploited financially. 'They (the stars) maintained it was not excessive as 10–15 per cent went to their agent; they were public figures and had to maintain a rather flamboyant lifestyle in dress, travel etc. and they had no idea whether or not their next film (or even their present film) would be a flop and so ruin their careers' (Gilbert, 1981, p. 17).

Contract stars were often hired out to rival studios if there was not sufficient work for them. Gainsborough, for example, 'leased' Lockwood to producer John Corfield to star in *Bedelia* (1946), which was shot at Ealing Studios. Henley, meanwhile, recruited his own specialist doctor 'to satisfy himself that stars were fit enough to stand the rigours of the production schedule' (Gilbert, 1981, p. 17). Sometimes, though, the trick was not to keep the stars working but to ensure that they stayed out of sight of the cameras. Gilbert claims that Laurence Olivier received a special, one-off payment of £15,000 for agreeing not to make a film for anybody else in the lull between Two Cities' *Henry V* (1945) and *Hamlet* (1948).

Ted Black, Gainsborough's starmaker-in-chief, quit the studio in 1945. Historians Roy Seaton and Ray Martin suggest that the rift between him and his boss, Ostrer, has been exaggerated: *The Man in Grey* and *The Wicked Lady* may have been a long way removed from the popular, realistic dramas Black wanted to make, they argue, but he was too much of a showman to turn up his nose at them. Nevertheless, his antipathy to Ostrer was apparent to all, and their shared distrust of Rank, who owned the studios, boded ill. Despite the box-office success of the costume melodramas, Rank felt Gainsborough was being inefficiently run. Not long after Black's departure, he eased out Ostrer too and replaced him with Sydney Box. Ostrer always liked to boast that production costs at Gainsborough had been kept low, even for the costume melodramas. *The Wicked Lady*, for instance, was budgeted at under £200,000 whereas Gabriel Pascal's all-star adaptation of George Bernard Shaw's *Caesar and Cleopatra* (1945), which was made in the same year with Gainsborough alumnus Stewart Granger in a leading role, came in at over £1 million. Under Box, Gainsborough was supposed to be run along strict lines. Nevertheless, there are reports of an extravagance which Ostrer would never have countenanced. Dermot Walsh, who starred alongside Lockwood in both *Hungry Hill* and the Technicolor costume spectacular *Jassy*

(1947), claims that his costumes in the former, all of which were designed and handmade for him on Savile Row, cost considerably more than he was paid for appearing in the film (McFarlane, 1997, p. 590).

Both Lockwood and Calvert made brief, unsuccessful forays to Hollywood. Lockwood was there in the late 1930s to appear as support for Shirley Temple in the terminally mawkish *Susannah of the Mounties* (1939) and for Douglas Fairbanks Jnr in the stolid historical drama *Rulers of the Sea* (1939), while Calvert headed out to the US in 1947 as part of Rank's 'star-exchange' scheme – one of the many such overtures the Yorkshire tycoon was making to the American industry at that time in an ill-fated bid to secure a market for British films in the States.[10]

'What will Hollywood do to Phyllis Calvert?' agonized *Picturegoer* when the magazine learned of her proposed trip to the US. Fans feared she would lose her position as the darling of the British studios whether or not she proved a success at Universal, who had signed her up to star in *Time out of Mind* (1947). In theory, this seemed an attractive vehicle. Calvert was to be directed by one of Hollywood's most respected directors, Robert Siodmak, who was still basking in the success of his recent films, *The Spiral Staircase* (1946) and *The Killers* (1946). She did not much like the script ('I didn't feel a bit excited about playing it') but was sold on the idea of Siodmak. 'His work appeals to me tremendously, and I think I'm very fortunate to be able to make my start in an American film under his direction.'[11]

Calvert's role – as a housekeeper's daughter who stumps up the money so the boss's handsome, arrogant son (Robert Hutton) can continue his music lessons – echoes her earlier doughty but put-upon Gainsborough heroines. Unfortunately, Siodmak was only making the film under sufferance. Too old for her part, Calvert was made to suffer by Universal's fussy, perfectionist make-up artists and technicians. As historian Erik Braun notes, 'Her performance was one of her least memorable: being then in her early thirties and playing a very young girl, she was under orders to avoid moving a muscle in her face, and to frown or cry was completely forbidden. Her make-up and hair-styles were designed to transform her own naturally square-shaped face into a conventional oval.'[12]

Calvert went to Hollywood, or so she claimed, 'as an ambassadress in the hope that her performance as a British star will help to increase the liking for British pictures by American audiences'.[13] Unfortunately, her

mission proved abortive. Neither the US critics nor the public liked *Time out of Mind* and she quickly returned to Britain to star in *Broken Journey* (1948), a routine Gainsborough drama inspired by producer Sydney Box's interest in the real-life crash of an American Dakota plane in 1946. She played a self-reliant, eminently sensible air hostess. It was a part which seemed to suit her. While some critics were dismissive of Box's attempts at 'making a Grand Hotel in the snow'[14] and complained about the artificiality of the sets ('the wind moans on the soundtrack and the actors sit in the snow as in a drawing room with unruffled hair'),[15] nearly all warmed to Calvert's no-nonsense performance. 'Henceforth, I shall always think of her in a blue uniform, bringing bad coffee from the back of the plane and briskly parrying the smiles of elderly male travellers as she fixes their safety belts.'[16] The role suited her better than her vengeful siren in *Root of All Evil* (1947), a character so furious about being jilted by her fiancé that she is galvanized into becoming a ruthless, power-crazed businesswoman.

At the time of *Broken Journey*, Calvert still hoped to return to Hollywood to star in three further American pictures (Stannage, 1947, p. 51). Although she did indeed secure a new contract with Paramount, her US career soon fizzled out. She appeared in the romantic drama, *My Own True Love* (1948), as the younger woman who catches the eye of widower Melvyn Douglas, and starred alongside Alan Ladd as a nun who witnesses a killing in *Appointment with Death* (1950), but soon afterward returned to Britain for good.

There is a hint of a false dichotomy about the opposition which casting agents and fan magazines sought to draw between Calvert and Lockwood. Whereas the former was generally photographed in fan magazines with her family or wearing dowdy floral dresses, the latter would be shown flaunting her legs, often beneath some provocative headline.[17] They were essentially very similar actresses – middle-class English rose types – who could easily have swapped roles. Lockwood's wicked ladies never really seemed as wicked as all that, whatever their misdeeds. She was 'obviously incapable of killing anything bigger than a bluebottle',[18] one critic commented after seeing her play the highwaywoman in *The Wicked Lady*. Even as the murderess heroine who poisons off her husbands one by one in *Bedelia* (1946) she still seems strangely homely. She originally wanted to play Clarissa in *The Man in Grey*, and was indignant when Calvert was given the role. After she had been talked into

playing the wicked Hester, she still remained 'doubtful about the character's motivation'.[19]

As Maddalena/Rosanna in Arthur Crabtree's *Madonna of the Seven Moons* (1944), Calvert showed a Lockwood-like relish for playing the voluptuous gypsy heroine. Thanks to a childhood trauma a victim of dual personality (a syndrome which has long fascinated script-writers), she is both Patricia Roc's mother – as demure and prim as any Home Counties matron – and a wild, passionate woman of the streets who enjoys a torrid relationship with the equally wild and passionate Stewart Granger. Given her volatile character, it is only fitting that the film has had such a topsy-turvy time with the critics. 'The purplest production English cinema has yet achieved,' Helen Fletcher wrote with less than admiration in *Time and Tide*.[20] In the *New Statesman* William Whitebait showed his customary mellow sneer: 'It is notably bad ... Jekyll and Hyde brought a hint of phosphorus but treacle is the element of Maddalena/Rosanna. Everything in *Madonna of the Seven Moons* is treacly; characters, dialogue, situations.'[21] Treacly the film most certainly was in that it had a rich and far-fetched storyline – and it was also, in the opinion of many critics and academics, one of the most intriguing efforts that the British studios made during the 1940s.

Lockwood's vehicles were often given an equally rough ride. When she played an Edwardian music hall star in *I'll Be Your Sweetheart* (1945), she provoked the critic Richard Winnington into a cruel comparison with 1940s alcohol rationing: 'Lockwood suggests the robust music-hall belle of that period about as much as the tepid concoction of potato juice and hops we are now allowed occasionally to buy suggests the beer they used to drink in those happy days.'[22]

The so-called 'quality' critics were often inclined to frown at historical melodramas and musicals. Reared on the Film Society and the puritanism of the Griersonian documentary tradition, they grimaced in the face of Margaret Lockwood's cleavage. Staunch docu-dramas like Pat Jackson's *Western Approaches* (1944) and Harry Watt's *Target for Tonight* (1941) were far more to their liking than Gainsborough Studios' mischief-making in the name of entertainment.[23]

Even within the Gainsborough orbit, there were echoes of the on-going conflict between the 'entertainers' and the 'uplifters'. Lockwood was bracketed with the former while Calvert seemed to represent the interests of the latter. One was painted as brash, gaudy – Hollywood-come-to-

Britain – the other as dignified and sensible, a sober character who might have stepped out of a documentary cast adrift in a rococo, extravagant and meretricious world of Maurice Ostrer's making. The antinomy spilled over into the pages of the fan magazines and studio publicity hand-outs. Calvert was a 'home girl' who liked nothing better than spending time with her family. In Gainsborough's 1945 effort, *They Were Sisters*, she played opposite her own real-life husband, Peter Murray Hill. She is the only happily married character in the film. One sister (Dulcie Grey) had made the fatal mistake of marrying James Mason, who bullies, humiliates and eventually drives her to her death. The other (Anne Crawford) is hitched to a stolid, decent chap (Barrie Livesey) she has no feelings for.

In an old issue of *Picturegoer*, there is a still from the film, presented as if it were a photograph from the actress's own album. It shows Calvert and Murray-Hill standing next to each other, smiling, as two children play in front of them. In the film, Calvert and her husband are unable to have children and end up adopting a niece and nephew. But the photo-graph presents an idealized image of the nuclear family. The text accompanying it, apparently written by Calvert herself, extols the virtues of 'a career – a home – and a family'. Calvert boasts about her own happy family life with her husband, baby daughter and two white Pekinese and then talks about all the dutiful hard work that went into achieving such an enviable lifestyle.[24]

The images of Margaret Lockwood offered by the same fan magazine are radically different. 'Margaret Lockwood is furious!' announces one banner headline after an American journalist has the temerity to criticize British actresses. 'Margaret commits murder!' trumpets another headline for a piece describing her role in *The Wicked Lady*. 'They've given me an extra murder . . . I hope my fans won't mind,'[25] she tells the journalist who comes to visit her on set. She also jokes about the tight, revealing period dress Elizabeth Haffenden designs for her to wear in the film. 'Yes, it may look nice . . . but the corset that goes with it doesn't allow for much expansion after lunch – at any rate, not for the hefty lunch I have just had!' In a piece entitled 'What Is A Star To Do?'[26] she is shown in her bathing suit and high heels, looking for all the world like a British Esther Williams. (This is not a pose one could imagine Calvert striking.) Discuss-ing the vexed issue of typecasting, she protests that she has played an enormous range of roles. In another profile, 'Margaret makes no bones

about the fact that she hates domesticity' (Lee, 1947), although, rather bizarrely, a photograph shows her with her daughter in an idyllic country setting.

Whereas Calvert is presented as polite and demure, Lockwood is always on the attack, responding to criticisms or issuing challenges. Just as in the Gainsborough films, she is high-spirited and conspiratorial. Each time she writes a piece or is profiled, a flood of letters follows.

In a recent essay about Lockwood, historian Margaret O'Connor argued that Lockwood's wicked lady image 'touched a chord in the "new woman" emerging from the disciplines of a long war'. Lockwood, she argued, could not help but appeal to 'British women who had tasted independence during the war years and were striving against attempts to impose submissive domesticity ... [she] provided her female audience with a fantasy role-model for the immediate post-war years' (Thomas, 1991). O'Connor's essay begs some provocative questions about Calvert, who was as popular with women fans despite projecting an entirely different set of values.

Despite the enthusiasm with which she tackled *Madonna of the Seven Moons*, it is not easy to think of Calvert as a wicked lady. Her choice of roles, for instance, her long-suffering, beatific mother in Ealing's *Mandy* (1953) and her devoted wife in *They Were Sisters*, ensured she would be pigeon-holed in the opposite way to Lockwood. Nevertheless, her career began in a very similar fashion. Had Gainsborough bosses Ted Black and Maurice Ostrer set out to make her the wicked lady, she might have carried off the part with an élan worthy of Lockwood, with her image in the fan magazines adjusted accordingly. After all, both actresses were different sides of the same coin.

British cinema thrives on the kind of false polarity that was drawn between Lockwood and Calvert. On one level, it is a variation on the Don Quixote/Sancho Panza syndrome, with Lockwood as Gainsborough's version of the earthy sensualist to Calvert's stiff-necked, idealistic matron. The wicked lady/beautiful innocent dichotomy was not just something dreamed up by Gainsborough studios to add a little colour to austerity-era Britain. It already existed as a leitmotif in British silent cinema. Witness, for instance, how Alma Taylor's dewy-eyed innocent in Hepworth's *Comin' thro the Rye* (1923) is deceived by the temptress who sends forged letters to her fiancé. Lockwood's other precursors include Violet Hopson, 'the dear delightful villainess', and Benita Hume, whose

British credits included *The Wrecker* (1928) and *Blame the Woman* (1932). There were also glamorous American sophisticates like Tallulah Bankhead and Marjorie Daw, who were periodically called upon to show up their dowdy British cousins.

The opposition between the wicked lady and the beautiful ingénue is so pervasive in romantic fiction and fairy-tales that it hardly bears pointing out. Even if these two stereotypes had existed almost as long as storytelling itself, Gainsborough Studios' decision to reanimate them in such flamboyant fashion in the mid-1940s is still significant. On the one hand, studio bosses Ted Black and Maurice Ostrer were reacting against the greyness and restraint of so much British wartime film-making. On the other, as Margaret O'Connor's essay on Lockwood suggests, they were providing female audiences with two competing 'fantasy role-models' for the immediate post-war years. It is simplistic to argue that Calvert stands for the old, pre-1939 norms of domesticity and submissiveness whereas Lockwood embodies the values of a changing society in which women are coming into the work-place and old class barriers are breaking down. (This was beginning to happen already in the inter-war years, before Lockwood was established as a star.) Nevertheless, the striking differences between Hester and Clarissa must have had a resonance for 1940s audiences. Whereas the latter is very passive in 'enduring all the blows of unkind Fate'[27] and does not seem able to fight for herself, the former shows enterprise and ingenuity. She knows where she wants to go and will not balk at a little wrong-doing, if it is necessary to get her there.

As many critics have pointed out, however torrid the Gainsborough melodramas seemed, they often ended on a note of conformity. Lockwood's disruptive, crinolined *femmes fatales* were generally banished by the final reel, and domestic harmony restored by Roc, Calvert or a poker-wielding patriarch like Mason. Nevertheless, Lockwood's villainesses were infinitely more flamboyant than the pallid heroines who survived them. While they were never exactly tragic figures like 1930s Warner Bros gangsters, they nevertheless had colour, depth and pathos. When Gainsborough director Leslie Arliss announced to *Picturegoer* 'Yes, I like wicked women on the screen!'[28] he was only acknowledging something that was already obvious to the millions of fans who voted Lockwood their favourite star every year. As he put it, 'virtue may be its own reward but I'm sure that wickedness brings them in at the box office'.

Regardless of how wicked ladies and beautiful innocents were viewed

as role models by 1940s cinemagoers, they suggested a radical departure in approaches to star-building. In particular, female sexuality was being foregrounded in a way hitherto unthinkable. The climactic finale to Powell and Pressburger's *Black Narcissus* (1947) in which two nuns wrestle over a Himalayan precipice, one trying to stop the other from ringing a huge, priapic bell, shows the tension between the two competing stereotypes at its most frenzied. Deborah Kerr is Sister Clodagh, a pious Phyllis Calvert-type who has taken religious orders to escape painful memories of a broken love affair in Ireland. 'The veritable Admirable Crichton among nuns,' as Powell characterized her, 'certain of her vocation' (Powell, 1987, p. 578). Kathleen Byron's Sister Ruth, by contrast, is the nun-as-wicked-lady. In one key scene, Ruth, out of her habit, is shown in gaudy vermilion dress and lipstick wandering through thick bamboo jungle toward the house of Mr Dean (David Farrar), the handsome Englishman who has befriended the nuns. The jungle is not naturalistic, but seems to represent the dark, antipodean realms of the imagination. Ruth is confronting her own burgeoning sexuality. She acknowledges it, but Sister Clodagh, prey to similar feelings for Mr Dean, tries to suppress such desires. Significantly, when the two women finally have their confrontation, the differences between their respective characters are eclipsed.

Born in Helensburgh, a seaside town on the west coast of Scotland, Kerr trained as a ballet dancer before making her screen debut in *Major Barbara* in 1941. She won her first leading role in the same year in John Baxter's adaptation of the Walter Greenwood novel, *Love on the Dole* (1941). Despite playing a working-class Lancastrian woman in that film, Kerr projected a typical Home Counties reserve. She was very much the English rose in Powell and Pressburger's *The Life and Death of Colonel Blimp* (1943), playing three separate roles, variations on the ideal woman the English soldier (Roger Livesey) searches for throughout his life. She appears first as an English governess in Boer War days, then as a First World War nurse, and finally as the soldier's driver in the Second World War. Powell had originally pencilled in Wendy Hiller as star. When she fell pregnant, Powell briefly considered Greer Garson before alighting on the young and inexperienced Kerr. Throughout the film, she is treated with something close to reverence – as poetic muse rather than flesh-and-blood character. As an actress, she is shy and aloof. This is what makes her sudden slip from grace in *Black Narcissus*, when she is drawn into a

catfight with Kathleen Byron, all the more startling. Like Fred Zinnemann who, a few years later, famously showed Kerr and Burt Lancaster rolling around on the beach together in *From Here to Eternity* (1953), Powell seemed determined to crack her very English reserve.

Calvert, Lockwood and Kerr all had a classless quality. There was nothing aloof about them, but nor did they indulge in bawdy comedy of the Squibs variety or play the 'bad time girl'. This was surely the bedrock of their appeal. However far they strayed, whether they went to Hollywood or were cast as exotic villainesses, their images remained unshaken with fans who cherished their very familiarity. In their British films, at least, they appeared in 'respectable' genres. (The Gainsborough melodramas may have been frowned upon by critics, but even they were steeped in familiar notions about class and privilege – the wicked lady was still a *lady*.) Such actresses were seldom to be seen in exploitation, science-fiction, gangster or horror pictures, genres still considered tawdry and unwholesome.

There was no escaping the paradox that the 1940s presented to the industry. On the one hand, this was an era of consensus and co-operation. Stars seemed almost an anomaly at a time when old hierarchies were crumbling. After the war, British film-makers attempted to increase production (120 films were produced in the UK in 1949 as opposed to 44 in 1946). Even as they did so, various parties squabbled as to whether the industry needed a star system at all. Tom O'Brien, MP and secretary of the National Association of Theatre and Kine Employees, argued in 1948 that 'the star system might have been OK once, but it's no good now; it's hampering production ... the star system with its salaries is so wasteful.'[29] Ironically, even as he was arguing against the extravagance of star salaries, a producer like Betty Box, who was struggling against the odds to make half a dozen films a year at the dilapidated Islington Studios, was complaining about the shortage of star power at her disposal. 'With more and more films being produced in this country,' she argued, 'the handful of big-name stars is becoming increasingly inadequate to handle all the assignments.'[30] It was against this background that her brother Sydney Box had formed the 'Company of Youth' and that the Rank Charm School was established.

Superficially, O'Brien's hostility to the star system of the 1940s seemed to make sense. Many films performed respectably enough at the box office without big-name casts. Even so, the most popular British pictures

of the period invariably featured Margaret Lockwood, James Mason, Anna Neagle and Stewart Granger. Wartime audiences may often have preferred young, largely unknown British actors to their Hollywood counterparts,[31] but that state of affairs was not going to last. If British producers were to continue competing with the big American studios, it quickly became apparent that they would have to groom new stars of their own.

Notes

1. *Daily Telegraph*, 14 March 1938.
2. *Evening Standard*, quoted in Tims (1989), p. 115.
3. William Whitebait, *New Statesman*, cutting found on BFI microfiche on *The Man in Grey*.
4. *Picturegoer*, 22 July 1944.
5. This advertisement is found in the *Kinematograph Weekly* throughout 1924.
6. *Sunday Times Magazine*, 1 November 1970.
7. Leslie Arliss, 'I Like Wicked Women', *Picturegoer*, 10 November 1945, p. 7.
8. Sydney and Muriel Box's diaries, 1945, BFI Special Collections.
9. James Mason, 'I May Find Myself Obliged to Emigrate', *Picturegoer*, 3 December 1945; 'Letters from Our Readers', *Picturegoer*, 9 January 1946.
10. For a more extended discussion of Rank's relationship with Hollywood, see Macnab (1993), pp. 51–81.
11. *Picturegoer*, 1 February 1947.
12. *Films and Filming*, October 1973, p. 34.
13. *Picturegoer*, 31 August 1946.
14. *Daily Express*, 19 April 1948.
15. Richard Winnington, *News Chronicle*, 17 April 1948.
16. Campbell Dixon, *Daily Mail*, 16 April 1948.
17. Contrast, for instance, Calvert with her family in *Picturegoer*, 23 June 1945, and Lockwood in her swimming outfit in *Picturegoer*, 9 December 1944.
18. Quote taken from BFI microfiche of cuttings on *The Wicked Lady*.
19. *Ibid.*
20. *Time and Tide*, 23 December 1944.
21. *New Statesman*, 16 December 1944.
22. *News Chronicle*, 30 June 1945.
23. For a more considered view of the relationship between the so-called quality critics and popular cinema, see J. Ellis, 'The quality film adventure: British critics and the cinema, 1942–1948', in Higson (1996).
24. *Picturegoer*, 23 June 1945.
25. *Picturegoer*, October 1945.
26. *Picturegoer*, 9 December 1944.
27. *Picturegoer*, 10 November 1945.
28. *Ibid.*
29. O'Brien is quoted in the *Daily Herald*, 21 February 1948.
30. *Picturegoer*, 7 December 1946.
31. See 'Are We Making Our Own Stars at Last?' *Picturegoer*, 14 December 1943.

Starmakers

> In that city of cheap human material, no dark and unusual passions can be aroused ... The Street of Crocodiles was a concession of our city to modernity and metropolitan corruption: obviously we were unable to afford anything better than a paper imitation, a montage of illustrations cut out from last year's mouldering newspapers. (Schulz, 1980, p. 66)

In Bruno Schulz's brilliant short story, 'The Street of Crocodiles', published in 1934, there is a prolonged description of what seems like a seething modern metropolis, complete with luxurious department stores, trams, businessmen scurrying between meetings, and bored, lascivious-looking shop-girls and prostitutes. Schulz is celebrating the sheer kinetic rhythm of city life and the almost erotic joys of mass consumption. The hub of his colourful, dynamic city is the Street of Crocodiles, a temple to shopping and decadence. The most exotic merchandise is available here. There is something titillating about the street itself, an alluring whiff of scandal. For the ingenuous, child-like narrator, walking along such a thoroughfare is a phantasmagoric, highly sensual experience, akin to trespassing in a forbidden palace. He describes it as 'an El Dorado for moral deserters' (Schulz, 1980, p. 68). The fact that the shop goods seem soiled and the salesgirls all have flaws in their beauty only adds to the exoticism.

Schulz is really satirizing the American dream: the irresistible lure of the idea of plenty fostered by Madison Avenue copywriters. The myth is so compelling that it extends even to a provincial 1930s Polish town like his own. However, when the shroud is lifted, he sees his little town as it really is. Like the gaudy paint on the cheap trinkets sold on the Street of Crocodiles, the veneer of sophistication conceals something tatty and

threadbare beneath. 'Reality is as thin as paper,' the narrator notes, 'and betrays with all its cracks its imitative character' (Schulz, 1980, p. 70).

On the face of it, Schultz's little parable does not seem to offer much of an insight into the predicament of British film production in the post-war years. However, the model that the Polish writer draws of a town attempting to emulate American-style luxury strikes a familiar chord. Like the denizens of the Street of Crocodiles, British film producers of the late 1940s were stymied by their lack of resources and intimidated by their rivals across the Atlantic. While it is glib and simplistic to dismiss British stars of the period as lesser imitations of their American counterparts, it is nonetheless true that the star system was modelled on its Hollywood equivalent. From the seven-year contracts which Rank offered its artists to the poses struck in publicity stills, the American influence was always evident. Along with it came an inferiority complex. On economic terms alone, British stars could never hope to compete with their American counterparts. They were not paid as much. Whereas there were eight studios regularly giving actors and actresses long-term contracts in Hollywood, there were only two outfits doing the same in Britain – the Rank Organization and the Associated British Picture Corporation – and neither had the resources or the expertise in star-building of, say, Metro-Goldwyn Mayer. (In 1949, its Silver Jubilee year, MGM had 80 stars under contract, Judy Garland, Fred Astaire, Gene Kelly, Frank Sinatra, Elizabeth Taylor, Ginger Rogers, Clark Gable and Lana Turner among them. At one stage, the Rank Organization had roughly the same number of artists under contract, but few were household names.)

The *Picturegoer Film Annual* of 1949 underlines both British cinema's dependence on Hollywood for its frame of reference, and the gulf which separated the two industries. Stars, editor Connery Chappell argues in his introduction, are what lure British cinemagoers into the theatres.

> What is it that takes us out on a cold evening in early winter, perhaps to queue for half an hour in the bite of an east wind? Why is it that we ignore discomfort to see the film of our choice? More than any other single factor, the answer is: the stars themselves ... they are the heroes, the heroines, the rascals or the comics of a shadow world into which millions of us are happy to escape. (Chappell, 1949, p. 3)

Having issued this manifesto, the annual then launches forth into a

series of essays about leading screen personalities. The majority of the stars featured are American, but there is also an attempt to foreground home-grown talent, for instance a laudatory piece about Anna Neagle, 'the premier film actress of Britain', by Wilson d'Arne which scolds highbrow British critics for looking down their noses at films like *Spring in Park Lane* (1948) and *Maytime in Mayfair* (1949). He warns such critics not to search for gloom and meaning in the Neagle films. 'They are always simple tales, simply told, dealing in the main with nice people doing nice things' (*ibid.*, p. 6). Leonard Wallace, meanwhile, muses on the ups and downs in Margaret Lockwood's career: '*The Wicked Lady* was, to my mind, shabby and pretentious but in spite of that it had, basically, a perverse romantic spirit that atoned for the deficiencies of its plot. Margaret herself was superb. She had never looked more beautiful and she wore her fine period clothes magnificently.'

Unfortunately, Wallace believed, her career had since come unstuck on the back of a series of inappropriate roles, 'the kind it is nicer to forget' (*ibid.*, p. 11). She had even been toppled from her place at the top of the fans' popularity polls by Neagle. Other sub-sections in the annual mention British supporting players such as Eric Portman ('He seems doomed to play sinister, psychopathic characters'; *ibid.*) and Jack Warner and Jimmy Hanley: 'Both have come up the hard way. Both have a neat sense of character and can do that rare thing – give a realistic study of a typical English working man' (*ibid.*, p. 36). There is even a chapter on British stars of the future. (Most of the names mentioned, Dirk Bogarde apart, are long since forgotten.)

Despite the enthusiastic flag-waving on behalf of British stars, the annual cannot help but defer again and again to Hollywood. It reads like a small-town catalogue in which local products are dutifully listed alongside the much more alluring merchandise from the big city stores. The air of defeatism is palpable. One essay proclaims: 'Frank and enthusiastic, Diana Dors is probably the closest thing we have in this country to a sex-appeal girl' (*ibid.*, p. 44). Dors is described as being 'something like an eighteen-year-old Mae West', but even as the comparison is made, it is acknowledged that she is an approximation, not the genuine article.

In the second half of the annual appear a series of short articles looking at certain types of star. These, too, are dispiriting reading from a British perspective. Each begins by listing the qualities of the Hollywood prototype,

and then assesses how closely its British counterpart comes to matching it. 'Stars for the Teenagers' pits Derek Bond, Ronald Howard and Maxwell Reed against the likes of Mickey Rooney and Judy Garland, but acknowledges that Hollywood's 'up-and-comers' have the edge. Again and again, the essays admit that, whether through their own short-comings or because of lack of opportunities offered them, the British stars do not quite match up. Maxwell Reed, for instance, possesses 'a mascu-line sex appeal that would have been exploited much more thoroughly in Hollywood than it has been in this country' (*ibid.*, p. 71), while British cinema's resident ingénues, Hazel Court and Carol Marsh, 'only need more specially tailored stories to put them on level terms with the Hollywood groomed Jane Powell and Elizabeth Taylor' (*ibid.*).

This special pleading continues in the chapter on child stars. Britain may never have produced its own Shirley Temple, but that is because of restrictive laws on child performers. Even 'in the teeth of these restric-tions', the annual suggests, the British have produced 'some brilliant youngsters': John Howard Davies, star of David Lean's *Oliver Twist* (1948), and Bobby Henrey, star of Carol Reed's *The Fallen Idol* (1948), among them. The young Petula Clark, whose credits already ranged from *I Know Where I'm Going!* (1945) to *Here Come the Huggetts* (1948) and *Don't Ever Leave Me* (1949), is also mentioned as a burgeoning new talent. The tendency to describe British stars solely in terms of how closely they approach Hollywood norms continues with the lengthy section on screen villains. 'Generally speaking, Britain has done little specialisation in this field. British producers have always relied on charac-ter actors to play the bad lads in character self-effacingly. They have not starred the brute, the tough egg, the suave cad' (*ibid.*, p. 116).

By the time the loyal *Picturegoer* journalists have gotten round to comparing 'Animal Stars of the Screen' on either side of the Atlantic, the mood has turned into one of grim defeatism. Marjorie Williams notes that Daisy, the dog who used to appear in the Blondie films, the popular series about small-town America made at Columbia in the late 1930s, earned £200 a week despite being 'of incalculable birth and features' (*ibid.*, p. 74). Skippy, the terrier from *The Thin Man* series, reputedly earned £900 a week when it was dragged over from the States to star opposite Gracie Fields. Even Buttons, the hairy mongrel who barked up a storm in Billy Wilder's *The Emperor Waltz* (1947), was insured for £6000. Few two-legged British actors received such lucrative or

favourable deals. Outside Cecil Hepworth's valiant mutt who saved the baby in *Rescued by Rover* (1905), no British dogs had made any sort of lasting impression on the movies. Hollywood's favourite pets earned more than the majority of British stars.

On one level, the fact that British film actors of the 1940s did not earn vast salaries or appear in glossy magazines wearing expensive clothes was to their advantage. Some fans welcomed the move away from fantasy and escapism to understated British realism. 'We are sick and tired of having American films (chiefly second-rate) rammed down our throats,' wrote one.

> And please don't say, 'Do you have to go, there is plenty else to do.' They may be slick of production and technically sound, but they are filled with oomph-oozing women, their bodies covered or uncovered to stimulate the sexual rather than the artistic senses ... Imagine, therefore, what refreshing contrasts are provided by British films full, as they invariably are, of superb acting by people full of character, and in which one can almost exist, so realistically and vividly are they portrayed.[1]

Another reader complained angrily after seeing publicity photographs taken of the Welsh-born actress Peggy Cummins after she had moved to America. 'Hollywood has been at its old game of glamourising again,' the letter-writer alleges. 'If Hollywood turns Peggy into just another "glamour girl" she will soon lose a host of fans over here. We do not judge an actress's acting ability by the strength of her beauty – we judge her for her acting alone.'[2] This, of course, was not true at all. British fans were no more immune to glamour than their American cousins. If anything, their hunger for glossy, Hollywood-style escapism was stronger than ever in the austerity-worn Britain of the 1940s. For every letter from a disgruntled cinemagoer about a British star being 'spoiled' by Hollywood, there were others endorsing the glamour and aloofness of the Americans.

There is supposed to be an element of transcendent mystery about stars. They are spoken about in terms of essences – as flickering shadows with strange totemic power. They make some sort of inscrutable pact with the fans who deify them. 'No machinery ever of itself and by itself made a star,' critic Richard Griffith observed. 'That takes place in the depth of the popular unconsciousness' (quoted in Dyer, 1979, p. 23). In

his influential book on cinema stardom, Edgar Morin drew a distinction between the silent era when, he suggests, stars were profane idols, 'prepared to steep themselves in death', and the 1930s, when they became more and more secularized (while still retaining their mythic qualities). 'The great archetypes of the movies give way to a multitude of hero-gods of "average greatness"' (Morin, 1960, p. 23).

Morin's mercurial, fascinating study makes sense as far as Hollywood is concerned, but is problematic when applied to British cinema history. British stars, even in the silent era, were never really archetypes. Whether because they emerged from the stage or music hall, or because they were 'created' in reaction to Hollywood avatars, or because they flitted between genres, they lacked mystique. Many of the most successful (Fields, Formby, Balfour) were popular not because they were glamorous and aloof, but because they were homely and accessible. Nevertheless, Hollywood set the template. Throughout the 1920s and 1930s, British fan magazines and trade papers are full of stories about 'the new Valentino' or the 'new Pickford' or the 'new Fairbanks'. In the face of bitter experience, which might have been expected to teach them otherwise, producers, casting directors and publicists continued to believe that it was possible to manufacture stars, and used a wide variety of ruses and stunts with this in mind.

Olive Dodds, in charge of Rank Contract Artists in the late 1940s, was involved in one of the British film industry's most thoroughgoing attempts at unearthing new stars, but her description of how Rank's notorious Charm School and contract artists system operated in the late 1940s and early 1950s offers plenty of clues why it, like so many other previous initiatives of the same sort, failed. The Rank star-making operation, it seems, was rooted in snobbery, eccentricity and a very British kind of amateurism.

'In our absolute heyday, we had seventy or eighty stars under contract,' Dodds recalled in an interview, 'but we didn't often get as far as that.'[3] Although the Rank Organization was seemingly determined to create a star system along Hollywood lines, senior executives weren't able to take the enterprise seriously. She remembers that when she was in charge of contract artists, she was invariably called in as light relief at the end of dreary boardroom meetings. 'And now, Mrs Dodds, what have you got to amuse us with this week?' was the question that would greet her arrival.

The Rank Charm School was a refinement of an initiative originally begun by independent British producer Sydney Box at the tiny Riverside Studios in London in late 1945. Box, an avowed admirer of Hollywood producer David Selznick's system of putting promising young artists under contract, was eager to do something similar in a British context. Inevitably, his enterprise would be on a modest scale, but he still hoped to nurture some new talent. 'We have signed up a youngster, Maxwell Reed, who looks exceedingly promising,' Box wrote in a diary entry in December 1945. 'We are signing up half a dozen more, in order to do six pictures under a new banner, the Company of Youth, which will be virtually a film repertory company for training young people.'[4] As his sister and co-producer Betty Box recalls, creating stars was not the main priority. What he offered his charges was the equivalent of a screen-acting apprenticeship:

> Sydney set up the Company of Youth to find people who looked as if they would be good actors or actresses. He wanted them to see how films were made. They could come whenever they liked to the studios and watch what was happening. We'd give them any parts we would find for them. They were all in their late teens or early 20s. They got paid every week and any clothes that were provided for them they were allowed to keep, and that sort of thing. And they were given lifts to the studio. It was very small-scale by present day standards.[5]

When Sydney Box was hired by Rank in 1947 to run Gainsborough Studios, he took the Company of Youth with him. In Rank's hands, it quickly mutated into the Charm School (the name itself was coined by journalists), which had a very different agenda. The onus now was on searching for potential stars, not simply encouraging young actors. 'The whole thing was based around good-looking girls,' Dodds observed. 'It was the way you looked nine times out of ten. We weren't putting character actors under contract at that stage.' Even Dodds acknowledges that some of the starlets 'were absolutely useless, except photogenically'.[6]

Procedure was soon standardized. Once a starlet was put under contract, she would have her picture taken by Cornel Lucas, Rank's official photographer, and would be given a three month trial. 'We'd pay her £20 a week, guaranteed, even if she didn't work.' Between film assignments,

the starlets were kept busy at the Charm School itself, a large church hall in Highbury (next to Rank's tiny Highbury Studios) where they would be taught elocution by the formidable voice expert Molly Terraine and made to wander round with books on their heads in deportment class to improve their posture, 'as if our goal was to be models in a department store' (Lee, 1978, p. 132). A few men were taken on as well as women, Anthony Steel and Christopher Lee among them. 'Molly took no impertinence, nor idleness,' Lee later recalled (Lee, 1978, p. 132). 'She was terrifying but her blue eyes twinkled.'

Steel, Dodds remembers, 'wasn't a very good actor. He was all right in action-adventures because he was athletic, he liked the open air and he spoke well. He was a sort of gent, you know, and in those days, that mattered a bit more than it does now. He went to a decent school.' Her recollections about how Terraine strained even the slightest hint of a vernacular accent out of Rank starlets like Susan Shaw (the erstwhile Patsy Sloots) and Diana Dors reinforces the impression that the Charm School was the British film industry's answer to a young ladies' finishing school. British films of the time, Dodds suggests, 'didn't take kindly to heroines being cockney unless they were playing Pygmalion or something.' Even an exuberant sex symbol like Diana Dors was put under pressure to conform. Dodds recalls driving along Knightsbridge one morning and seeing Dors walking down the pavement. 'She was wearing red shorts which barely reached her thighs and a very open-necked blouse. She was carrying a large brown paper bag full of cherries. She was eating the cherries and spitting the stones out onto the pavement.' Dodds called her into the office for a severe reprimand. 'Diana, you can't do that! You just can't, darling. You'll get terrible press. Remember you're supposed to be a lady!'[7] It took a long while for the Rank Organization to realize that Dors was (in Olive Dodds's phrase) 'of the people'. Confronted with the British film industry's one serious sex symbol, they wanted to stop her peroxiding her hair and conceal her bustiness – in short, to strain out her individuality.

The Charm School retains its fascination both as a sociological phenomenon and as one of the British film industry's boldest publicity coups, but it conspicuously failed to create many new stars. Sydney Box's original intention was to train up young actors. By the late 1940s, sceptics argue, it existed solely for the purpose of discovering as many pretty girls as possible. Before they had even appeared in any films, these young

ingénues were dispatched to film premières in dresses from the studio costume department and sent in convoys all over the country to meet a British public, who, during austerity days, were starved of any kind of glamour. If they read in the paper that a Rank starlet was coming to town, they were prepared to give her the benefit of the doubt, even if they did not have a clue who she was.

Recruitment at the Charm School proceeded on an ever more eccentric basis. Many fledgling starlets were chosen because they bore a slight resemblance to some Hollywood name or other. A certain Constance Smith, for instance, was put under contract because she looked like Hedy Lamarr from a distance.[8] There was also a steady supply of beauty contest winners whose prize was a month's placement and, with it, a tantalizing prospect of a long-term film contract.

When they weren't servicing the British public, the starlets had an even more inglorious function. Every week, David Henley, Rank's head of contract artists would throw a cocktail party, ostensibly to allow producers and directors to size up the new acting talent. Cynics believe that it was not only the acting talent the producers were interested in. Given Rank's strict Methodist background, the idea of the Charm School as a glorified seraglio seems incongruous, but according to some of the starlets themselves, this was what it became. In a BBC documentary, Diana Dors recalled that she was only fifteen when she arrived in Highbury, having been discovered by Sydney Box a few months earlier.[9] She believed she was being sized up as a prize catch. Only when Sydney Box issued a statement warning Rank's would-be satyrs that she was under age did the harassment stop.

The key criticism levelled again and again at the Charm School was that it did not guarantee its charges, old or new, any work. Some might occasionally be given bit parts in the low budget B-pictures being shot one door up the road at Highbury Studios. One or two landed reasonable roles in Ealing films (waif-like Peggy Evans was drafted in as Dirk Bogarde's girlfriend in *The Blue Lamp* (1950) and Barbara Murray was cast in *Passport to Pimlico* (1948)) but none of Rank's producers were under any obligation to hire the starlets, most of whom couldn't act anyway. Christopher Lee recalls that his best, and probably only valuable, experience during his stint at the Charm School was when he was called upon to 'stooge' for other, more established actors during the screen tests for *Saraband for Dead Lovers* (1948).[10] This meant that he

stood with his back to the camera and fed lines to the stars auditioning for the main parts. By watching these stars in action, he claims, he learned more in an afternoon than he did in weeks of walking round, doing breathing exercises for Molly Terraine's benefit. (The school itself did not have any movie cameras.) Nevertheless, he was not entirely cynical about his time in Highbury. 'It was a brave idea, even a good idea. Learning acting techniques takes at least ten years and it can't be taught, but there's no reason why a school shouldn't make a start' (Lee, 1978, p. 132).

Interviewed in early 1995, Dodds continued to defend the Charm School. 'It was the sort of further training that they wouldn't get normally', and confirms that many of the Rank starlets made 'good marriages', even if they conspicuously failed to make good films or, indeed in many cases, any films at all. Theo Cowan, Rank's tireless publicity chief, also maintained that it was a good idea. In the late 1940s and early 1950s, he pointed out, there were many, many more newspapers and magazines than a generation later, and all of them had a seemingly inexhaustible demand for pictures and little stories about the starlets. The starlets themselves were often disconcerted at receiving all this publicity when they had done nothing to deserve it, but Cowan and his colleagues were merely catering to press demand, which itself was fuelled by public demand.[11]

In the end, the Charm School graduates risked losing their individual identities. They were the equivalent of members of a chorus line or cigarette girls. They were known by the generic term 'Rank starlet'. This, of course, defeated the purpose of setting up the school in the first place. By whatever definition, stars are supposed to be individuals, not homogenized as part of some publicist's idiosyncratic campaign. Some of the starlets, however, did go on to become fully-fledged stars. The emergence of Dors, Lee and Steel was not a bad return on a short-lived enterprise. Even if it didn't do much with the young talent at its disposal, the school kept that talent within the Rank orbit until such time as other studio producers were ready to employ it. Nor can it be said that Rank's young contract artists were denied experience. Lee appeared on stage at the Connaught Repertory Theatre in Worthing (with whom Rank had struck an agreement to allow his young, would-be stars stage experience) and on television during his time at Highbury.

There is something paradoxical about setting up a school which is going to train its charges to be unique. In their 1951 comedy, *Lady*

Godiva Rides Again, Launder and Gilliat lampoon the entire benighted enterprise. A story of a waitress who wins a beauty contest and is taken in at the school as a result, it shows both the absurdly authoritarian regime run by Terraine and the shaky career prospects for any of her charges not lucky enough to contract a good marriage. The heroine in this case (Pauline Stroud) becomes a striptease artist before she is finally tracked down and rescued by her family.

The Charm School's lasting legacy to the Rank Organization was of dubious value. Although it was closed down during Rank's financial crisis of 1949/50,[12] the contract system remained and indeed blossomed in the 1950s. More and more actors were signed to Hollywood-style seven-year deals at 'the Rankery', as it was nicknamed. Ironically, at the time that the Rank Organization was expanding its star stable, the Hollywood contract system was breaking down. In the wake of the Paramount decrees of 1948, the studios' stranglehold on the US market was loosened. The majors, who were vertically integrated, were forced to sell off theatres. Television was beginning to replace filmgoing as the dominant leisure pursuit. Production fell, revenue fell. As Tino Balio notes, 'in an attempt to reduce overheads, actors, writers, producers and directors were taken off long-term contracts or pared from the pay-rolls. Actors were particularly affected: in 1947, 742 were under contract; in 1956, only 229' (Balio, 1976, p. 316). In the mid-1950s, Rank, a single studio in opposition to Hollywood's eight, had over 50 artists under contract (McFarlane, 1997, p. 542). On the face of it, this suggests that the British star system was in better health than its American counterpart. However, the statistic is deceptive. The stars who flourished in Hollywood in the 1950s continued to overshadow their British rivals both in profile and in earnings. This was the era of Marilyn Monroe and Jayne Mansfield; of Elizabeth Taylor and Grace Kelly. Donald Sinden, who was a Rank contract artist with a standard seven-year contract, was left in no doubt about the gulf between British and Hollywood stars when he was loaned out by Rank to appear opposite Clark Gable, Ava Gardner and Grace Kelly in John Ford's *Mogambo* (1953). One morning, shooting in location in Africa, he was sitting back in the make-up chair, having a snooze, when he noticed – to his horror – that an assistant was shaving off his chest hair. Sinden was hirsute but Gable was not. The MGM bosses refused to risk their own ageing star being eclipsed by a more masculine-seeming British newcomer.[13] Not only did Sinden suffer the indignity of

having his chest shaved. The pecking order was also made clear to him when he came back to London to do the studio work for the same film. 'Gable received £750 a week apart from his salary – I don't know what that was – as his living expenses. I was being paid £50 a week in total. However you look at it, there is a discrepancy there' (McFarlane, 1997, p. 543).

For his £50 a week, Sinden was expected to behave; with Rank's contract stars, the emphasis was always on propriety. The men dressed and behaved like teachers in a public school. The women – Diana Dors and Joan Collins excepted – were put before the public as if they were the film world's answer to débutantes – the young female aristocrats who, after attending a succession of lavish tea parties and balls, were presented every year at court (in front of royalty, not magistrates) as part of a bizarre ritual known as 'coming out'. In short, Rank's contract artists were gentrified.

A 1956 Christmas edition of *Picturegoer* features a photospread of a leading British star in what fans must have assumed was his natural habitat: 'a charming Tudor house set in the middle of an olde worlde English garden', as the magazine puts it.[14] John Gregson, the actor in question and star of such quintessential 1950s British movies as *Angels One Five* (1952) and *Genevieve* (1953), is shown at home with his wife. He is wearing a tweed jacket and smoking a pipe. That was only to be expected of 'the chap'. A series of photographs show him in different poses. He is, variously, 'the ardent gardener', 'the book lover', 'the expert chef', 'the accomplished musician' and 'the life and soul of the party'. All the pictures are undercut with the irony which passed for humour at Pinewood in the 1950s. For instance, Gregson as 'book lover' is shown poring over the pages of a trashy magazine while Gregson as 'connoisseur of fine art' is busy scrutinizing a selection of pin-up girls.

The picturespread, like the films Gregson appeared in, seems caught in a time-warp. This is late 1956, but Gregson belongs in a different universe from Brando, Dean or Elvis Presley. No hints of disruptive youth culture enter his orbit. Like John Mills, Gregson was expert at playing decent, self-effacing characters, most typically his shy young airman in *Angels One Five*. He was a soft-spoken and introspective screen presence. On one level, this ought to have been a strength. Many of the best-known Hollywood stars – actors like Gary Cooper, John Wayne, Robert Mitchum and William Holden – were equally quietly spoken. Unlike

Kenneth More or Ian Carmichael, Gregson did not have one of those braying, affectedly cheerful public school voices. Nor was he hampered by the West End mannerisms that so many British stage-trained actors took with them to the screen. He belies critic Gilbert Adair's sweeping criticism that a 'British [screen] actor's face tends to be corroded by his experience . . . like his theatrical counterpart, the British film actor has not been trained to relax, to let go; to achieve the affecting stillness, the glorious laziness, of a Gary Cooper or a Robert Mitchum – no, even within a single frame enlargement, he can still be seen acting madly away' (Adair, 1986, p. 22).

Nevertheless, Gregson seems mild-mannered and anodyne rather than rugged and iconic. His low voltage may have been attributable to the type of films he appeared in. Driving a vintage car to Brighton in *Genevieve* hardly offers the same opportunities for striking heroic poses as, for example, saving a town single-handed, as Gary Cooper does in *High Noon* (1952).

One of the charges levelled at British films of the 1950s was that they were complacent. Whether Gregson in *Genevieve*, Kenneth More as Douglas Bader in *Reach for the Sky* (1956) or Dirk Bogarde as Simon Sparrow in *Doctor in the House* (1954), middle-class actors were invariably cast in middle-class roles. They could not help but seem smug. As Peter Stead observes in his study, *Film and the Working Class*,

> Quite obviously British cinema was waiting for its own Brando, for an actor who could embody social anger and yet combine it with some indication of his own confidence and vitality. More than anything else, the British cinema was crying out for an uninhibited display of masculine energy, preferably from an actor untouched and unprocessed by traditional home county and film studio blandness. (Stead, 1989, p. 90)

If the men lacked the rugged machismo that Stead suggests audiences were hankering for, the women were deemed short on glamour, sex appeal and even acting ability. While Diana Dors made headlines in Britain and the USA with her colourful private life, and even managed to land one or two tough, uncompromising roles, Margaret Lockwood's career was in terminal decline by the mid-1950s. In spite of her powerful performance in *Mandy* (1952), Phyllis Calvert was no longer the same force as in the 1940s. After *The Browning Version* (1951), Jean Kent only

appeared sporadically in British films. Jean Simmons had left Britain for Hollywood in 1950. Even Anna Neagle's best days were behind her. Their replacements hardly seemed to pass muster. Dirk Bogarde provoked outrage when asked by a *Picturegoer* journalist to compare British actresses with Brigitte Bardot, his co-star in *Doctor at Sea* (1955). 'Brussels sprouts and porridge! . . . When they [the British actresses] try to copy the foreign girls, they're just clowns. With their dyed hair, false bosoms and phony allure, they're affected, frankly comical . . . You see, Brigitte takes the trouble to put across sex as an act. With our girls, it's a farce.'[15]

Playwright John Osborne was even more damning in his comparison between Rita Tushingham, somebody he admired, and the actresses who then dominated British cinema. 'This apparently ugly duckling,' he remarked of Tushingham, 'has more expression and beauty when she crooks her little finger than most of those damned starlets will ever have – even if they waggle their oversized bosoms and bottoms from here to eternity.'[16]

Inevitably, British cinema of the 1950s was eventually jolted out of its complacency and forced to acknowledge that Dinah Sheridan ('with her friendly charm and crinkly, good-humoured eyes') and Kenneth More were not necessarily the only stars audiences wanted to see. The 'soap-flake arcadia'[17] of the Macmillan era was not as idyllic as some British film-makers liked to pretend. True, there was virtually full employment; cars, televisions and refrigerators were selling in profusion and new towns were springing up all over the country, but whatever the leaps in consumer culture and rise in the general standard of living, pockets of poverty and neglect still existed. Teenagers may have had more money than ever before, but with their increased spending power and independence, they now had the power to intimidate adults. The spiv of the post-war years – the type played by Bogarde in *The Blue Lamp* – metamorphosed into the Teddy boy, the rocker and the mod.

'The most damning thing one can say about most British films is that they're made for Mummy,' remarked Gavin Lambert, editor of *Sight and Sound* (Stead, 1989, p. 188). By the mid-1950s, though, a new generation of critics, film-makers and actors was ready to harness some of the energy and anger of those caught in the margins of the new Britain. Lindsay Anderson, later a key film-maker in the British New Wave, was exhorting his colleagues to stand up, stand up! and get out and push! in a series of

polemical, bad-tempered articles written for the magazines, *Sequence* and *Sight and Sound*.[18] He railed against the dreary complacency of 1950s British cinema.

> One of the worst things was this restriction in terms of class; the subjects were almost invariably middle-class and the characters were middle-class, and this very much restricted the range of British cinema. Going with that middle-class quality was a lack of emotion and dynamic, a certain politeness which we didn't warm to and made us, back in those days of the late '40s and early '50s, prefer American films. (McFarlane, 1997, p. 10)

Older film-makers persevered in treating any subject that fell outside their own norms of decency and good taste as 'other'. As John Hill has observed, between 1953 and 1963, a new genre emerged – the social problem film. 'Topics such as juvenile delinquency, prostitution, homo-sexuality and race became standard preoccupations.' The social problem film invariably offered an exploration of some social malaise or other. It patronized its subjects, treating them as guinea pigs to be observed rather than as characters in their own right. Films like *Violent Playground* (1958), *Flame in the Streets* (1961) and *The Angry Silence* (1960) approached juvenile delinquency, racism and (a little bizarrely) trade unionism as if each was a problem which could be parried by the very act of dealing with it in dramatized form.

As the 1950s progressed, the 'chaps' – Kenneth More, Jack Hawkins, John Gregson *et al.* – were challenged by a new kind of star embodying what John Boorman has described as 'the best qualities that came out of the post-war upheavals of Britain' (quoted in Feeney-Callan, 1983, p. 1). As Boorman argues, 'The reform of education, the busting of the BBC's monopoly and so on allowed a lot of talent to flourish.' There was a new egalitarianism, reflected in such political initiatives as the 1944 Butler Education Act, which raised the school-leaving age to 15 and the expan-sion in state education and school building which accompanied it. Any child from whatever background who passed the 11+ exam and won a place at grammar school was given the sort of opportunities which hitherto had been the exclusive preserve of a tiny public school elite. Academia was further opened up by the establishment of seven new universities (Sussex, East Anglia, York, Kent, Warwick, Lancaster and Essex) in the early 1960s.The forming of the Independent Television

Authority (the ITA) in 1954 and the start of commercial TV in the UK a year later heralded a new populism.

Actors like Stanley Baker, Patrick McGoohan and, a little later, Sean Connery brought a physicality to their roles in *Hell Drivers* (1957), *The Criminal* (1960) and *Dr No* (1962) which their tweed-jacketed predecessors could not match. There was also a shift in the type of stage actor recruited by British cinema. Instead of mellifluous Shakespearian stars like Gielgud or Olivier, rougher, more aggressive tyros were lured in front of the camera. The *Evening Standard* labelled the youngsters (Peter O'Toole, Albert Finney, Richard Harris) who moved between theatre and cinema in the late 1950s as the 'ginger group'.

> On a wave of whisky and expletives, these young performers, from Salford, from Ireland, from the East End of London, have risen to power in a revolution that may have been bloodless, but has certainly not been 'bloody'-less. Even such long-established terms of theatrical endearment as 'Dahling' and 'Deah Boy' are being superseded by 'mate' and 'cock'.[19]

The phenomenon of 'the angry young man' has been exhaustively discussed elsewhere (for example, in Ritchie, 1988). It was only to be expected that the impact of *Look Back in Anger*, which was first mounted at the Royal Court in May 1956, and of such novels as John Braine's *Room at the Top*, Alan Sillitoe's *Saturday Night and Sunday Morning* and David Storey's *This Sporting Life* – all later to be made into movies – would be felt eventually by British cinema.

Critics of the time were often hostile to Britain's New Wave directors, Tony Richardson, Lindsay Anderson, Karel Reisz and John Schlesinger, who came to cinema via Oxbridge and the Royal Court Theatre. In a dismissive review of *This Sporting Life* (1963), the *Guardian* sneered at the way these middle-class southerners fetishized the industrial north, going 'in search of the tougher living and richer accents which suit their sociological tastes'.[20] Dilys Powell dismissed the rebelliousness of the Arthur Seaton character in *Saturday Night and Sunday Morning* (1960) as little more than adolescent truculence: 'A rebellious start to life has always been common,' she observed. 'In the eighteenth century the rebel turned highwayman and was hanged. Today, he is merely rude in pubs – until he gets tired of it.'[21] Meanwhile, C. A. Lejeune pronounced herself baffled by the unusually frank sex scenes in *Room at the Top* (1958), one

of the first mainstream British films to be given an X-certificate. 'I wasn't much impressed with what I saw, and what remains in my mind is a series of enormous close-ups, so large that every pore was magnified, with the forehead frequently cut off to make room for the nude upper torso, registering the supposed ardours and satisfactions of a physical relationship.'[22]

The X-category had been introduced in 1951, but had previously been associated with exploitation films. As historian Robert Murphy notes, the Secretary of the British Board of Film Censors regarded *Room at the Top* as 'an ideal opportunity to re-establish its respectability' (Murphy, 1992, p. 15). No longer would 'adult' entertainment be synonymous with seediness. The relaxation in censorship encouraged film-makers to broach subjects which would previously have been regarded as taboo. Whether pregnancy outside marriage (*A Kind of Loving*, 1962), homosexuality (*The Leather Boys*, 1963; *Victim*, 1960), juvenile delinquency (*The Loneliness of the Long-Distance Runner*, 1962), race relations (*Sapphire*, 1959), film-makers were prepared to broach much tougher subjects. A young generation of British directors, strongly influenced by the French *nouvelle vague*, were determined to shoot their movies on location, away from the anaesthetized world of the studios. This encouraged a shift in British film acting towards a new kind of naturalism. Roughness and improvisation were encouraged. The Free Cinema manifesto proclaimed that perfection was not the aim ... life was more important (Richardson, 1993, p. 109).

The 'northern' is sometimes cited as Britain's answer to the Western. The industrial heartland is seen as a tough, mythical landscape which provides the same contrast to the soft south of England as the wild west does to the east coast of America. In the 1930s and 1940s, 'northern' cinema consisted of Frank Randle, Gracie Fields and George Formby vehicles, none of them held in especially high regard by the London-based critics. Twenty years later, the New Wave films were often greeted in equally sceptical fashion. Both geographically and in terms of their storylines, they were considered too radical a departure from the cosy certainties of 1950s British cinema. They were all too clearly not films 'made for mummy'.

Albert Finney's Arthur Seaton in *Saturday Night and Sunday Morning* is the antithesis of 'the chap'. A Nottingham lathe operator who refuses to be browbeaten by either his bosses or his family, he shows the same

restless energy as, say, Brando in *On the Waterfront* (1954). Whether haranguing a colleague while simultaneously gobbling a ham sandwich, scaring a fellow worker with a dead rat, downing pint after pint of beer, or casually running after and jumping on a bus, he sets the terms. He has his own pet mantra: 'Don't let the bastards grind you down!' He channels his anger and frustration into a defiant hedonism: 'All I want is a good time, the rest is propaganda.'

Finney, a former understudy to Laurence Olivier, had trained at RADA and was an acclaimed classical actor. But there was nothing rarefied about him. Born in 1936, the son of a bookie, educated at Salford Grammar School, he was a long way removed from the public schoolboy-type heroes who featured so prominently in 1950s British cinema. Critic Kenneth Tynan likened him to John Garfield, 'a romantic star who made his name playing earthy, minority roles, mostly of working class. Garfield was Jewish. Finney comes from the North County, which is British showbiz equivalent.'[23] The comparison may seem outlandish – to most eyes, the small, pugnacious American star of *The Postman Always Rings Twice* (1946) and *Force of Evil* (1948) seems nothing like Finney – but it highlights the shortage of other, similar British role models. For Finney in *Saturday Night and Sunday Morning*, Brando and Garfield, not David Farrar, were the points of reference.

As if to further distance himself from the 'chaps', Finney refused to take part in Rank-style publicity campaigns. After extensive screen tests, he turned down the lead role in David Lean's *Lawrence of Arabia* (1962) because he did not want 'to become a star'. As he put it, 'I hate being committed – to a girl, or to being a film producer, or to being a certain kind of big-screen image' (Turner, 1994, p. 44). Finney had a three-picture deal with Tony Richardson's Woodfall Films (Richardson, 1993, p. 120) but this was not comparable to being a contract artist with the Rank Organization. He did not do publicity chores or open village fêtes or invite *Picturegoer* journalists into his home. His disdain for the very idea of stardom was shared by his contemporary, Tom Courtenay, who also refused to play the studio game after his initial success in *The Loneliness of the Long Distance Runner* and *Billy Liar* (1963). 'I never did anything about my stardom, it never meant anything to me,' Courtenay later reflected. 'I'm not sure that being a movie star appeals to many English actors' (McFarlane, 1997, p. 142).

Arguably, Finney and Courtenay's blithe disregard for the phenom-enon of stardom made them all the more credible as stars. Unlike the actors who appeared at premières and in magazine photospreads, they were not in the business of ingratiating themselves with fans. Their aloofness, individualism and flat northern accents gave them a distinct identity which most packaged personalities lacked. Although they were compared to Brando and Garfield, they were never accused of trying to imitate them.

In all the key New Wave films, the heroes are made to suffer. In *The Loneliness of the Long Distance Runner*, Courtenay is shown in near-agony at the end of a cross-country race. In *Saturday Night and Sunday Morning*, Finney is unceremoniously beaten up by the brothers of his married mistress. Most brutal of all is *This Sporting Life*, which begins with Richard Harris's rugby league star Frank Machin crumpled in agony on a doctor's chair. The rawness, bruising and indignity – the sheer masochism of the films – provides a stark contrast to the sanitized world shown in bright, cheerful films like *Doctor in the House* and *Genevieve*. While Reisz, Anderson and co. risk reinforcing macho old stereotypes about the grim north (for some reason, always shot in black and white), they also achieve an emotional intensity rarely found in the gentrified Pinewood comedies or war films of the 1950s. As Penelope Gilliat notes of *This Sporting Life*, 'It has a blow like a fist. I've never seen an English picture which gave such expression to the violence and capacity for pain that there is in the English character.'[24] Audiences were warned that the film 'would break over them with chilling, bone-crunching ferocity. It is just about the most savage, blood-congealing film ever made in this country.'[25]

Frank Machin and Arthur Seaton may be working-class characters with few prospects, but Anderson and Reisz give them a mythic, larger-than-life quality. As one reviewer noted of *This Sporting Life*: 'Mr Harris's very stature is so cosmic that, when he gathers a rugger ball, he holds it as mightily as Atlas holding the world.'[26]

John Hill has argued that 'misogyny was embedded in the very struc-ture' of Britain's New Wave films, and that they should not therefore be seen as 'progressive' (Hill in Curran and Porter, 1983, p. 304). He further suggests that Anderson, Reisz and their colleagues placed such emphasis on 'the ideology of the individual' that their attempts at representing working-class communities were bound to fail. Still, the prevailing mood

of machismo in *This Sporting Life* and *Saturday Night and Sunday Morning* ought to be put in context. In Anderson's work, there is at least the hint of a homo-erotic subtext. He fetishizes the male body. Neither Seaton's nor Machin's treatment of women is markedly different from, say, the way Brando's character behaves toward Eva Marie Saint in *On the Waterfront* (1954) or James Dean toward Julie Harris in *East of Eden* (1955). It may be true, as Hill observes, that the women in the New Wave films 'function either as elusive objects of desire or as threats to the social/sexual order ... and, either way, must be brought under some kind of male control', but, by the same token, Simone Signoret in *Room at the Top*, Rachel Roberts in *Saturday Night and Sunday Morning* and *This Sporting Life*, Rita Tushingham in *A Taste of Honey* (1961) and Julie Christie in *Darling* (1965) are all fully-hewn characters. Like Harris and Finney, they are allowed to show a rawness and vulnerability that would never have been countenanced in the demure, more mainstream comedies and dramas being made at Pinewood. As Christie put it, 'suddenly naturalism – or realism – came in ... women were allowed to look natural. They didn't have to have their hair permanently fixed or make-up all over their face. We were able to challenge audiences to accept us, which they did' (McFarlane, 1997, p. 122). She describes the 1950s as a 'a very, very bad time for women in films'.

Christie, a graduate of the Central School of Speech and Drama, regarded film in the same haughty, suspicious way as John Gielgud and Michael Redgrave a generation before. Her language echoes theirs: 'I wasn't in the least interested in film acting, in fact I rather looked down on it. The films were an inferior way of expressing your art ... ' (McFarlane, 1997, p. 122). She railed against the 'fabrication of stars' and the 'sexual objectification of women'. Ironically, though, as with Harris and Finney, her sheer exasperation with traditional approaches to star-building was what made her seem so fresh. Her persona as a rebellious outsider was far more attractive to young filmgoers than the carefully contrived screen images of the typical British actresses of the time. Arguably, by ignoring the whole rigmarole of star-building, she actually made herself a bigger star. She won an Oscar for *Darling*, a sign that she was taken more seriously in Hollywood than most of her contemporaries. In *Billy Liar*, actress and role merge. Liz (Christie's character) is not bound by geography, class or convention. As Billy (Tom Courtenay) says in admiration, 'She works till she gets fed up and then

she goes somewhere else. She has been all over!' Whereas Billy is stuck in a small, provincial town and can only day-dream of leaving, Liz travels where she pleases. She tells Billy, 'You get on a train and four hours later you're in London.' Of course, the city brings its own set of problems. There, the rebelliousness which Christie personifies is regarded as merely chic. After *Darling*, she became one of swinging London's key icons. She became exactly what she set out to avoid – a movie star.

Christie's antagonism toward the star system of the time is easily understandable. The constraints under which 1950s British screen actresses worked were often oppressive. Rank Chairman John Davis demanded that Dinah Sheridan, the star of *Genevieve*, give up working after she married him. When the teenage starlet Shirley-Ann Field began her screen career in 1956, *Picturegoer* struck an absurdly moralistic note about her behaviour out-of-hours. 'Consider,' pontificated an editorial, 'the reputation that Shirley-Ann has garnered for herself over the past year – late or absent at appointment time, fond of high-living and visiting night spots, the girl has earned herself labels like Miss Sexy and Sexy Sarah ... a couple of weeks ago, I would have dubbed her one of the silliest girls in show business.'[27] When even the fan magazines were so prudish and censorious, it is little wonder that British actresses seemed all but shorn of glamour. The New Wave film-makers may not have been progressive in their sexual politics, but at least they didn't treat their actresses as overgrown children.

In the late 1950s, there was evidence of a shift away from the 'the league of gentlemen' (the title of a 1960 comedy starring Jack Hawkins and Nigel Patrick). Instead of dapper Anglo-Saxons, the Celts began to move into the limelight. Two of the most prominent, both actors who achieved international success, were the 'valley boys', Stanley Baker and Richard Burton.

Not long after Baker's death in June 1976, Burton wrote an extraordinary tribute to him. 'Lament for a Dead Welshman', a murderous love letter as Burton called it, is a rambling, mournful dirge, part obituary, part manifesto, which evokes the South Wales valleys, whence both actors emerged, with a mix of bitterness and awe. 'What the hell can you do if you come from such a murderous background?' Burton asks before going on to describe the bleak, denuded landscape that he and Baker inhabited as children. 'Those low hills, those lowering valleys, the Rhondda fawr, the Rhondda fach, and their concomitant buses and grey

roofs and pit-heads and dead grass and crippled miners and cages endlessly falling with your father inside and smashed to bits.'[28]

Baker's father was indeed injured in a mining accident. He lost his leg and with it his job. Times were tough. Still, in Burton's account suffering and deprivation take on a roseate hue. Even a little youthful delinquency is there to be celebrated. Burton recalls with relish the way Baker used 'to pelt the privileged as they came out of the grammar school because he was disallowed entry' and refers to his old friend as 'a terrifying old boot . . . with a face like a clenched fist'. Above all, he suggests that Baker lived life on an epic scale; that he was a colossus who, 'with a convulsive heave . . . shrugged off the mighty mountains and strode across Europe'.[29]

In his enjoyably hagiographic biography, *Rich*, Melvyn Bragg does something similar for Burton. At least, he first of all provides a context against which the tall tales told by the Welsh bards about their heroes must be judged. 'They [the Welsh] needed their myths. For the Twentieth Century facts were that they were a small, oppressed people, in thrall to the then almighty English and their sole singularity was the Welsh language, and only a quarter of them spoke that' (Bragg, 1991, p. 18).

Having issued this proviso early on, Bragg proceeds to weave a fine, embellished tale which even Thomas Mallory would struggle to match. He casts Burton as a latter-day Celtic king, Elizabeth Taylor as his improbable Guinevere, and suggests that every problem the actor faced in his professional and private life was a challenge he would have to overcome before he would 'properly be able to call himself a hero'. Even Burton's (indeed legendary) drinking is incorporated into the grand narrative without in any way affecting his status: 'another layer was added to the story: that of the hero taunting the fires of destruction and proving himself indestructible' (Bragg, 1991, p. 658).

Baker and Burton provide a stark contrast to the cheerful optimism which surrounded Rank's contract stars in the 1950s as they opened village fêtes, made personal appearances at cinemas and went off on jaunts to film festivals. The two Welshmen were truculent and self-destructive, not at all the types to do the publicists' bidding. Notions of loss, disappointment and betrayal are central to any understanding of their careers and of how they managed to become stars. They were both frequently accused of squandering their gifts. Towards the end of his life, Baker himself acknowledged that he had made more than 80 films, and 'all but five of them had been bad'. Burton was charged with an even

grosser dereliction of duty. He had been acclaimed as the greatest classical actor of his generation, but had abandoned Stratford and the Old Vic to seek riches in Hollywood. Critics were shocked to see him in the Cinemascope epic, *The Robe* (1950), and accused him of acting with his knees. (One might argue that this was a compliment: it is hard to think of many British actors who had the physical presence to appear in a toga without looking ridiculous.) They were equally startled to see him bleach his hair to play the title role in *Alexander the Great* (1956).

After Burton's death in the summer of 1984, an event which made front-page news on both sides of the Atlantic, his many obituarists were quick to quote Gielgud's off-the-cuff remark about 'his rather mad way of throwing away his theatre career'. They failed to appreciate that it was precisely this wastrel, carefree quality which made Burton such a star in the first place. Although, as Bragg points out, he was one of the highest paid actors of all time, precious few of his screen performances are especially memorable. His range was limited and he was only really at his best when playing losers. Defrocked priests, disgruntled teachers and crumpled, seedy spies were his speciality. (There was a little purple patch in the early 1960s when *The Night of the Iguana*, 1964, *Who's Afraid of Virginia Woolf*, 1966, and *The Spy Who Came in from the Cold* 1965, followed each other in fairly rapid succession.) But even a bad Burton performance had a certain gravitas. His rich, lyrical voice, stillness and self-assurance marked him out from the other lightweight leading men of 1950s British cinema.

Baker, too, was an imposing figure. 'He has the muscles, sinews and solidity of a young oak tree ... he is the handsomest and most manly looking man in British films,' enthused a *Daily Express* journalist in 1959,[30] before going on to bemoan the lack of decent parts Baker was given. A schoolboy boxing champion with a renowned mean streak, Baker had even managed to terrify his teacher, Glynne Morse. Morse recalls first meeting him in the autumn of 1939, as the Second World War was about to break out. 'It was at this time of violent eruption that Stanley Baker stuttered onto the stage of my life. It was the beginning of term at Ferndale Secondary School and among the new boys stood Stanley, dark, satanic' (Storey, 1977, p. 10). Baker's air of menace must have put off casting directors as well: the 'chaps', well-bred and in their flannel trousers, still monopolized most of the leading roles while Baker was reduced to character parts, often playing heavies.

Two American directors who came to Britain to escape the McCarthy witch-hunts were largely responsible for rescuing Baker's career. Cy Endfield and Joseph Losey spotted the Welshman as an actor in the mould of Lee Marvin or Robert Ryan, a square-jawed bruiser who was both surly and defiant. Endfield first used him in *Hell Drivers* (1957) opposite an equally stubborn Patrick McGoohan. Baker is cast as a petty criminal, just released from prison, who finds a job driving lorries full of ballast round narrow country lanes. He also starred as Lieutenant John Chard, a fearsomely courageous officer in a Welsh regiment who helps protect a tiny mission station against 4000 Zulu warriors in Endfield's *Zulu* (1963).

Perhaps Baker's quintessential role, though, was in Losey's *The Criminal* (1960). He plays Johnny Bannion, a professional crook. (His performance was based on Albert Dimes, a real-life London gangster with whom the actor was friendly.) Baker is at his most adamantine as Bannion. He refuses to defer to anyone, sneering at police officers and prison warders, raising his fist or his voice when anyone gets in his way. It is a genre commonplace that the lawless individual will always be stifled by the system. Too arrogant to compromise, Bannion ends up dead in the very ditch where he had hidden his stolen money. In his biography of Losey, historian David Caute observes that the director 'invariably used him [Baker] as the outsider, the loner who never fully belongs and does not wish to' (Caute, 1994, p. 187).

Arguably, Baker's and Burton's identities also risked becoming blurred. All too often, these Welsh heroes, full of antipathy for all things English, ended up cosseted within the establishment, knighted and asked to play English kings, generals, politicians or professors. Burton was cast as Henry II, Henry VIII, and even went so far as to play Churchill for television, surely a supreme act of treachery for a Welshman reared in the Rhondda. Baker played a range of police officers and army inspectors. However, even if their Welshness came under threat, they desperately clung to their masculinity. They sometimes gave the impression that they felt slightly embarrassed by acting; that it wasn't a manly thing to do. Brawling, drinking, invoking the myth of the Celtic hero born with an abundance of natural talent to squander must have been a way of compensating for the indignity of it all. Forced to wear flouncy costumes, pretend they were Anglo-Saxons and prance in front of the cameras, they could hide behind the coat-tails of their own national myths.

For both men, their mentors were schoolteachers. As Gwyn Williams points out in his critical history, *When Was Wales?*, during the Depression the only escape route from the pits was the exam obstacle race.[32] Through their very success in this race, Baker and Burton were wrenched away from their class and background. There was something of the Faustian pact about the journey which led them to become film stars. The pair were condemned to be outsiders, though deracination was a vital part of the myth that was woven around them.

Another Celtic actor in the same mould was Sean Connery, a working-class Scot whose progress from Edinburgh milkman to front-rank movie star is a conventional enough journey in Hollywood, but has few parallels in British cinema. Thomas (Big Tam) Connery was born in Fountainbridge, Edinburgh, in 1930. It is not quite clear when and why he changed his name to Sean. One theory suggests he borrowed it from the film, *Shane* (1953). (There is a certain irony in the idea of the big Scotsman taking his name from Alan Ladd, the most diminutive of all the Hollywood stars.) Connery's father drove vans. His mother was a charlady. He spent his childhood in an overcrowded tenement flat. When he was eight years old, he was delivering milk in the mornings and helping out in a baker's shop in the evenings. He left school at thirteen and worked as a cement mixer, a bricklayer, a steel bender, a lorry driver and a coffin polisher. He spent two years as a sailor before being invalided out of the navy with duodenal ulcers. But then he discovered his body. He started to pump iron, became a lifeguard at Portobello swimming pool, and moonlighted as an artist's model.

This in itself marks an interesting contradiction. On the one hand, Connery's image is of a dour, reserved man who achieved success through sheer toil. On the other, he is an exhibitionist who became famous by offering his body as a fetish object. He is at once an idol of consumption – a cut-out figure to be admired for his looks – and an idol of production – someone whose solid achievements are a spur to others, an example to be emulated. When he was lured back to play James Bond in *Diamonds Are Forever* in 1971, he demanded (and was given) what was reputedly the best deal since Mary Pickford's day. He donated most of his fee to a Scottish educational trust, and insisted that United Artists finance two further films of his choice. The first of these (the second is yet to be made) was Sidney Lumet's *The Offence* (1972), in which he played the far from sympathetic role of a policeman corrupted by many years of service who

loses his rag when confronted with a supposed child molester. It was one of his best performances, but seemed an unlikely choice of part for a star so concerned about his appearance that a few years later he would sue a magazine which had the temerity to suggest he was overweight. (Connery won his case: he was able to prove that his waistline was the same in 1983 when he made *Never Say Never Again* as it was in 1962.)

An archetypal Scot who made his fortune playing an archetypal Englishman, Connery's press releases and biographies, with their emphasis on his deprived upbringing and big heart, read like a piece of fiction concocted by the McIlvanney brothers, William and Hugh, who have been writing novels and filing sports reports about Scottish working-class heroes, bare-knuckled boxers and premier league football gods for years. (Connery himself, it turns out, was once almost a professional footballer with Matt Busby's Manchester United.)

Star stories are meant to be gilt-edged fables. Connery's exemplary rise abounds in both hardship and lucky breaks, the two key publicity elements. An official version was moulded in the early 1960s to fit the whims of Albert Broccoli and Harry Saltzman. The producers launched the search for James Bond with all the predatory showmanship of David Selznick on the prowl for Scarlett O'Hara. Trevor Howard, Cary Grant, Richard Burton, Patrick McGoohan, Roger Moore (two years older than Connery) and even David Niven were touted as possible 007s. In the end, Connery was chosen, ostensibly because he was 'unknown' and his star persona would not dent or erode Bond's appeal. Publicity proclaimed 'Sean Connery is James Bond'. He was the star as trademark: he was to connote Bond and nothing else.

The producers did not mind the stories about his tough childhood or his body-building, but they drew a veil around his previous acting career. In fact, by the time he was cast in *Dr No* (1962), Connery was already an established actor. His first appearance on stage was with Anna Neagle, when he was an extra in a production of *Sixty Glorious Years* at the King's Theatre, Edinburgh. In the early 1950s, arriving like many other penniless or fortune-seeking Scots in London, Connery won a bronze medal at a Mr Universe contest in the Scala Theatre. He was subsequently cast in a touring version of *South Pacific*, and was taken under the wing of a venerable old thespian, Robert Henderson, who prescribed him a stiff of highbrow literature – Stanislavsky, the whole of Proust, Thomas Wolfe. Just as he had catered for his muscles with the dumb-bells, now he

assiduously cultivated his mind: this was self-improvement taken to extremes.

Although he did not receive much formal training, Connery studied for three years with Yut Melmgeren, a Swedish dancer. Despite his difficulties in finding work – his pronounced Edinburgh accent grated on the nerves of numerous casting directors – he was more interested in movement and gesture than elocution. He had the conviction that information on screen could be conveyed visually: it did not need to be spelled out. This, perhaps, explains why American audiences, notoriously suspicious of the British accent in all its manifestations, were prepared to accept him. He knew how to move gracefully. Moreover, he was always as interested in cinema as in theatre. He did not have the contempt for the movies evinced by so many of his contemporaries, who seemed to regard the medium as a useful money-spinner but a very second-rate thing by comparison with the stage.

Connery made his film début in 1956 in *No Road Back*, a thriller in which he played a Scottish crook with a speech impediment. The following year, he had a bit part in Cy Endfield's *Hell Drivers* (1957). Opposite Patrick McGoohan and Stanley Baker, actors in a similar mould, he played one of a gang of reckless lorry drivers who haul ballast at breakneck speed down England's leafy byways. This was predictable casting: Connery as a working-class villain. Lead roles tended to be kept for better-mannered chaps. Although his was a relatively minor part, he was given the opportunity to strut around in his leather jacket to good effect, and to get involved in a bit of brawling and drinking.

Connery's first breakthrough came when he was given the role of punch-drunk boxer Mountain McLintock in a live BBC TV version of Rod Serling's play, *Requiem for a Heavyweight*. He garnered excellent reviews and earned a contract with Fox on the back of them. This, though, proved a false start. Fox had little idea how to use him and often left him languishing or hired him out to other studios. Thus he appeared opposite Lana Turner in *Another Time, Another Place* (1958) and was the romantic interest in the whimsical Disney fable of 1959, *Darby O'Gill and the Little People*. Arguably, he was too dark and brooding a presence for a Disney family film, but it was in *Darby O'Gill* that he was first noticed by Mrs Broccoli, who noted with alarm the violent way in which he kissed the heroine (Janet Munroe). Along with Anthony Quayle, he was the baddy gunning for Bond's iconic predecessor Tarzan

(Gordon Scott) in *Tarzan's Greatest Adventure* (1959), but his Hollywood career seemed to stutter from false start to false start.

It was on television that he had his biggest success. His outsize personality could barely be contained by the medium – it was inevitable that he would make an impression. And he was lucky with his roles. He was cast against type (dour, dark Scot as sun-bleached Greek hero) in Terence Rattigan's *Adventure Story*. Then, in 1961, he landed the plum part of Vronsky in Rudolf Cartier's BBC adaptation of *Anna Karenina*. Here, he boasts an impressive aristocratic swagger as well as an early version of the Connery moustache, and counters Claire Bloom's delicate, nervous performance in the central role with an earthy flamboyance. His most noticeable traits are his supreme self-confidence and relaxation. He is also threatening, bringing an undercurrent of malevolence and sadism to his role as Karenina's lover which would be further explored not just in the Bond series but, notably, in Hitchcock's *Marnie* (1964).

At around this time, Connery played Hotspur to Robert Hardy's Prince Hal in a staid BBC adaptation of Shakespeare's history plays, *The Age of Kings*. He appeared as a charismatic heavy in a noirish British thriller, *The Frightened City* (1961), and, in the same year, landed his first starring role in films, opposite Alfred Lynch in Cyril Frankel's *On the Fiddle*, an indulgent, eccentric British comedy of the type that would make Truffaut throw up his hands in horror. Set in the war years, it tells of a Cockney spiv who is inveigled into enlisting to avoid a court fine. The Cockney takes the brawny but simple-minded gypsy Pedlar Pascoe (Connery), under his wing, and together the two try everything in their power to 'fiddle' the army. The relationship between gentle giant Connery and sharp-as-needles Lynch recalls that between Lon Chaney and Burgess Meredith in *Of Mice and Men* (1939). Connery is encouraged to be gormless and displays a nice line in vacant smiles and self-deprecating humour, but this is as far away from Bond as you can get.

However closely he became identified with Fleming's character in the public mind, Connery refused to behave like Bond. In 1965 he directed a political documentary, *The Bowler and the Bunnet*, about shipbuilding on the Clyde. Connery himself narrates, and spends much of the time riding around Harland and Wolff's disused shipyard, wearing a cloth cap and looking like an old-style union leader. His easy switch from international spy to ardent trade unionist hints at what made Connery the star he was – his authenticity. At a time when British film actors seemed as

bland as the mass-produced, consumer goods that were pouring into people's homes, he was mercurial and contradictory. Like Burton and Baker, he combined physical presence with articulacy. It is intriguing to speculate what might have happened to him had he ever had the misfortune to be enrolled in the Rank Charm School. He would no doubt have been taught to speak in twanging BBC tones rather than in his Scottish burr. The costume department might have fitted him out with a tweed jacket and a pipe. Indeed, if it had been left to the British, Connery might never have become a star at all.

Notes

1. *Picturegoer*, 16 March 1946.
2. *Picturegoer*, 16 February 1946.
3. Olive Dodds, interviewed in London by the author in 1995.
4. Sydney Box's diaries, BFI Special Collections.
5. Betty Box, interviewed by the author in March 1996.
6. Dodds, interviewed by the author in 1995.
7. *Ibid.*
8. Barry Norman in the BBC documentary, *The Charm School*.
9. Diana Dors, *ibid.*
10. Christopher Lee, *ibid.*
11. Theo Cowan, *ibid.*
12. For an account of how the Rank Organization plunged £15 million into the red, see Geoffrey Macnab (1993).
13. From the author's interview with Donald Sinden, 1992.
14. *Picturegoer*, 22 December 1956.
15. *Picturegoer*, 10 November 1956.
16. John Osborne, quoted in the production notes of *Diamonds Are for Breakfast* (1968).
17. The phrase is used by John Hill in *Sex, Class and Realism* (London: BFI, 1986).
18. Lindsay Anderson, 'Stand up, stand up', *Sight and Sound*, Autumn 1956.
19. *Evening Standard*, 16 September 1960.
20. *Guardian*, 6 February 1963.
21. Dilys Powell, *Sunday Times* review of *Saturday Night and Sunday Morning* (BFI microfiche).
22. C. A. Lejeune, *Observer* review of *Room at the Top* (BFI microfiche).
23. *Sunday Times*, 10 January 1968.
24. *Observer*, 10 February 1963.
25. *Daily Express*, 6 February 1963.
26. *Daily Herald*, 6 February 1963.
27. *Picturegoer*, 29 December 1956.
28. The material about Burton, Baker and Connery is adapted from two pieces written by the author for *Sight and Sound*: 'Valley boys' (March 1994) and 'Before Bond' (October 1992).
29. *Sunday Times*, BFI microfiche cuttings on Baker.
30. *Ibid.*
31. Taken from the Stanley Baker cuttings, BFI microfiche.
32. See Gwyn A. Williams, *When Was Wales?* (Harmondsworth: Penguin, 1985).

The End of the Studio System

Whereas the break-up of the Hollywood contract system in the early 1950s gave the leading American stars the power to raise their fees to heights unheralded since the 1920s, while their tax laws gave them the incentive to set up in production with their own companies, the British actor had no high pay, no tax advantages and no power of any kind in the industry. (Walker, 1974, p. 93)

'THE TEENAGERS DID IT!' Thus reads a prominent headline in the very last issue of *Picturegoer*, which was published on 23 April 1960. The headline refers obliquely to the television presenter, Daniel Farson, who had become an overnight celebrity after devoting an entire edition of his show, *Living for Kicks*, to the problems of Britain's disaffected youth. There is, though, a large measure of irony about the story. The teenagers may indeed have made Farson famous, but it was also largely thanks to them that the UK's longest running film fan magazine was about to shut down.

Picturegoer, first published in January 1921, could not help but look anachronistic forty years on, in an era of pop music and X-movies. By the end, it was a magazine with no clear sense of its own agenda. On the one hand, it was naive and nostalgic: the world it evoked was full of gallant, handsome leading men and demure young starlets. On the other, it tried (without much conviction) to embrace teen culture as represented by Tommy Steele, Adam Faith, Cliff Richard and Elvis Presley (all of whom also had screen careers).

Picturegoer ended up absorbed by a short-lived magazine called *Date* (also published by Odhams Press), which billed itself as 'a gay new colour

weekly – with absolutely everything for out-and-about girls.'[1] Now film news, reviews and features had to take their place alongside the show-jumping column by Pat Moss (sister of the racing driver Stirling Moss), the knitting and beauty features, and 'the coffee club'. The film influence lingered on in *Date*, both in the reviews by Margaret Hinxman and David Hammond and in the occasional feature in which veteran British actor Jack Hawkins was pressed into service as an agony uncle, but this was a lifestyle magazine aimed squarely at young, would-be housewives. The emphasis was on romance and etiquette. In the weekly column, *The Right Thing to Do*, the magazine offered its readers all sorts of useful advice. 'If you've stayed the night at the home of your boyfriend's parents,' *Date* pronounced, 'always write a thank-you letter the very next day – even though you have thanked them before leaving. Remember to address it to your friend's mother – she was your hostess.'[2]

Picturegoer readers who wanted more than tips on how to ingratiate themselves with their prospective in-laws were guided in the direction of *Films & Filming*, a more highbrow read but also a magazine full of glossy pictures.

Why did *Picturegoer* close? The article on Daniel Farson offers some clues: 'Off-screen Dan is one of the shyest men I know – ironical for the interviewer who receives such publicity,' ventures the *Picturegoer* journalist. 'He lives quietly in one of the grimier reaches of Limehouse ... "Girlfriends? I haven't the time," Dan says casually.'[3]

If Farson's own account of the period is anything to go by, *Picturegoer*'s characterization of the young writer/broadcaster as studious and shy is way off-beam. According to his various memoirs, most notably *The Gilded Gutter Life of Francis Bacon*, Farson spent much of the 1950s and early 1960s 'raging around Soho' (Farson, 1994, p. 82) in a drunken stupor with his friends Bacon and John Deakin. If he did not have the time for girlfriends, it was probably because he was too busy fighting over boyfriends with Bacon (*ibid.*, p. 114).

The *Picturegoer* feature on Farson hints at the competing forces which were driving the publication to destruction. It is a piece about a television programme in a magazine ostensibly devoted to cinema. Its focus is on the disruptive power of youth, an unlikely choice of subject-matter for a magazine which desperately needed teenage readers to survive.

Whether or not *Picturegoer* noticed it, the make-up of the British cinema-going audience had changed: 'The percentage of 16–24-year-olds

in the adult audience nearly doubled between 1940 and 1960,' Sue Harper and Vincent Porter point out in an essay on changing audience tastes in 1950s Britain.

> The balance of men and women in the audience shifted too. In 1946, 62 per cent of adults were women and only 38 per cent were men. In 1950, the ratio of women to men fell to 52:48, and by 1952 the proportions were approximately equal. After 1953, men progressively constituted a larger share. By 1960, the proportion of men to women was 53:47.[4]

In other words, by 1960, when *Picturegoer* folded, young males made up the bulk of the cinema-going audience.

On a symbolic level at least, the demise of *Picturegoer* marked the end of the old-style studio star system. It was no accident that the magazine closed at a time when Pinewood and Elstree were in the doldrums. In December 1957, the Rank Organization failed to renew the contracts of many of its most important stars, John Gregson and Donald Sinden among them, for the simple reason that it could no longer afford them (Quinlan, 1984, p. 268). Production had been halved at Associated-British. As Rank and ABC made cutbacks, it was inevitable that fan magazines and trade journals alike would suffer in their wake. *Kinematograph Weekly*, which had been running for even longer than *Picturegoer*, was another casualty of the times, closing down in late 1959. As David Quinlan has written, 'the day of the big studio in Britain, financed by its proprietor's own films, was clearly over' (Quinlan, 1984, p. 288).

British films were still being made in considerable quantity, but the system had changed. Rather than a studio like Rank fully financing an ambitious slate of movies, the emphasis was on co-productions. Stars were now as likely to be attached to individual producers as to big studios. In the early 1960s, for example, Michael Caine was under contract to Harry Saltzman; Albert Finney had a contract with Tony Richardson's Woodfall Films; Peter Sellers was briefly under contract to the Boulting Brothers. As in Hollywood, the stars were also now more inclined to form their own production companies. In 1959, actors Richard Attenborough, Jack Hawkins and Bryan Forbes pooled resources with film-makers Michael Relph, Basil Dearden and Guy Green to form Allied Film-makers, a production and distribution outfit which received some financial backing from Rank (see Macnab, 1993, p. 226).

Sellers briefly joined with writer–producer Wolf Mankowitz to form Sellers–Mankowitz Productions Ltd. These were short-lived enterprises but they showed that the wheel had come full circle – now, rather than the company controlling the star, the international star was just as likely to control the company. As Alexander Walker points out (see above, p. 201), British screen actors boasted nothing like the influence of their Hollywood counterparts. While one or two (for instance, Peter Sellers and Richard Burton) wielded enormous power, the majority were employed on a film-by-film basis; they did not have their own production companies, and did not take producer or executive-producer credits on their movies.

Their attitude had certainly changed. No longer would British stars meekly do the publicists' bidding. In *Photoplay*, there is a comic account of Susannah York (or 'Susannah Scruffy' as the magazine nicknames her) turning up in a dishevelled state for the première of her film, *The Greengage Summer* (1961):

> It is very annoying when you hold a big première for a picture and the girl who stars in the film arrives with her face scrubbed clear of make-up, her hair brushed nonchalantly back and wearing an off-the-peg dress that looks more suitable for a teenage party ... Susannah explained that her invitation suggested she should come dressed 'as if for a picnic in the south of France', but the publicity man was not satisfied. Go home and change, he ordered. Susannah wouldn't.[5]

Despite occasional moments of high-minded censoriousness, *Photoplay* survived when *Picturegoer* didn't because it catered for the teen audience rather than preaching down to it. A glance at a selection of magazine covers from 1962 reveals just how much the culture had shifted. The new pin-ups were not Rank Charm School starlets – they were pop stars. Elvis Presley, whose film career was getting under way in earnest in Hollywood, was a well-nigh ubiquitous presence. He appeared three times on the cover in under a year. When Presley wasn't being hyped, Connie Francis, Billy Fury, Tommy Steele, Cliff Richard and Adam Faith were in the limelight instead. There was also evidence of a new internationalism. Sophia Loren, Brigitte Bardot and Claudia Cardinale appeared as regularly as their British counterparts.

In the UK, this might be described as the era of the anti-star. Susannah

York's youthful irreverence was matched by that of Albert Finney, who blithely told *Sight and Sound* 'I don't give a damn whether I'm a star or not.'[6] As if to prove the point, he followed up his success in the Oscar-winning *Tom Jones* (1963) by playing a psychopathic murderer in *Night Must Fall* (1964). Rebellion was clearly in the air. Even staunch old Rank contract actors like Kenneth More were turning obstreperous. In late 1958, in a fit of drunken bravado, More had heckled Rank boss John Davis at a swanky reception at London's Dorchester Hotel. He lost his role in *The Guns of Navarone* (1961) as a consequence and did not work for the studio again. Fellow Rank alumnus Anthony Steel also suffered in the new era. Steel – Cambridge graduate, army officer and the first husband of Anita Ekberg – disappeared off to the Continent in the early 1960s and was hardly seen again by the British critics until he appeared in a porn film, *The Story of O*, in 1975. Meanwhile, Jack Hawkins grumbled when his cameo as the priest in Cy Endfield's *Zulu* (1963) was whittled down in the editing process to such an extent that he claimed not to recognize the performance at all and Kenneth More was equally unhappy when his role in William Wyler's *The Collector* (1965) disappeared altogether.

Whereas much British film-making of the 1950s had been glossy without necessarily engaging the emotions, the new aesthetic encouraged by the Free Cinema was rougher. 'The thing can be appalling in many ways technically,' proclaimed Tony Richardson, as if writing a manifesto, 'and yet still be a wonderful and marvellous film. Gloss guarantees nothing ... whereas the gloss of technical perfection hampers the industry' (quoted in Murphy, 1992, p. 16).

There was a move away from studio-based film-making. Richardson and his colleagues preferred to work on location. When the most memorable roles were as down-at-heel women (Carol White in *Poor Cow*, 1967), borstal boys (Tom Courtenay in *The Loneliness of the Long Distance Runner*, 1962) or charming delinquents (Michael Caine in *Alfie*, 1966), and the actors themselves so vehemently disdained the trappings of stardom, there was little chance of studio publicists choreographing 1950s-style events like garden fête openings or Cannes Film Festival visits.

Despite the new realist aesthetic, the 1960s stars easily matched their predecessors in terms of both profile and glamour. If anything, their occasional surly behaviour made it that much easier for the teenage

cinemagoers to identify with them. It has long been accepted that British stars hold little sway in the US market. Nevertheless, in the 1960s, as US distributors grew more willing to invest in UK production, there was a new vogue for British movies and British actors alike. In 1965 it was calculated that 75 per cent of the films made in the UK were American-financed. In the following year, that figure was closer to 90 per cent (Robinson and Lloyd, 1986, p. 311). Whether showcasing Albert Finney roistering away in the title role in the United Artists-funded *Tom Jones* (1963), Michael Caine in the Paramount-backed *Alfie* (1966) or the Beatles in UA's *Help* (1965), US distributors now had a financial incentive to make sure that the new British films in which they invested were handled aggressively in the States. 'When I did Alfie, I had to do 175 loops to make it understandable in America,' Caine revealed with a measure of exasperation,[7] but the very fact that the studio was prepared to take such painstaking measures shows how much importance was placed on the film's American release.

From today's vantage point, the early 1960s seems the most paradoxical period in British film history. On the one hand, this was an era in which film-makers foregrounded local identity, and even stars started talking about a new style of 'folk acting',[8] earthy, demotic, and in stark contrast to the blandishments of the West End and Pinewood Studios. On the other hand, there was an emphasis on internationalism as Britain paid host to 'runaway' American productions and to a variety of big-name continental directors and actors. There was a new 'realism' in British cinema, but that in turn was complemented by an extraordinary will-to-fantasy. Whether Tom Courtenay day-dreaming in *Billy Liar* (1963) or Alan Bates living out the wish-fulfilment ideal of the young braggart-about-town in *Nothing but the Best* (1964), most of the protagonists in the so-called 'realist' films were determined to escape the constraints of their respective backgrounds. Some critics (notably John Hill, 1986) have railed against the machismo of the kitchen sink films, accusing them of an in-built misogyny. Still, the roles that women played in these films were infinitely richer and stronger than anything that their predecessors had tackled at Pinewood in the 1950s. (Kay Kendall was never offered a role to match that played by Julie Christie in *Darling*, 1965. Nor do you find Dinah Sheridan playing any character as hardbitten and recalcitrant as Rachel Roberts's widow in *This Sporting Life*, 1963.)

Whatever the contradictions, it was clear that the old-style star system

was gone for good. It was no longer viable for the studios to keep vast numbers of young actors under contract. 'Gone are the days when Mr Rank had his stables of stars, starlets and directors to fill the Odeon and Gaumont screens,' wrote one critic in 1966, as if looking back on an era already beyond recall (quoted in Murphy, 1992, p. 108). Actors themselves were markedly less enthusiastic about the contract system than they had been a generation before. 'People didn't want contracts any more. There was a period when people didn't like being tied down ... they didn't want to be told what to do,' recalled Olive Dodds, Rank's head of contract artists. 'Besides, the Rank Organization didn't want to be committed to paying people whether they were working or not. It became uneconomic.'[9] As Dodds pointed out, there was no specific point at which the contract system was brought to an end. Rather, it was allowed to die out gradually. 'You didn't renew contracts and in the end there were no contracts left to renew – so that was that.'

The passing of the studio era marks an appropriate point at which to end this study. By a neat quirk of irony, at least as many international stars were discovered in the immediate aftermath of the studio system as had ever been unearthed by Rank's and ABC's assiduous publicists and casting directors at Pinewood and Elstree. This, though, only underlines a fact that ought already to have become apparent throughout this study – in the UK, searching for stars will always remain the most inexact of sciences.

Notes

1. See advertisement for *Date* in *Picturegoer*, 23 April 1960.
2. *Date*, 30 April 1960.
3. *Picturegoer*, 23 April 1960.
4. *Journal of Popular British Cinema*, No. 2 (1999).
5. *Photoplay*, February 1962.
6. *Sight and Sound*, Spring 1961.
7. Caine interviewed by the author, Scarborough, October 1997.
8. *Sight and Sound*, Spring 1961.
9. Olive Dodds, interviewed by the author, March 1999.

Bibliography

Adair, G. (1986) *Myths and Memories*. London: Fontana.

Aspinall, S. and Murphy, R. (eds) (1983) *BFI Dossier 18: Gainsborough Melodrama*. London: BFI Publishing.

Baker, M. (1978) *The Rise of the Victorian Actor*. London: Croom-Helm.

Bakhtin, M. (1984) *Problems of Dostoevsky's Poetics*. Manchester: Manchester University Press.

Barr, C. (1977) *Ealing Studios*. London: Cameron & Tayleur/David & Charles.

Barr, C. (ed.) (1986) *All Our Yesterdays: 90 Years of British Cinema*. London: BFI Publishing.

Balcon, M. (1969) *Michael Balcon Presents . . . A Lifetime in Films*. London: Hutchinson.

Balcon, M. (1984) *The Pursuit of British Cinema*. New York: The Museum of Modern Art.

Balio, T. (1976) *United Artists: The Company Built by the Stars*. Madison. University of Wisconsin Press.

Barker, W. G. and Hepworth, C. (1935) *The Pioneers*. London: British Kinematograph Society.

Beauman, N. (1983) *A Very Great Profession: The Woman's Novel, 1914–1939*. London: Virago.

Benjamin, W. (1970) *Illuminations*. London: Jonathan Cape (pb edn, Fontana, 1992).

Bogarde, D. (1978) *Snakes and Ladders*. London: Triad–Granada.

Bouchier, C. (1995) *Shooting Star: The Last of the Silent Film Stars*. London: Atlantis.

Bragg, M. (1991) *Rich: The Life of Richard Burton*. London: Coronet.

Bratton, J. S. (ed.) (1986) *Music Hall: Performance and Style*. London: Open University Press.

Brett, D. (1995) *Gracie Fields: The Authorized Biography*. London: Robson Books.

Brunel, A. (1949) *Nice Work*. London: Forbes-Robertson.

Calder, A. (1991) *The Myth of the Blitz*. London: Jonathan Cape.

Calder, A. (1992) *The People's War*. London: Pimlico.

Caute, D. (1994) *Joseph Losey: A Revenge on Life*. London: Faber.

Chanan, M. (1980) *The Dream That Kicks*. London: Routledge.

Chappell, C. (ed.) (1949) *Picturegoer Film Annual*. London: Odhams Press.

Cockburn, C. (1975) *Bestseller*. London: Penguin.

Cohan, S. (1993) *Screening the Male: Exploring Masculinities in Hollywood Cinema*. London: Routledge.

Collier, C. (1929) *Harlequinade: The Story of My Life*. London: John Lane.

Cook, P. (ed.) (1985) *The Cinema Book*. London: BFI Publishing.

Cook, P. (ed.) (1997) *Gainsborough Pictures*. London: Cassell.

Curran, J. and Porter, V. (eds) (1983) *British Cinema History*. London: Weidenfeld & Nicolson.

Durgnat, R. (1970) *A Mirror for England*. London: Faber & Faber.

Dyer, R. (1979) *Stars*. London: BFI Publishing.

East, J. (1977) *Max Miller the Cheeky Chappie*. London: W. H. Allen.

Ellis, J. (1991) *Visible Fictions*. London: Routledge.

Farson, D. (1994) *The Gilded Gutter Life of Francis Bacon*. London: Virago.

Feeney-Callan, M. (1983) *Sean Connery*. London: W. H. Allen.

Fields, G. (1960) *Sing As We Go*. London: Frederick Muller.

Fisher, J. (1973) *Funny Way To Be a Hero*. London: Muller.

Fisher, J. (1975) *George Formby*. London: Woburn–Futura.

Forbes-Robertson, J. (1925) *A Player under Three Reigns*, London: Unwin.

Fussell, P. (1975) *The Great War and Modern Memory*. London: Oxford University Press.

Gielgud, J. (1981) *An Actor and His Time*. London: Penguin.

Gilbert, F. L. (1981) 'Production Facilities Ltd'. Unpublished memo held in the British Film Institute's Special Collections.

Gledhill, C. (ed.) (1991) *Stardom: Industry of Desire*. New York and London: Routledge.

Granger, S. (1981) *Sparks Fly Upward*. London: Granada.

Hansen, M. (1991) *Babel and Babylon: Spectatorship in American Silent Film*. Cambridge, Mass: Harvard University Press.

Hepworth, C. (1951) *Came the Dawn*. London: Phoenix House.

Higson, A. (1995) *Waving the Flag: Constructing a National Cinema in Britain*. Oxford: Clarendon Press.

Higson, A. (1996) *Dissolving Views: Key Writings on British Cinema*. London: Cassell.

Hill, J. (1986) *Sex, Class and Realism*. London: BFI Publishing.

Hoggart, R. (1958) *The Uses of Literacy*. London: Hogarth Press (pb edn, Pelican).

Howard, R. (1981) *In Search of My Father*. London: Kimber.

Kardish, L. (1984) *Michael Balcon: The Pursuit of British Cinema*. New York: The Museum of Modern Art.

Katz, E. (1980) *The International Film Encyclopedia*. London: Macmillan.

Korda, M. (1980) *Charmed Lives*. London: Allen Lane.

Kulik, K. (1990) *Alexander Korda: The Man Who Could Work Miracles*. London: Virgin.

Lee, C. (1978) *Tall, Dark and Gruesome: The Autobiography of Christopher Lee*. London: W. H. Allen.

Lee, S. (1947) *Screen Souvenir, 1946–7*. London: Findon.

Low, R. and Manvell, R. (1948) *The History of the British Film 1896–1906*. London: Allen & Unwin.

Low, R. (1971) *The History of the British Film 1918–1929*. London: Allen & Unwin.

Low, R. (1973) *The History of the British Film, Vol 1: 1906–1914; Vol. 2: 1914–18.* London: Allen & Unwin.

Low, R. (1985) *Film-making in 1930s Britain: The History of the British Film 1929–1939.* London: Allen & Unwin.

Lowenthal, L. (1961) *Literature, Popular Culture and Society.* Englewood Cliffs, NJ: Prentice Hall.

Macdonald, K. (1994) *Emeric Pressburger.* London: Faber.

McFarlane, B. (1997) *An Autobiography of British Cinema.* London: Methuen.

Macnab, G. (1993) *J. Arthur Rank and the British Film Industry.* London: Routledge.

Macqueen-Pope, W. (1952) *Ivor.* London: W. H. Allen.

Manvell, R. (ed.) (1947) *Penguin Film Review*, 4. London: Penguin.

Matthews, J. (1974) *Over My Shoulder.* London: W. H. Allen.

Merson, B. (1926) *Fixing the Stoop 'Oop.* London: Hutchinson.

Montgomery, J. (1954) *Comedy Films.* London: George Allen & Unwin.

Morgan, K. O. (1990) *The People's Peace.* Oxford: Oxford University Press.

Morin, E. (1960) *The Stars.* London: John Calder.

Morley, S. (1983) *Tales from the Hollywood Raj.* London: Coronet.

Murphy, R. (1992) *Realism and Tinsel.* London: Routledge.

Neagle, A. (1974) *'There's Always Tomorrow'.* London: W. H. Allen.

Noble, P. (1951) *Ivor Novello.* London: Falcon Press.

Nuttall, J. (1978) *King Twist.* London: Routledge & Kegan Paul.

Oakes, P. (1975) *Tony Hancock.* London: Woburn–Futura.

Orwell, S. and Angus, I. (eds) (1979) *The Collected Essays, Journalism and Letters of George Orwell*, Volume 1: *1920–1940 An Age Like This.* London: Penguin.

Orwell, S. and Angus, I. (1980) *The Collected Essays, Journalism and Letters of George Orwell*, Volume 2: *1940–1943 My Country Right or Left.* London: Penguin.

Pearson, G. (1957) *Flashback.* London: Allen & Unwin.

Pearson, R. (1992) *Eloquent Gestures: The Transformation of Performance Styles in the Griffith Biograph Films.* Berkeley, CA: University of California Press.

Powell, M. (1987) *A Life in Movies.* London: Methuen.

Powell, M. (1992) *Million-Dollar Movie.* London: Heinemann.

Pym, J. (ed.) (1998) *Time Out Film Guide 7.* London: Penguin.

Quinlan, D. (1984) *British Sound Films: The Studio Years 1928–1959.* London: Batsford.

Richards, J. (1973) *Visions of Yesterday.* London: Routledge & Kegan Paul.

Richards, J. (1989) *The Age of the Dream Palace: Cinema and Society in Britain 1930–1939.* London: Routledge.

Richardson, T. (1993) *Long Distance Runner.* London: Faber.

Ritchie, H. (1988) *Success Stories: Literature and the Media in England, 1950–59.* London: Faber.

Robinson, D. and Lloyd, A. (eds) (1986) *The Illustrated History of the Cinema.* London: Orbis.

Schatz, T. (1989) *The Genius of the System.* New York: Parthenon.

Schickel, R. (1962) *The Stars.* New York: The Dial Press.

Schulz, B. (1980) *The Street of Crocodiles.* London: Pan.

Seaton, R. and Martin, R. (1982) 'Gainsborough: The story of the celebrated film studio', *Films and Filming* (May) and 'Gainsborough in the 40s', *Films and Filming* (June).

Singer, K. D. *The Laughton Story: An Intimate Story of Charles Laughton*. Philadelphia: John C. Winston.

Spoto, D. (1994) *The Dark Side of Genius: The Life of Alfred Hitchcock*. London: Plexus (first published 1983).

Stannage, R. (1947) *Stars by Day*. London: Film Book Club.

Stead, P. (1989) *Film and the Working-Class*. London: Routledge.

Studlar, G. (1993) 'Valentino, optical intoxication and dance madness', in Cohan (1993).

Tabarez, G. (1996) 'Ivor Novello'. www.mdle.com/Classic Films/Guest/novello.htm

Taylor, A. J. P. (1985) *English History 1914–1945*. London: Pelican.

Thomas, N. (1991) *International Dictionary of Films and Film-makers*. London and Chicago: St James Press.

Thomson, D. (1994) *A Biographical Dictionary of Film*. London: André Deutsch.

Thornton, M. (1974) *Jessie Matthews*. London: Hart-Davis.

Tims, H. (1989) *Once a Wicked Lady: A Biography of Margaret Lockwood*. London: Virgin.

Truffaut, F. (1967) *Hitchcock*. New York: Simon & Schuster.

Turner, A. (1994) *The Making of David Lean's 'Lawrence of Arabia'*. Limpsfield: Dragon's World.

Vardac, N. (1949) *Stage to Screen*. Cambridge: Harvard University Press.

Walker, A. (1974) *Hollywood, England*. London: Michael Joseph.

Wapshott, N. (1990) *The Man Between: A Biography of Carol Reed*. London: Chatto & Windus.

Warren, L. (1937) *The Film Game*. London: T. Werner Laurie.

Wilcox, H. (1967) *Twenty-five Thousand Sunsets*. London: Bodley Head.

Wilson, S. (1975) *Ivor*. London: Michael Joseph.

Yates, E. H (1877–9) *Celebrities at Home*. London: Reprinted from *The World*.

Index